THE ARTIST AND THE
WRITER IN FRANCE

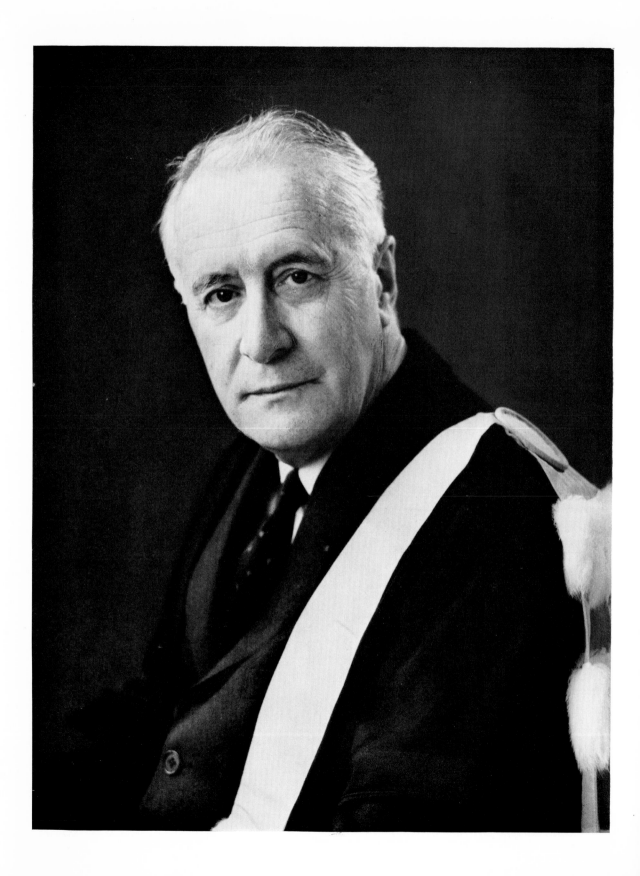

THE ARTIST AND THE WRITER IN FRANCE

Essays in honour of
Jean Seznec

EDITED BY

Francis Haskell, Anthony Levi
and
Robert Shackleton

CLARENDON PRESS · OXFORD
1974

Oxford University Press, Ely House, London W.1

GLASGOW NEW YORK TORONTO MELBOURNE WELLINGTON
CAPE TOWN IBADAN NAIROBI DAR ES SALAAM LUSAKA ADDIS ABABA
DELHI BOMBAY CALCUTTA MADRAS KARACHI LAHORE DACCA
KUALA LUMPUR SINGAPORE HONG KONG TOKYO

ISBN 0 19 817187 0

© *Oxford University Press 1974*

*Printed in Great Britain by
William Clowes & Sons, Limited
London, Beccles and Colchester*

FOREWORD

THE first major work of Jean Seznec, *La Survivance des dieux antiques*, appeared in circumstances ill contrived to ensure immediate success. Written in French and printed in France, it was published in London in 1940. Its author was a young man of 35 and known only to a select few, and the learned journals scarcely noticed its appearance. They were at fault, for the work was a masterpiece of innovating scholarship. At the same time a contribution to the literary history of the Middle Ages and of the Renaissance, to the history of art, to comparative religion and mythology, *La Survivance des dieux antiques* is a peerless work of synthesis. The author moves in the high line of inquiry of Fontenelle, Renan, Andrew Lang, Frazer, and Cumont, but he writes with no comparable preceding work to provide a pattern or to teach a method. He showed himself to be one of the few scholars who 'pour leurs coups d'essai veulent des coups de maître'. It is not surprising if, the next year, he received an appointment at Harvard or, on a lower level, if a young scholar at the start of his career in Oxford, reading *La Survivance des dieux antiques* in 1946, was struck with a sudden onset of admiration which he remembers to this day, and with the hope that one day the author might be attracted to Oxford.

Of Breton and (two generations back) of Breton-speaking origin, Jean Seznec is a *normalien*; he spent some seven years before the last war in Italy (Rome and then Florence), the visits being separated by two years at Cambridge and two years as *professeur de lycée* at Marseilles. He went to Harvard as associate professor in 1941 and soon became full professor. Since 1950 he has been in Oxford. He took up in that year the Marshal Foch professorship of French literature to which he had been elected on the retirement of its first holder, Gustave Rudler. He quickly made himself at home both in the University and at All Souls, to which the chair is attached, and his Oxford years have been and continue a period of mature and massive scholarly activity.

During his stay in Harvard, where Herbert Dieckmann was his colleague, he had formed a deep interest in Diderot. This received expression in his elegant *Essais sur Diderot et l'antiquité* (Oxford, 1957), delivered as the Flexner lectures at Bryn Mawr in 1955, in which much learning is lightly borne and much is added to our understanding of Diderot and of his age. The first of the four impressive quarto volumes of his *maximum opus* had appeared earlier in 1957: the critical edition of the *Salons* of Diderot, in which his collaborator for Volumes I to III was Jean Adhémar (whose personal note we are thus content to publish in this volume). This is not the place for a critical appreciation of the edition of the *Salons*, of which Georges May, reviewing the last volume

in *French Studies,* wrote: 'l'ensemble est à la fois énorme, admirable et en tous points monumental.' Let it simply be said that it is definitive in text and judgement, and that extraordinary skill has been shown in tracing the present locations of the works of art described by Diderot. The fine arts, which were used in *La Survivance des dieux antiques* as a source of evidence for intellectual history, become here more nearly an object of study in themselves, and a great degree of professional expertise is shown in the handling of them.

This foreword does not aim at giving a full account of the life or works of its subject, since Jean Seznec is an active and productive scholar, preparing a second edition of the *Salons* (a rare distinction for so grandiose a publication), collaborating in the new edition of the complete works of Diderot, and working on yet other subjects in the field he has made his own. Nor therefore is this volume in any sense a memorial volume. The editors in their desire to honour Jean Seznec have not sought to assemble a collection of articles on diverse themes by his many friends, pupils, and colleagues, and they have abstained from including any contribution of their own. Their aim has been to present to Jean Seznec a volume with some subject unity, in the particular area in which he is a master, that of the relation between French literature and the fine arts, and in seeking contributions they have attended more, though not exclusively, to the subject than to the author. Some of the contributors are his close friends, as are the editors; others are as yet almost unknown to him. But they all join in wishing to honour one of the great scholars of the century, a man who is perfectly at home in four countries, who has made outstanding contributions to the two distinct disciplines of French literature and the history of art, and who in the area in which they meet is *il maestro di color che sanno.* It is the hope of its editors that in honouring him they may give pleasure also to his wife.

1 July 1973 *R.S.*

CONTENTS

LIST OF PLATES

FRONTISPIECE: Jean Seznec. *Photograph Zoë Dominic*

<div align="center">(At end)</div>

I

NAPLES AS SEEN BY FRENCH TRAVELLERS 1630–1780

Anthony Blunt

ITALIAN writers on Neapolitan Baroque art love to make the point that French travellers in the eighteenth century failed to understand it and condemned it lock, stock, and barrel on their own standards. In support of this they usually quote the sweeping and scathing comment of Montesquieu in the diary which he wrote on his visit to Naples in 1729: 'A Naples, il me paroît qu'il est plus facile de se gâter le goût que de se le former. J'ai vu aujourd'hui 4 ou 5 églises: j'y ai trouvé des ornements, de la magnificence; aucun goût';[1] and this quotation could be supported by other equally sharp comments by the Président de Brosses and the abbé de Saint-Non, but, telling though these remarks are, they only represent a small part of the picture, and a study of the comments of French visitors to Naples in the century and a half from 1630 to 1780 shows that many of them were deeply impressed not only by the beauty of the Bay—on that subject they are all monotonously enthusiastic—but also by the buildings which they saw.

A study of the views on Neapolitan architecture expressed by French travellers is made easier by the fact that, with few exceptions, they all concentrate on a single group of buildings, the major churches and palaces put up in the first half of the seventeenth century, so that it is possible to compare their reactions to the same works. It may therefore be convenient to give a brief description of these buildings before examining the comments on them made by the French visitors.

All travellers mention the Palazzo Reale and the Palazzo degli Studi, now the Museo Nazionale, built in the last years of the sixteenth and the first years of the seventeenth century, but these are not typical of Neapolitan architecture properly speaking because they were designed by the Roman Domenico Fontana, who brought with him the style which he had invented for the buildings commissioned from him by Sixtus V, the Lateran Palace and the wing added by the Pope to the Vatican.

[1] *Voyages de Montesquieu*, ed. Baron Albert de Montesquieu (Bordeaux–Paris, 1896). For a full bibliography of the writings of travellers in Italy in the 17th and 18th cent. see L. Schudt, *Italienreisen im 17. und 18. Jahrhundert* (Vienna–Munich, 1959). Ceci's *Bibliografia per la storia delle arti figurative nell'Italia meridionale* (Naples, 1937), though excellent on Italian sources is much less complete about foreign travellers.

One other building of this period always attracted attention, the Gesù Nuovo, which was begun by the Jesuit Giuseppe Valeriano in 1584 on a classical Greek cross plan, though the decoration, begun after Valeriano's death, was in a fully Baroque style and is one of the most splendid examples of the skill of Neapolitan architects in creating harmonies of marble, gilding, and fresco.

Almost all visitors comment on three churches by the most important architect of the next generation, Fabrizio Grimaldi: S. Paolo Maggiore, the SS. Apostoli, and the Cappella del Tesoro in the cathedral, all fine examples of the same type of decoration, with frescoes dominating at S. Paolo and SS. Apostoli and marbling in the Cappella del Tesoro where the effect is heightened by the series of bronze statues and silver bust reliquaries and by the magnificent gilt-bronze grille.[2]

Most writers also show some interest in the Oratorian church of the Gerolomini, built in the last years of the sixteenth century by the Florentine architect Dionisio di Bartolomeo Nencioni, but richly decorated by local painters and marblers in the following century.[3]

The architect who really created the Neapolitan Baroque was Cosimo Fanzago, and it is over his work that the greatest differences of opinion arise among French travellers. They all visited the Certosa di S. Martino where they examined with varying degrees of enthusiasm or criticism the great cloister which owes its character mainly to his grey and white marble decoration, and the church where he created the most resplendent of all Neapolitan interiors with the aid of a brilliant team of marblers and of painters, who included Belisario Corenzio, Ribera, and Stanzione (Pl. 1). Most visitors also comment on the series of inlaid marble High Altars which he added to some of the most important Neapolitan churches, many of them of much earlier date: S. Domenico Maggiore, the Annunziata,[4] S. Maria la Nova, Monteoliveto, and SS. Severino e Sossio.[5] Some of them also speak of the marble decoration by his immediate followers, such as the choir of the Carmine and the steps leading up to the High Altar over the Confessional in S. Maria della Sanità. In domestic architecture Fanzago's palaces also come in for frequent comment, notably the Palazzo Carafa di Maddaloni, where he built the terrace and the monumental rusticated door, and the Palazzo di Donn'Anna, that fantastic creation standing like a palace from a Claude landscape jutting out into the sea beyond Mergellina (Pl. 4). It is also interesting to notice the reaction of French travellers to the *guglie*, or obelisks, which are a feature of Neapolitan—and all south Italian—architecture, and which frequently puzzled foreigners because in spite of their name they were not at all like the obelisks of antiquity (cf. Pl. 3)!

Only the latest visitors were able to comment on the buildings commissioned by

[2] Curiously enough none of them mentions what is probably Grimaldi's masterpiece, S. Maria degli Angeli, perhaps because it lay off the beaten track on the heights of Pizzofalcone.

[3] Its façade was altered in the late 17th cent. by

Dionisio Lazzari and again in the 1770s by Ferdinando Fuga.

[4] Destroyed by fire in 1757 and rebuilt by Vanvitelli.

[5] A 16th-cent. church remodelled after being seriously damaged in the earthquake of 1731.

Charles III—Capodimonte, Vanvitelli's Caserta, and Fuga's Albergo dei Poveri—and, as we shall see, these did not generally satisfy French taste.

The first French visitor to leave any clear account of the buildings of Naples was Jean Jacques Bouchard, who was there in 1632.[6] Bouchard was far from being a specialist in artistic matters—*libertinage* (in all its senses) was his special line—but he came with letters of introduction from Cassiano dal Pozzo, and though what really interested him was Neapolitan life, he reserved a section of his diary for the city's architecture. He first praises the Palazzo Reale and the Palazzo degli Studi, but he also mentions the Palazzo Gravina, begun in 1513 by Ferdinando Orsini, duca di Gravina, and says of it '[il] seroit beau s'il estoit achevé'.[7] On the churches he writes enthusiastically:

Reste a parler des eglises esquelles est la plus grande beauté et la plus grande magnificence des bastiments de Naples, et si vous autez cinq ou six eglises des plus anciennes de Rome, come St. Pierre, St. Jean, Ste. Marie majeure, St. Paul, St. Sebastien, etc., il n y a point de doute que les eglises de Naples vont de pair et peut estre surmontent celles de Rome en grandeur, en beauté d architecture, en dorures et autres enrichissements, mais surtout en sumptuosité d ornements, d argenterie et de tentures, la plus part estant toutes tendues de ces grands *coltre*, ou poiles funeraux de velours ou drap d or tous couverts de broderies d or.[8]

This is high praise indeed, even if it is not based on a very sophisticated understanding of the arts.

Of the other French travellers who visited Naples before the end of the seventeenth century Monconys,[9] Grangier de Liverdis,[10] Jouvin de Rochefort,[11] and Huguetan[12] have little to say on the arts and generally speaking simply quote from the local guidebooks, and Montfaucon, who was there in 1698, had eyes only for the remains of Antiquity.[13]

Of a quite different order of interest is the diary left by the marquis de Seignelay who was sent to Italy in 1671 by his father, the great Colbert. He only spent a few days in the city itself but his comments on what he saw are both observant and personal.[14] He found the Gesù Nuovo 'très belle' and pointed out a—not very close—similarity to St. Peter's in plan, and he also admired the marble decoration of the interior.[15] He was even more enthusiastic about the Certosa di S. Martino, where he admired the

[6] For a summary of Bouchard's travel diary see L. Marcheix, *Un Parisien à Rome et à Naples en 1632* (Paris, 1902). The full manuscript, which is in the library of the École des Beaux-Arts, has never been published.

[7] op. cit., p. 63. Marcheix prints *Granigna*, but the Palazzo Gravina is clearly meant since it is said to be opposite Monteoliveto.

[8] Ibid., p. 64.

[9] Balthasar de Monconys, *Journal des voyages de Monsieur de Monconys* (Lyon, 1665–6).

[10] Balthasar Grangier de Liverdis, *Journal d'un voyage de France et d'Italie* (Paris, 1670). The journey actually took place in 1660–1.

[11] A. Jouvin de Rochefort, *Le Voyageur d'Europe* (Paris, 1672).

[12] Huguetan, *Voyage d'Italie curieux et nouveau* (Lyons, 1681).

[13] Bernard de Montfaucon, *Diarium italicum* (Paris, 1702).

[14] P. Clément, *L'Italie en 1671* (Paris, 1867). On his way to Naples Seignelay had admired in the cathedral of Gaeta an ancient vase used as the font (op. cit., p. 178). This is the vase decorated with a relief of the Birth of Bacchus, signed by Salpion of Athens, which is now in the Museo Nazionale at Naples. It was also much admired by Poussin (cf. Blunt, *Nicolas Poussin* (New York and London, 1967), I.138).

[15] Clément, *L'Italie en 1671*, p. 182.

great cloister, and the church, of which he says: 'l'église est fort belle, très riche, en marbre de toute sorte de couleurs; tout l'ordre en est bizarre, et les chapiteaux des colonnes de même.'[16] He may have been surprised, but he was apparently not shocked either at the richness of the marbling or at the *bizzarrerie* of the order. In fact he seems to have positively enjoyed Fanzago's marble inlay and rich decoration, because he says of his High Altar at S. Domenico Maggiore (Pl. 2) 'leur grand autel est très-beau, composé de plusieurs sortes de marbres de différentes couleurs',[17] and of the old church of the Annunziata, destroyed by fire in 1757: 'Ce que j'y ai remarqué de plus particulier c'est le tabernacle et deux anges qui sont à côté de l'autel, tout d'argent massif.'[18]

Seignelay is the first writer—whether French or Italian—to describe the great staircase in the Palazzo Reale and his description is of interest both as providing information about the staircase itself and as throwing light on his own taste. The staircase, which had been built about 1650 almost certainly by Francesco Antonio Picchiatti,[19] was badly damaged by fire in 1837 and its present decoration dates from the restoration after that disaster. It is often assumed that in this restoration the structure of the staircase was changed and given its present magnificent form, but Seignelay's description is detailed enough to prove beyond any question that in all essentials it had this form in its original state. His note reads as follows:

L'après-dînée de cette même journée, j'ai été voir le vice-roi et j'ai fort remarqué le grand escalier par lequel on monte à son palais. Il est situé en entrant à gauche dans une grande cour carrée entourée, au premier et au second étage, de loges soutenues par de gros pilastres carrés. Cet escalier a quelque chose de fort grand et magnifique; la cage a de largeur deux fois sa longueur, qui est d'environ 14 toises. On trouve d'abord au milieu et en face, lorsqu'on y monte, une grande rampe de figure ronde qui conduit à un palier assez grand, au côté duquel sont deux larges piédestaux qui portent deux grandes figures couchées; on trouve à droite et à gauche de ce palier et de ces figures deux autres grandes rampes qui conduisent encore à deux autres paliers desquels on monte à droite et à gauche aux loges supérieures.[20]

This corresponds exactly to the present staircase, except for the fact that there are now no recumbent figures flanking the bottom flight.[21]

Seignelay's admiration for the staircase is of interest in the context of French architecture, because the design has many features in common with Le Vau's Escalier des Ambassadeurs, which was begun just before Seignelay left France, and was even more

[16] Ibid., p. 194. For *colonnes* he should have written *pilastres*.

[17] Ibid., p. 186.

[18] Ibid., p. 189. In the same church he admired an altarpiece by 'Claude Lorrain', whom Clément identifies as Claude Gellée but who was of course in reality Claude Mellin. As further evidence of the lack of classical prejudice in Seignelay's judgement it is worth noticing that he greatly admired Borromini's Filomarino altar in SS. Apostoli (ibid., p. 188), and the High Altar of the same church, now removed, which was one of the most splendid examples of Neapolitan

work, employing not ony marbles but semi-precious stones such as jasper and lapis lazuli.

[19] The evidence about the attribution will be discussed in my forthcoming book on Baroque and Rococo architecture in Naples.

[20] Op. cit., pp. 183 f.

[21] Seignelay's description is confirmed by the plan of the palace as it is shown on the map of Naples made about 1750 on the order of the duca di Noia (cf. C. de Seta, *Cartografia della Città di Napoli* (Naples, 1969), III, sheet 18).

closely related to earlier plans by Le Vau for a staircase in the west wing of the Louvre. It was possibly this similarity that attracted Seignelay, who may have known the designs for the Louvre and was certain to have seen that for Versailles; and it is worth noticing that several French travellers—even Montesquieu, as we shall see—found something to praise in it.[22]

Enthusiasm reached its highest point in the writings of three travellers who visited Naples in the last years of the seventeenth and the first years of the eighteenth century: Misson in 1688, and Rogissart and Blainville in 1707.

Although Misson only devotes a few pages to the city his comments could hardly be more favourable. He describes the city as 'une des plus nobles Villes du monde, et peut-estre la plus egalement belle... Londres, Paris, Rome, Vienne, et quantité d'autres Villes fameuses ont à la vérité de beaux hostels, mais ces hostels sont entremeslez de vilaines maisons, au lieu que Naples est généralement toute belle',[23] an unusual view because most visitors were struck—as one is today—by the contrast between the grandeur of the palaces and the squalor of the poorer houses in Naples. Equally unexpectedly Misson says: 'les ruës sont droites et larges pour la pluspart', whereas other travellers record that there were two or three broad streets—via Toledo, via Forcella, and via Monteoliveto—in a maze of narrow streets and culs-de-sac. He praises the fountains and many individual palaces, including Fanzago's Palazzo Carafa di Maddaloni, but when it comes to the churches he becomes lyrical:

Mais ce qui nous a paru le plus extraordinaire à Naples, c'est le nombre, et la magnificence de ses Églises: Je puis vous dire sans exagérer, que cela surpasse l'imagination. Si l'on veut voir de beaux morceaux d'Architecture, il faut visiter les Églises; il faut voir les portrails, les Chapelles, les Autels, les Tombeaux. Si l'on veut voir de rares peintures, de la Sculpture, et des charettées de Vaisseaux d'or et d'argent, il ne faut qu'entrer dans les Églises. Les voutes, les lambris, les murailles, tout est ou revestu de marbres précieux et artistement rapportez; ou à compartiment de bas-reliefs, et de menuiserie dorée et enrichie des ouvrages des plus fameux Peintres. On ne voit par tout que Jaspe, que Portphyre, que Mosaïque de toutes façons, que chef-d'œuvres de l'art. J'ay visité vingt-cinq ou trente de ces superbes édifices: on s'y trouve toujours nouvellement surpris.[24]

His taste is clearly for the full Baroque decoration of Fanzago and his followers, and this is confirmed by the fact that he praises individually all the churches mentioned above as typical of the richest Neapolitan Baroque.

The two Frenchmen who visited Naples in 1707, Rogissart[25] and Blainville,[26] write of the city at much greater length than Misson, but their accounts are coloured by

[22] Picchiatti's plan is of great importance in the development of staircase designs as it forms a link between the earlier imperial staircases in Spain (Alcazars of Madrid and Toledo), Genoa (Palazzo Doria-Tursi), and Venice (S. Giorgio Maggiore) and Le Vau's Escalier des Ambassadeurs.

[23] *Nouveau Voyage d'Italie* (5th edn., Utrecht, 1722), II.28.

[24] Ibid.

[25] *Les Délices de l'Italie* (Paris, 1707). Rogissart's book is illustrated with copies of the engravings in Samelli's *Guida dei forestieri*, first published in 1685 and frequently reprinted.

[26] Only published in English under the title *Travels through Holland, Germany, Switzerland and other parts of Europe But especially Italy* (London, 1745).

exactly the same somewhat naïve enthusiasm[27] and they show the same admiration for the richness of the churches and the magnificence of the palaces. Rogissart sums his views up in a paragraph at the end of his account of the city:

Voila ce que nous avions à dire des Églises de cette superbe ville. Nôtre description a esté un peu longue; ... Naples étant peut-être la ville du monde où il se rencontre le plus de belles choses, et les Églises de Naples étant ce qu'il y a de plus superbe et de plus magnifique dans la ville, ... Passons à present aux Palais profanes, dont nous ne promettons pas un détail exact: toutes les maisons de Naples pouvant passer pour des Palais, comme nous l'avons dit cy-dessus; mais nous nous contenterons de parler des principaux.[28]

Blainville does not make any such compendious statement, but his appreciation comes out in the description of every individual building.

Generally speaking, Rogissart and Blainville pick out for praise the churches mentioned by Misson, but each adds a certain number of his own special favourites. Rogissart extends his admiration for Fanzago to include the Cappella Cacace in S. Lorenzo Maggiore, one of the richest examples of his inlay,[29] and he also admires the choir of the Carmine, by Pietro Giuseppe Mozzetti and the interior of S. Gregorio Armeno with its magnificent gilt-wood organ and carved ceiling,[30] and the *guglie* of S. Gennaro (Pl. 3) and S. Domenico.[31]

Blainville, like Seignelay, greatly admired the staircase in the Palazzo Reale, but notes the fact that it is disproportionate to the palace itself: 'The Stair-case, raised by Order of Count *d'Ugnate*, would be one of the finest in the World, was the Court answerable to the Extent of the Palace.'[32] His individual taste is revealed by the monuments which he particularly praises and which are not noted by other travellers. One is the statue of the Madonna and Child by Pietro Bernini in S. Martino of which, he says, unexpectedly, that it 'far exceeds all the best performances of his son', the great Gianlorenzo Bernini,[33] and at the other extreme is the tomb of the brothers Giovanni Battista and Guiseppe Brancaccio by Pietro Ghetti in S. Angelo a Nilo,[34] a late Baroque fantasy which for us is difficult to appreciate as it challenges comparison with Michelozzo's and Donatello's tomb of Cardinal Rinaldo Brancaccio which faces it across the choir of the church.

The comte de Caylus who visited Naples in 1715[35] was the first French traveller who came with an expert knowledge of the arts, and with him the naïve enthusiasm of Misson, Rogissart, and Blainville disappears, to be replaced by a much cooler appreciation. Although he occasionally says that something is 'beau', his more normal term of praise is 'pas laid', which is applied to Solimena's ceiling fresco in the sacristy of S. Domenico Maggiore, the High Altar of the Gerolomini, and some frescoes in S. Maria Nuova;[36] of the interior of the last church he says that, instead of being marbled

[27] Rogissart frequently copies sentences from Misson verbatim.
[28] Op. cit. III.202 f. [29] Ibid., p. 100.
[30] Ibid., pp. 131, 148. [31] Ibid., pp. 82, 189.
[32] Op. cit. III.300.

[33] Ibid., p. 239.
[34] Ibid., p. 269.
[35] Cf. *Voyage d'Italie 1714–1715*, ed. A. A. Pons (Paris, 1914).
[36] Op. cit., pp. 200, 201, 204.

like most Neapolitan churches, it is 'doré mais assez mal', and the High Altar of the Duomo and the statue of S. Gaetano in front of S. Paolo Maggiore are described as 'vilains'.[37]

Given this cautious approach towards Neapolitan Baroque, it is somewhat surprising that he should be attracted by the richly inlaid High Altar in S. Teresa agli Studi (now removed) and Fanzago's incredibly elaborate chapel of S. Teresa in the same church, as well as the church of S. Martino which he describes as 'de rapport magnifique'.[38]

Caylus is the first French traveller to speak in any detail of Neapolitan painting. He shows a predilection for Ribera, whose works in S. Martino he describes as 'magnifiques',[39] and he calls Solimena 'habile homme' in connection with his decoration of the Sacristy of S. Paolo Maggiore.[40] As we shall see, this taste was to become canonical with French visitors.

The cold wind had started to blow and for the next twenty-five years it was to grow steadily chillier. The concept of *le bon goût*—or rather its negative aspect *le mauvais goût*—first rears its head in the comments of the Lyonnais architect Ferdinand Delamonce.[41] Delamonce was born in 1678 in Munich, where his father, a Lyonnais by birth, was working for the Elector of Bavaria, but the family returned to Lyons in 1682 and the boy received his training in that city. He spent the years 1710 to 1729 in Italy, visiting Naples in 1719. His view of Neapolitan Baroque is clearly stated in his general comment on the churches:

Plusieurs de ces édifices manquent encore de façades, et n'ont rien de remarquable par dehors; mais l'intérieur est au contraire d'une magnificence surprenante, quoique la plus grande partie soit de trés mauvais goût, parce qu'elles sont remplies, ou plutôt chargées de marqueterie en marbres pretieux d'un prodigieux travail, et souvent même, enrichies de bronze doré à feu. Tous ces superbes collifichets y sont prodigués jusqu'aux pavés et aux appuis des balustrades, en sorte qu'ils causent partout une confusion, qui choque étrangement les yeux des connoisseurs. Il est vrai qu'il y a quelques autres églises, où ce deffaut ne se fait pas remarquer et qui au contraire peuvent aller de pair avec plusieurs des belles églises de Rome.[42]

and this criticism is applied to several particular churches: the Gesù Nuovo is *maestoso* (*majestueux*?) but 'decoré d'un très mauvais goût'.[43] Unlike Rogissart he condemns the *guglia* of S. Domenico 'le dessein en étant d'un très mauvais goût et chargé d'un trop grand nombre de colifichets'. Unfairly, since Fanzago only designed the base of the monument, he takes it as a stick with which to beat this architect: 'le chevalier Cosimo Fanzago... a infecté cette ville par toutes ces ridicules productions qui éblouissent un peuple ignorant et auxquelles une infinité d'étrangers, peu initiés dans le bon goût, se

[37] Ibid., pp. 201, 203. [38] Ibid., p. 204.
[39] Ibid., p. 202. [40] Ibid., p. 201.
[41] Delamonce's views on Naples are recorded in a lecture, which was delivered to the Académie de Lyon in 1740 and of which the manuscript is preserved in the library of the Academy. It has never been fully published but selections are given by Ceci in "Viaggiatori stranieri a Napoli, III, Ferdinando Delamonce", *Napoli Nobilissima*, XV (1906), 145 ff. Ceci's trans-

cription occasionally slips into Italianized spelling which I have tried to correct, but I have not been able to check the text with the original manuscript.
[42] Op. cit. p. 149.
[43] Ibid., p. 150. Delamonce savagely condemns the façade of this church but he does not realize that it was composed of the materials of the 16th-century palace of the Principe di Salerno.

laissent encore surprendre';[44] yet he admires Fanzago's fanciful steps at the Trinità delle Monache, the interior of the Carmine ('des plus magnifiques'), and the marble steps in S. Maria della Sanità.[45] He is also enthusiastic about Borromini's Filomarino altar, which he describes as 'un vrai bijou'.[46]

Like Caylus he admired Ribera and Solimena, though he extended his approval to the work of other Seicento Neapolitan painters, particularly Mattia Preti and Luca Giordano.[47]

It was, however, with Montesquieu, who visited Naples in 1729, that the concept of 'le bon goût' found its first ruthless application. His sweeping condemnation of Neapolitan churches has already been quoted, and more of the same kind is to be found in his comments on individual buildings. In the Gesù Nuovo he found the architecture of the interior 'assez bonne', but immediately adds: 'excepté que les autels sont trop chargés d'ornements',[48] and later he develops this theme in more general terms: 'Les Napolitains aiment fort la multiplicité des ornements: ils en accablent leur architecture; ce qui fait que leurs églises sont infiniment riches et de mauvais goût. Ce ne sont pas des statues de marbre, mais d'argent, de métal; du reste, peu de bons ouvrages de sculpture; mais leurs sacristies sont pleines d'argenterie.'[49]

The only church to which he allows any merit is SS. Severino e Sossio, which was still substantially a sixteenth-century church.[50] Like most French visitors he allows some grudging praise to the Palazzo Reale ('très grand') and the Palazzo degli Studi ('un beau palais, qui n'est que commencé'),[51] and about the staircase in the former we are staggered to read that it is 'le plus beau de l'Europe'. Did he really mean that it was better than Versailles? It seems hardly credible. These further comments on the staircase are more curious: 'Il est du dessin du cavalier Fontana. Le cavalier Bernin disoit que le palais passeroit par l'escalier. Cependant, le palais est très grand; mais il n'est pas achevé.' The first statement is, as we have seen, untrue, and the second is unlikely in the extreme, since Bernini did not as far as is known, visit Naples after he left it with his father at the age of 2, half a century before the staircase was built. Finally we may note that Montesquieu follows what was becoming conventional taste among French visitors and praises Giordano and Solimena as painters.[52]

[44] Ibid., p. 150. [45] Ibid., pp. 149 f.

[46] Ibid., p. 150. Some confusion has been caused by his reference—with approval—to a building which he describes as the palace of Solimena and as being in the same street as the Palazzo Maddaloni and the Palazzo Filomarino. This is of course wrong because Solimena's house is just below S. Potito, near the Palazzo degli Studi. Ceci, in his comment on this passage, complicates matters by not realizing that in addition to the Palazzo Filomarino in the Piazza dei Banchi Nuovi, which is a long way from the Palazzo Maddaloni, there is another palace belonging to the same family, also called the Palazzo Bisignano, which is only a stone's throw from the latter. In fact Delamonce is probably referring to the Monte di Pietà

which corresponds with his description in position and in its general form. This is a late-16th-cent. building by Cavagna, built in a grand severe style which would have appealed to Delamonce's taste.

[47] Ibid., p. 151. The most curious passage in Delamonce's lecture (p. 148) is one which does not concern Neapolitan art; in it he attacks the architects of ancient Rome for the monotony of their temple designs which he says are all based on rectangles, whereas the moderns have used polygonal and all sorts of irregular plans. A very bold doctrine for an 18th-cent. Frenchman!

[48] Op. cit., II.7 [49] Ibid., p. 9.

[50] Ibid., p. 11. [51] Ibid.

[52] Ibid.

Ten years later the Président de Brosses saw Naples through the same eyes: 'Il n'y a pas un seul bon morceau d'architecture; des fontaines mesquines; des rues droites à la vérité, mais étroites et sales; des églises fort vantées et peu vantables, ornées sans goût et riches sans agréments.'[53] Speaking of earlier travellers who have taken a more favourable view of Naples he says:

S'ils veulent louer les églises pour leur grand nombre et les richesses immenses qui y sont prodiguées, j'en suis d'accord; pour le goût et l'architecture, c'est autre chose: l'un et l'autre sont, à mon gré, la plupart du temps assez mauvais; soit qu'ils le soient en effet, comme je le crois, ou que, comme on juge de tout par relation, j'aie les yeux trop gâtés par les véritables beautés des édifices de Rome. Les dômes sont oblongs, de vilaine forme, sans lanterne au-dessus, les tremblements de terre les ayant renversés, en un mot, de vrais Sodômes (sots dômes). Véritablement, les maîtres-autels, et surtout les tabernacles, y sont dignes de remarque, superbes et ornés de marbre et de pierres précieuses, avec une étonnante profusion. J'avais pris sur des tablettes une notice de ce qu'il y a de mieux à remarquer dans les principales églises, mais je ne sais plus ce que j'en ai fait. J'en dis autant des palais des particuliers que des bâtiments publics; ils n'ont point au dehors cet air de noblesse qui prévient, si l'on en excepte un petit nombre, comme ceux de Caraffa, Monte-Leone et principalement celui de Montalte, bâti avec des péristyles, galeries et colonnades, sur le bord de la mer: c'est un grand et beau morceau.[54]

The exceptions which he makes are of some interest. By 'Caraffa' he presumably means Fanzago's Palazzo Carafa di Maddaloni; 'Monte Leone' is the Palazzo Pignatelli di Monteleone next to the Piazza del Gesù Nuovo, which had recently been remodelled by Ferdinando Sanfelice; and from its description we can conclude that 'Montalte' must refer to the Palazzo di Donn'Anna,[55] so the Président de Brosses was not quite blind to the merits of Neapolitan Baroque, though he evidently thought it better suited to secular than to ecclesiastical use.

The Président de Brosses visited Italy to satisfy his own curiosity and was at least as much concerned with social and economic problems as with art. Cochin came in quite different circumstances. He was chosen in 1749 to be a member of the small train selected by the marquis de Marigny, brother of Mme de Pompadour and Directeur général des bâtiments du roi since 1746, to accompany him on his tour of Italy. Since the purpose of the visit was to perfect Marigny's taste, it is not surprising that the idea of le bon goût should play an important part in the comments of Cochin, who, though writing in his own name, evidently expressed views which were to some extent common to all the party, that is to say Marigny, Soufflot, and the abbé Le Blanc whose functions were to advise on matters of architecture and painting respectively.

Cochin himself was evidently much more interested in the paintings which he saw

[53] Lettres familières sur l'Italie, ed. Y. Bézard (Paris, 1931), I.408.

[54] Ibid., pp. 413 f.

[55] It is not clear why he calls it Montalte. It was built by Anna Carafa, Principessa di Stigliano and her husband the duca di Medina, and was later bought by a Mirelli, Principe di Teora. The name of Montalto does not seem ever to have been associated with the palace.

On the subject of Neapolitan painting de Brosses is chilly. He admired Ribera, dismissed Solimena as 'fade', and says of Giordano that he was 'presque digne d'être parmi les peintres de la seconde classe' (ibid., pp. 418, 433).

than in the buildings, and the section on Naples contains not only an account of the Farnese pictures in the Palazzo Reale and the antiquities of Herculaneum and Pompei at Portici, but also valuable details about the most important private collections in the city. The Neapolitan painters in whom he shows the greatest interest are, as we have come to expect, Ribera, Giordano, and Solimena, but on the whole he is more critical of them than his predecessors, and particularly of Solimena in whose frescoes he finds 'peu de vérité, mais beaucoup d'art'.[56] His notes are of interest, however, since he is the first Frenchman to mention the followers of Solimena, particularly Francesco De Mura and Paolo De Matteis, for both of whom he has qualified praise.[57] His most detailed analysis, devoted to Giordano ('le plus séduisant de tous'), is too long to quote here, but is very revealing as a statement of Cochin's views of Italian Baroque painting in general.

In connection with the painted decoration of Neapolitan churches, Cochin has one criticism to make which comes as a surprise from a French critic with classical taste. In several cases he complains that the ceiling frescoes are not 'de plafond'—i.e. not *plafonnants* or seen in proper perspective *di sotto in sù*[58]—and so takes the side of the full Italian Baroque painters such as Pietro da Cortona and Solimena, against their opponents Andrea Sacchi and Poussin, just at the moment when, in Rome at least, the most advanced painters—i.e. those heralding the return to classicism—were beginning to turn consciously against Baroque illusionism.

On Neapolitan architecture Cochin has some sharp things to say, much in the spirit of Montesquieu and de Brosses:

Le goût moderne de l'architecture, à Naples, est fort mauvais; les ornemens de la plûpart des chambranles extérieurs des fenêtres, sont tout-à-fait ridicules. On bâtit dans cette ville, avec beaucoup de dépense, des aiguilles ou pyramides, toutes revêtues de marbre, mais de la plus mauvaise forme, du plus méchant goût, et assommées de mauvaise sculpture. Il en coûteroit beaucoup moins pour les faire belles, et d'un goût sage et simple.

Il y a presque partout, sur le bord de la mer, des fontaines pour l'usage des matelots: mais elles sont toutes décorées de mauvais goût et de mauvaise sculpture, excepté une, où il y a deux figures d'hommes debout, qui soutiennent une architrave: ces figures sont assez belles.

Il y a un palais du Roi, sur une hauteur, dans les fauxbourgs de la ville, que l'on appelle, *Capo di monte*: il n'étoit que commencé lorsque nous l'avons vu; mais ce qui en étoit élevé, étoit beau et d'excellent goût. On croit que c'est *Van-Vitelli*, Romain, qui en est l'architecte.[59]

This passage requires some comment. The fountain to which he refers with approval is presumably the Fontana di S. Lucia, which then stood by the sea in S. Lucia, but was moved to the public gardens on the Riviera di Chiaia in the nineteenth century.

[56] *Voyage d'Italie* (Paris, 1758), I.145. Later (p. 196), however, he describes him as 'peintre d'un très-beau génie et d'une grande facilité'.

[57] Cochin's comments on painting are so extensive that it is only possible here to give this very brief summary. They are to be found scattered through the greater part of his account of Naples, mainly in pp. 130–202, with a summary on pp. 196–202.

[58] For instance the ceilings by Fabrizio Santafede in the Duomo (1621, p. 141), Lanfranco's in SS. Apostoli (1618–46, p. 160), Francesco De Mura's in SS. Severino e Sossio (1745, p. 166).

[59] Ibid., pp. 195 f.

De Brosses is, of course, wrong in ascribing the palace of Capo di Monte to Vanvitelli, who was only concerned with Caserta among royal palaces. Capodimonte was the result of an unhappy collaboration between Giovanni Antonio Medrano and Antonio Canevari. It was, as Cochin says, barely begun when he saw it and was not completed till nearly the end of the century by Ferdinand IV.

Cochin has, however, occasionally a kind word for an individual building. Of the Gesù Nuovo he says: 'elle est très belle pour le tout-ensemble de l'architecture',[60] the façade of the Palazzo Reale is 'd'un goût sage et grand', and Cochin adds: 'L'escalier est grand, d'une belle proportion, et susceptible d'être magnifiquement décoré; jusqu'à présent il ne l'est point.'[61]

The last two French writers of regular guide-books, the abbé Jérome Richard and Joseph-Jérôme La Lande, both visited Naples in 1765–6.[62] They say little that is novel about Neapolitan art, but they are of some interest in showing that not all French visitors were as inhibited as Montesquieu, de Brosses, and Cochin by the idea of *le bon goût*.

Richard praises the great Baroque churches with warmth. The Gerolomini is 'grande, belle et richement ornée',[63] and the Gesù Nuovo and the SS. Apostoli are each qualified as 'une des plus belles [églises] de l'Europe'.[64] La Lande is more cautious. He repeats Richard's words about the Gerolomini,[65] but for him the Gesù Nuovo is the most beautiful church in Naples, not in Europe,[66] and the SS. Apostoli is only 'grande et belle'.[67] Rather unexpectedly Richard finds Domenico Antonio Vaccaro's High Altar in the Ascensione—a bold piece of Neapolitan Rococo design—'travaillé avec goût',[68] but even more surprisingly La Lande has words of praise for Fanzago's façade of S. Teresa a Chiaia ('une belle façade'),[69] which had given pause even to Celano, the great advocate of Neapolitan Baroque, who describes it as 'una bizzarra facciata' approached by 'un bizzarra scala',[70] but both writers are shocked by the Neapolitan *guglie*. Richard says, somewhat naïvely, 'le goût de ces monuments n'a rien de la belle simplicité antique', and he quotes as examples the *guglia* of S. Gennaro (Pl. 3) and the *guglie* of the Immaculata recently erected outside the Gesù Nuovo,[71] both of which are criticized by La Lande in very similar but even more violent terms.[72]

Richard and La Lande are the first two French travellers to have the opportunity of seeing the new public buildings begun by Charles III and of judging the two architects

[60] Ibid., p. 163. Like everyone else he condemns the façade of the church without realizing the reason for its strange appearance (cf. above, p. 7, note 43).

[61] Ibid., p. 129. This remark is the only direct evidence to show that the original staircase never received its intended decoration.

[62] Richard's book appeared in 1766 under the title *Description historique et critique de l'Italie*, whereas La Lande did not publish his *Voyage en Italie* until 1789. Richard ran to six octavo volumes, La Lande to eight with a quarto volume of plates. Richard's book was reprinted in 1769 and 1770, apparently without major alterations, but La Lande brought his second edition of 1786 (quoted in this article) up to date either by a second visit to Italy or, more probably, by drawing on later guide-books.

[63] Op. cit. IV.147. [64] Ibid., pp. 133, 137.

[65] Op. cit. VII.89. [66] Ibid., p. 41.

[67] Ibid., p. 113. [68] Op. cit., p. 155.

[69] Op. cit. VI.575.

[70] *Notizie del bello dell'antico e del curioso della Città di Napoli* (Naples, 1856–60), V.569 (first published 1692).

[71] Op. cit., p. 121. [72] Op. cit. VII.39 f, 93 f.

whom he had called to Naples to build them, Luigi Vanvitelli and Ferdinando Fuga. Both writers are fairly cool about Fuga. La Lande simply describes him as 'un architecte fort connu' and mentions his Albergo dei Poveri without either praise or blame;[73] Richard cautiously says that the Albergo 'sera pour l'architecture un des plus beaux édifices de la ville'.[74]

Of Vanvitelli they speak with great admiration. La Lande says he was considered 'le premier architecte de l'Italie', adding 'enfin il fit éclore le goût de la bonne architecture à Naples',[75] and he gives a list of his works in Naples and prints a long description of Caserta, written, he says, under the eye of the architect.[76] Richard does not give any general estimate of the architect, but his account of Caserta, though shorter than La Lande's, is highly laudatory: 'Tous les voyageurs s'accordent à dire que quand cette maison royale sera finie, elle sera la plus belle et la plus regulière de l'Europe.'[77]

After the commonplaces of Richard and La Lande, the abbé Saint-Non's *Voyage pittoresque ou description des royaumes de Naples et de Sicile*[78] comes as a breath of fresh air. The abbé made the journey in company with Fragonard and Hubert Robert, and many of the engravings which make the *Voyage pittoresque* one of the most attractive of all travel books are based on their drawings. The party set out from Marseilles on 4 November 1777 and reached Naples in the first days of December.[79] Later they set off for the south, but we are only concerned here with the first volume which deals with Naples, and cannot wander into the fascinating accounts of Campania, Calabria, and Sicily which fill the remaining four folios.

Saint-Non was not competing with the writers of guide-books. He wrote about and illustrated what interested him, in landscape, antiquities, architecture, painting, or scenes of Italian life. What he did not like he either ignored or damned in perfectly clear terms.

In this last category falls the architecture of the Baroque, for which the fresh air turns into a blast even icier than that breathed by Montesquieu. 'Il n'y a pas à Naples une église qui ait un beau portail... Il n'y a pas au reste un beau palais... L'histoire de l'architecture de Naples sera donc bien courte, puisque tout ce que l'on peut dire de plus en sa faveur, c'est qu'il n'y en a pas.'[80] After this condemnation it is surprising to find that Saint-Non illustrates several Baroque buildings. In fact he goes so far as to describe the front of the Gerolomini as 'un des plus riches et des plus reguliers',[81] and of the interior he says: 'la peinture, la sculpture et l'architecture concourent et s'accordent à y former l'ensemble d'un beau Temple',[82] but in order, as he says, to add interest

[73] Ibid., pp. 139, 250. He calls the Albergo the 'Serraglio', confusing it with Sanfelice's Serraglio near the Ponte della Maddalena. In his note about Fuga La Lande also mentions the Neapolitan architect Mario Gioffredo, one of the leaders of the movement towards classicism who had recently rebuilt the church of the Spirito Santo.

[74] Op. cit. IV.196. [75] Op. cit. VII.249 f.

[76] Ibid., pp. 568 ff. [77] Op. cit. IV.227.

[78] Five folio volumes, Paris, 1781-5.

[79] Op. cit. I.36, 55.

[80] Ibid., pp. 69 f.

[81] The engraving which shows the church in its present form as remodelled by Fuga is of interest as showing that his alterations were complete by 1777, since their date is not recorded in available documents nor exactly deducible from the guide-books.

[82] Op. cit. I.69.

to the plates he shows the church decorated for a *festa* with processions filling one aisle of the interior and the whole of the piazza in front of it, an arrangement which adds to the picturesqueness of the engraving but obscures the character of the architecture. The only other Baroque buildings to be excepted from the general condemnation are the church of S. Martino, which, surprisingly, is said to be decorated 'avec beaucoup de goût',[83] and the Palazzo di Donn'Anna (Pl. 4).

About the latter Saint-Non goes as far as to say: 'Sans être d'une architecture bien pure, il a de la majesté; sa forme générale, sa situation avantageuse lui donneront toujours un aspect de noblesse qui fera passer sur les détails; et en l'achevant tel qu'il est il serait le plus beau palais de Naples';[84] and it is clear that one member of the party at least shared his admiration, for the engraving of the palace after a drawing by Hubert Robert gives perhaps the most vivid and striking impression of what it must have been like before it was reduced to the slum condition from which it is only just beginning to emerge.[85]

The most remarkable feature of Saint-Non's account of Neapolitan architecture is the fact that the only building in Naples which arouses his real enthusiasm is the Castel Nuovo; and this he views not, like previous writers, as a monument full of tragic historical association but as a noble piece of architecture: 'Ce monument du quator-zième siècle[86] est le seul de Naples qui ait en même-temps de la magnificence et du caractère. Sans pouvoir être cité ni pour l'architecture, ni pour la sculpture, il peut être regardé comme une production bien surprenante du siècle où il a été fait, et prouve que les arts n'y étoient point du tout ignorés.' Of the Triumphal Arch he wrote: 'très peu de personnes y prennent garde, quoique ce soit le plus beau, et peut-être le seul Edifice de la ville qui puisse être cité; tous les autres semblent être élevés en l'honneur du mauvais goût.'[87] With this final slap at the Baroque in the name of *le bon goût* Saint-Non shows himself a loyal follower of Montesquieu, but in his praise of the Castel Nuovo he opens up vistas which lead on to the nineteenth century, to the romantic views of Naples by artists as different as Géricault and Ruskin, both of whom made drawings of the Castel Nuovo from the *molo* which ran out from the quay just south of the Castle.[88]

Saint-Non's interest is not entirely confined to the past, and he devotes some attention to the works of Vanvitelli, the construction of which had been continued by his son Carlo since his death in 1773; but he is far from enthusiastic. In connection with the Annunziata, which Vanvitelli had begun to rebuild after the fire of 1757, he speaks of 'le génie de l'auteur', but complains that the site led to the building being too long and narrow.[89] Of the semicircular piazza designed in honour of Charles III, now the Piazza Dante, he says: 'Cette place est agréable par sa forme; mais son architecture

[83] Ibid., p. 77. [84] Ibid., p. 79.

[85] The engraving is inaccurate in several details, but is none the less impressive.

[86] It was, of course, largely rebuilt in the 15th cent.

[87] Ibid., p. 69.

[88] Géricault's drawing is in the sketch-book at Zurich, and Ruskin's in the collection of Mr. and Mrs. G. M. Whittin.

[89] This criticism is puzzling, as the church is in fact broad and spacious.

tout-à-fait lourde et maigre, en ôte tout l'effect.'[90] 'Bien lourde et bien froide' is also the phrase which he applies to Caserta, to which he only concedes great size and the richness of marbling, but even this richness is said to be 'en pure perte' owing to the coarse style of the whole. No doubt he was comparing Caserta mentally with the architecture of Ange-Jacques Gabriel, and, not unreasonably, found the comparison to Vanvitelli's disadvantage.

Saint-Non, Fragonard, and Hubert Robert visited Naples at the last moment of its architectural glory. Ferdinand IV's attempts to continue the works begun by Charles III were interrupted by political events, and the completion and decoration of Caserta and Capodimonte had to wait till after the Restoration of the Bourbons in 1814. In the intervening period many Frenchmen—too many indeed—had come to Naples, but as conquerors not visitors, and the Decennio, as their ten years' occupation is still called, left an indelible mark on the city. Religious houses were suppressed and often converted into barracks or administrative offices; their treasures were seized and their archives destroyed to a degree which makes the writing of the history of Neapolitan architecture a frustrating occupation. Most of the great families lost their estates and sold their palaces, which sank into slum conditions. But the French were not entirely blind to the need for improvements in the city, and, though they built little, they left one great work of engineering, the road to Capodimonte, carried on a boldly constructed viaduct over the valley in which stand S. Maria della Sanità and S. Gennaro extra moenia. It involved the destruction of several Baroque monasteries and palaces, but it created a magnificent approach to the city, which the visitor arriving from the Autostrada del Sole can still appreciate with gratitude today.

[90] Op. cit. I.67. While this essay was in the press I came upon two further descriptions of Naples by French visitors which are typical of their respective periods. The first is the *Journal d'un voyage de France et d'Italie fait par un gentil-homme françois l'Année 1661*, published in Paris in 1667. The author (pp. 517 ff.) is enthusiastic about 'la quantité de ses magnifiques Palais entre les plus superbes [d'Italie]... la magnificence de ses églises... la beauté de son pavé entre les plus commodes du monde'. The architecture of the Gesù Nuovo (p. 521) is 'bien entendue et encore mieux pratiquée'; the church of S. Martino is 'un chef d'œuvre dans son architecture et une merveille pour toutes ses beautés' (p. 524); and the staircase of the Palazzo Reale is 'des plus magnifiques de toute l'Italie' (p. 538). On the other hand Dupaty in his *Lettres sur l'Italie*, published in Rome in 1789, says quite simply: 'Les beaux-arts ne sont plus cultivés à Naples, si vous en exceptez la musique' (II.155).

II

DIDEROT AND HOUDON: A LITTLE-KNOWN BUST

Francis Watson

HOUDON first exhibited his sculpture at the *Salon* in 1769, but the five works he showed that year were not included in the published *Livret* and in consequence Diderot made no comment on them at all in his discussion of the exhibition in the *Correspondance littéraire*. In any case none of the sculptor's exhibits was a portrait bust of a contemporary of the type on which Houdon's fame rests. There was a *Buste d'une paysanne de Frascati* and a *Tête d'enfant*, but that is hardly the same thing. The other three works the sculptor showed were of a religious character. The next *Salon*, in 1771, included four of Houdon's portrait busts, but the commentary printed in the *Correspondance littéraire* is well known to present considerable textual difficulties. In fact Diderot leaned so heavily on the writings of others that his criticism is of much less interest than those of previous years. His original contribution consists merely of a series of laconic comments which he seems to have jotted down in front of the works themselves. The truth appears to be, as Jean Seznec emphasizes in his introduction to his edition of this *Salon*, that the whole business of writing regular commentaries on "ce maudit Salon" was becoming a bore to Diderot.[1] When it came to writing about the *Salon* of 1775, at which Houdon exhibited seven portrait busts, including two that posterity has agreed to be amongst his greatest masterpieces, the busts of Sophie Arnold and Gluck, he omitted to discuss the sculpture at all.

It is only from his last *Salon*, the commentary on the 1781 exhibition, that we learn anything of Diderot's views on Houdon as a portrait sculptor and here his comments are dry, unenthusiastic, and even unfriendly. On the famous life-sized marble of the seated Voltaire intended for the Académie française (but placed almost at once in the entrance hall of the Comédie-Française) his comments are distinctly critical. 'On n'en trouve pas l'attitude heureuse,' he wrote, 'c'est qu'on n'est pas assez touché de sa simplicité.' He found the drapery unsatisfactory and added, 'Pourquoi ces souliers sont-ils quarrés?', a remark which seems of little relevance today. Only the hands come in for praise: 'Les mains sont très bien.' On the life-sized *Maréchale de Tourville*, executed by Houdon for the series of *Grands Hommes de France* commissioned on the King's

[1] *Diderot: Salons*, ed. Jean Seznec (1967), IV.xiv.

behalf by d'Angiviller, the Surintendant des Bâtiments, and also exhibited in 1781, Diderot's remarks are a little more favourable. But even here the sharp comment appears: 'ce n'est pas de la sculpture, c'est de la peinture, c'est un beau Vandyck.' On Houdon's other works shown in this *Salon* (which included a bust of his friend Tronchin) Diderot's comments are minimal. All this is a little surprising since his personal relations with the sculptor were warm.

One of the laconic comments on the *Salon* of 1771 referred to above is, however, of some interest, though on personal and psychological rather than aesthetic grounds. A bust of Diderot himself by Houdon was no. 39 in the *Livret* of the *Salon* and against this entry the sitter merely notes 'Très ressemblant'. He was not alone in his view that it was a good likeness, for in discussing this *Salon* in the *Mémoires secrets*, Pidansat de Mairobert declared: 'On doit louer le feu que M. Houdon a su mettre dans son ouvrage. L'enthusiasme du brûlant auteur des Bijoux indiscrets semble avoir gagné l'Artiste dont les autres ouvrages n'annonce pas un caractere chaude & ardent.'[2]

Although the material used for this bust is not specified in the catalogue, the exhibited bust has generally been identified as the terracotta presented to the Louvre by Hippolyte Walferdin in 1880.[3] A number of repetitions of this terracotta bust in different materials, and occasionally with slight changes, are known. The most famous of these is a bust in white statuary marble in the Hermitage Museum at Leningrad. It had been created for Diderot's great admirer and patron, the Empress Catherine II of Russia. At the back, along the shoulders, it is incised:

Mr. Diderot. Fait en 1773 par Houdon

and has the following inscription cut into the square podium supporting the circular flared and moulded socle of Sicilian marble on which the bust rests:

Il eut de grands Amis et quelques bas jaloux
le soleil plait à l'aigle, et blesse les hiboux

the letters being filled in with black wax.

This surely must be the bust of which Diderot writes in a letter dated 23 March 1770: 'Le prince Galitzine fait faire mon buste.'[4] The reference must be to Prince Dimitri Alexeivitch Gallitzine who, as minister plenipotentiary from St. Petersburg to the French court, would thus have been the most suitable person to place the Empress's orders in Paris at this period.[5] Gallitzine was greatly admired by Diderot, who wrote of him a few years later: 'C'est un des hommes les plus honnêtes et les plus aimables, non pas de la Russie seulement, mais du monde entier.'[6] And it would have been in

[2] *Mémoires secrets* (edn. of 1788), XIII.108.
[3] *Catalogue des sculptures... de la Renaissance et des temps modernes* (1922), Cat. no. 1355. It is illustrated in L. Réau, *Houdon: sa vie et son œuvre* (1964), II, Pl. LIV.
[4] *Denis Diderot: Correspondance*, ed. Georges Roth (1955–70), X.40. The letter is addressed to his sister.

[6] He was appointed Russian representative in Paris in 1765. After mid-1774 Baron Grimm became the Empress's principal agent and adviser on art purchases in Paris and elsewhere in Western Europe.
[6] *Correspondance*, XIII.217. Letter to Dr. Cleve dated 8 Apr. 1774.

accord with Houdon's usual practice to have exhibited the preliminary terracotta before proceeding to cut the marble.

A second bust in marble, similar to the other in every respect and with almost exactly the same signature, date, and inscriptions, was also made for Russia and is illustrated here (Pl. 5). It was mentioned briefly by Réau in 1914,[7] but it was only in 1922 that it was brought to the attention of the general public in a guide to the Strogonov Palace Museum issued by the Soviet government, in which it is stated to be standing in the Hubert Robert Room, so named from the large number of works by that artist hanging on its walls.[8] These last, and one or two other works of art, were removed to the Hermitage when, in 1931, the greater part of the Strogonov art collection was sold by the Soviets in Berlin; in the sale the Houdon bust of Diderot formed lot 225 and was illustrated in the handsomely produced catalogue. It fetched DM 45,000.[9] After that it vanished from sight until a few years ago, when it was acquired by Mr. and Mrs. Charles B. Wrightsman of New York. At the moment of writing it is on loan to the Victoria and Albert Museum.[10]

This second marble bust must have been commissioned from the sculptor concurrently with the version ordered for Catherine II, by Alexander Sergevitch Strogonov who was residing in Paris at the time. Strogonov was a passionate francophile. After his return to Russia, the Empress wrote of him, 'Stroganof n'a garde d'oublier Paris; il n'a que cela à la bouche.'[11] During his stays in Paris (he was there twice, from 1752 to 1754 and again from 1770 to 1779) Strogonov moved in artistic and literary circles. He was on terms of friendship with most of the *Encyclopédistes* and knew Diderot well. In the very year that the bust was executed Diderot wrote: 'Je suis lié très étroitement à M. et Mad^e de Stroganoff.'[12] In addition, the Russian was a great patron of the arts and formed a large collection of French art of the period, with which he furnished the rooms of the great green and white palace which Rastrelli had built for his family on the Nevsky Prospect, where it still stands, though looking a little the worse for wear today. It would therefore have been natural, in any case, for Strogonov to have wished to possess a bust of the famous editor of the *Encyclopédie*. But there was a further reason. Strogonov was already patron of Houdon and had quite recently commissioned an unusually large bust of Catherine II herself from him, which was exhibited in the *Salon* in 1773.[13]

[7] 'Les Œuvres de Houdon en Russie', *Bulletin de la Société de l'Histoire de l'Art français* (1914), p. 52.

[8] СТРО АНОВСК Й КРАТКИЙ ПУЕВОА ТЕАБ (STROGANOFF MUSEUM, BRIEF GUIDE) (Leningrad, 1922), p. 7.

[9] *Sammlung Stroganoff*, Leningrad (Rudolph Lepke) 12–13 May 1931. No copy of the catalogue with the purchasers' names seems to survive. The auctioneer's own copy was destroyed during the last war.

[10] H: 32½ in.; W: 8¾ in.; D: 9¾ in.; the only difference from the Hermitage version is that in the inscription the 'F' of the word 'Fait' is not capitalized, and the point preceding it is omitted.

[11] L. Réaux, *Correspondance artistique de Grimm avec Catherine II* (*Archives de l'Art français*, 1932), p. 71.

[12] *Correspondance*, XII.229. Letter to Falconet and Mlle Collot dated 30 May 1773.

[13] *Livret*, no. 231. According to Réau, *Houdon: sa vie et son œuvre*, II.28, no. 97, it is now in the Hermitage Museum where there is also a bronze copy cast by Yakimov in 1908. As Houdon had never visited Russia, it seems likely that he had based his likeness on a portrait miniature by the enameller J.-C. de Mailly with whom he was on close terms of friendship.

Into the middle of his discussion of the sculpture in the *Salon* of 1773 Pidansat de Mairobert inserts a curious passage apparently referring to the busts of Diderot, although there is no suggestion in the *Livret* that either was exhibited on that occasion: 'L'auteur du Buste de M. Diderot', he writes, 'en nous le reproduisant une seconde fois, veut peutêtre nous dédommager de l'absence de ce savant & ne pas nous laisser refroidir sur son compte.'[14] It seems probable that he had seen the Strogonov bust, which was to remain in Paris for some years after the first marble had been dispatched to Russia. In the second part of this passage the author is, of course, referring to the fact that Diderot had left Paris for Russia in mid-1773 to visit the Empress Catherine (and was to remain there until the autumn of 1774).

When on 23 August 1780 the Conseil Municipal of Langres resolved to ask the famous writer for his portrait,[15] Diderot gave the town a bronze head which is only a slight variant of the marble original. That he should have chosen it for presentation to his birthplace, rather than a copy of one of the several painted portraits of himself which were in existence, is a further indication of his belief that it was the best available likeness. In connection with this gift Diderot wrote: 'Houdon s'est conduit très généreusement avec nos officiers municipaux; il leur en a envoyé ou doit leur en envoyer, cinq terres cuites. C'est un présent qu'ils ne sauront peutêtre trop apprécier.'[16] For Houdon to have modelled four more terracottas at this late stage would have been a very surprising thing. However, a letter of Mme de Vandeul, his daughter, makes it clear that they were in fact merely plaster casts of the bust, as one would have expected. 'La ville', she writes, 'envoya je ne sais quelle bagatelle à M. Houdon, qui de son côté répondit en envoyant à ces Messieurs des plâtres du buste dont ils avaient honoré de bronze.'[17]

That they were plasters (possibly coloured to resemble terracotta) and not modelled in terracotta is in keeping with the sculptor's usual practice, for Houdon was accustomed to supply his sitters with plaster casts of their portrait busts (to which the seal of the Houdon *atelier* was almost always attached as a guarantee of authenticity). They were doubtless intended for his sitters to present to their friends, just as a signed photograph might today be given away. The sculptor is, for instance, known to have furnished the actress Sophie Arnould with no less than twenty-nine plasters from the lively marble bust of her, long in the Hertford/Wallace Collection and now in the Louvre. There is no reason to think that anything like this number were produced of the Diderot bust, but several with the seal of the Houdon *atelier* are known. One coming from the Vandeul family and patinated to resemble bronze still belongs to the Tronchin family in Switzerland today. At least three are in Germany, notably an example painted black in the Bayerisches National museum, and another in the Gotha museum. A further

[14] *Mémoires secrets*, ed. cit., XIII.153.
[15] The documents are published by Maurice Tourneux in *Bulletin de la Société de l'Histoire de l'Art français* (1913), pp. 184–91. The Langres bronze is illustrated in G. Giacometti, *La Vie et l'œuvre de J. A. Houdon* (1929), II.39.

[16] *Correspondance*, XV.354. Letter to Mme de Vandeul dated 28 July 1781.
[17] Quoted by Roth in a footnote to the passage mentioned in n. 16, above.

example is in the National Museum at Stockholm, and still another belongs to the well-known authority on Houdon, Charles Seymour, Jr. of New Haven. Some of these may have come from amongst the four plasters given to the municipal officials at Langres.

In addition, two other marble versions of the bust of 1771 exist. In the Musée de Versailles is an example inscribed: 'A M. Robineau de Bougon Houdon sculpsit 1775'. This was presented by a descendant of Robineau to King Louis-Philippe in 1838 for the museum of portraits of famous Frenchmen he was assembling at Versailles. Another, coming from the Vandeul family, is in the Louvre with the original terracotta.[18]

To amplify this fragmentary excursion into the iconography of a writer whose aesthetic ideas and writings on art have been so penetratingly studied by M. Jean Seznec, it is perhaps worth mentioning two other related works here. In his book on the sculptor, Giacometti mentions[19] that Houdon made several reductions of the bust of Diderot. I have only been able to trace two. One in plaster, formerly in the Henri Piazza and Jules Strauss collections, is signed and dated 1780.[20] A second, said to be of terracotta but more probably of plaster coloured to resemble a *terre cuite*, appeared recently in an auction sale at the Hôtel Drouot in Paris.[21] Both are about one-third the size of the Hermitage and Wrightsman busts. It is also perhaps worth recording that, after the sitter's death, Houdon executed another head of Diderot of smaller size and varying slightly from the 1771 prototype. He exhibited it at the *Salon* of 1789 (no. 249).[22]

When the Diderot bust was sold in Berlin in 1931, a companion bust of Voltaire was sold with it. The two are shown in an illustration in the sale catalogue as standing on fluted half-columns in a small domed library (not the Hubert Robert room) in the Strogonov palace. The marble Voltaire was stated in the catalogue description to be dated 1775. This was puzzling, as Voltaire is known not to have sat to the sculptor before 1778, and as the bust had been lost sight of like the Diderot, it was impossible not to wonder if it might not be one of the numerous later copies of Houdon's busts of Voltaire, purchased merely to form a pendant to the Diderot. (No doubt this scepticism is reflected in the lower price of DM 18,000 which the bust fetched at auction in 1931.) In fact this, too, has recently come to light and has just been acquired by the Metropolitan Museum, New York (Pl. 6).[23] It is clearly a genuine and, indeed, an exception-

[18] *Catalogue des sculptures*, no. 1356. It is signed and dated 1775. The Versailles bust is illustrated in Reau, *Houdon: sa vie et son œuvre*, Pl. LV, no. 115.

[19] G. Giacometti, op. cit., I.38.

[20] It is illustrated ibid., II.163.

[21] *Tableaux anciens, meubles et objets d'art principalement du XVIIIe siècle*, Paris, Hotel Drouot, 6 Mar. 1972 (119). It is illustrated on the cover of the catalogue.

[22] Houdon seems to have kept a plaster of the bust of Diderot in his studio. It is to be seen in the top right-hand corner of the well-known painting *Houdon dans son atelier modelant le buste de Laplace* by Louis Boilly in the Musée des Arts décoratifs in Paris.

Maurice Tourneux in op. cit. above, n. 15, reproduces a further bronze head in the hands of a Paris *antiquaire* at that date. But Giacometti records that several modern surmoulages had been made in bronze, so its authenticity remains open until it has been examined.

[23] It was purchased after the 1931 sale by Mrs. Otto Kahn and was subsequently in the collection of Mrs. John Barry Ryan. It formed lot 224 in the Berlin sale. The dimensions are H: 18⅞ in.

ally fine example of what is perhaps Houdon's most popular and most often repeated subject. At the back it bears an inscription and the date 1778 which had evidently been misread by the Berlin cataloguer. Certainly Strogonov had purchased direct from the artist one of the very first versions in marble of the bust of Voltaire, as he had done in the case of Diderot five years earlier.[24]

[24] Réau, *Houdon: sa vie et son œuvre*, II.115, asserts that the bust of Diderot was engraved by Tardieu but there is no print in the Bibliothèque Nationale or the British Museum, nor is it recorded in any of the standard works. The writer would welcome any information about the existence of such a print by Tardieu or any other French 18th-cent. engraver.

III

ARTISTS AND *PHILOSOPHES* AS MIRRORED BY SÈVRES AND WEDGWOOD

Samuel Taylor

AFTER 1771 Diderot was to review only two more *Salons*, those of 1775 and 1781, and in these unfortunately his receptivity to new trends was dulled as he lost interest and had recourse to an element of plagiarism.[1] Having rounded on the 1769 *Salon* for presenting 'presqu'aucun morceau d'histoire, aucune grande composition'[2] he failed to perceive the first stirrings of an art that was conscious of a social and national purpose in the Louvre exhibitions from 1777 onwards. The over-all extent of this trend was small, but it stemmed from a new official policy[3] for the encouragement of painting and sculpture, on themes reflecting France's cultural heritage, military prowess and the glory of her monarchy. From 1776 onwards, the Directeur général des bâtiments du roi, d'Angiviller, began a series of royal commissions for painting and sculpture. At each biennial *Salon* from 1777 until the Revolution there appeared two or more historical paintings and four sculptures of major national figures.[4] By 1789 a dozen or more paintings and twenty-eight sculptures had been commissioned by d'Angiviller on behalf of Louis XVI, many by rising artists in whom stirred the first signs of the neo-classical spirit. Their subjects were from the past rather than the present, only the sculptures of Montesquieu and Rollin having any contact with the eighteenth century. If the work is didactic, it was not with the bourgeois ethic of a Lillo, a Lessing, or a Diderot, but with an aristocratic nostalgia for the heroic and with a patriotism founded in the achievements of the reign of Louis XIV. The association of the monarchy, and of the new monarch Louis XVI, with the prestige, the chivalry, military honour, and valour of the France of the classical age was an exercise in nostalgia as much as in propaganda.

The periodicals of the day reported a succession of works in the vein of de Sacy's *L'Honneur françois, ou histoire des vertus & des exploits de notre nation, depuis l'établissement de la monarchie jusqu'à nos jours,*[5] or the *Modèles d'héroïsme & des vertus mili-*

[1] See Jean Seznec, *Diderot: Salons*, Vol. IV: *1769, 1771, 1775, 1781* (Oxford, 1967), p. xxi.

[2] Ibid., p. 65.

[3] J. Leith, 'Nationalism and the fine arts in France 1750–1789', in *Studies on Voltaire and the Eighteenth Century*, LXXXIX (1972), 919–37. See also J. Seznec, *Salons*, IV.300.

[4] See lists printed by J. Leith, art. cit., pp. 935–7.

[5] 12 vols., Paris, 1769–84, see *Année littéraire* (1783), V.3.

taires; ou Histoire abrégée des plus célèbres guerriers, à l'usage de la jeunesse françoise.[6]
Fréron noted this new nationalism in the 1783 *Salon*:

On ne saurait porter les regards sur le *Salon* sans rendre de nouveaux hommages au monarque
bienfaisant qui encourage les beaux-arts avec autant de zèle que de magnificence. C'est les
rappeler à leur institution primitive que de les consacrer à célébrer, à immortaliser les actions
vertueuses. La peinture en nous offrant des traits sublimes de grandeur d'âme, de courage,
de générosité, prise dans les fastes de la nation; la sculpture par les statues des héros magna-
nimes qui se sont dévoués pour la patrie, & de ces génies mortels qui l'ont illustrée par les
ouvrages.[7]

Even the first serious historical accounts by antiquarian scholars of the medieval chivalry
and literary culture of pre-Renaissance France contributed to this growing sense of a
national heritage. There were moves to institute a national gallery of art in the Louvre,
though they were to achieve nothing before the Revolution. Various pictorial series
contributed to this patriotic mood. A *Galerie des hommes illustres vivants* was announced
in 1782 with the purpose, Fréron noted, of encouraging 'le désir des Sciences, l'amour
de la gloire, & la pratique de toutes les vertus; il excitera la plus noble émulation parmi
ceux qui consacrent leurs talents, leurs travaux & leur zèle, au bonheur & à la gloire
de leur patrie.'[8] Another similar series, *Les Illustres Français*,[9] by the engraver N.
Ponce, appeared from 1790, though its Prospectus appeared as early as 1785. D'Angi-
viller, in announcing the royal commissions for the *Salons* in 1774, effectively sealed
the betrothal of the arts and national propaganda in a well-known letter: '[Le Roi]
verra avec un intérêt particulier les peintres de son Académie retracer ces actions et ces
faits honorables à la nation. Quel plus digne emploi pour les arts que cette espèce
d'association à la législation des mœurs?'[10] A number of studies have appeared recently
emphasizing the profound mutations that overtook the concept of patriotism in these
closing years of the *ancien régime*.[11] Our present study leads inevitably to further in-
teresting conclusions on this subject.

The present work arose from the simple observation that a Sèvres porcelain series of
Figures des Grands Hommes, based on the royal commissions for the *Salons*, had a direct
counterpart and contemporary in the Josiah Wedgwood series of *Heads of Illustrious
Moderns, from Chaucer to the present time*. In each series literary genius was ranked
alongside military valour, spiritual leadership and eloquence, statesmanship and
scientific eminence, as objects of veneration. Yet the two views of the world of letters
that are offered in these parallel series differ so radically and expose the shifts in French

[6] 2 vols., Paris, 1779–80, see *Année littéraire* (1780),
III.121.
 [7] *Année littéraire* (1783), VI.220.
 [8] Ibid. (1782), VI.61.
 [9] *Les Illustres Français, ou Tableau historique des
grands hommes de France pris dans chaque genre de
talent* (Paris, 1790–), in folio, announced *Journal de
Paris*, 25 Aug. 1785.
 [10] *Apud*. P. Marat, 'Les Peintres et la vie politique

en France au XVIIIe siècle', *Revue du XVIIIe siècle*,
IV (1913), 358–9.
 [11] See Louis Trénard, 'Patriotisme et nationalisme
dans les Pays-Bas français au XVIIIe siècle' in *Studies
on Voltaire*, XC (1972), 1625–57. Also Werner Krauss,
'*Patriote, patriotique, patriotisme* à la fin de l'Ancien
Régime' in W. H. Barber *et al.*, *The Age of the En-
lightenment. Studies presented to Th. Besterman*
(Edinburgh, 1967).

social attitudes so sharply that the two ceramic galleries present themselves as social documents.

At the Manufacture royale de porcelaine at Sèvres, the comte d'Angiviller commissioned the series of *Figures des Grands Hommes* as library-size reductions in biscuit, which is an unglazed and uncoloured porcelain giving the effect of true sculpture in stone. The same sculptors who produced the originals for the Louvre were commissioned to fashion terracotta models of some 40 to 50 cm in height, from which moulds could be made and porcelain figures cast. At the new Etruria factory opened in 1769, Josiah Wedgwood and his partner and sales agent Thomas Bentley created a series of *Heads of Illustrious Moderns*. Though a British potter, Wedgwood included a formidable array of French figures,[12] past and present, in his collection, and the two series, composed at the same time and with very similar titles, offer views of the French literary world, but with what a difference!

Ceramic sculpture was largely a creation of the mid-eighteenth century. Although Meissen and other German factories had produced outstanding figures since the earlier part of the century, these were essentially ornamental and their high glaze and brittly beautiful colouring subordinated the subject-matter to a decorative transformation and rebirth. Earthenware, on the other hand, was far too crude a medium to give an accurate likeness. It was the discovery by Josiah Wedgwood in the 1760s and 1770s, first of the black basaltes body and then of his famous jasper body that made true likenesses possible. At Sèvres the abandonment of glaze and colour for a biscuit finish in the 1750s had earlier made ceramic sculpture a possibility. First of all in the soft, or artificial paste, and then from 1772 in a true or 'hard-paste' porcelain, the Sèvres sculpture department achieved the means of disseminating to a considerable public copies of works of plastic art that themselves achieved the highest artistic standards. By the same process, the mantleshelf and library furnishings of the gentry became a visible record of the dissemination of the works of major writers and thinkers through society.

Wedgwood established the vogue for the collection of ceramic portraits largely by his own efforts, and with the collaboration first of James Tassie and then of John Flaxman who supplied him with casts and models. The growth of the collection may be traced in the *Catalogues*[13] published by Wedgwood and Bentley from 1773 onwards, although the precise dating of particular models is not always possible. From these catalogues, however, and from the indications furnished by the materials used, the

[12] 'The bulk of our particular manufactures you know is exported to foreign markets, for our home consumption is very trifling in comparison to what is sent abroad', letter dated 2 Mar. 1765, in *Letters of Josiah Wedgwood 1762–1772* (London, 1903), I.31; also *Letters of Josiah Wedgwood 1772–1780* (London, 1903), *Correspondence of Josiah Wedgwood 1781–94* (London, 1906). Subsequent references will be by date, thus: *Letters* (7 Nov. 1784).

[13] *A Catalogue of cameos, intaglios, medals and bas-reliefs ... made by Wedgwood and Bentley ...* 1st edn., London, 1773 (British Museum T447[3]); 2nd edn., 1774 (BM: 1651–197); French edn., 1774 (BM: T259[6]); 4th edn., 1777 (BM: 824b17[7]); 5th edn., 1779 (*apud* W. Mankowitz, *Wedgwood* (London, Spring Books, 1966), pp. 213 ff.); 6th edn., 1787 (after Bentley's death) (BM: 679, d22[3]).

signatures, and records and letters in the Wedgwood archives, etc., enough evidence exists to give helpful pointers. The series entitled *Heads of Illustrious Moderns, from Chaucer to the present time*, marked a deliberate attempt by Wedgwood and his partner to match their reproductions of gems and figures from Greek, Roman, and Egyptian sources with a modern counterpart. By 1787 they had amassed some 229 separate portraits of which a substantial proportion were French.

The 1773 *Catalogue* listed a mere six French names (Boileau, Gassendi, Mme Dacier, Montesquieu, Voltaire, and Rousseau), the entire series of Moderns at this date being a commercial experiment. Saint-Évremond joined the list in 1774, and thereafter the list expanded so rapidly that by 1777 the catalogue gave a very representative French collection of figures from the sixteenth to the eighteenth century. Though we are concerned here exclusively with writers, a respectable group of non-literary eminences grew up with them: Le Tellier, Fleury, Mazarin, the Cardinal de Rochefoucauld, Louis XIV, Louis XV, Louis XVI, Marie Antoinette, the Maréchal de Saxe, the Cardinal de Noailles, the Prince de Condé, the duc de Sully, Colbert, and Henry IV in particular. The *Heads* series consisted exclusively of cameos, though Wedgwood also produced a less ambitious series of intaglios for use as seals etc. with some of the same figures. There were in addition series of busts and of portrait figures, these being an entirely separate undertaking to the cameos. The Cameos appeared in many differing sizes from a mere inch in diameter to the size of a large plaque of ten or more inches (see Pl. 7).

The French names listed in 1777 give some considerable insight into the British taste for Continental writers and thinkers at the time.[14] The period was one of a considerable penetration of the English reading public by French writers both through the medium of translation and in the original French. Josiah Wedgwood's extensive portrait lists reflected a genuine and informed taste for French writers in Britain. Like his translator counterparts, Josiah Wedgwood placed before the public of his day scientists, divines, dramatists, poets, novelists, historians, encyclopedists, political theorists, moralists, deists, theologians, and every conceivable shade of intellectual activity. Like the many retranslations of the more popular authors, following their first appearance in translation, the portrait medallion and cameo of Wedgwood appeared in a range of sizes for those authors whose literary penetration assumed the proportions of a cult.

The list of 'Philosophers, Physicians &c' in the 1779 Catalogue of *Illustrious Moderns* includes thirty-four portraits of whom nine are French (Gassendi, Descartes, Rousseau, d'Alembert, Diderot, Montaigne, La Condamine, Fontenelle, and de Moivre) and the remainder are Italian, Swedish, Swiss, and American as well as British. French entries in the lists of 'Divines, Artists, Antiquaries, Poets &c' are even more comprehensive and include Boileau, Anne Lefèbvre, Mme Dacier, Saint-Évremond, Voltaire, Montesquieu, Mazarin, Préville the actor, the duc de Sully, M. de Sartine the police chief and

[14] See *The New Cambridge Bibliography of English Literature*, ed. George Watson, Vol. 2: *1660–1800* (Cambridge, 1971) [Literary relations with the continent (France), cols. 77–152, also Translations from French, cols. 1501–38].

minister, Crébillon, Molière, d'Alembert, Agnès Sorel, Henry IV of Navarre, Mlle Clairon the actress, Mme du Bocage, Mme de Pompadour, Mme du Châtelet (scientist and friend of Voltaire), Pierre Corneille, Mme de Sévigné and daughter Mme de Grignan, Marmontel, Coysevox, Mme de la Sage [Antoine René le Sage?], Mme du Barry, Madeleine de Scudéry, Mme d'Estrées, Mme de Montespan, Fénelon, La Fontaine, Mme des Houlières, Pascal, Ninon de l'Enclos, Racine, Pierre Gassendi, Turenne, and finally Descartes. The French entries totalled over half of the sixty-six names in the full list and a number are repeated in different sizes. A more comprehensive and a more modern list could hardly be conceived of, as the list includes names from most branches of science, philosophy, and *belles-lettres*. Though some names may have been intended for the French market primarily, this seems an unlikely suggestion, and the list is designed for a British public very well-informed of French thought and of the French social scene of their day. Women figure prominently in the lists and rise to the proportions of a separate list of famous or notorious ladies, consorts, writers, and royal favourites. For the English public these names did not represent prominent foreigners so much as the dominant figures in their own cosmopolitan culture.

The inclusion of a name amongst the busts, and even more so amongst the statuettes, became an explicit statement by Wedgwood as to their fame and reputation in England. He had only William Hackwood on whom to draw for most of his detailed work of this order, and he was under severe pressure to complete orders for more profitable lines. Josiah Wedgwood wrote to Bentley in London that he could not accede to his constant demands for more busts and figures since 'Hackwood is employed constantly in repairing gems, Massey in making seals, Bedson in gems & bass-reliefs, & Barnet at vases, flowerpots, lamps & handling, & these are all the hands we have besides Rbt., the turners, & odd men so that moulding from the busts & figures, & making them is at present unprovided for & all the T.pots & flowerpots, vases &c we can be suppos'd to get up with one finisher & an apprentice must be very small.'[15] It was about a week's work for Hackwood to finish off the model for a bust, despite which Wedgwood yielded to his friend's persuasion and announced that he would establish 'a collection of the finest heads in this world'[16] over a two-year period from 1774. None the less after Bentley's death in 1780, Josiah allowed the list of busts and figures to stand fast in the catalogue with no significant addition to their numbers. For all his business doubts, Wedgwood did not lose a sense of the historical and philosophical importance of such figures:

Those who duly consider the influence of the fine arts upon the human mind, will not think it a small benefit to the world to diffuse their productions as widely, and to preserve them as long as possible; for it is evident, multiplying the copies of fine works in durable materials, must have the same effect upon the arts as the invention of printing has upon the sciences; by these means the principal productions of both kinds will be for ever preserved; and most effectively prevent the return of ignorant and barbarous ages.[17]

[15] *Letters* (2 Mar. 1774).
[16] *Letters* (16 Aug. and 11 Sept. 1774).
[17] 1779 Catalogue *apud* Mankowitz, p. 253.

The statement is an historic one claiming a new social function for reproductive art, and establishing it quite deliberately as one of the forces acting as an enlightening influence upon man. Wedgwood is conscious of the role of the plastic arts as an instrument for the diffusion of reason and humanity throughout educated society.

Two collections were issued by Wedgwood, the one being of cameo portraits, the other of busts and figures. Cameos formed a popular and relatively cheap mode of reproduction, and were collected in sets by persons of moderate means. The popularity of certain particular portraits is immediately visible from the variety of sizes in which they would be available to the public. This indication is even clearer for busts and statues, in which Voltaire and Rousseau dominate the scene totally amongst Frenchmen, with the exception of a single bust portrait of Montesquieu. In the series of 'Busts, small statues, boys, animals &c' Voltaire and Rousseau appear in more versions than any other figure, British or Continental, with the exception of Locke and Newton. Outside the catalogues even this exception disappears, there being at least two other versions of Voltaire and Rousseau that were completed some time after 1780 and did not figure in the catalogues.[18] The public paired Voltaire and Rousseau in its imagination much as it paired Newton and Locke, pairs of busts being a natural furnishing for mantleshelf, cabinet, or desk. Moving from busts to statuettes, Voltaire and Rousseau appear as the only modern entries in the list, regardless of nationality, all the other statuettes being of subjects from Antiquity. With such insistent pairing of the names of Voltaire and Rousseau it is easy to forget the very sharp personal and philosophical differences separating them in the flesh. Wedgwood's linking of the two names is clear indication that the process of myth-formation that linked their names in France had a parallel in Britain.

Wedgwood's first model for his Voltaire appears to have been the sculpted portrait by Joseph Rosset of Saint-Claude in the French Jura, a remarkable ivory sculptor. He was to use the Rosset bust, and later the Rosset standing figure of Voltaire. The Rosset *statuette en pied* reached him in July 1777,[19] and he is reported to have completed several basaltes figures later that same year for dispatch to London (see Pl. 9). Wedgwood remained faithful to the various Rosset likenesses for some years, but then transferred his allegiance to the superior likeness offered by the Lunéville ceramic sculptor, Paul-Louis Cyfflé. The facts relating to this transfer are uncertain but it was possibly during the 1780s. An example of the Cyfflé passed at Christie's in 1773, but it had been on sale in France since 1767 and was the most widely imitated likeness of Voltaire for many years, itself following Lemoyne in many respects. All the known Wedgwood Rousseau busts follow the Cyfflé model, though Wedgwood may have borrowed the likeness from a Derby Rousseau of *c.* 1775. With a standing figure of

[18] C. T. Gatty, ed., *Liverpool Art Club: Catalogue of a Loan Exhibition of the Works of Josiah Wedgwood 1879* (Liverpool, 1879). A 20 in. bust of Voltaire (no. 1120) and a 7 in. bust of Rousseau and of Voltaire are listed (nos. 1150–1). An 8 in. bust of Rousseau passed at the Oster Sale, Sotheby, 16 May 1972,

lot 417, dated *c.* 1785 by Mr. G. W. Elliott of City Museum and Art Gallery, Stoke on Trent.

[19] *Letters* (10 July 1777), a reference supplied by Mr. W. A. Billington of the Wedgwood Museum, Josiah Wedgwood & Co. Ltd.

Voltaire on his lists, Wedgwood naturally seized the chance to add a companion figure of Rousseau in 1778. He met Brooke Boothby, the publisher of Rousseau's *Dialogues*, in Lichfield in July 1778 and obtained from him a copy of the Mayer drawing of Rousseau 'venant d'herboriser dans les jardins d'Ermenonville au mois [de] juin 1778'.

This figure will make an excellent companion to Voltaire & I intend to have it modelled for that purpose. He is drawn with a walking stick in his left hand & his hat under his arm. His other hand extended a little forward & contains a nosegay or plants. I am in doubt whether to follow the drawing in that respect, as our statue if it gives him any character at all, should bestow that on him for which he is the most famous, & that I apprehend is not the botanist.[20]

The 'Herboriseur' Rousseau was finished on 2 September 1779 and was sold as a pendant to Voltaire in the black basaltes finish (Pl. 8). Voltaire's black sheen was not 'an indication of the great philosopher's presumed connection with the devil', as one person had it,[21] nor even clerical fervour on the part of Josiah, who noted with a smile that 'The clergy will buy him in that colour & we will make him in white for the laity.'[22] The black basaltes gave the effect of antique bronze and flattered saint and sinner alike. Wedgwood had indirect contacts with Rousseau through Brooke Boothby and also through members of the Davenport family,[23] though in neither case were the contacts close. His comments on Rousseau in fact are remarkable not for any trace of personal regard but rather for the manner in which he asserts the aim to portray not merely the man but also the nature of his reputation in Britain. In actual fact he retained the reference to Rousseau the botanist in the statuette and it went on sale, with the Voltaire, at 31*s.* 6*d.* each.[24] Compared with the shilling cameos, these were luxury items. That the busts caught on is evidenced by the swiftness with which other Staffordshire potters as well as the Derby porcelain factory offered versions,[25] all stemming from the Cyfflé models.[26]

The multiple hues of French Enlightenment thought are all visible in the portrait gallery composed by Wedgwood, as well as the outstanding figures in the French classical culture of the late seventeenth and early eighteenth centuries. His collection of *Heads* is a remarkably faithful reflection of British sensitivity to French intellectual and literary life in the eighteenth century. It reveals both the enormous range of this

[20] *Letters* (28 July 1778).

[21] Miss Metyard's words, quoted by F. Rathbone, *A Catalogue of the Wedgwood Museum Etruria* (Etruria, 1909), pp. 103 ff.

[22] *Letters* (24 Aug. 1778).

[23] 'Our neighbour Mr. Sneyd of Keel has married one of his daughters to young Mr. Davenport of Davenport. You knew his father, who gave Rousseau a hermitage in Derbyshire.' *Letters* (4 May 1777).

[24] *Letters* (28 July 1778, Sept. 1779, 8 May 1779).

[25] The Derby Rousseau is in the Victoria and Albert collection (Schreiber I.361) thought to be *c.* 1775. A companion figure of Voltaire is listed by F. Brayshaw

Gilhespy, *Derby Porcelain* (London, 1961), pp. 125–6, and attested to by Royal Crown Derby Porcelain Ltd. See also V & A Schreiber I.361 (Derby Rousseau); Schreiber II.312 (Burslem Rousseau); C306–1915 (Leeds Rousseau).

[26] N.B. not Leclerc. I am indebted to R. A. Leigh for detailed information regarding Rousseau's change of dress, which excludes the traditional dating of the Leclerc medal. Prof. Leigh also suggests that 1761 [MDCCLXI] is merely a misreading or misengraving of MDCCLXVI (1766) on the medallion; cf. H. Buffenoir, *Les Portraits de J.-J. Rousseau* (Paris, 1913), p. 118.

impact and also the extent to which the emergence of Voltaire and Rousseau as representative figures of the age was common to both countries.

Josiah Wedgwood was in every sense a Modern. An outstanding industrial chemist, the industrialist who transformed ceramic processes and gave the Potteries an international reputation, and a mercantilist, he was also something of a radical and a philosopher. He was remarkably well-informed, and cosmopolitan to a degree that found no parallel in French manufacturing circles. The greater part of his trade was with countries abroad, in America, the West Indies, and Continental Europe. He was one of the many who rejoiced in 1789 that the French would now share the liberties that England had gained in the Glorious Revolution many years before. He wrote to a friend, Dr. Darwin:

I know that you will rejoice with me in the glorious revolution which has taken place in France. The politicians tell me that as a manufacturer I shall be ruined in France, but I am willing to take my chance in that respect, nor do I yet see that the happiness of one nation includes in it the misery of its neighbours. . . . A gentleman who has just come from his travels has been here a day or two, & he assures me that the same spirit of liberty is developing itself all over Germany, & all over Europe.[27]

He mulled over a project to produce a commemorative plaque or figure in which were to be shown 'a figure of public faith on an altar & France embracing Liberty in the front'.[28] He was one of the many English of the day who were unaffectedly pleased that the French might now share the benefits of freedom, and who saw the Revolution in France as the successor to and in part the consequence of the earlier English revolution.

He was an enemy of slavery, active in trade and in the sciences, a friend of James Watt and Dr. Priestley, and he took an active part in public affairs, politics, and such schemes as inland waterways. He was Voltaire's ideal Englishman, educated, cosmopolitan, politically concerned, and active in trade and industry. His *Heads of Illustrious Moderns*, and their companion busts and statuettes, are as direct a reflection of the European Enlightenment as may be found in art. They form a total contrast with the Sèvres series of *Figures des Grands Hommes* to which we now turn.

The Sèvres factory, or Manufacture royale de porcelaine, is principally known for its superb élite products: dinner services, vases, *pots-pourris*, and other decorative ware, but in the space of nine short years, Étienne-Maurice Falconet created a brilliant department of sculpture in porcelain. From 1757 until his departure for Russia in 1766 he worked to create a department without parallel in Europe, and the reputation of Sèvres now lies balanced equally between the soft- and hard-paste table and decorative ware and the ceramic figures. Sèvres figures and groups in the Boucher, Rococo manner continued to be made and to expand after Falconet's departure, under the general

[27] *Letters* (July 1789). [28] *Letters* (28 July 1789).

supervision of Jean-Jacques Bachelier, the factory's art director. He handed over this aspect of his work in 1772 to Louis-Simon Boizot, and between them Bachelier and Boizot supervised a gradual shift in taste from exclusive preoccupation with the Rococo to portrait sculpture.

Serious study of these portrait figures and busts is impeded by the absence of catalogues and the lack of detailed archival sources. Partial studies of sales records and of dates on moulds have yielded some results, and a project is now under way to compile the first comprehensive inventory of Sèvres sculpture in biscuit porcelain. Large gaps may remain, owing to an orgy of vandalism at one point in the Revolution and to the habits of earlier modellers, one of whom merely heaped models in a pile on the floor, leaving a chaotic disorder behind him on his death in 1772. Sèvres figures in the eighteenth century were neither signed nor dated, and the general state of confusion in 'documentary' sources and catalogues at present available is added to by the fact that the most highly accredited catalogue known, by Émile Bourgeois, dates from *c.* 1910 and was compiled 'without reference to any documents', according to a modern authority.[29] Where it is not vague it can be dangerously misleading. The addition of a chronological list of Sèvres figures and busts of illustrious Frenchmen in this present study offers some tentative corrections based upon outside sources and valuable help received from the Manufacture nationale de Sèvres, the adjacent Musée national de céramique, and the Victoria and Albert Museum.

Portraits of modern figures by Sèvres modellers began not unnaturally about 1750 with a number of busts, figures, or equestrian studies of the royal patrons and owners of Sèvres. With Falconet's departure, Bachelier sanctioned portrait busts of literary figures, composers, actors, and even American revolutionaries. There appeared—over a period of years—a number of busts of Voltaire, Rameau, Diderot, the actors Préville and Dazincourt, Franklin, Washington, Gresset, Mirabeau, Descartes, and Rousseau. Yet far from achieving recognition as a series or collection, these few names were the only ones—so far as we know—to have appeared before about 1795, with the exception of the series referred to within the Manufacture as the *Figures des Grands Hommes,* from 1783 onwards. Only the disconnected, desultory busts of Voltaire and others come anywhere near matching the *Illustrious Moderns* series of Josiah Wedgwood in its portrayal of contemporary thinkers, writers, and scientists. No single foreign figure was to be reproduced, with the exception of the American revolutionaries, who of course were supported by the French in their fight against the English. For Voltaire to be modelled at all by the Manufacture—like Gobelins, a royal establishment—was an unusually liberal gesture and one that was possibly due to Bachelier himself. He is known to have had contacts with Voltaire through a mutual friend in 1769 when he

[29] See W. B. Honey, *European Ceramic Art from the End of the Middle Ages* ... (London, [1949]), p. 562. The sole reliable source is the work of X. de Chavagnac and A. de Grollier, *Histoire des manufactures françaises de porcelaine* (Paris, 1906), which lists earliest references in the archives of the *manufacture* (pp. 271 ff.).

canvassed support for a scheme of technical education.[30] Sèvres produced their first
bust of Voltaire, or indeed of any *philosophe*, in 1767, to judge by sales records.[31] This
too was based on the bust of Voltaire by Rosset de Saint-Claude, though the finished
bust is no great likeness (Pl. 10). Voltaire had sat for Rosset in 1765, and the miniature
busts caused a stir in Paris from 1767.[32] Sèvres copies in biscuit porcelain were certainly
available in 1767 or 1768.[33] Voltaire regarded it as 'le meilleur buste qui ait été fait' of
himself and urged Pigalle to use this as a model for his proposed statue in 1770 and
so avoid the long journey to Ferney to model Voltaire, who drew himself as 'du vieux
parchemin collé sur des os'.[34]

The Sèvres bust of Voltaire is so little known that it has never figured in iconographies
of Voltaire and remained unknown to Voltaire researchers of this century before
Theodore Besterman. In addition to the Rosset-based bust of 1767[35] there were pos-
sibly as many as three more versions from different models done by the Manufacture
before 1800, but details of them are confused in official Sèvres sources. All such sources
agree in attributing a second bust of Voltaire in 1768 to the hand of Lemoyne, and
yet the latter's known busts of Voltaire are firmly dated 1748 and 1774.[36] Their features
are exactly the same, the later one being a mere copy of the first, and neither bears any
resemblance to the supposed 'Lemoyne' in Sèvres porcelain. Over and above this, the
Sèvres bust quite clearly derives from the Houdon bust of 1778, of which the Louvre
possesses a bronze, and the Angers Museum a marble. The '1768' copy of Lemoyne
therefore turns out to be no earlier than 1778, and probably dated from the 1780s or
even the period after the outbreak of the Revolution. It follows not Lemoyne, moreover,
but Houdon (see Pl. 11). Where, in all this comedy of errors, we situate reports of a
1770 miniature ceramic bust after Caffiéri[37] it is hard to say. None is known, but this
might well have been the so-called 'Lemoyne' bust if one actually existed, since Caffiéri
was a pupil of Lemoyne, and based his own full-size head of Voltaire on Lemoyne's
well-known bust. It was the original of this Caffiéri bust based on Lemoyne that appeared
on the Comédie-Française stage in the famous 'couronnement' ceremony in 1778, so
far as can be told. What, too, of the Boizot studies of Voltaire listed by Sèvres? They
appeared in three different sizes, according to Chavagnac, and date from 1793. Pending
some skilful detective work by the Sèvres cataloguers, the only authenticated bust of
Voltaire by Sèvres prior to the Revolution remains the Rosset-based portrait bust
(Pl. 10) of 1767. It would hardly be surprising if all others date from the period after
the Revolution.

[30] See Voltaire's reply 9 May 1769. *Voltaire's
Correspondence*, ed. Th. Besterman (Geneva, 1962),
letter 14662 (henceforth referred to as Besterman
1234).
[31] See n. 29, above.
[32] See Besterman 12269, also Grimm, *Correspon-
dance littéraire...* (Paris, 1877–82), VII.284. The V &
A version is dated 1768. See also Besterman 13204,
13263, 13307, etc.

[33] Besterman 14486, 26 Jan. 1769.
[34] Besterman 15347, 21 May 1770; also Besterman
18425, 5 July 1775.
[35] *Musée national de céramique* copy is dated 1905.
[36] *Musée de Chaalis* and *Musée d'art et d'histoire
Genève*. The V & A has a 19th-cent. copy after Caffiéri
in imitation of Lemoyne's bust.
[37] See G. Savage, *Seventeenth and Eighteenth
Century French Porcelain* (London, 1969), p. 161.

The situation for Rousseau is little better, since at least one of the busts commonly dated 1777 in the catalogues by Bourgeois also follows a 1778 Houdon model, but with differences in hair-styling that suggest 1789–1815 (Pl. 12). Rousseau's iconographer Girardin unfortunately confused the Cyfflé terre de Lorraine bust of Rousseau with Sèvres biscuit and did not list a true Sèvres bust of Rousseau.[38] No Rousseau bust is therefore established as appearing prior to the Revolution. With Diderot the details we possess are also rather vague, and it may well be that Voltaire, Diderot, and Descartes constitute the sum total of busts of illustrious moderns produced by Sèvres before 1790. The sheer lack of authentication is itself indication that very few, if any, Sèvres representations of Rousseau can have appeared prior to the Revolution.

We are left, therefore, with the fact that even the very limited number of Sèvres portrait busts of eighteenth-century figures found in available lists appears seriously erroneous and exaggerated. Very little at all can be demonstrated to have been produced before the Revolution, and the fact emerges that Sèvres made no serious attempt to compose a gallery or list of modern *philosophes*, and certainly came nowhere near rivalling the list of Frenchmen included in Josiah Wedgwood's lists.

Sèvres's real incursion into a gallery of Illustrious Moderns came, not in a series of bust portraits, but in the famous series of statuettes commissioned by d'Angiviller in 1782 and which appeared between 1783/4 and 1787. As Directeur général des bâtiments, d'Angiviller wrote on 12 January 1782:

Je crois Monsieur, vous avoir déjà parlé du dessein où je suis de faire exécuter en porcelaine et en petit les statues des grands hommes que sa Mté. a déjà fait exécuter en marbre par les principaux sculpteurs de son Académie. J'ai en effet lieu de croire que ces morceaux auront beaucoup de succès et seront achetés avec empressement. J'ai donc déjà chargé M. Pierre de demander aux artistes qui ont exécuté des morceaux des modèles en terre pour former les creux nécessaires.[39]

The full-size originals were exhibited at the Salons from 1777 to 1789, though none of the 1789 sculptures and not all of those of 1787 had time to join the Sèvres collection before the Revolution came. The principal sculptors involved on the life-size originals and terracotta reductions were Pajou, Mouchy, Goix, Lecomte, Caffiéri, and Rolland. Eight other sculptors contributed a single sculpture and reduction. The bulk of the modelling of those which had already been exhibited at the Salons of 1777, 1779, and 1781 was done in 1783–4, and the artists received a further 1,000 francs, on top of their original 10,000, for the reduction. The terracottas were to be of 40 or 50 cm in height, and they are still stored in the basement of the Musée national de céramique at Sèvres with the other remaining models from which moulds were made. The photographs used to illustrate this study are of these remarkable terracottas (Pl. 13–17).

These models may be quite precisely dated from the correspondence at the Archives

[38] Cf. F. de Girardin, *Iconographie de J.-J. Rousseau* (Paris, 1909), no. 1164, which is probably a mistaken identification of Cyfflé's bust of JJR.

[39] MS. letter kindly communicated by Archives of the Manufacture nationale de Sèvres. I am obliged to Mme Préaud for her communication of detailed information on many of these points.

of the Manufacture. The first to be prepared, in 1783, were Étienne Goix's *L'Hôpital*, Pajou's *Pascal* (Pl. 13), Claude Dejoux's *Catinat*, Caffiéri's *Pierre Corneille* (Pl. 14), Pajou's *Turenne*, and Louis-Philippe Mouchy's *Sully*.[40] To these six were added Félix Lecomte's *Fénelon*, Pajou's *Descartes*, Pierre Berruer's *d'Aguesseau*, Pajou's *Bossuet* (Pl. 15), Mouchy's *Montausier*, and Charles Antoine Brindan's *Vauban*. These twelve formed an initial 'Suite complète de figures des Grands Hommes', as it was commonly styled. These were available in biscuit porcelain by May–June 1784, to be joined by Houdon's *Tourville* and Clodion's *Montesquieu* (Pl. 16), whose sculptors had to be reminded sharply to fulfil their obligations.

This larger set of fourteen was then extended to include Caffiéri's *Molière*, Pierre Julien's *La Fontaine*, Boizot's *Racine* (Pl. 17), Goix's *Molé*, Claude Martin Monnot's *Duquesne*, and Philippe Lament Roland's *Condé* in 1785. By this point the Sèvres series had caught up with the sculptures already exhibited at the *Salons* in previous years. Only three of the sculptures exhibited in 1787 were to join the Sèvres series (Brindan's *Bayard*, Lecomte's *Rollin*, and Mouchy's *Luxembourg*); the *Vincent de Paul* by Stoyf did not reach the stage of a porcelain figure. Needless to say, all the 1789 sculptures failed to see Sèvres, these being statues of *Duguesclin*, *Poussin*, *Cassini*, and *Lamoignon*.

The statues commissioned for the Louvre and for Sèvres were seated or standing figures and they portrayed the subjects in the dress of their day. The better examples have a remarkable command of gesture and a physical eloquence or rhetoric of posture that marks them as the summit of a certain tradition.

D'Angiviller's optimism over sales was to be dampened; at a present-day value of £130 per figure and £1,200 for the initial set of twelve pieces, it was small wonder that d'Angiviller was notified of a 'cessation absolue de la vente' in a letter of 11 February 1786 and that the price of pieces was reduced first to 15 and then to 12 or even 10 louis. At this last figure they would still have cost £100 in today's values. A fair proportion of the sets produced were used for royal or diplomatic gifts, and private sales were so low that it was agreed to keep stocks of only two examples of each item (7 November 1784). Small wonder that the figures are so rare in collections.

The Sèvres porcelain figures offered 23 of the total of 28 *Salon* sculptures, but far from diffusing them to a wide public, the price did nothing to encourage their popularity. Their purchasers were if anything a more exclusive and restricted audience than those who were able to see them at the *Salons*. Any moral or propagandist intentions in the mind of d'Angiviller must have been severely disappointed.

To dismiss the series as jingoistic or chauvinistic would be both an anachronism and inaccurate, since patriotism as it was seen here was anything but popular, and reflected the traditional values of a small élite. The series was a prestige venture, produced for the nobility and gentry by a luxury factory. The appeal to the traditional virtues of honour, military valour, and religious dedication and to the literature of the court of Versailles under Louis XIV is unmistakable. It has overtones not of the eighteenth-

[40] Archives letter of 17 June 1783.

century bourgeois ethic and sentimentality, but of an aristocratic or Cornelian heroism and for many of the same reasons that made Corneille's heroes popular in his day. The essence of this new mood was nobility in mind, soul, and sword. It was narrowly nationalist in outlook and, if not xenophobic, was at least rigidly French in conception.

All trace of eighteenth-century French philosophy was expunged, as well as any whiff of English empiricism. None of the *philosophes* figured in the series, and the only eighteenth-century figures represented, Montesquieu and Rollin, were born in the earlier century, and are represented under orthodox colours. Montesquieu appears as a *magistrat*, not as a political theorist, and even Pascal sheds his Jansenist colours and appears as a mathematician, a pure intellect purged of heresies. A rumour circulated that Mouchy had been commissioned to sculpt figures of Voltaire and of the Maréchal de Saxe in 1778, but this proved to have no connection with the *Série des Grands Hommes* and certainly came to nothing so far as Voltaire was concerned.[41] At no point had there been any intention to include Voltaire in the series, a fact underlined by the appearance at the 1781 *Salon* of Houdon's remarkable *Voltaire assis*. This would have been unsuitable for inclusion in the series, not only because of the use of antique dress, but also of the anti-*philosophe* character of the *Série des Grands Hommes*, inspired by royal patronage, it should be remembered. One of the very first official acts of Louis XVI was to order the seizure of all Voltaire's papers on his death. The monarch who could have taken time in a smallpox epidemic to order officials to make arrangements for such a course was hardly likely to include Voltaire as the sole illustrious modern in this series celebrating France's national grandeur.

The *Figures des Grands Hommes* series marked the birth of an 'official' art style and had clear links with the neo-classical movement that later developed. It was a deliberate exploitation of art as a means of state propaganda and it contrasted strongly with the *Illustrious Moderns* series by Wedgwood. Where Wedgwood embraced the new science and philosophy, the Sèvres series invoked the glories of a former age. Its purpose was to combat political dissension, philosophical scepticism, ecclesiastical reticence, aristocratic Frondeurs, and the *philosophes* as agents of corruption and national decadence. The patriotism of the *Série* is in large part nostalgia for a golden age of national grandeur and social unity, the invocation of a myth that Voltaire had done much to construct of the intellectual, cultural, and military glories that were now remembered as the hallmarks of a period once shunned as the age of absolutism. The Age of Louis XIV became for the French under Louis XVI a metaphor for virtues, for want of which society threatened to run headlong into national decline and a catastrophic confrontation between Crown and aristocracy, Crown and the courts. An element of Golden Age mythology can be seen in this artistic propaganda as the seventeenth century's achievements are hailed and enhanced in a flight of fantasy and nostalgia. The Crown created its own myths of national greatness and unity as a response to threats of anarchy, not amongst the lower orders but in the highest levels of society, traditionally the seat

[41] See Besterman 19921, letter of 24 Feb. 1778.

of honour, patriotism, and loyalty to the Crown. Myth compounded nostalgia as the Court of Louis XVI used art as one of several means of restoring national unity. In the *Série des Grands Hommes* nationalism is not opposed to cosmopolitanism so much as to sectional and vested interests within French society. All the ecclesiastical literature of the day and much of court opinion regarded the *philosophes* as agents of national moral degeneration, seditious and irreligious. It was inconceivable that they should figure in any series of the type envisaged by d'Angiviller.

The question forces itself upon us as to whether the entire series might arise, not from a sense of national self-esteem, but from a growing feeling of national decadence. The literary, political, and intellectual cohesion of the Age of Louis XIV contrasted sharply with the apparent mediocrity, loss of faith, and degeneration of taste that presented themselves to the Jeremiahs of the day. On all sides there was resistance to central control, and a loss of patriotic concern. In a fit of national self-denigration and of incantation of the glories of an earlier age, myths weighed more heavily than sober realities and the whole idea of the *Série des Grands Hommes* is tinged with an aura of myth. Voltaire had hailed the age of Louis XIV as the equal in many ways of the three great ages of mankind: the great civilizations of Greece, Rome, and Renaissance Italy. The court fostered just such a myth for its own purposes.

If the Wedgwood series was a mirror held up to modern science and philosophy, literature and society, the Sèvres series was a looking-glass reflecting an enhanced image of the nation in its 'prime'. The prestige of Louis XIV's France was an inspiration for the present and the *Série* marked a flight from the modern. Where the Wedgwood series accepted modern intellectual and literary developments along with science, and other examples of contemporary advance, the French series withdrew into a myth of childhood involving a total rejection of contemporary literature and thought. Not merely was modern literature irrelevant to the purpose of the Sèvres series, it was one of those elements most frequently quoted by the Church as being responsible for this decadence and lack of patriotism. The two represent entirely opposed views of the world of letters, and of the nature of social advance.

A PROVISIONAL CHECK-LIST OF WEDGWOOD PORTRAIT BUSTS, FIGURES, AND CAMEOS OF FRENCH 'ILLUSTRIOUS MODERNS'

The following check-list derives from the various lists published by Wedgwood and Bentley, and then by Wedgwood alone following Bentley's death in 1780: *A Catalogue of cameos, intaglios, medals, and bas-reliefs . . . made by Wedgwood and Bentley*. London, 1773 (British Museum T447(3); 1774 (BM: 1651/197); 1774 French translation (BM: T259(6)); 1777 (BM: 824b17(17)); 1779 (W. Mankowitz, *Wedgwood* (London, Spring Books, 1966)); 1787 (BM: 679d22(3)). More detailed information derives from the Wedgwood correspondence in its various editions, as well as from manuscript sources in the Wedgwood Museum. The items listed exclude non-literary or non-scientific figures, including royalty. Likenesses were drawn from models by James Tassie from *c.* 1769, and then by John Flaxman, who worked on contract to Wedgwood from 1775. Other outside sources also supplied likenesses. William Hackwood worked on medallions and was principally responsible for vases, busts, and statuettes.

The basic black basaltes body developed *c.* 1767–8 was followed by the jasper body in 1774–6, being perfected as jasper-dip by 1777. The *Wedgwood & Bentley* signature gave way to *Wedgwood* on Bentley's death in 1780. Early cameos are in the black body, jasper copies usually being later and being offered in white on a variety of colours (blue, lilac, green, etc.). The term *intaglio* implies that the likeness is sculpted out of the body, for use as a seal.

Sincere thanks are expressed to all who have offered their specialized knowledge of Wedgwood ware, or have allowed me to photograph their collections, notably: Mr. W. A. Billington, curator of the Wedgwood Museum, Josiah Wedgwood & Sons Ltd., Barlaston; Mr. R. J. Charleston, Keeper of Ceramics, Victoria and Albert Museum, Mr. John Mallett of the same department, Mr. Terence Hodgkinson, Keeper of Sculpture at the same Museum; Miss Jennifer Montagu, curator of Photographic Collection, Warburg Institute; Mr. A. R. Mountford, Director of the City Museum and Art Gallery, Stoke-on-Trent; Mr. G. W. Elliott, First Assistant at the same museum, who has spared so much of his time; and last but not least my good friend Theodore Besterman.

[Dates in brackets refer to Wedgwood letters in the published edns.]

1772: Small bust of Voltaire (after Rosset) reported by Barnard (p. 152) though not in 1773 *Catalogue*.

1773: First *Catalogue* of *Cameos, Intaglios, etc.* with Heads (Cameos and Intaglios) of Gassendi, Boileau, Mme Dacier, Montesquieu, Voltaire, and Rousseau, in Class X.

1774: 2nd edn. of *Catalogue*, with addition of Saint-Évremond to 'Heads'. Also a French version 1774. Includes number of French monarchs and statesmen.

1774–6: Major expansion of lists of '*Heads*' in basaltes, then in jasper 1774–6, and jasper-dip 1777–.

Composition of list of portrait *Busts* modelled by Hackwood (11 Sept. 1774, 2 Mar. 1774). N.B. Derby factory produce porcelain bust of Rousseau after Cyfflé *c*. 1775 (Schreiber I.361 at V & A).

1777: 4th edn. of *Catalogue*. Unclassified list includes following French portraits, those in *italic* being earlier entries:

Gassendi, Descartes, *Rousseau*, Pl. 7, d'Alembert, Diderot, Montaigne, La Condamine, Fontenelle, de Moivre, *Boileau, Mme Dacier, Saint-Évremond, Voltaire* Pl. 7,, *Montesquieu, Mazarin*, Préville, *duc de Sully*, de Sartine, Crébillon, Molière, Agnès Sorel, Henry IV, Mlle Clairon, Mme du Bocage, Mme de Pompadour, Mme du Châtelet, Pierre Corneille, Mme de Sévigné, Marmontel, Coysevox, Mme de Grignan (Mme de Sévigné's daughter), Comtesse de La Sage [M. Le Sage?], Mme du Barry, Mme de Scudéry, Gabrielle d'Estrées, Mme de Montespan, Fénelon, La Fontaine, Mme des Houlières, Pascal, Ninon de l'Enclos, Racine, Turenne, *cardinal de Fleury, Louis XIV, Louis XV, maréchal de Saxe, cardinal de Noailles, Condé, Colbert.*

Busts: J. J. Rousseau [after Cyfflé?], Voltaire [after Rosset?], Montesquieu.

1777: J. Wedgwood received Rosset standing figure of Voltaire (10 July 1777, Nov. 1777). Several completed by late 1777–early 1778 (24 Aug. 1778, Sept. 1779, Oct. 1779). *Pl.* 9.

c. 1778: Cameo portrait head of Rousseau (8 May 1779).

1778: Wedgwood received Mayer drawing of Rousseau 'venant d'herboriser dans les jardins d'Ermenonville' of 1778. Model for his standing figure of Rousseau, intended as 'companion to Voltaire'. Completed 2 Sept. 1779, see also 28 July 1778. *Pl.* 8.

1778: Commemorative bust (or plaque) of Voltaire in white jasper (5 Dec. 1778).

1779: Cameo portrait head of Voltaire after Rosset proposed to match existing Rousseau head (8 May 1779). Not the first Voltaire portrait, obviously, but an additional size, it would appear.

1779: 4th edn. of *Catalogue* (reprinted in W. Mankowitz, *Wedgwood*, 1966). Additions include a standing figure of Voltaire [of 1777]. Rousseau [of 1779] too late for inclusion. Busts of Voltaire and Rousseau [of 1777–] now in 4–5 sizes, from 4 in. to 20 in. Montesquieu only in 4 in.

c. 1780–5: [Wedgwood adopts Cyfflé model for Voltaire bust in preference to Rosset, which has served to date?]

1787: 6th edn. of *Catalogue*, listing 229 separate portraits from all countries and sources. No new French names amongst busts. Busts and statuettes in general less emphasized after Bentley's death in 1780. Voltaire and Rousseau now paired as statuettes, Class XII, ii.

c. 1790: [Burslem bust of Rousseau, probably by Enoch Wood, after Cyfflé (V & A Schreiber II.312).]

c. 1800: [Leeds bust of Rousseau (V & A C306–1915).]

c. 1810: [Staffordshire bust of Voltaire after Cyfflé (V & A 68–1874).]

A PROVISIONAL CHECK-LIST OF SÈVRES PORTRAIT BUSTS AND FIGURES OF FRENCH WRITERS, 1750–1800

The following check-list conflates information derived from Sèvres archives published by X. de Chavagnac and A. de Grollier, *Histoire des manufactures françaises de porcelaine* (Paris, 1906) with other sources, notably manuscript and other data kindly furnished by Mme Préaud, archiviste-bibliothécaire at the Manufacture nationale de Sèvres. Other sources are: J. Leith, 'Nationalism and the fine arts in France 1750–1789', *Studies on Voltaire and the Eighteenth Century*, LXXXIX (1972), 919 ff.; E. Bourgeois and G. Lechevallier-Chevignard, *Le Biscuit de Sèvres: Recueil des modèles de la manufacture de Sèvres* (2 vols., Paris (Lafitte) [*c.* 1910]). References in the check-list deriving from this source are given as follows (e.g. E. Bourgeois, no. 192). See also E. Bourgeois's *Le Biscuit de Sèvres au XVIII^e siècle* (2 vols., Paris (Goupil), 1909); together with *Voltaire's Correspondence*, ed. Th. Besterman (107 vols., Geneva, 1953–65).

A considerable debt of gratitude is acknowledged to Mme T. Préaud, archiviste-bibliothécaire at the Sèvres manufacture, and to M. H. P. Fourest, Conservateur of the Musée national de céramique, Mlle Antoinette Fay, assistante au musée, and M. Guy Sarraute de Menthière, without whose good-humoured assistance my photographic work would have been impossible. Mr. W. J. Sainsbury, Mr. R. J. Charleston, Keeper of ceramics at the Victoria and Albert Museum, and Mr. Terence Hodgkinson, Keeper of Sculpture at the same museum, have been invaluable guides and I thank them warmly.

Considerable reserves are expressed as to the certainty of any date not accompanied by an asterisk. Where the *Figures des Grands Hommes* are concerned, the dates quoted are those of the terracotta models being in the hands of the factory. Readers are reminded that authentic eighteenth-century Sèvres biscuit figures and busts were never signed or dated, and that where dates of moulds are noted, these may be later moulds, replacing broken originals.

1767: *Voltaire*, bust (after Rosset) 13 cm (18·5 cm with base) Sale 1767. [1905 version Musée national de céramique.] *Pl.* 10.

1768: *Rameau*, bust (Caffiéri) 19 cm, 1768 sale, 1783 mould. [19th-cent. version Musée national de céramique.]

Diderot, bust (after J. B. Lemoyne [?]) 13 cm. No archival ref. Source E. Bourgeois, no. 192. [Musée national de céramique has biscuit bust as well as Houdon terracotta of Diderot.]

?1770: [Voltaire (by Caffiéri) reported by G. Savage. Possibly source of reports of a 'Lemoyne' Voltaire (see below), Caffiéri having copied Lemoyne's bust of 1748 on various occasions.]

1775: *Préville as Figaro* (Leriche) 29 cm, 1775 sale.

Dazincourt as Crispin (Leriche) 31 cm, no archival ref. Source E. Bourgeois, no. 177.

1777: *Franklin,* (after Houdon) bust and medallion. Medallion sale 1778. Source E. Bourgeois. *Le Biscuit de Sèvres,* II.

[1780–1800?]: *Voltaire* (after Houdon, usually attributed to Lemoyne) bust 20 cm, E. Bourgeois, no. 617. [Sèvres factory copy.] *Pl.* 11.

[1780–1800?]: *Rousseau* in Roman costume, after Houdon bust of 1778, minus hair-band, with Empire hair-line. 26 cm. Reputedly 1777, probably Revolution period. [Sèvres factory copy.] *Pl.* 12.

[1780–1800]: Rousseau in 18th-cent. French costume, E. Bourgeois, no. 541, 30 cm. [no example known] (After Houdon, or after 1753 La Tour pastel?) Usually attributed to 1777.

1782: *Washington* bust (Boizot). Size not known, listed in E. Bourgeois, *Biscuit de Sèvres,* II, 1782 sale but not listed in Chavagnac and Grollier.

Gresset. Listed in Chavagnac and Grollier [1782?] mould.

1783: ?*Descartes,* figure [by Brachard? or confusion with Pajou's standing figure from *Figures des Grands Hommes* series], mould 1783.

Mirabeau, bust (Boizot), sale 1792, mould 1783.

1783–4: *Série de Figures des Grands Hommes,* sets of 12, then 14.

Corneille (Caffiéri) seated figure [*Salon* 1779] 41 cm, mould 1783, sale 1784 [letter 17 June 83]. *Pl.* 14.

L'Hôpital (Goix) standing [*Salon* 1777] 50 cm, mould 1783, sale 1784 [letter 17 June 83].

Sully (Mouchy) standing [*Salon* 1777] 47 cm, mould 1783, sale 1784 [letter 17 June 83].

Catinat (Dejoux) standing [*Salon* 1781 and 1783, modified] sale 1784, mould 1786 [letter 17 June 83].

Pascal (Pajou) seated [*Salon* 1781] 34 cm, sale 1784 [letter 17 June 83], mould marked 1781, date of *Salon. Pl.* 13.

Turenne (Pajou) standing [*Salon* 1783] 52 cm, sale 1784, mould 1785, model delivered 1783 [letter 17 June 83].

Fénelon (Lecomte) standing [*Salon* 1777] 52 cm, sale 1784 [letter 20 June 84], terracotta signed 'Lecomte 1783'.

Descartes (Pajou) standing [*Salon* 1777] 50 cm, mould 1783, sale 1784 [letter 20 June 84].

D'Aguesseau (Berruer) standing [*Salon* 1779] 47 cm, mould 1783, sale 1784 [letter 20 June 84].

Boussuet (Pajou) standing [*Salon* 1779] 50 cm, mould 1783, sale 1784 [letter 17 June 83, model delivered]. *Pl.* 15.

Montausier (Mouchy) seated [Salon 1781] 40 cm, mould 1783, sale 1784 [letter 29 May 84].

Vauban (Rolland [or Bridan?]) standing [*Salon* 1783] 47 cm, mould 1783, sale 1785.

(These compose initial set of 12 figures available in porcelain. Price 3,000 francs approx. £1,200.)

Tourville (Houdon) standing [*Salon* 1781] 47 cm, mould 84, Sèvres press for model June 1784, delivered by 23 Sept. 1784 [letters 20 June and 23 Sept. 84], sale 1784.

Montesquieu (Clodion) seated [*Salons* of 1779 and 1783, modified] 39 cm, Sèvres press for model June 1784, delivered by 1 Aug. 1784 [letters 20 June and 1 Aug. 84], sale 1784. *Pl.* 16.

(These compose set of 14 offered in Letter 23 Sept. 84.)

Molière (Caffiéri) seated [*Salon* 1783] 39 cm, Molière modelled Jan. 1785 [letters 27 and 29 Jan. 85], model dated 1783 [Chavagnac and Grollier].

La Fontaine (Julien) seated, with fox at chair back [*Salon* 1783], mould 1780–1800 [letter 27 Jan. 89], 43 cm.

Racine (Boizot) seated [*Salon* 1785] 42 cm, mould 1780–1800. *Pl.* 17.

Molé (Goix) seated [*Salon* 1785] 40 cm, sale 1785.

Duquesne (Monnot) standing [*Salon* 1785] 52 cm, sale 1786.

Condé (Rolland) standing [*Salon* 1785] 52 cm, sale and mould 1785.

Bayard (Bridan) standing [*Salon* 1787] 54 cm, mould and sale 1787.

Rollin (Lecomte) seated [*Salon* 1787] 40 cm, mould 1783[??], sale 1787.

Luxembourg (Mouchy) standing [*Salon* 1787] 47 cm, sale 1787.

(End of series of *Figures des Grands Hommes*.)

1788: *Franklin* bust, mould 1788, 3 sizes. Not listed in Bourgeois.
1793: *Diderot* (Boizot) bust, mould 1793, 3 sizes.
 Rousseau (Boizot) bust, mould 1793, 2 sizes [after Houdon?].
 Voltaire (Boizot) bust, mould 1793, 3 sizes [after Houdon?].

IV

HOMER ABANDONED: A FRENCH NEO-CLASSICAL THEME

Jon Whiteley

ON 18 Brumaire, in the year 3 of the Republic, Jacques Louis David sent a letter of complaint to a friend from his cell in the Luxembourg:

On m'appelle un homme dur et féroce. Ils ne me connaissent pas comme vous, à qui je parlais à cœur ouvert. On aura confondu la figure toujours pensive de l'artiste avec le masque hideux du conspirateur. On ne veut pas voir l'artiste sans cesse occupé de son art. Cette nuance échappe à bien des hommes, même à ceux qui sont les mieux intentionnés. Je m'ennuie actuellement parce que mon sujet d'Homère est totalement composé. Je brûle de le mettre sur la toile parce que je sens intérieurement qu'il fera un pas de plus à l'art. Cette idée m'enflamme et l'on me retient dans les fers. On m'empêche de retourner à mon atelier dont, hélas, je n'aurais jamais dû sortir.[1]

In fact, David's *Homère* was never developed further than two drawings, one highly finished, showing Homer singing the *Iliad* in a Greek township (Pl. 18),[2] the other, less finished, of Homer dreaming on the same spot (the latter remained in the artist's studio after his release) (Pl. 19).[3] Instead, David concentrated his attention on the *Sabines*, the best known of a number of works produced by artists towards the end of the century as a protest against the continuing wars. Like the *Sabines*, the idea of Homer singing his epics for a subsistence was intimately connected with the artist's situation at the time. The sense of wrong from which he suffered in prison was consistent with his idea of Homer as an outcast. His idea of Homer, however, does not entirely conform to the historical account.

The main source of information about Homer was a pseudo-Herodotan fragment known as the *Life of Homer*. Previous scholarship had been consistently sceptical about accepting its authenticity, and interest in the *Life* in the 1790s occurred at a time when the very existence of Homer became the 'Homeric Question'. The *Life* subsequently gained a certain value as a refutation of Homer's critics, but the interest in certain

[1] J. David, *Le Peintre Louis David* (Paris, 1880), p. 657.

[2] Ibid., p. 658. J. Guiffrey and P. Marcel, *Inventaire général des dessins du Musée du Louvre et du Musée de Versailles, École française* (Paris, 1909), IV.75. A. Sérullaz, *Dessins français de 1750 à 1825, le néo-classicisme* (Paris, 1972), no. 52.

[3] Guiffrey and Marcel, p. 75. The drawing was no. 37 in the sale of David's studio in 1826. A. Sérullaz, op. cit., no. 53.

details from the *Life* among artists had no probable connection with academic questions of authorship or historical accuracy; David and his pupils willingly distorted the narrative in order to emphasize the element of persecution. Chénier's 'L'Aveugle', the first and perhaps the most famous work on the theme, offers a nearer source for David's drawings; both are works on the theme of begging genius. However, Chénier's poem, though written before the Revolution, was not published till 1819, by which time the imagery of the wandering Homer had long been part of the stock-in-trade of French studios. Nor does the episode chosen by David precisely fit any episode in 'L'Aveugle', but is most probably adapted, as Chénier's poem is, from the *Life* or from Mme Dacier's popular version appended to her translation of the *Iliad*. Nevertheless, the influence of Chénier cannot be discounted.[4] The artist and the poet share the same conception of Homer suffering in 'Les ténèbres, l'exil, l'indigence et la faim',[5] and it is quite possible that David, even if he did not know 'L'Aveugle' directly, was well acquainted with the poet's ideas on the relationship between genius and society. Chénier confirms this in his first published poem, dedicated to David, in 1791:

> Reprends ta robe d'or, ceins ton riche bandeau,
> Jeune et divine poésie:
> Quoique ces temps d'orage eclipsent ton flambeau,
> Aux lèvres de David, roi du savant pinceau,
> Porte la coupe d'ambroisie:
> La patrie, à son art indiquant nos beaux jours,
> A confirmé mes antiques discours:
> Quand je lui répétais que la liberté mâle
> Des arts est le génie heureux;
> Que nul talent n'est fils de la faveur royale;
> Qu'un pays libre est leur terre natale.[6]

It only required the successive political reversals of the 1790s, which claimed Chénier himself as a victim, to put an end to this optimism in the future of the poet in republican society and give the theme of Homer as the archetypal outcast its full significance.

It is instructive to compare the original version with the variants composed around 1800 in France. In the *Life*, there is no emphasis on Homer's periods of hardship; on the contrary, the narrative is designed to show how his talents were widely appreciated. According to the author of the *Life*, Homer went to Cumae, after the completion of the *Iliad*, where his poetry was received with rapture and would have earned him a grant of money from the senate had one magistrate not opposed the plan. Subsequently he went to Chios in order to expose an impostor who had been singing Homer's works as his own. He crossed to the island with some fishermen but, on the way to the town, was

[4] Cf. Millevoye's 'Homère mendiant' (*Œuvres complètes* (Paris, 1837), p. 89), which offers a parallel episode to that chosen by David, but was, in fact, inspired by Chénier's 'Aveugle'.

[5] A. Chénier, *Œuvres poétiques* (Garnier Frères, Paris, 1884), ed. Louis Moland, I.39. According to F. Scarfe (*André Chénier*, Oxford, 1965, p. 170), the identification of Homer with the blind beggar in the poem was a 'brilliant afterthought'.

[6] 'Le Jeu de Paume', op. cit. I.3–4.

set upon by a goatherd's dogs. The goatherd, Glaucus, called off the dogs and invited the stranger to his house. Glaucus's master was impressed by the poet and charged him with the education of his children. The impostor, hearing that Homer was in the neighbourhood, fled from the island. Homer set up his own school in the town, where he grew rich, married, and had two daughters. Eventually, on the advice of friends, he set out for Athens, but died on Io, where he was given an honourable funeral.[7]

The episode chosen by Chénier and others, his landing on Chios and the attack by the goatherd's dogs, is an ancient invention to explain the description of Ulysses' arrival on Ithaca, the attack by dogs, and his rescue by Eumaeus. It was not meant to be read as an example of misfortune. Moreover, in the original account, Homer, at first refused a passage to Chios, summoned a tempest to his aid, which persuaded the fishermen that it was in their interest to take him to the far shore; there he slept the night and in the morning he walked to the neighbouring hamlet. The narrative gives no suggestion that his night on the shore was an unusual hardship. Mme Dacier, however, writing in a more sensitive age, imposed her own gloss upon the episode: the fishermen 'eurent la cruauté de l'abandonner sur le rivage où il passa la nuit. Un aveugle ne pourrait que s'égarer dans un pays si désert: il se mit pourtant dès le lendemain et erra près de deux jours sans trouver personne qui put le secourir et le conduire.'[8]

This suggestion of misfortune was eagerly adopted at the turn of the century by artists in search of pathetic motifs. Landon, commenting on Gérard's *Homère* in 1814, explained that Homer, according to tradition, wished to cross to Chios 'et ne trouva pour arriver qu'un bateau de pêcheurs, qui après l'avoir débarqué, eurent la cruauté de l'abandonner sur le rivage où il passa la nuit...'[9] The story of the tempest was strangely inverted by Gassies in his explanation of his painting in the *Salon* of 1819: Homer 'fut reçu dans une barque de pêcheurs. Ceux-ci, croyant qu'il était la cause d'une tempête, l'abandonna sur un rivage inconnu.' Coupled with this work, Gassies exhibited *Homère chantant ses poésies devant les bergers*: 'après avoir erré deux jours et deux nuits sans trouver d'habitation, il allait succomber de fatigue et de faim lorsqu'il fut aperçu par de jeunes bergers.'[10]

The episode chosen by David, Homer singing in a public place in Greece, derives from various incidents in the *Life*, particularly from Homer's reception at Cumae where a suggestion of hardship is introduced to explain the origin of a Homeric Hymn in which the author lays a curse on Cumae. Artists after David exploited the possibilities of the account. 'Les offrandes', said Landon of Bouchet's *Homère*, 'qu'il reçoit de la foule dont il est entouré indiquent son affreuse indigence.'[11] (Pl. 20.) The episodes chosen by Chénier and by David were the parts of the *Life* which appealed to artists

[7] K. Mackenzie, 'The Life of Homer attributed to Herodotus of Halicarnassus', in T. Buckley, *The Odyssey of Homer with the Hymns, Epigrams, and Battle of the Frogs and Mice* (London, 1851), pp. vi–xxxi.

[8] A Dacier, *L'Iliade d'Homère traduite en français avec des remarques*, I (Paris, 1741), p. 15.

[9] C. Landon, *Annales du Musée* (Paris, 1814), p. 91.

[10] Anon., *Explication des ouvrages* (Paris, C. Ballard, Imprimeur du roi, 1819), p. 56.

[11] Op. cit., p. 58.

almost to the exclusion of all other parts. Before 1830, the scene of Homer and the shepherds was illustrated by Bosio,[12] Perrenot, Blondel,[13] Gérard (Pl. 24),[14] Bergeret, Gassies, and Granger (Pl. 23);[15] that of Homer singing in the towns of Greece was the subject of works by Fragonard,[16] Hennequin,[17] Rolland, Bouchet,[18] Lethière (Pl. 26),[19] Valin, and Lafond.[20] This wealth of images ended by convincing contemporaries that Herodotus really had described Homer as a victim of neglect. 'M. Roland', said the critic of the *Moniteur*, 'a supposé Homère dans la situation décrite par Hérodote, isolé, aveugle, mendiant, chassé par le besoin d'un lieu dans un autre et prodiguant son admirable talent pour trouver les moyens de soutenir sa misérable existence.'[21]

If this account is not strictly that of the *Life*, it does approximate to that of a much later historical character, Belisarius, whose unhappy story had been popularized by Marmontel in 1767. Aware that the story which he derived largely from Procopius was implausible, Marmontel justified his tale of royal injustice on the grounds that 'l'idée de Bélisaire aveugle et mendiant est devenue si familière qu'on ne peut guère penser à lui, sans le voir comme je l'ai peint'.[22] And so Belisarius was painted by dozens of French artists between the year of publication and 1824. The iconography of *Homère et son guide* and *Homère et Glaucus* resembles that of Belisarius with his young guide (Pl. 22), and David had only to turn to his own Belisarius, exhibited in 1784 (Pl. 21), for the general type of his drawings of the indigent Homer. Bouchet's *Homère chantant ses poésies dans une des places de la Grèce* includes a veteran of the Trojan War, moved by Homer's recitation of his old campaigns, for whom there is no justification in the *Life*, but who does indeed figure in David's *Bélisaire*. In 1795 Gérard exhibited one of his most successful works, showing the blind general carrying his guide who has been bitten by a snake (Pl. 25). Népomucène Lemercier was moved by this melancholy exhibition to borrow the painter's imagery for his own pleasant fable on the sufferings of Homer which appeared in 1800; the process by which Lemercier has adapted the narrative of the *Life* is a familiar one; not only is Homer abandoned by the fishermen,

[12] 'Exposition à la fête de la République' (*Magasin Encyclopédique*, 1798, III.423).

[13] *Explication des ouvrages*, 1812, no. 6388; 1812, no. 102.

[14] C. Landon, *Annales du Musée*, p. 91.

[15] *Explication des ouvrages*, 1807, no. 36; 1810, no. 336; 1819, no. 494, 495; 1819, no. 525.

[16] A. Chudant, *Musées de Besançon, Catalogue des peintures et dessins* (Besançon, 1920), p. 68. I am grateful to Virginia Lee for drawing my attention to this interesting drawing.

[17] J. Guiffrey and P. Marcel, op. cit. VI.84; A. Sérullaz, op. cit., n. 74.

[18] *Explication des ouvrages*, 1806, no. 452; 1814, no. 130.

[19] *City of Nottingham Art Gallery, Jubilee Exhibition, 1878–1928* (Nottingham, 1928), p. 23. I am grateful to David Wakefield for indicating the present loca-

tion of this important work painted in 1816. It was not exhibited at the Paris *Salon*, as Lethière sent it to England with his *Brutus* in 1816 where it was exhibited by Bullock (*The Times*, 9 May 1816), and apparently sold.

[20] *Explication des ouvrages*, 1822, no. 1286; 1824, no. 996. Cf. also no. 530 and no. 839, Carstens and Thorwaldsen in *The Age of Neo-Classicism* (The Arts Council of Great Britain, 1972).

[21] A.L.C. [Castellan], 'Salon de 1812', *Moniteur universel*, 1812, p. 1411.

[22] J. Marmontel, *Bélisaire* (Paris, 1767), p. 1. The process by which Guérin transformed *Bélisaire* into his fictitious victim of civil war, Marcus Sextus, offers a parallel to the appearance of Homer in the 1790s (A. Soubiès, *Les Directeurs de l'Académie de France* (Paris, 1903), p. 22).

but they steal his money and carry off 'son seul guide, son chien'. The dog leaps overboard in a successful but tragic attempt to reach his master;

> Il expire et sa langue en mourant le caresse,
> O triste Méonide! oh! quels furent les cris!
> Quels soupirs tu poussais près de ces froids débris.
> Tel qu'un jeune pinceau nous montra Bélisaire,
> Aveugle, errant le soir près d'un lac solitaire
> Et portant sur son dos, son seul guide inanimé
> Que blessa d'un serpent le dard envenimé;
> Tel Homère, assailli de mortelles alarmes,
> Le sein gros de soupirs, les paupières de larmes,
> Laissant tomber ses bras d'abord levés aux cieux.[23]

Gérard returned the compliment in 1814 in a painting of Homer which was widely recognized as the pendant of his *Bélisaire*;[24] Lemercier suspected that he was responsible for Gérard's choice, and the source is proved by the substitution of a young girl for the traditional shepherd in the painting, corresponding to the introduction of Glaucus's daughter, Euplocamie, in Lemercier's poem.[25]

The involvement of writers and artists in French politics after 1789 created a sense of injustice and disillusion which gave artists an incentive to illustrate their own fate in terms of the hardships of the archetypal poet. David, as if to give emphasis to the point, gave the Greek city the very un-Greek architecture of the Luxembourg in which he was imprisoned at the time. Philippe-Auguste Hennequin, the original of Anatole France's revolutionary artist, Évariste Gamelin, executed a drawing of Homer singing to the nymphs and shepherds, a work which dates from Hennequin's imprisonment in the Temple after the Thermidor reaction of 1797. At the Restoration, Hennequin went into an embittered exile;[26] David, more fortunate, found a rich welcome in Brussels and resisted all attempts to persuade him to return to his native France where he believed he had suffered a lifetime of persecution.[27] When he was composing his *Homère* in 1814, Gérard had reason to fear reprisals for the part he had played in the revolutionary tribunals, although, like David, he enjoyed the continued goodwill of a conciliating monarch and of his directeur du Louvre, himself a former pupil of David. Louis XVIII, who had a pronounced taste for the neo-classical, let his opinion of Gérard's *Homère* be known to the artist: 'l'ordonnance est belle, la figure du poète est si noble, si expressive et si touchante à la fois qu'en le regardant, je crois entendre sortir de sa bouche ces belles paroles: " les pauvres et les étrangers vous sont envoyés par Jupiter"'[28]—a royal

[23] N. Lemercier, *Homère, Alexandre* (Paris, 1800), p. 40.

[24] C. Landon, *Annales du Musée*, p. 91.

[25] H. Gérard, *Correspondance de François Gérard* (Paris, 1869), p. 319. As late as 1845, Baudelaire noticed an affinity between Corot's *Homère* and the type of Belisarius, *Curiosités esthétiques*, ed. Henri Lemaitre (Paris, 1962), p. 62.

[26] For the tribulations of Hennequin see: J. Hennequin, *Hennequin* (Paris, 1933); C. Saunier, 'Philippe-Auguste Hennequin et "les Remords d'Oreste"', *Revue des Études napoléonniennes* (Jan.–Feb., 1917).

[27] J. Delestre, *Gros, sa vie et ses ouvrages* (Paris, 1867), pp. 221–2.

[28] H. Gérard, op. cit., p. 323.

view which well accords with the scenes of antique charity popular in the eighteenth century and actively encouraged by the restored régime, but which accords ill with the probable sense of Gérard's composition, that the destiny of the artist in every age and under every régime is calumny and neglect.

The sense of persecution which encouraged the theme of the wandering Homer in art was caused, not by a lack of the recognition due to talent, but by political events. There is an element of vainglory in the readiness with which artists transformed political consequences into the stereotype of the artist misunderstood by society, so that every misfortune in an artist's career was attributed to the fatality of genius. After 1815 the theme was sustained by the insecure economic position of the artist and by the development of art criticism as a major form of journalism. Ingres, who had no political motive for his self-imposed exile, assimilated his fate to that of real political exiles as if he wished to implicate society directly for his apparent failure, echoing David's sense of bitter ingratitude in the words of another political exile, Chateaubriand: 'Annibal, Philopoemen, Scipion, moururent à peu près dans le même temps, tous trois victimes de l'ingratitude de leur pays. L'Africain fit graver sur son tombeau cette description: "Ingrate patrie! Tu n'auras pas mes os!"'[29]

While he was at work on the *Apothéose d'Homère* for the new Musée Charles X, Ingres began work on a painting, not completed till 1861, of *Homère et son guide*, illustrating the more traditional episode;[30] the subject of the ceiling, by contrast, was entirely new in 1827; the theme is also apparently less pessimistic than was usual. The origin of this anachronistic gathering of the talents may well have been the visit of Dante to the limbo where the ancients were confined, but there are significant differences between Dante's choice and Ingres's. Most notably, Aristotle has been dethroned and Homer has been moved from the periphery of limbo to the place of honour. It is possible that Ingres had in mind, not so much Dante himself, as Lemercier's own adaptation of the episode from the *Inferno* which he inserted in his light epic *Homère*, in the form of a dream. Homer, having fallen asleep in the fisherman's boat, dreams of his successors through the ages; Solon, Plato, Sophocles, Apelles mingle with Milton, Ovid, Tasso, Shakespeare, and some three dozen others.

> Homère, dans le songe où flottent ces images
> Tu vois les nations te garder leurs hommages.[31]

At the end of the poem, Jupiter, moved by the wretchedness of Homer, builds a temple for him and effects his apotheosis.

> Tels furent les destins d'Homère mendiant
> Et la gloire et la paix qui fuit longtemps la gloire
> Couronna sa vieillesse au temple de Mémoire.[32]

[29] N. Schlenoff, *Ingres, ses sources littéraires* (Paris, 1956), p. 70.

[30] G. Wildenstein, *Ingres* (London, 1954), p. 226.

[31] N. Lemercier, op. cit., p. 37.

[32] Ibid., p. 70. Lemercier would have made contact with David's pupils in David's studio where he was, himself, a pupil: G. Vauthier, *Essai sur la vie et les œuvres de Nepomucène Lemercier* (Toulouse, 1886), p. 4.

In any case, the image of Homer receiving the homage of his successors was not unique to Lemercier. Chênedollé in 1815, perhaps echoing his friend's verses, used the idea in his *Homère*:

> Chaque siècle à ta grande image
> Apporte un tribut solennel.[33]

Possibly the majority of works on the sufferings of Homer are not so much illustrations of texts as variations on a commonplace. As early as 1789, one finds an anonymous *salonnier* consoling Joseph Vernet in the precise idiom that one associates with these later commentators:

L'envie et l'injustice s'élèvent toujours contre les génies; on leur refuse tout, même les honneurs. Poussin, le plus habile peintre de son siècle, fut persécuté; Homère vécut errant et pauvre; le Tasse fut le plus malheureux des hommes de son tems; Milton et cent autres dont le temple de mémoire fourmille, furent encore plus malheureux. . . .[34]

Vigny, in whose poetry the theme of persecution recurs like a leit-motiv, interpreted Ingres's ceiling, forty years after the publication of this account, in analogous terms. Supposing that Plato, the type of the legislator who had persecuted the poet through the ages, might reappear in Louis-Philippe's France, Stello's doctor suggested taking the philosopher

au Musée Charles X (pardonne la liberté grande, je ne lui sais d'autre nom) sous le plafond sublime qui représente le règne, que dis-je? le ciel d'Homère. Nous lui montrerons ce vieux pauvre assis sur un trône d'or avec son bâton de mendiant et aveugle, comme un sceptre entre ses jambes, ses pieds fatigués... ces hommes sont les plus grands dont les noms aient été conservés, les Poètes, et si j'avais dit les plus malheureux, ce seraient eux aussi. Ils forment de son temps au nôtre, une chaîne presque sans interruption de glorieux exilés, de courageux persécutés...[35]

[33] C. Chênedollé, *Études poétiques* (Paris, 1822), p. 117.

[34] *Les Élèves au salon ou l'Amphigouri* (Paris, 1789), in Coll. Deloynes, B. N. Est., XVI, no. 416.
I am grateful to Virginia Lee for drawing my attention to this passage.
Compare also the report by the abbé Grégoire to the National Convention one month before David had completed his drawings on the theme of Homer: 'On a fait nombre d'ouvrages sur les malheurs des gens de lettres. Leur patriarche Homère chantoit ses vers dans les villes de la Grèce pour obtenir quelques morceaux de pain. Képler, après avoir dévoilé le ciel, trouve à peine un coin de terre pour reposer sa cendre; le Tasse expire la veille du jour qui devoit le consoler de ses maux; le Corrège succombe sous la fatigue d'un voyage entrepris sur porter à sa famille pauvre une somme modique, mais pesante, en monnoie de cuivre; Erasme dans ses derniers temps payoit son dîner avec un volume de sa bibliothèque. Le Dante, l'Arioste, le Camoëns, Cervantes, Malherbe, Jean-Baptiste Rousseau périssent sous les lambeaux de l'indigence; en un mot, le génie frappé des anathèmes de la fortune, est avec elle dans les mêmes rapports que la vertu avec la beauté; c'est à dire, presque toujours en guerre: la même route conduit à la gloire et à la misère.' Grégoire, *Rapport sur les encouragemens, recompenses et pensions a accorder aux Savans, aux Gens de Lettres et aux Artistes; séance du 17 vendemiaire, l'an 3 de la République une et indivisible* (Paris, an 3), p. 2. The report at times is prophetic of Vigny: 'la vie d'un homme de génie', wrote Grégoire, 'est presque toujours semée d'épines. Il est en avant de son siècle: dès lors il est dépaysé... Il est harcelé par la jalousie des demi-talens qui lui font expier sa supériorité. Eh! dans quel siècle les talens furent-ils plus atrocement persécutés que sous la tyrannie de Robespierre?' (Ibid., p. 3.) Grégoire's role, first as a reforming abbé who occupies a central position in David's *Jeu de paume*, and then as an opponent to the excesses of the Revolution, makes his testimony especially interesting.

[35] A. de Vigny, *Stello* (Paris, 1882), pp. 389–90.

It is quite possible that Ingres himself regarded his ceiling as a sort of Universal Martyrology. 'Homère repoussé, misérable, mendie,' he wrote in his notes, 'Apelles accusé par la calomnie est sauvé par la vérité; son œuvre lui sert de justification, Phidias injustement accusé, meurt misérablement, si ce n'est pas violemment'; Socrates, Euripides, Theocritus, Aesop, Dante, Jean Goujon, 'meurent de mort violente ou sont tourmentés comme devraient l'être les méchants: Lesueur enfin! Poussin, notre grand Poussin, persécuté par un Fouquières, dégoûté, quitte la France qu'il devait orner. Et Dominiquin, et tant d'autres, et Camoëns!'[36]

Was the suffering of the poet a political accident? The experience of the Terror brought an end to the optimism which made Chénier, in 1791, associate it with monarchy alone, and Vigny used Chénier's own fate to illustrate the universality of the poet's destiny, typically involving the issue of his poetry with the purely political events which led to his execution. 'Je les regarde comme les plus dangereux ennemis de la patrie,' said Vigny's Robespierre of poets and writers. 'La Convention doit traiter tous ceux qui ne sont pas utiles à la République comme des contre-révolutionnaires.'[37] On the other hand, Vigny, writing less than two years after the July revolution, ingeniously associated the deaths of Gilbert and Chatterton with the politics of their respective countries in order to prove that under no system of government is the poet secure from incomprehension and neglect. Homer, 'cet homme, symbole de la destinée des poètes',[38] suffered on account of a fatal necessity which history has illustrated in the life of every poet since Homer. By 1832 the attribution of suffering to genius was a commonplace. Lamartine had described Homer, in 1817, as 'mendiant au prix de son génie un pain mouillé de pleurs',[39] and the theme was implicit in art. 'Il est vrai', continued Ingres in his notes, 'que même dans les temps héroïques Midas préféra Pan à Apollon. Les grands hommes sont persécutés comme s'ils avaient mérité le supplice des coupables par les Furies, précisément parce qu'ils sont de grands hommes.'[40] The poet was not even safe in Augustan Rome where the reverse of Ingres's *Virgile* could be found in Delacroix's *Ovide en exil*, a work thematically related to that of Homer and the shepherds.

David's pupil, Pierre-Nolasque Bergeret, is better known today as a passionate advocate of artists' rights than as an artist himself. Like Ingres, his one-time friend and colleague, Bergeret was certainly touched with paranoia. He was extremely sensitive to the neglect he suffered at the hands of successive administrations—a neglect more apparent than real when one considers the commissions and purchases from which he

[36] H. Delaborde, *Ingres, sa vie, ses travaux, sa doctrine* (Paris, 1890), pp. 156–7.

[37] A. de Vigny, op. cit., p. 316.

[38] Ibid., p. 396.

[39] A. de Lamartine, *Œuvres poétiques complètes* (Paris, Bibliothèque de la Pléiade, 1963), p. 41. Lamartine made particular use of Homer as a symbol of the poet's destiny. See the passage in the 'Chant du Pèlerinage d'Harold', ibid., p. 217.

Cependant l'univers de tes traces rempli

T'accueillit comme un Dieu!—par l'insulte et l'oubli!
On dit que sur ces bords où règne ta mémoire,
Une lyre à la main, tu mendiais ta gloire.
Ta gloire! Ah! qu'ai-je dit? Ce céleste flambeau
Ne fut aussi pour toi que l'astre du tombeau!
Compare also the image of Homer as the type of the 'Génie dans l'obscurité', ibid., p. 422, and particularly the account in *Homère, Socrate* (Paris, 1863).

[40] H. Delaborde, op. cit., p. 157.

benefited under the Empire, Restoration, July Monarchy, Second Republic, and Second Empire.[41] It is no surprise to find that he composed a number of works on the theme of the wandering Homer; an early lithograph, a *paysage historique* in 1817, and a work exhibited in 1822 entitled *Tableau de la justice des hommes* which survives in the artist's description: 'Homère meurt de misère sur son grand chemin et n'a plus pour défendre son cadavre des oiseaux carnassiers et des reptiles dévorans que son chien.'[42]

This was one of the last works on the theme to appear in the *Salons* for a decade. Apart from the ageing and disheartened Gérard, Guérin and Gros, David's pupils abandoned the inspiration of antiquity for the fashionable annals of medieval and Renaissance history. Bergeret, one of the pioneers in the treatment of Renaissance subjects, considered the theme of the despised artist in a letter published in 1848:

pour éclaircir cette matière et avant de voir ce que sont les calculs contemporains, considérons l'effet des intrigues passées; laissons cependant de côté Homère et sa misère, trop d'obscurité enveloppe son existence et sa fin; Apelles victime de la calomnie; Phidias mourant en prison pour prix de ses chefs-d'œuvre; ces faits sont trop loin de nous, les traces des complots sous lesquels succomberont ces hommes de génie sont effacés par le temps et ne fait aux sceptiques de nos jours des preuves irrécusables.

These proofs were provided by the fates of Domenichino, La Fontaine, Poussin, and, with revealing immodesty, of Bergeret himself.[43]

The theme remained popular in art in examples from modern history—the misfortunes of Tasso, Camoëns, Milton—when classical allusion had gone out of fashion. Artists later in the century searched classical antiquity for equivalents to the exotic and medieval subjects of Romanticism, so that the life of Homer returned to fashion as a variant of the theme of the poet as martyr, which had been principally illustrated by the life of Tasso. This thematic continuity ensured the life of Homer an almost unique position as a subject equally popular before 1825 as it was after 1840, when the major sources of neo-classical inspiration, the works of Ovid and Homer, remained virtually 'lettres closes'. Belisarius was the only one of the heroes of neo-classicism who vanished in the 1820s without return. The *Iliad* in particular was neglected as a source of pictorial inspiration, whereas the *Odyssey* was found to contain new examples of moral truth applicable to the mid-century—the fidelity of Penelope or the story of the Sirens—which ensured it a lasting place in the art and letters of this later period. It would be true, however, to say that the sorrows of Homer were remembered by artists when the reputation he had shared with Sophocles as the artists' poet had been forgotten.

The *Prix de Rome*, which was the chief agent in this revival of the antique in art, reintroduced the wandering of Homer into the artists' repertory in 1834. Normally the competitors were given extensive details concerning the scene and its interpretation;

[41] For his commissions see P. Bergeret, *Lettres d'un artiste sur l'état des arts en France* (Paris, 1849); E. Bellier de la Chavignerie and L. Auvray, *Dictionnaire général des artistes* (Paris, 1882), Vol. I; P. Angrand, 'L'État Mécène', *Gazette des Beaux-Arts*, I (1968) 320.

[42] *Explication des ouvrages*, 1822, p. 14.

[43] P. Bergeret, op. cit., pp. 138–40.

in this case, however, the title was unusually short: 'Homère parcourant les villes de Grèce en chantant ses poésies.' The *Journal des Artistes*, remarking that it was an opportunity for the artist to use his imagination, observed that almost all the ten finalists reproduced practically the same composition;[44] the formula evolved by their masters for treating the subject was too familiar to allow a deviation. Indeed, Couture, confusing the two episodes traditionally illustrated, exhibited a Homer 'marchant par les villes comme un mendiant plutôt que chantant comme un poète. Il va précédé de son jeune guide, comme un aveugle de son chien.'[45]

One of the finalists, Holfeld, exhibited his *Homère* at the following *Salon*. Leloir, another finalist in 1834, sent variants on the theme to the *Salons* of 1841 and 1859. 'M. Leloir', said *l'Artiste* in 1841, 'a su rajeunir un sujet si épuisé par la pureté du style et la noble simplicité de l'action.'[46] Leloir was a pupil of Picot, by far the most successful artist of the nineteenth century in sending pupils to the Villa Médicis, and it was Picot's pupils who particularly adopted the subject: Thirion, Bénouville, Couturier, Bouguereau, and Giacomotti. Other artists approached the subject. Corot borrowed the story of Homer and the shepherds from Chénier for the painting which he exhibited in the *Salon* of 1845. Hamon adopted Homer and his guide for his cryptic *Comédie humaine*, commissioned from the Sèvres factory in 1851,[47] and Glaize exhibited *Le Pilori* in 1855 which included Homer with Christ, Socrates, Kepler, Palissy, Correggio, Dante, Cervantes, Joan of Arc, Columbus, Salmon de Caux, Papin, and Dolet as the chief victims of misery, ignorance, violence, and hypocrisy.[48]

There is a curious irony in the choice of the father of poetry as a symbol for the isolation of the artist; as the various group compositions suggest, artists did not make any rigid distinctions between types of genius; the astronomer rubs shoulders with the potter, the soldier with the explorer. The oddity in the choice, which a recent discussion has made abundantly clear, lies in the rarity with which artists chose examples from their own profession to illustrate the plight of genius. Apelles or Phidias might have offered more consolation to the nineteenth-century artist suffering from a sense of wrong than did the blind Homer. Consideration of nineteenth-century illustrations from the lives of the great artists, however, indicates 'a sort of counter-attack on the whole tradition, never more flourishing than during the nineteenth century, which represented painters as disreputable bohemians, quarrelsome and crippled by poverty'.[49] Whatever the reason, it remains an outstanding fact that Bergeret, in his *Honneurs rendus à*

[44] *Journal de Artistes*, II (1834), 193. I am grateful to Linda Whiteley for drawing my attention to this valuable article. Delécluze throws some interesting light on the flimsy attention which many artists paid to their sources when dealing with a commonplace theme such as the abused Homer. In 1825, Delécluze visited Dugas-Montbel: 'il y fut question de l'incertitude de l'existence du personnage d'Homère. Je lui disais à ce sujet que je n'avais même pas pris la peine de consulter la vie de ce poète, faussement attribuée à Hérodote, pour composer le sujet dont j'ai fait le dessin que je venais de lui donner.' *Journal de Delécluze 1824–1828*, ed. Robert Baschet (Paris, 1945), pp. 162–5.

[45] *Journal des Artistes*, II (1834), 195.

[46] 'Salon de 1841', *L'Artiste*, VII (1841), 193.

[47] Travaux des Ateliers: Archives de la Bibliothèque de Sèvres, Nov. 1851.

[48] M. Du Camp, *Les Beaux-Arts à l'Exposition Universelle de 1855* (Paris, 1855), p. 161.

[49] F. Haskell, 'The Old Masters in Nineteenth Century French Painting', *Art Quarterly*, XXXIV (1971), 68–70.

Raphaël, proposed the reverse of the message contained in the *Mort d'Homère* and described in his book on the state of the arts in France, that the talent of the artist is in inverse proportion to the honours he receives.[50]

The acceptance of this premiss had an important effect on the way in which contemporaries viewed the artist's career. David, in particular, was cast in the role of the persecuted genius despite the fact that his talent was rarely questioned in his lifetime, even among his political opponents. In 1835 the author of a paper on the destination of the arts gave David's career as proof of the truism that 'le privilège du génie, le privilège le plus incontestable, c'est d'être dénigré'.[51] The ramifications of this premiss, supported by the action of the juries and the critics of the *Salons*, had far-reaching effects on the biography of French artists; persecution became *de rigueur* in the hagiography of genius. Gautier named Ingres, Géricault, and Prud'hon as types of the despised artist. 'C'est leur sort à tous! Ces hommes qui, de notre temps, ont toujours eu quelques hautes qualités ont été en lutte aux ignobles plaisanteries!'[52] When Thackeray was attending classes in Gros's studio in the 1830s he was told that Géricault had pined and died from 'want of fame' because 'no-one in his day would purchase his pictures and so acknowledge his talent'.[53] Popularity, correspondingly, was suspect. There are few instances in the nineteenth century of the artist in fiction who combines success with talent. 'L'artiste dont les ouvrages réunissent le plus grand nombre de voix se croit le plus grand,' wrote Bergeret. 'Cependant ce grand nombre de voix ne peut être obtenu que par les ouvrages qui renferment le plus de trivialités, qualités superficielles, faites d'éducation préalable.'[54]

Bergeret's contention, that public recognition was no guarantee of talent, that, on the contrary, it was a sign of inferior worth, was logically derived from the stereotype of the abused genius, but was probably not originally part of the story of Homer as David saw it. In many of the compositions, particularly among the early ones, Homer suffers from the fear, scorn, anger, incomprehension, and neglect of aristocrats, magistrates, and politicians, but is appreciated by the crowd. David's drawing perhaps reminds one of his own faith in public taste as the best arbiter of true genius.[55]

In the episode of Homer and Glaucus there is a lingering belief in pastoral innocence as the corrective to the corrupt city; abused by his fellow citizens, Homer finds recognition only among the simple country shepherds. Ponsard, in 1843, read parts of his short epic *Homère* in the presence of Lamartine; although closer to the Herodotan *Life* than most of the works considered here, the poem develops into an attack on the influence of the rich and ignorant in society.[56] This limited view of Homer's sufferings was old-

[50] P. Bergeret, op. cit., p. 138.

[51] C. Farcy, 'Du but et de la destination des beaux-arts', *Annales de la Société Libre des Beaux-Arts*, V (1845), 34.

[52] T. Gautier, 'Salon de 1833', *France littéraire* V–VI (1833), 141.

[53] W. Thackeray, *The Paris Sketch Book* (London, 1840), I.107.

[54] P. Bergeret, op. cit., p. 138.

[55] J. L. David, *Le Tableau des Sabines* (Paris, an 8), pp. 2–3.

[56] C. Latreille, *La Fin du théâtre romantique et François Ponsard* (Paris, 1899), p. 220.

fashioned by 1843. Lamartine, considering the career of Homer, had long before extended the sense of the image:

> C'est la loi du destin, c'est le sort de tout âge,
> Tant qu'il brille ici-bas tout astre a son nuage.[57]

This was the classic formulation of a theme which had become a commonplace of art and poetry in the years 1815–20:

> Ainsi donc, le mortel sublime
> Qu'aux Arts le ciel a condamné
> De son propre destin douloureux victime
> A d'éternels revers paraît être enchaîné.
> Le génie est impitoyable
> Des talens dont il nous accable
> L'Éclat, par l'infortune est toujours expié!
> Malheur à ces esprits et profonds et sensibles
> Qui sur des autels inflexibles
> Une fois ont sacrifié![58]

Thus Chênedollé, the author of a series of odes on the fates of Homer, Dante, Michelangelo, Bossuet, and Milton, writes of Camoëns.

It is, in a sense, false to the mentality of the artist at the beginning of the nineteenth century to isolate Homer from his fellow sufferers, Tasso, Ossian, Camoëns, Chatterton, Gilbert, Milton, Moses, and others. The similarity between the supposed fate of the literary hero of neo-classicism *par excellence* and that endured by the heroes of Romanticism is one of the interesting aspects of the theme, prefiguring the melancholy and sense of decadence which is apparent in many of the works of late neo-classicism in the first three decades of the nineteenth century. As a theme in painting, it originated, above all, in the studio of David, encouraged by political events, and it retained a strong political element even after it had been transformed by disillusioned artists and by 'poètes poitrinaires' into a general statement about the ridicule and incomprehension that attends genius. The invention of the rejected Homer was only part of a gradual process of distortion which has had a lasting effect on the emphasis on hardship and isolation in the biography of nineteenth-century artists; it was an essential part of a definition of genius which significantly reversed the contention implicit in Vasari, that honours and riches are the rewards of true greatness.

[57] A. de Lamartine, op. cit., p. 217.
[58] Chênedollé, *Études poétiques* (Paris, 1822), p. 140. My attention was drawn to Chênedollé's poetry by Maurice Schroder's interesting work on the theme of the isolated artist, *Icarus, the Image of the Artist in French Romanticism* (Harvard, 1961), p. 33.

V

BARON GROS'S NAPOLEON AND VOLTAIRE'S HENRI IV

Robert Herbert

'Les grands hommes aiment la gloire de ceux qui leur ressemblent.'
(words Napoleon had inscribed on the monument to Henri IV at Ivry)
'Tous les jours à midi, il sera joué sur les places, vis-à-vis des hôpitaux, par la musique des corps, différents airs qui inspirent de la gaieté aux malades et leur retracent les beaux moments des campagnes passées.'
(Napoleon's order of the day, Cairo, 21 December 1798)

FOR his painting of *Napoleon on the battlefield of Eylau*, Baron Gros borrowed essential elements from Gravelot's illustrations for the *Henriade*, Voltaire's epic poem on Henri IV. Was this purely to serve the purposes of formal composition, or was the implied relationship to Henri IV an intentional one? Napoleon had discouraged mention of the founder of the Bourbon dynasty, and was furthermore known to hate Voltaire, so it would seem unlikely that Gros would risk such a comparison. Surprising though it may appear, however, Gros's borrowing confirms a covert imitation of Henri IV which Napoleon permitted as early as 1802 and which he encouraged from 1806 onward. Unravelling this curious history provides a singular lesson in the manipulation of art for political ends.

On the eve of the French Revolution there predominated two separate but not contradictory aspects of Henri IV's life.[1] One was the *vert galant*. Beginning with Collé's play of 1766, *La Partie de chasse de Henri IV*, there was a rush of operettas, plays, and songs which had the gallant Henri turn from battle to fall into the arms of Gabrielle d'Estrées,

[1] For the summary of Henri IV's fame before the Revolution, as well as for some facts and publications after 1790, I am much indebted to M. Reinhard, *La Légende de Henri IV* (Saint-Brieve, 1935). He largely overleaps the Revolution and Empire, and records only about one-fourth of the relevant events. In the preparation of this paper I was given the kind help of Vivian and John Cameron in obtaining photographs and information. I am grateful also to Jean Adhémar, Conservateur du Cabinet des Estampes, Bibliothèque Nationale, and to Jacques Foucart of the Louvre for putting at my disposal the materials under their care.

or forsake a hunting party to join the festivities in a country inn. The dramatic events beginning in 1789 gradually pushed aside this aspect in favour of the other: Henri the warrior king, pacifier of warring factions, reformer of government, sponsor of more equitable taxes, ruler by virtue of the love his people bore him, beloved because of his humanity and, above all, because of his clemency. This view of the noble Henri was fortified by the largely mythical concept of the *grand dessein*, chiefly the invention of the king's minister Sully, well after his monarch's assassination in 1610. Sully put forward the view, always congenial to the French mind, that Henri IV wished to lead a supra-national council of Europe which would permit a balance of Catholic and Protestant governments, of hereditary and elective ones.

Voltaire's *Henriade*, published in 1723, had done much to confirm the tradition of the all-wise Henri IV.[2] Voltaire took up most of the noble features of Henri's legend and presented his famous conversion not as a pious act, as the seventeenth century had had it, but as a political one. In 1756 he published an edition of the *Henriade* (one of nearly fifty during his lifetime) with the famous preface by Frederick the Great, and in the *Encyclopédie* Diderot praised the poem by stating that there was 'plus de philosophie dans ce poème que dans *l'Iliade*, *l'Odyssée* et tous les poèmes épiques fondus ensemble'. The secular impulsion given Henri IV by Voltaire continued to grow over the century. As the Revolution approached, Henri IV was customarily incorporated into arguments against the Church, and his government was used as a standard against which to measure that of Louis XVI. A whole flurry of publications celebrated Henri in the opening years of revolution, and his statue on the Pont Neuf was the scene of repeated homages.[3] While there was still hope that Louis XVI might emulate Henri, Voltaire's *Henriade* was often cited. The first-recorded *autel de la patrie*, in 1790, incorporated three cita-tions from the poem, including

> Il fut des citoyens avant qu'il fut des maîtres.
> Nous rentrons dans les droits qu'ont perdus nos ancêtres.[4]

After 10 August 1792, however, no French monarch could be viewed favourably, and Henri IV, although the last to do so, also fell into eclipse. On 14 August the Section Henri IV changed its name to the Section Pont Neuf, and the famous equestrian statue, so recently honoured, was demolished. The *Henriade* fell out of favour also because of its espousal of monarchy and its glorification of heroes, therefore of inequality.[5] The climactic insults to the memory of the first Bourbon occurred in 1793. In September Thirion publicly burned the hearts of Henri IV and Marie de Médicis (separated from their bodies and kept at La Flèche),[6] then on 12 October occurred the profanation of the

[2] Th. Besterman, *Voltaire* (London, 1969), pp. 91–9, and Owen R. Taylor, 'La Henriade, édition critique', in *Studies on Voltaire and the Eighteenth Century*, ed. Th. Besterman, Vols. XXXVIII–XL, *passim*.

[3] François Boucher *Le Pont-Neuf* (2 vols., Paris, 1925–6), II, Pl. 10 and *passim*.

[4] Albert Mathiez, *Les Origines des cultes révolu-tionnaires, 1789–1792* (Paris, 1904), pp. 30 f. In 1790 there was published an edition of the *Henriade* 'imprimée par ordre du Roi pour l'éducation de Monseigneur le Dauphin'.

[5] Taylor, op. cit., p. 210.

[6] F. A. Aulard, ed., *Recueil des actes du Comité de Salut Public* (Paris, 1896), VII.47.

royal tombs at Saint-Denis. The body of Henri IV was propped upright in his coffin for all to marvel at. The good king was easily recognized, thanks to the remarkable state of preservation of his body—a fact that was much embellished in 'underground' legends over the next decade. Among the more famous acts of the day was that of a soldier who cut off part of the king's beard to make a moustache for himself.[7]

It was Napoleon who rescued Henri IV from the obscure place he was assigned after 1793, and in a manner that would flatter himself.[8] The first sign that he would claim this heritage was given in the autumn of 1802. On 29 October, while making a state visit to Normandy, he spent a day at Ivry, the site of Henri's decisive victory of 1590 over the Ligue and its Spanish allies. He visited the emplacement of the monument to Henri IV destroyed in the Revolution and ordered that it be rebuilt. He provided texts for inscriptions on the new obelisk which show the manner in which the first Bourbon was to serve the first Bonaparte.

Les grands hommes aiment la gloire de ceux qui leur ressemblent.

Les malheurs éprouvés par la France à l'époque de la bataille d'Ivry, étaient le résultat de l'appel fait par les différents partis français aux nations Espagnoles et Anglaises; toute famille, tout parti qui appèle les puissances étrangères à son secours a mérité et méritera dans la postérité la plus reculé, la malédiction du peuple Français.[9]

In reply to these modest texts, the local notables greeted Napoleon as the 'pacificateur de l'Europe'. This phrase, for all of Napoleon's bellicose warnings about foreign alliances, seemed appropriate in the autumn of 1802. The concordat with the Church had been signed the previous year, and the peace of Amiens that spring. Napoleon

[7] Reinhard, op. cit., pp. 129 f.

[8] Already in April 1800, only five months after Brumaire, the First Consul was compared favourably to Henri IV by Jaucourt in a major address to the Corps législatif: Lewis Goldsmith, ed., *Recueil de decrets, ordonnances... de Napoléon Bonaparte* (London, 1813), I.362 f. Hardly had Henri appeared than Sully also was found. On 13 September 1801 Talleyrand wrote to Napoleon, 'Permettez-moi d'emprunter à l'histoire d'une amitié très célèbre ce qu'un ministre d'Henri IV disait à son maître: *Depuis que je suis attaché à votre sort, je suis à vous, à la vie et à la mort.*' Pierre Bertrand, ed., *Lettres inédites de Talleyrand à Napoléon, 1800–1809* (Paris, 1899), p. 11.

[9] The two other inscriptions were: 'L'An XI de la République Française, le 7 Brumaire, Napoléon Bonaparte, premier Consul, après avoir parcouru cette plaine, a ordonné la Réedification du monument destiné à consacrer le souvenir d'Henri IV et de la victoire d'Ivry' and 'Napoléon Bonaparte, Premier Consul, à la mémoire d'Henry IV, Victorieux des ennemis de l'Etat aux Champs d'Ivry, le 14 Mars 1590. Le roi se reposa en ce lieu après la victoire.' The inscriptions are recorded in A. de Morard, *Le Ré-*

tablissement de la pyramide de Henri IV (Évreux, 1810). Napoleon's visit of 1802 was widely reported in the press, and his words spoken then were nearly identical with the inscriptions actually placed on the obelisk: *Journal des débats*, 11 Brumaire XI (2 Nov. 1802), *Le Moniteur*, 10 and 13 Brumaire. An abridged history of the monument is given in the anonymous brochure *Notice sur la pyramide d'Épieds*, dated *Épieds*, 2 Aug. 1842. It was first erected in 1778 by the duc de Penthièvre. Under the threat of the Revolution, the duke removed the medallion portrait of Henri IV, carved in white stone. The site was taken over by the department of Évreux in 1798 and the pyramid sold to the mayor of Ivry, who demolished it for the sake of the stone. The rebuilding of the monument reintegrated the medallion of Henri IV, but new stone was brought for the mass of the obelisk, about 35 feet high. The reconstruction finally got under way in 1807 and was finished in 1808. It stands today on the plain outside Épieds, near Ivry-la-Bataille. The original inscriptions have been effaced with time, and partly replaced by modern metal plaques.

could claim that, like Henri IV, he had ended religious and civil discord, brought about a new period of prosperity, and had defied France's enemies while accomplishing the consolidation of her expanded borders.

The optimism born of the period of peace after Amiens, when Napoleon was turning his attention to reforms in agriculture and commerce, invited comparisons with Henri IV's reign. These included the famous *Théâtre d'agriculture* by Olivier de Serres, identified with the enlightened outlook of Henri's government. When A. M. Gisors republished the *Théâtre* in 1802, he began his preface by invoking the new era of peace and, after likening it to Rome under Augustus, he wrote: 'Henri IV victorieux, donna la paix à la France, et y rétablit l'ordre; de même *Bonaparte*, déjouant toutes les factions, et couvert de lauriers, vient d'assurer notre bonheur, en la procurant à l'Europe...' In 1804 and 1805, a much more ambitious republication of the *Théâtre*,[10] this time an official government commission, incorporated the same flattering comparison. Olivier de Serres, the preface stated, 'écrivait sous un héros qui avait retiré la France du cahos des guerres civiles; nous avons le même avantage'.[11]

With the founding of Empire in 1804, comparisons with Augustus, Charlemagne, and Cyrus the Great became commonplace. Next to them, Henri IV seems almost provincial, and Napoleon's feeling of rivalry with the defunct Bourbon line—and his fear of monarchist plots—were powerful deterrents to public joining of their names. The most frequent linking was the obvious one: Napoleon as founder of the fourth *race* of rulers, succeeding Henri as founder of the Bourbon line. There was no objection to the general comparisons which continued to state simply that Napoleon had restored national harmony as had his Bourbon predecessor. In this modest flow of historical analogies, however, there was one strong surge in 1806, surrounding the *Mort de Henri IV*, a play by Gabriel Legouvé. The circumstances leading to its presentation reveal with unusual clarity the manner in which Napoleon manipulated events to his own advantage.

The first element in the reformulation of Henri's fame was the denial of the secular interpretation so important to Voltaire and to the early years of the Revolution, and in its place the insistence upon the genuineness of his conversion and his role as protector of religion. This was accomplished in 1805 and 1806. The clergyman Tabaraud was allowed to publish his attack on the *Henriade* in 1805,[12] a full-scale requisitory that condemned Voltaire for superimposing his own irreligion on the king and upbraided democracy and Protestantism for undermining monarchy. In the same year, the senator Lemercier, visiting La Flèche where Henri's heart had been burned in 1793, sought

[10] N. François *et al.*, eds., published by 'Mme Huzard'.

[11] The editors also quoted from the *Henriade* despite Napoleon's well-known dislike for Voltaire, and this is one of the rare *officieuses* mentions of the famous poem under his government.

[12] Mathieu Mathurin Tabaraud, *De la philosophie de la Henriade, ou supplément nécessaire aux divers jugements qui en ont été portés*. Although clearly labelled 1805, this book has been wrongly listed as 1809 in the printed catalogue of the Bibliothèque Nationale, which other publications have followed.

out Doctor C. Boucher, who was rumoured to have saved the ashes. Boucher wrote a memoir which suggests that Napoleon stood behind the inquiry.[13]

On 20 February 1806 Napoleon ordered the restoration of the royal tombs of Saint-Denis, left in miserable condition since the profanation of 1793. He was rewarded that spring by Joseph Treneuil's poem *Les Tombeaux de Saint-Denis*, the first of several publications on the subject. A prefatory citation from Plutarch recounted the story of Alexander punishing the perpetrator when he discovered that the tomb of Cyrus the Great had been violated, thus establishing the welcome equation: Alexander is to Cyrus's tomb as Napoleon is to Henri IV's. The poem itself constituted a veritable homage to the living emperor. While jackals and hyenas prowl around the profaned tomb, the spirit of Henri IV is made to predict the coming of Napoleon. At the end of the poem, the unnamed new hero is urged to surpass all former rulers in clemency.[14] In view of the fact that French and enemies alike were soon to suffer more murderous battles than any previously known, the poem's stress upon peace and compassion was a vital element of propaganda, and the most useful link attaching Napoleon to the legend of Henri IV, one which would reappear both in Legouvé's play and, covertly, in Baron Gros's *Eylau*.

To be presented at all, Legouvé's play had to overcome the formidable obstacle of the emperor's known opposition to plays about the first Bourbon. From 1802 onward he had intervened on several occasions to forbid presentations of Collé's *Partie de chasse de Henri IV*,[15] an innocuous comedy whose only offence could be the pretext it might offer the royalists to applaud a hero. In June 1805 he protested against Legouvé's new play which, although not yet published, was already being talked about: 'Je lis dans un journal qu'on veut jouer une tragédie de Henri IV. Cette époque n'est pas assez éloignée pour ne point réveiller des passions. La scène a besoin d'un peu d'anti-quité et, sans trop porter de gêne sur le théâtre, je pense que vous devez empêcher cela,

[13] 'M. le Sénateur, pendant son séjour en cette ville, a voulu que nous lui rendissions compte de l'existence des cendres d'un souverain cher à celui sous lequel nous avons le bonheur d'exister. Nous nous sommes fait un devoir sacré de remplir ses ordres avec le respect dû à la vérité et au caractère dont Sa Majesté l'Empereur et Roi l'a revêtu pour le bien de notre pays.' The memoir was anonymously edited for the serial *Souvenirs et mémoires*, 19 Apr. 1900, and re-edited, with notes, by E. L. Chambois, 'Le Cœur de Henri IV et la Révolution', *Revue Henri IV*, I (1905–6), 33–6, erroneously as the 'first publication' of Boucher's text.

[14] In his preface, Treneuil hopes that his poem, devoted to the 'trois dynasties anciennes' will help re-establish 'le respect pour les tombeaux, et à rallumer, dans le cœur des Français, leur amour antique pour la monarchie! Puissions-nous désormais, ainsi que tous les peuples instruits par nos longues discordes et nos longues misères, regarder les souverains comme

des êtres sacrés, les envoyés du Très-Haut et ses images inviolables!' Toward the end of the poem, Napoleon is openly praised as the hero of the Nile, pacifier of factions, and restorer of religion, then God is apostrophized:

> Joins encore à l'éclat de ses lauriers vainqueurs
> Les touchantes vertus qui subjuguent les cœurs;
> Qu'il soit, comme Henri, le père de la France;
> S'il l'égale en valeur, qu'il l'efface en clémence.
> Rends-nous dans ce Héros, enrichi de tes dons,
> Charles cinq, Louis douze et le chef des Bourbons,

God addresses the French in the final two lines:

> Appaisez par vos pleurs la colère des morts:
> La vertu se rallume au flambeau du remords.

The poem was undeniably popular, it should be said, and had three editions in 1806, a fourth in 1808, a fifth in 1810, and a sixth in 1814.

[15] Henri Welschinger, *I a Censure sous le Premier Empire* (Paris, 1887), pp. 219, 226.

sans faire paraître votre intention.'[16] Six months later, Mme Rémusat, a member of Josephine's entourage, attended a private reading of Legouvé's *Mort de Henri IV* and saw the parallels with the current saviour of the nation.

Ce qui m'a paru fort bien, c'est un morceau du roi dans lequel il déploie tout le plan qu'il allait exécuter contre la maison d'Autriche, et qui est l'histoire exacte de cette dernière campagne [of Napoleon]. ... enfin on est ému et on pleure, et je crois que, malgré quelques défauts, c'est une pièce remarquable, et tellement bien entendue, que les moyens de rapprochements sont tous sentis sans être indiqués, et qu'il serait impossible, en ce moment, en applaudissant Henri IV, de ne pas penser tout de suite à l'empereur.[17]

Mme Rémusat was thinking especially of the opening of the play which celebrates Henri's *grand dessein* of uniting Europe through war.

> Oui, l'instant est venu, je pars; et dès demain
> Paris voit aux combats voler son souverain.
> Plus prompt que l'ennemi qui croyait me surprendre,
> Je conduis mes guerriers aux rives de la Flandre,
> Dont l'Espagne ose encore menacer le repos:
> De là je marche à Vienne, où, plantant mes drapeaux,
> Je veux, sur les débris d'une altière puissance,
> Relever des Germains l'antique indépendance.

Sully urges him on by assuring him that the people are 'avide de gloire' and that domestic quarrels will be overcome in pursuit of the common goal. Henri disavows intentions of empire, and claims to wage war only to put an end to 'des démêlés affreux'. He will create a council of monarchs who shall act as a tribunal to guarantee eternal peace. These noble aspirations, however, are only the preface to the play's actions, which instead concern the intrigues of Marie de Médicis, religious extremists, and the Spanish that result in Henri's assassination.

At some point early in 1806, Legouvé succeeded in reaching Napoleon directly.[18] He overlooked nothing that could help his cause, and brought Talma with him to read the play. Napoleon excluded everyone from the reading but Josephine. Both sovereigns were much taken with the play and at the end, when Sully praises the murdered king, Napoleon exclaimed, 'Le pauvre homme! l'excellent homme!', while Josephine wept. Napoleon gave Legouvé permission to produce the play, and we must assume that he did so with every expectation that the public would make the appropriate historical

[16] *Correspondance de Napoléon Ier* (Paris, 1858–70), X.8821. Letter to Fouché from Milan. The 'peu d'antiquité' that he prefers, in that marvellous phrase, is the classical theatre of Corneille and Racine. Even a 14th-cent. setting was unpalatable, and in this same letter Napoleon asks Fouché if he could not encourage the playwright Raynouard, fresh from his triumph with *Les Templiers*, 'à faire une tragédie du passage de la première à la seconde race? Au lieu d'être un tyran, celui qui lui succéderait serait le sauveur de la nation.'

[17] Paul de Rémusat, ed., *Lettres de Mme de Rémusat* (Paris, 1881), I.400 f., Letter to her husband, 29 Dec. 1805. Welschinger, op. cit., p. 235, wrongly places Mme Rémusat's reaction to the play six months later, at the time of its public presentation.

[18] L. Henry Lecomte, *Napoléon et le monde dramatique* (Paris, 1912), pp. 400–12. Lecomte had the account from one Bouilly, who had recorded it from Legouvé's own words. Legouvé was undoubtedly aided by his friends in high places, who included his brother-in-law Mahérault, a government censor for the theatre.

connections. The theatre was the major form of entertainment in the Empire, and was closely associated with *actualité*. For example, on 24 October 1805, after news of the surrender at Ulm had been announced from the stage, the audience enthusiastically applauded these lines from *Iphigénie*,

> Mais qui peut dans sa course arrêter ce torrent?
> Achille va combattre, et triomphe en courant.

On 12 February 1806, Mlle Raucourt isolated these verses from *Sémiramis* to thunderous acclaim,

> Ce qui fond un État peut seul le conserver.
> Il vous faut un héros digne de cet empire.[19]

And when the *grande épopée* got under way in the autumn of 1806, Napoleon's army bulletins were regularly read from the stage.[20]

Legouvé's play finally reached the public stage on 25 June 1806, with Talma in the leading role. It had at least fourteen performances over several months, and in printed form went through several editions, but its reception was decidedly mixed.[21] This was owing partly to the mediocre quality of the play, but principally to its presentation of the plot on Henri's life as founded in religious passion. The most favourable review was in the *Moniteur*,[22] which took its cue from the emperor himself in expressing some worry over events so 'voisins de nous' but stating that the author had carried it off. Most reviewers were less charitable and charged the play with slandering the memory of Marie de Medicis and with being anti-religious, thereby playing into the hands of 'professors' and others who were using their positions to preach anti-religious sentiments.[23]

It is curious that these attacks on Legouvé, which might seem at first glance to support the government, were made by those opposed to Napoleon. In fact he visited their journals with new measures of censorship and even forbade the *Journal de l'Empire* to mention Henri IV and the Bourbons.[24] This was not because of an undue admiration of the new play. On the contrary, it seems likely that Napoleon had given way to a liberal impulse when he authorized its presentation, and also that he saw more of Spain than of Catholicism in the plot to murder Henri.[25] The real reason, and a more subtle

[19] Léon de Lanzac de Laborie, *Paris sous Napoléon* (Paris, 1905–13), VII.141 f.

[20] Rémusat, op. cit., Vol. II, *passim*.

[21] For example, *Mercure de France*, 28 June 1806, pp. 612–14, or *Journal de l'Empire*, 27 June 1806, pp. 1–4. Other judgements of the play can be found in J. F. Ruphy, *Lettres champenoises* (Paris, 1809), in Babault's *Annales dramatiques*, VI (1810), 402–5, and in the report of the prize jury of 1810, recounted in Lecomte, op. cit., pp. 375 f.

[22] 27 June 1806, pp. 837 f., signed 'S'.

[23] De Bonald in the *Mercure de France* and later, repeating his arguments, the *Journal de l'Empire*, 22 Feb. 1807, pp. 3 f. (unsigned, probably Fiévée or

Geoffroy). Legouvé defended himself (citing the *Henriade* in the process) in the long appendix to his play after the first edition. He did not respond to the charges (justified) that his play leans heavily on the structure of Voltaire's *Mahomet*.

[24] Welschinger, op. cit., pp. 153 f.

[25] Napoleon was consistent in his view of Henri IV and usually praised him for having saved France from Spanish domination. As for Legouvé's play, its 14 performances in 1806 should be contrasted with the 100 enjoyed by a play Napoleon really liked, Esménard's *Le Triomphe de Trajan*. Its transparent homage to the emperor gave it a long life on the stage beginning in October 1807 (Lecomte, op. cit., p. 166).

one, for opposing the detractors of the play was his conviction that they were monarchists! In 1806 and 1807 Napoleon made it clear to Fouché and the censors that those who openly opposed the Revolution and the *philosophes* (although he did himself) were supporting the royalist cause.[26] He feared the royalists more than the heirs of revolution, partly because of the challenge to his legitimacy the monarchists represented, partly because he had rather successfully co-opted the spirit of the Revolution and had little opposition on his left.

In the week in which Legouvé's play first appeared, there were other signs of the government's willingness to permit the return of Henri IV to public attention. The same journals that reviewed Legouvé's play took notice of three literary events concerning the first Bourbon. A new comic opera by Saint-Just and Méhul, *Gabrielle d'Estrées, ou les amours de Henri IV*, opened the same day, and music for it was separately advertised, including the song 'Vive Henri IV'. The opera was very popular and was still playing in April 1807. The second event was a new edition of *Mémoires-Anecdotes pour servir à l'histoire du règne de Henri IV, Louis XIII, Louis XIV et Louis XV*, and the press recalled that it had been suppressed in the Revolution—the last edition had been in 1791.[27] The third was Mme de Vannoz's *Profanation des tombes royales de Saint-Denis* which, like Treneuil's poem of a few weeks earlier, gave central place to Henri IV. This modest revival was abetted later by the appearance in the *Salon* of 1806 of four pictures devoted to the king, including Richard's painting of Henri's exhumed body in the crypt of Saint-Denis in 1793.[28]

In the months that followed Legouvé's play and the expiation of the sacrilege of 1793 in the bad but romantic verse of Treneuil and Mme Vannoz, Henri's supposed *grand dessein* was undertaken by Napoleon. In July 1806 the Confederation of the Rhine was formed, with Napoleon as protector of the German principalities, and a month later the old Holy Roman Empire was laid to rest when Francis of Austria renounced the imperial crown. Opposition to the garrisoning of Germany by the French came from Prussia and its ally Russia, but Napoleon seemed invincible. The main Prussian army was routed at Jena on 14 October, and the French entered Berlin two weeks later. From there Napoleon proclaimed the blockade of Great Britain, and prepared to meet the

[26] Welschinger, op. cit., pp. 153 f. Napoleon had predicted this in 1802. An ostensibly generous reason for banning Collé's *Partie de chasse de Henri IV* was that if it were permitted, 'C'est même tendre un piège aux royalistes. Car à la fin, s'ils se montraient trop à découvert, il faudrait bien frapper dessus.' (Ibid., p. 219.)

[27] Napoleon had the 1806 edition with him at Saint Helena, but need not necessarily have purchased it in 1806. It is listed in Victor Advielle, *La Bibliothèque de Napoléon à Saint-Hélène* (Paris, 1894).

[28] No. 429. The others were by Duperreux and Demarne (no. 180), Granet (no. 235), and Laurent (no. 314). Mention should also be made of the statues Napoleon ordered in 1806 for the rebuilding of the Palais Bourbon as the legislative hall: *Sully* by Beauvalet, *l'Hôpital* by Deseine, *d'Aguesseau* by Foucou, and *Colbert* by Dumont. Sully was of course Henri's minister, and l'Hôpital and d'Aguesseau were heroes to the Protestants. The statues, still in front of the building, must have been completed by the time of Napoleon's marriage with Marie-Louise in 1810, since they are noted in the official ceremonies.

Russians to his east. The French army entered Silesia that winter, and then turned north-east to meet the Russians at Eylau.

The battle of Eylau began in snow and bitter cold (about − 26 °C) on the morning of 8 February 1807. About 74,000 Russians and Prussians, the Russians in the majority, faced slightly less than their numbers of French and allied troops. The Russians had superior position and well-placed artillery, but the French were reinforced as the day progressed and finally outnumbered their enemy by several thousand. The French suffered very badly at first from the entrenched artillery, and Augereau's corps had such heavy losses that it was subsequently disbanded. The terrible encounter lasted until nightfall and was a deadlock. During the night the Russians and Prussians withdrew, apparently willing to settle for a draw. The French had encamped in their positions, however, and when Napoleon mustered them on the morning of 9 February, he claimed victory on the principle that the victor occupied the field. He was especially in need of a victory to excuse the massive slaughter his army had absorbed. Although actual figures are uncertain, participants agreed that, proportionate to the numbers involved, it was the most murderous battle in human history. The Russian communiqué (of course claiming victory) admitted to 20,000 wounded and dead, but the number was surely higher, perhaps 25,000. Napoleon admitted to 7,600 casualties, but more reliable accounts put the figure at nearly 20,000.[29]

It is in this perspective that Baron Gros's painting of Eylau (Pl. 28) must be seen. The piled-up bodies were the reality of the Prussian campaign. When the Emperor visited the battlefield on the morning of the 9th, the dead and wounded were so numerous that he could not avoid them with his horse; at one point he let go of the reins so that his mount could pick its own way.[30] 'Ce pays est couvert de morts et de blessés,' he wrote to Josephine on the 14th, 'Ce n'est pas la belle partie de la guerre. On souffre, et l'âme est oppressée de voir tant de victimes.'[31] Caring for the wounded at Eylau required an entire week on the site, and then further weeks in several evacuation hospitals especially established for the purpose.[32] Russian as well as French wounded were cared for. In the memoirs of the two most famous military surgeons at Eylau, Percy and Larrey, these humanitarian actions are verified, although the exclusive presence of Russian wounded in Gros's painting might well make us fear mere propaganda.

Percy, the chief army surgeon, is shown in Gros's picture on the left, looking at Napoleon, his hands on either side of the Lithuanian whose knee is being bandaged.

[29] For example, *Mémoires du Général Baron de Marbot* (Paris, 1891), I.339.

[30] F. F. Billon (A. Lombard-Dumas, ed.), *Souvenirs d'un vélite de la garde sous Napoléon I^{er}* (Paris, 1905), p. 88.

[31] *Correspondance*, XIV.379.

[32] E. Longin, ed., *Journal des campagnes du Baron Percy, chirurgien-en-chef de la Grande Armée* (Paris, 1904), pp. 160–85, and Dominique Larrey, *Mémoires de chirurgie militaire et campagnes* (Paris, 1812–17), III.35–60. Eylau undoubtedly contributed substantially to the staggering figures, known to be correct, of approximately 400,000 hospital registries for the French army from Oct. 1806 to Oct. 1807, of which 32,000 died (G. G. F. Lechartier, *Les Services de l'arrière à la Grande Armée en 1806–1807* (Paris, 1910), pp. 505, 533).

Beginning in 1800, Percy had proposed an international agreement whereby opposing armies would treat one another's hospitals as inviolable, care for enemy wounded equally with their own, and return enemy wounded after their rehabilitation. This agreement was never signed, but Napoleon carried out its intention, and on 18 February returned 1,500 Russian convalescents to their army.[33] Percy is therefore in Gros's painting to honour his own humanitarian efforts, as well as to call the emperor to witness that his merciful orders are being carried out.[34]

Larrey, surgeon of the Imperial Guard, is actually given pride of place among the doctors in the painting. He is shown to the right of centre, offering a bandage to an incredulous enemy. Larrey had added to a reputation already remarkable by operating through the entire bitter night of the 8th/9th.[35] He and the other medical officers are limiting their care to offering drink and simple bandages, preparatory to the evacuation of the wounded. The reasons for this are not entirely noble. The medical supplies that supported the services were farmed out to entrepreneurs and they had failed miserably at Eylau. The entire corps of assistants and nurses, with the supplies, were far behind, and the wounded at Eylau were cared for solely by the officers. Percy had agitated for a major reform, and renewed his pleas at Eylau. The battle and its aftermath decimated his *service de santé*, and the low morale led to desertions. Napoleon promised reforms but did not carry them out.[36] The official commission of the Eylau picture, besides glorifying the emperor, was therefore also a way of making amends to the army doctors.

It was only two months after Eylau that the announcement came of a competition for the commissioning of a painting devoted to the emperor's visit to the battlefield the morning after the encounter. Napoleon said later[37] that he ordered the picture in order to remove doubts about who had won the battle. A public competition would draw much more attention than a direct commission to one artist. Vivant Denon, director of the Musée Napoléon, who was with the army in the east, sent a carefully worded text

[33] *Correspondance*, XIV.388 f.

[34] Of the seven doctors in the picture (three lower right and three more, besides Percy, lower left), Percy is the only one not actively caring for the wounded, but this is to show his role as chief of the surgeon corps, guiding the work of the others.

[35] Napoleon later honoured him by giving him his own sword and a unique decoration with 'Eylau' stitched on it. See Paul Triaire, *Dominique Larrey et les campagnes de la Révolution et de l'Empire, 1768–1842* (Tours, 1902), pp. 93 f., 423. Larrey was a friend of both Gros and Girodet. He proposed to Girodet that he paint a scene of his improvised operating quarters in the snow near Eylau. In the sketch for Eylau (private collection, Toulouse) Gros gave Larrey prominence and did not include Percy at all. That the surgeon-in-chief is a politic addition to the final

painting is felt in his squeezed position. Larrey was doubtless a more appealing figure to Gros, in any event. He had had a dazzling career, distinguishing himself in the Egyptian campaign, in a number of medical innovations, in several publications, and in the invention of an effective field ambulance.

[36] Napoleon cried at the time 'Quelle organisation! Quelle barbarie!' (Percy, op. cit., pp. 168 f.). John McCoubrey, 'Gros' *Battle of Eylau* and Roman Imperial Art', *Art Bulletin*, XLIII (June 1961), 135–9, draws attention to the fact that the Eylau commission was a way of countering the rumours about the demoralized medical corps. See Lechartier, op. cit., pp. 108 f., 118 ff., 133.

[37] Cited in Charles O. Zieseniss, 'Napoléon à Eylau, une esquisse de Charles Meynier', *La Revue du Louvre*, X (1960), 213–20.

(see Appendix A) that was reprinted in identical form in the journals of 2 April.[38] It asked the artists to show Napoleon having the Russian wounded cared for at the moment when one of them, a Lithuanian hussar, cried out, 'César, tu veux que je vive; eh bien! qu'on me guérisse, je te servirai fidèlement comme j'ai servi Alexandre.' These words may well have been spoken, but not necessarily in the tone suggested by the programme. The *Journal de Paris* remarked astutely, 'Il y a dans son discours un mélange de finesse et de naïveté que la situation rend singulièrement touchant; on ne pouvait rien imaginer de plus spirituel pour fixer les regards du monarque, et appeler sur soi les soins de ceux qui distribuaient les secours à cette multitude de blessés.'[39] An ink drawing of the site was made available to the artists, accompanied by thirteen detailed notes which specified costumes, the colour and type of Russian cannon that had been captured, the location of all salient buildings and positions, and which stated that the observer's vantage point is that of the enemy's front line.

Concentrating as it does upon care for the Russian wounded, the programme tried to make the French forget their own losses at Eylau. One aspect of Napoleon's visit to the battlefield that was not put into the picture was the reaction of the French wounded. They knew that their losses had never been so great, and one regiment flew a black cloth of mourning instead of the eagle. Napoleon was furious.[40] Some cried, 'Vive la paix!' and 'Du pain et la paix!', and since the emperor was suffering reproaches for the poor organization of medical services, we can easily see why, a few weeks later, the subject of the commemorative painting should insist upon enemy wounded. This should be further emphasized by mentioning Napoleon's fears that the numbers of his own wounded would demoralize the home front and discourage enlistments. He ordered French wounded to be kept east of the Rhine, and in some cases went so far as to move them in a direction away from the French border.[41]

When the competition was announced on 2 April, the artists were told to prepare their entries for public viewing in six weeks' time. Napoleon and Denon were already thinking of the propaganda value of the exhibition in conjunction with other events celebrating the push into Prussia. The journals in early April[42] published a 'Relation de la bataille d'Eylau par un témoin oculaire (traduite de l'allemand)', a transparent invention of Napoleon that was no more than a rewriting of several army bulletins. In

[38] *Journal de Paris*, pp. 659 f. (front page of that issue), and *Le Moniteur*, p. 363. Pierre Lelièvre, 'Napoléon sur le champ de Bataille d'Eylau par A. J. Gros, précisions sur les conditions de la commande', *Bulletin de la société de l'histoire de l'art français* (1955), pp. 51–5, reprints an altered version of this text from the later handwritten copy in the Deloynes Collection, Cabinet des Estampes, Bibliothèque Nationale, instead of from the published text. Denon is likely to have had a major part in determining the programme for the picture, and he was at Eylau. We cannot be sure, however, that he was the author of the lost drawing offered as guide to the artists. Many drawings

by military artists and by Denon survive from the Prussian campaign, but those for Eylau seem to be lost.

[39] 22 May 1807, p. 3, signed 'M. B.' [Malte-Brun?].

[40] Général Comte de Saint-Chamans, *Mémoires du général comte de Saint-Chamans, ancien aide-de-camp du maréchal Soult, 1802–1832* (Paris, 1896), pp. 59 f., one of the most reliable sources for the dissension in the army after Eylau.

[41] Lechartier, op. cit., p. 133.

[42] *Journal de Paris*, 3 Apr.; *Moniteur*, 4 Apr., and *Journal de l'Empire*, 5 Apr.

June, just after the exhibition, the *Bataille de Preussisch-Eylau* was published, a government brochure incorporating the 'témoin oculaire' and the relevant army bulletins, with plans and maps.[43] The chief supplement to the exhibition of the competition sketches, which opened in the Louvre on 19 May, was the public ceremony the day before to celebrate the depositing in the Invalides of the sword of Frederick the Great.[44] Among the speeches of the day was a rather ingenuous one which congratulated France on having a leader who, despite his conquests, 'a toujours gémi des désastres de la guerre. C'est parce qu'il en connaît tous les fléaux qu'il a soin de les porter loin de nous.'[45] The two-week exhibition of the Eylau sketches was a success, to judge by the constant crowds and wide notice in the press.[46] Gros was awarded the commission, Meynier second place, Thévenin third, and Roehn and Brocas consolation awards.

By reuniting several of the competition entries and some of the derivatives (Appendix B) we can guess the nature of the lost drawing that accompanied the programme.[47] Napoleon was probably in approximately the pose Debret (Pl. 30) gave him; Murat would have had a more active pose, next to him, probably close to that of Zix (Pl. 29); the Lithuanian obviously had one arm extended; and doctors would have been offering drink and bandages to the wounded. Among the dead one would have had his head reversed as in Gros's figure below Napoleon's horse, an invention that struck Meynier (Pl. 31, lower left), Debret and Zix (in both cases, lower right). Napoleon's entourage would have been a rather solid grouping with an opening to the right in which horsemen would have been in motion in the middle distance, as in the unknown artist's work (Pl. 32) and Gros's. One or more cannon were in the lower right corner, there was a cleared space in front of Napoleon, and the disposition of background elements would have been much as Debret recorded it.[48] Even the popular broadsides on Eylau (Pls. 33 and 34) seem to reflect the lost drawing, if at a further distance. They were a response to the popularity of the theme and probably most of them were produced during and after the May exhibition.

The particular value of these comparisons is to distinguish Gros's personal inventions

[43] Announced in *Journal de Paris*, 7 June, p. 1136.

[44] Napoleon had made much of his acquisition of the sword months earlier, and had sent a delegation of senators to Berlin to accept it for the nation. The Berlin reception was the subject of a painting by Berthou, no. 29 in the *Salon* of 1808.

[45] De Fontanes, reported in the *Moniteur*, 18 May, pp. 542 f.

[46] The more interesting reviews are those in the *Journal de Paris*, 19 and 23 May, and the *Journal de l'Empire*, 22 May (Appendix). The police, perhaps unduly influenced by their own reactions to the pictures, feared adverse public opinion. 'Les artistes ont accumulé tous les genres de mutilation, les variétés d'une vaste boucherie, comme s'ils eussent à peindre précisément une scène d'horreur et de carnage, et à rendre la guerre exécrable.' (Police report of 25 May, cited by Lanzac de Laborie, op. cit., p. 379.) The participants' names were not made public until after the judging in June, but the reviewers' descriptions favoured Gros first, then Meynier, Thévenin, and Roehn.

[47] At various times modern historians have claimed that one or another of the compositions (Gros, Zix, Lejeune, and Debret have vied for this honour) must have been the prototype, but the artists were all looking at the competition drawing provided by Denon.

[48] His composition is the easiest to correlate with the numbered notes that accompanied the guide-drawing.

from the prototype. The detailed programme and its guide-drawing supplied much of the exactitude for which he is traditionally given credit, and many of the basic elements of the final composition. Gros's force as an artist resided in the ways in which he implemented the common programme. He had the sense to give his dead and wounded grotesque poses rather than the 'beautiful' ones of the other competitors, which evoke the studio more than the battlefield. Another example of his inventiveness is the brilliant rendering of Murat.

Murat was the most famous of Napoleon's generals in 1807, and Gros had painted his victory at Aboukir (Versailles) for the *Salon* of 1806. He was the embodiment of impetuous action and personal valour, and on the morning of the 9th, after the visit to the battlefield, Napoleon had sent him after the enemy to harry them into their winter quarters. He is shown by Debret, Gros, Lejeune, and the unknown artist as the active force in contrast to the emperor's contemplative mood. Debret made him seem to be asking for permission to pursue the enemy, while Napoleon draws his attention instead to the consequences of war. Gros also makes him into the emperor's instrument of passion and battle, but more subtly. Murat seems impatient to be off, all the while admiring Napoleon. His imminent departure is hinted at by his rearing horse and his proximity to the spatial aperture to the right, in which mounted guardsmen, one looking over his shoulder, seem to be leading him away. His elegant costume also separates him from Napoleon. Witnesses to the battlefield visitation noted that Napoleon appeared in soiled, plain clothing of the previous day which he had not removed, whereas Murat, his horse covered in a magnificent bear's skin, had renewed himself by putting on a splendid Polish costume, catering alike to his vanity and to his aspirations (for he hoped to be given the Polish crown). Gros made him the principal figure of the right half of the picture, almost rivalling Napoleon (the centre line passes between them), and might seem to have risked the emperor's jealousy.[49] The ostensible rivalry does not diminish his lustre, however, for Murat really is used as a *faire valoir*. Denon had already pointed out that it was wise to surround the emperor with officers in magnificent costume, since that made his simpler dress all the more distinctive.[50] Napoleon is framed by triads of officers and is receiving the homages of many, but Murat is relatively isolated and his boot seems almost to trample the outstretched hand of an enemy.

Of course Gros's most important variation upon the common programme for Eylau is the virtual deification of Napoleon. Meynier stretches out the conqueror's arm, but in a gesture of authority. Gros raises the arm higher and opens the palm towards us, a gesture of compassion that calls us to witness his own act as well as the appeal to divinity which is vested in his upturned gaze. Both gesture and gaze recall images of

[49] Gros feared so for a time, according to one of his friends whom Delacroix cites ('Peintres et sculpteurs modernes, III, Gros', *Revue des Deux Mondes*, XXIII (1848), 649–73).

[50] In directions Denon sent to Gérard, 2 Nov. 1806, about a painting of the Austerlitz victory (Lanzac de Laborie, op. cit., VIII.379).

saints who perform acts of piety in God's name.[51] His other hand holds the reins while resting on the edge of his saddle, from which hangs a pouch embellished with the imperial eagle. It is astonishing that these contrived poses work so well. We see the oversized bodies in the foreground, and with horror in our eyes we look up to the emperor above, prepared to acquiesce in the compassion which mitigates that horror. Gros has gone beyond the spirit of mere propaganda and has made of the whole a set of interlocked dramatic incidents which function so well in their own terms that we are forced to accept them, despite our recognition of their implausibility.

Gros's *Eylau* was exhibited in the *Salon* of 1808, by which time further battles had made the image of clemency all the more desirable. The exhibition opened on 14 October, the date chosen by Denon to commemorate another battle of the Prussian campaign, Jena. It was a *salon* singularly fertile in notable pictures, but Gros's painting held its own[52] in company with David's *Sacre*, the coronation of Josephine and Napoleon in 1804, with Prud'hon's *Justice and Divine Vengeance pursuing Crime*, and his *Psyche*, with Gérard's portraits of Josephine, Caroline Murat, and Talleyrand, as well as with a number of pictures celebrating various victories of Napoleon. The emperor returned to Paris a week after the opening, and singled out Gros by his famous gesture of removing his own decoration and giving it to the painter. Contemporary reviewers made much of Napoleon's clemency, 'de ses sentiments qui animent les grands hommes, et particulièrement ceux qui, comme lui, ne font la guerre que pour donner enfin le bonheur et la paix au monde.'[53]

The devotion to noble compassion in *Eylau* had the sanction of official precedent. In Gros's great triumph of the 1804 *Salon*, *Napoleon in the Pesthouse at Jaffa* (Louvre), the awful consequences of war are transformed by the consolation of the miracle-working ruler. In the *Salon* of 1806 there were pictures of three instances of Napoleon's clemency, including one government commission, Debret's *l'Empereur honorant le*

[51] For example, the etching by Hérisset and Dupin of Vincent de Paul and his order on the field of battle. Gros's Napoleon is none the less modest compared to Lejeune's, who is illuminated by a celestial ray that pierces the clouds, and over whose head floats a large eagle. We should remind ourselves that until Napoleon, French rulers were usually portrayed with attributes of divine and antique sanction. Gros's painting represents a large step towards the realism of the nineteenth cent.

[52] It had a place of honour, as is learned from the contemporary *Première journée d'Cadet Buteux au Salon de 1808* (anon., in Deloynes Coll. XLIII, no. 1141):

J'montons, et d'la dernier' marche
J'admirons Eylau,
La porte sert d'la comme d'une arche
Dont s'trouve bien c'tableau:

Pour êtr' vu d'une grande distance,
Gros l'dut calculer;
Car si d'trop près on s'avance,
Ses Russes font r'culer.

[53] Anon., *Observations sur le Salon de l'an 1808*, Deloynes Coll. XLIII, no. 1139. The exact title in the *salon* catalogue gives the right emphasis: 'Champ de bataille d'Eylau. Le lendemain de la bataille d'Eylau. L'Empereur visitant le champ de bataille, est pénétré d'horreur à la vue de ce spectacle. S. M. fait donner des secours aux Russes blessés. Touché de l'humanité de ce grand monarque, un jeune chasseur Lithuanien lui en témoigne sa reconnaissance avec l'accent de l'enthousiasme. Dans le lointain on voit les troupes françaises qui bivouaquent sur le champ de bataille, au moment où S.M. va en passer la revue.' One could wish that Napoleon were the last ruler who waged war in the name of peace.

malheur des ennemis blessés,[54] which showed Napoleon saluting a train of Austrian wounded. Walter Friedlaender[55] has shown that in *Jaffa* and *Eylau,* Napoleon is the *roi thaumaturge,* in traditional conception the king who heals with his touch. John McCoubrey[56] proves that he is also Trajan, the emperor endowed with the virtues of clemency and piety, and contemporaries referred his acts of generosity also to the heritage of Alexander and Cyrus. To what extent can he also be considered Henri IV?

Of all French rulers that preceded Napoleon, none seemed so clearly to predict him as Henri IV. Henri had founded a new dynasty, so had Napoleon. Henri had consolidated his rule after a period of civil and religious strife, so had Napoleon. Henri reformed both government and military and encouraged innovation in commerce and agriculture, and so also Napoleon. Henri was an activist, not an intellectual, and had easy *rapport* with his soldiers, so also Napoleon. Henri had his mythical *grand dessein* to unite Europe, so Napoleon would realize this great French dream. And above all, countless stories were told of Henri's humanity during and after battle, so that he was the French ruler most noted for clemency to the enemy. Frederick the Great himself, whose ghost Napoleon had defeated in Prussia, had emphasized this in the preface to the *Henriade* he had written for Voltaire.[57]

Gros's borrowing from Gravelot's Henri IV (Pl. 27) was therefore entirely logical. We should perhaps first remove any doubts that it was indeed his source. It is true that the pose of a ruler on horseback like Gravelot's or Meynier's (Pl. 31) was a *topos,* so often used that one cannot be sure what might be a precise source in any one instance.[58] But Gravelot's Henri is closest to Gros's figure because the king's hand is raised higher, and the upper body leans to that side; the enemy approaches the ruler's leg in a similar manner, as though Gros's soldier had completed the action initiated by Gravelot's; a dead body is beneath the victor's mount in both cases; bodies are in the foreground slightly to the right of the rulers' horses, and in the similar intervals of space, weapons protrude meaningfully. If the right half of Gros's *Eylau* is blocked off, the proximity of the left side to Gravelot becomes very striking. In other illustrations by Gravelot for the *Henriade,* there are prototypes for individual dead or wounded figures. The prominent Russian in the centre, with his head upside-down, is close to figures in Gravelot's illustrations for the second and sixth *chants* of Voltaire's poem. Gros's composition

[54] No. 131. The others were by Rigo, nos. 437 and 438. Debret's picture was lavishly praised by P. Chaussard, *Le Pausanias français... Salon de 1806,* pp. 143 f., in terms that virtually predicted the Eylau subject.

[55] 'Napoleon as "Roi thaumaturge"', *Journal of the Warburg and Courtauld Institute,* IV (1940–1), 139–41.

[56] Art. cit. McCoubrey offers by far the most subtle analysis of the picture, including its compositional structure and the significance of the changes in the large canvas compared to the sketch. His ingenious comparison of Eylau with the Ludovisi Sarcophagus and with Trajan's column is finally unconvincing in detail. Trajan's column led to a vast number of battle

compositions and there is no need to posit contact with the original to explain Gros's distant relationship to it. Despite the frieze-like order of Napoleon's entourage (which is more a retention of Davidian structure than a derivation from antiquity), individual figures are radically foreshortened and joined in spatial interlockings entirely foreign to Roman sculpture. The treatment of figures in Lebrun's great battle pictures is closer to Gros.

[57] Edition of 1790, pp. xiii, xiv.

[58] For the frontispiece of the presentation copy (Malmaison) of General Berthier's *Relation de la Bataille de Marengo* of 1805, Carle Vernet portrayed Napoleon in the pose Meynier used.

resembles Gravelot's illustrations in the striking foreshortening—so different from that of antique bas-relief—and generally in the spatial structure of fore- and middlegrounds.[59] The fact that the drawing that guided the competitors, whose composition has been deduced from the participants' entries, had the general structure found in Gravelot proves the pervasiveness of the style he represents, and makes more understandable Gros's adaptation of it.

The appropriateness of Gros's borrowing is not just to the historical legend, but to the particular emphasis of Voltaire's *Henriade*. The opening lines of the poem sing the praises of the heroic king who knew how to calm discord, to conquer and to forgive, 'Et fut de ses sujets le vainqueur et le père'. The passage to which the Gravelot illustration is attached seems designed for the Eylau picture.

> Sur un champ de bataille, au sein de la victoire,
> On voit en un moment ces captifs éperdus,
> Contens de leur défaite, heureux d'être vaincus.
> Leurs yeux sont éclairés, leurs cœurs n'ont plus de haine;
> Sa valeur les vainquit, sa vertu les enchaîne;
> Et s'honorant déjà du nom de ses soldats,
> Pour expier leur crime ils marchent sur ses pas.
> Le généreux vainqueur a cessé le carnage;
> Maître de ses guerriers, il fléchit leur courage.
> Ce n'est plus ce lion qui, tout couvert de sang,
> Portrait avec l'effroi la mort de rang en rang;
> C'est un Dieu bienfesant, qui laissant son tonnerre,
> Enchaîne la tempête et console la terre.
> Sur ce front menaçant, terrible, ensanglanté,
> La paix a mis les traits de la sérénité.
> Ceux à qui la lumière était presque ravie,
> Par ses ordres humains sont rendus à la vie;
> Et sur tous leurs dangers, et sur tous leurs besoins,
> Tel qu'un père attentif, il étendait ses soins.[60]

[59] It is tempting to speculate on two further relationships. The Gravelot illustration following the one here illustrated shows Henri being received as conqueror in a pose generally similar to Murat's in the Eylau painting, as though Gros were embodying the two sides of Napoleon in the two figures. And for his *Battle of Aboukir* (Versailles) Gros had apparently already borrowed from illustrations to the *Henriade*, this time from those by Moreau-le-Jeune. The illustration to the third *chant* seems to have given Gros the inspiration for his central figure Murat, for the motif in the lower left of an enemy's throat being stabbed, and for the standard protruding from the smoke of battle overhead. Moreau-le-Jeune shares with Gravelot a common method of spatial organization and of foreshortening the bodies in the foreground, to the point that most of Gros's figures in *Eylau* are closely approximated by one or the other set of images for the *Henriade*. The body of Voltaire illustrations formed a veritable gallery of motifs for artists from the 1780s to the 1840s. For his *Socrates* (Metropolitan Museum) David studied Moreau-le-Jeune's death scene, dated 1785, for Voltaire's *Socrate*, and for *Liberty on the Barricades* (Louvre), Delacroix must have looked at Moreau-le-Jeune's and Eisen's battle scenes for the *Henriade*.

[60] Even the propaganda value of Eylau is adumbrated in the verses which follow shortly after. Rumour proclaims Henri's victory:
Du Tage à l'Eridan le bruit en fut porté;
Le Vatican superbe en fut épouvanté:
Le Nord à cette voix tressaillit d'alégresse;
Madrid frémit d'effroi, de honte, et de tristesse.
As for Spain, Napoleon wrote to his brother Joseph, the new king, on 19 July 1808, 'You must not think it extraordinary to conquer your kingdom. Philip V and Henri IV were compelled to conquer theirs.' (Albert Carr, ed., *Napoleon Speaks* (New York, 1941), pp. 248 f.)

Napoleon had referred publicly to himself as *père* in the aftermath of Eylau: 'Un père qui perd ses enfants ne goûte aucun charme de la victoire. Quand le cœur parle, la gloire même n'a plus d'illusions.'[61]

Gros may have felt that, as in Legouvé's play, the linking of Henri's *grand dessein* and his clemency with Napoleon would be acceptable to the emperor were he to become aware of it. One would like to think that perhaps Denon sanctioned the parallel. He was close to Gros and had previously helped him document his paintings. He had known Voltaire slightly and later his death sale included a terracotta of Voltaire by Pigalle as well as that macabre souvenir, the piece of Henri IV's beard cut from his exhumed body in 1793! The fact that contemporaries did not remark on the allusions in Eylau does not deny the parallel. They did not refer in 1804 to *Jaffa* and the tradition of the *roi thaumaturge* either, but nothing is more certain. Gros was perfectly capable of embedding the comparison in his picture as being that kind of learned and profound reference which was intended to remain discreet.

Other correspondences between the two rulers gave something of a context for the Eylau gloss. It has been forgotten that David's *Sacre* (Louvre) shown in the same *Salon* of 1808 contained many principal figures from the 1804 ceremony dressed in Henri IV coiffures and hats, and both reviewers and the authors of the published description of the commissioned picture[62] drew attention to them. These, and the fact that David's painting is an obvious derivation from Rubens's *Coronation of Marie de Medicis*, would seem to indicate that Napoleon and not just David was conscious of emulating the Bourbon ceremony. Also in 1808, in June, a new edition of Treneuil's *Tombeaux de Saint-Denis* had been published with its extraordinary prediction of Napoleon by the ghost of Henri IV and its celebration of clemency,

> Qu'il soit, comme Henri, le père de la France;
> S'il l'égale en valeur, qu'il l'efface en clémence.[63]

And still again, in 1807 and 1808, there rose the Ivry monument that Napoleon had first ordered in 1802. The project was re-activated in 1807 and completed in 1808—by what stimulus we do not know—and Paris papers in 1808 announced a competition sponsored by Évreux for the best poem on the theme of Napoleon's rebuilding of the monument to Henri IV.[64]

Napoleon's covert rivalry with Henri IV continued throughout his reign, more in the form of modest indications of his ambition and his fears than in any major monuments

[61] Frequently published that winter and spring, the words were from Napoleon's own hand: *Correspondance*, XIV.371, dated 12 Feb. 1807.

[62] Anon., *Nouvelle Description du tableau exposé au Musée Napoléon représentant le sacre de LL. Majestés*, 1808, in Deloynes Coll. XLIII, no. 1117.

[63] See above, n. 14. The second edition was accompanied by *l'Héroïsme de la piété fraternelle*, another

poem by Treneuil recounting a true story of a Princess Amélie de Hohenzollern who cared for a mass grave of victims of the Terror. Napoleon is compared to Cyrus for allowing the faithful to mourn their dead.

[64] See above, n. 9. The first entries, judged on 3 July 1809, were disappointing and the competition was prolonged until 1 June 1810; *Journal de Paris*, 10 July 1809, p. 1426, and *Le Moniteur*, 14 July, p. 770.

or events. The school in La Flèche named after Henri IV, its founder, he turned into a military academy, and contemporaries compared the two great men, 'Et pour nous Bonaparte est un autre Henri.'[65] In 1809 Napoleon's bust was installed in La Flèche to sounds of similar praise, and in the summer of 1810 was published de Morard's poem, winner of the Évreux prize contest on the rebuilding of the Ivry monument. The emperor's care in authorizing published comparisons continued, and in addition to repeatedly banning Collé's *Partie de chasse de Henri IV*, he rejected Raynouard's new play *Les États de Blois* after a private reading in 1810, ostensibly because Henri appeared in it as 'un vrai Philinte'.[66]

The *Salon* of that year had no fewer than eight paintings of Henri IV, one of them acknowledging Legouvé's play as the inspiration,[67] as well as four pictures devoted to Napoleon's clemency towards prisoners. There was also Meynier's commissioned painting of Napoleon visiting the French wounded at the Île Lobau (Val de Grace, replica at Versailles), which shows Larrey, the hero of Eylau, amidst a large number of seminudes, as though male models in a painting school had suddenly all fallen ill together. The most political note was struck by the only anonymous entry in the whole *Salon*, no. 1200, *Henri IV et Sully. Sully déchire une promesse de mariage qu'avait faite Henri IV à Mlle d'Entragues*. The picture was rushed in at the last moment as a supplement and, although no one mentioned the fact, its relevance to the great event of 1810 must have been evident to everyone.

The singular occurrence of 1810 was the marriage with Marie-Louise, for which parallels abounded in Henri's second marriage, with Marie de Médicis. The year before, the senate committee that supported Napoleon's divorce from Josephine invoked a number of rulers whose duty constrained them to break the bonds of marriage, and Henri IV was naturally among them.[68] The official programme for the public celebrations on the Champs-Élysées in honour of the marriage listed as the first item in the open-air concert 'Ouverture et entr'acte d'Henri IV'.[69] For the theatre on the eve of the coronation of Marie-Louise, Napoleon himself chose *Zaïre* despite his known dislike of Voltaire,[70] which proves his willingness to accommodate the author of the *Henriade* as well as its hero.

When Napoleon abdicated the first time, in 1814, one feature of the return of the monarchy was a veritable fireworks of homages to Henri IV, founder of the dynasty

[65] Cited in Reinhard, op. cit., p. 134. It must have been the conversion of the Henri IV school into an academy that prompted the recovery of the ashes of the king in 1805 (see above, n. 13).

[66] Victor Hallays-Dabot, *Histoire de la censure théâtrale en France* (Paris, 1862), pp. 224 f.; Welschinger, op. cit., pp. 195, 249, 304 f., 393 f.

[67] By Mongin, no. 580. The others were nos. 41, 42, 480, 679, 825, 1152, and 1200. Pictures on the theme of clemency were nos. 191, 451, 456, 478.

[68] On 16 Dec. 1809: Goldsmith, op. cit., III.744 f. Napoleon's affection for Josephine was such that he

isolated her at Malmaison to spare her feelings. He told her that Marie-Louise 'te croit vieille. Si elle te voit, elle pleurera et je serai obligé de te chasser. Ce n'est plus comme du temps d'Henri IV, où tu aurais été obligée de porter la queue de sa robe.' (Baron Gourgaud, *Sainte-Hélène, journal inédit de 1815 à 1818* (Paris, 1899), II.402.)

[69] Anon., *Programme des jeux, spectacles... le 2 avril 1810, à l'occasion du mariage de S.M. l'Empereur.*

[70] Frédéric Masson, *L'Impératrice Marie-Louise* (Paris, 1902), p. 65.

whose exemplar was back on the throne. One sign of continuity was the retention of Napoleon's alertness to the political uses of art, and the restoration government included in its plays and musical presentations 'utiles à la direction de l'esprit public'[71] the long-banned *Partie de chasse de Henri IV*, *Les États de Blois*, *Le Souper de Henri IV*, *La Bataille d'Ivry*, and *Henri IV et d'Aubigné* (a play Napoleon had earlier authorized when François Ier was substituted for Henri). In June of 1814 Talleyrand, who once aspired to be Bonaparte's Sully, proposed that Napoleon's image on the Legion of Honour decoration be replaced by that of Louis XVIII, but it was more appropriately supplanted by Henri IV.[72] After the Hundred Days, the homages to Henri IV, such as the many reprintings of the *Henriade* and the publication of long-suppressed plays, books, and poems, came thick and fast. There were dozens each year[73] until the early 1830s, by which time the Bourbons had sufficiently disgraced themselves and the Bourgeois King began to look elsewhere for a heritage.

The competition between Napoleon and Henri IV lingered on past Waterloo[74] in one particular form. This concerned the site of the first statue of Henri IV installed in 1614 on the tip of the Île de la Cité, at the Pont-Neuf. The statue had been largely destroyed in 1792. David's plan of 1793 to replace it with a giant 'Statue of the People' was never carried out, and in 1809 the people were invoked in another fashion. The emperor ordered preparations for a gigantic obelisk on the site, one which would have been inscribed 'Napoléon au Peuple Français' and embellished with bas-reliefs of the hero's great victories, including Eylau.[75] Supporting and enlarging the foundations for the monument proved complex, and the work was not completed before Waterloo. The statue of Henri IV was so important as a symbol of the restored Bourbons that H. Roguier was commissioned to design a temporary plaster statue for a ceremony in May 1814 (Pl. 35), and the architect Belanger began a rebuilding of the site. The engineering work already undertaken in Napoleon's time was incorporated, an ironic bit of support for Henri IV.

Frédéric Lemot was awarded the order for the definitive bronze statue, and he worked on it from 1815 to 1818 while the tip of the island, no longer following the original Belanger proposal, was shored up. The bronze for the huge statue was provided by melting down Chaudet's *Napoléon* from the Vendôme column, Houdon's *Napoléon* from the Boulogne column, and Dejoux's monument to Desaix (the bronze for these, in their time, had been subsidized by the melted images of the later Bourbon monarchs). This bronzy cannibalism seems the more macabre when we reflect that Lemot, that

[71] Hallays-Dabot, op. cit., pp. 234 f.

[72] A. Thiers, *Histoire du Consulat et de l'Empire* (Paris, 1860), XVIII.232 f.

[73] See Reinhard, op. cit., *passim*.

[74] And was revived by Louis Napoleon in such acts as re-rebaptizing the Lycée Henri IV in 1849 as the Lycée Napoléon (the erstwhile convent of Sainte-Geneviève, secularized in 1790, had been made into the Lycée Napoléon in 1804).

[75] Boucher, *Pont-Neuf*, op. cit., II.82–107 on the period of Revolution and Empire, from which comes my account of the events. For the story of Mesmel (sometimes Mesnel) which closes the present essay, Boucher does not give his source, but when he can be checked against published records he proves invariably correct.

Talleyrand of sculptors, had competed for the Davidian 'Statue of the People', had done *Brutus* and *Lycurgus* for the Directory legislature, and *Napoléon sur un char de triomphe* for the Louvre colonnade. And Dejoux, author of the Desaix monument whose bronze would flow into the new Henri, was Lemot's own teacher.

In August 1818 the monumental statue was hauled through the streets of Paris (Pl. 36), its shrouded image bedecked with the fleur-de-lys and surrounded with rampant flags, as though preparing for a joust. On 25 August it was duly installed in a grand ceremony, and, in emulation of an old practice, commemorative objects had been sealed in the horse's hollow interior. One of the objects was the Kehl edition of Voltaire's *Henriade*.

On Napoleon's foundation, in Napoleon's bronze, bearing Voltaire's epic poem in his mount's belly, the image of *le bon Henri* looks out over Paris (Pl. 37). He carries still the evidence of Napoleon's covert admiration: the Bonapartist Mesmel, one of the sculptors who aided in the casting, secreted some anti-monarchist tracts in the horse, and in Henri's raised arm he inserted a tiny statue of Napoleon.

APPENDIX A

Documents for the Eylau competition

See above, n. 38. The identical text appeared in several journals beginning 2 April 1807, datelined 'Prusse. Thorn, 17 mars' and signed simply 'Denon'. The following abridgement has been made by omitting whole sentences and paragraphs, but no words have been altered and none within sentences has been omitted. Brackets indicate editorial interpolations.

Comme toutes les batailles ont un caractère de ressemblance, il [Denon] a pensé qu'il étoit préférable de choisir le lendemain de celle d'Eylau, et le moment où l'Empereur visitant le champ de bataille, vient porter indistinctement des secours et des consolations aux honorables victimes des combats.

Lesdites esquisses devront être déposées au secrétariat du Musée Napoléon, où elles seront reçues jusqu'au 15 mai 1807 inclusivement.

Le directeur général joint ici une description faite sur le champ de bataille d'Eylau, au moment où, le lendemain de cette bataille, l'Empereur a fait la revue des corps qui y avoient combattu.

Pour donner une idée juste des positions, le directeur général a fait déposer à la direction du Musée Napoléon un croquis du champ de bataille. Chaque artiste qui voudra concourir, pourra le consulter en s'adressant au secrétaire général, qui lui communiquera une note détaillée pour le site et les costumes. Les groupes de figures du croquis, tels vrais qu'ils soient, ne doivent pas gêner les artistes dans leur composition. Tout ce qui est mobile dans le premier plan est absolument à la volonté du peintre et au choix qu'il fera des situations énoncées dans la description suivante.

L'armée française, victorieuse, le 8 février 1807, a *Preuss-Eylau*, avoit bivouaqué pendant la nuit, sur le champ de cette mémorable bataille, que l'armée russe, complétement battue, avoit abandonné précipitamment pendant cette même nuit.

Vers midi [of the 9th], l'Empereur monta à cheval, il passa en revue plusieurs divisions des corps des maréchaux Soult, Augereau et Davout, qui se trouvoient encore sur le champ de bataille, et parcourut successivement toutes les positions qu'avoient occupées la veille les différens corps français ou russes. La campagne étoit entièrement couverte d'une neige épaisse, sur laquelle étoient renversés des morts, des blessés et des débris d'armes de tout espèce.

De longues lignes de cadavres russes, de blessés, de débris d'armes et d'havre-sacs abandonnés, dessinaient, d'une manière sanglante, la place de chaque bataillon et de chaque escadron. Les morts étoient entassés sur les mourans au milieu des caissons brisés ou brûlés, et des canons démontés.

L'Empereur s'arrêtoit à chaque pas devant les blessés, les faisoit questionner dans leur langue, les faisoit consoler et secourir sous ses yeux. On pansoit devant lui ces malheureuses victimes des combats; les chasseurs de sa garde les transportoient sur leurs chevaux; les officiers de sa maison faisoient exécuter ses ordres bienfaisans. Les malheureux Russes, au lieu de la mort qu'ils attendoient, d'après l'absurde préjugé qu'on leur imprime, trouvoient un vainqueur généreux; étonnés, ils se prosternoient devant lui, ou lui tendoient leurs bras défaillans, en signe de reconnoissance. Le regard consolateur du grand homme sembloit adoucir les horreurs de la mort, et répandre un jour plus doux sur cette scène de carnage.

Un jeune hussard lithuanien, auquel un boulet avoit emporté le genou, avoit conservé tout son courage au milieu de ses camarades expirans; il se soulève à la vue de l'Empereur: 'César, lui dit-il, tu veux que je vive; eh bien! qu'on me guérisse, je te servirai fidèlement comme j'ai servi Alexandre.'

The *Journal de l'Empire*, 22 May 1807, p. 104, in its review of the exhibition of sketches, published the text of the notes that accompanied the guide-drawing. It is again abridged.

Un croquis à la plume, avec renvois à une Notice explicative, que les concurrens ont été admis à consulter au secrétariat du Musée, déterminoit les autres détails de la composition de la manière suivante: 'Le spectateur est censé placé du côté de l'ennemi; la ligne qu'occupoit l'armée russe forme le premier plan.

1. La ville de Preuss-Eylau, maisons à un seul étage, très-simples, entourées de granges, couvertes de chaume ou de tuiles, de la neige sur presque toutes: l'église en briques, sur une petite éminence.'

'5. L'Empereur, visitant la ligne que les Russes occupoient, fait donner des secours aux blessés: il est entouré de princes, maréchaux et officiers de sa maison.

Son costume étoit une pelisse, ou polonaise de velours gris de perle, ganses d'or, fourrure de martre.

Le prince Murat: Pelisse velours vert; une toque polonaise plate, de martre, velours ponceau, plumet blanc.'

'Le hussard lithuanien: Pantalon vert, dolman couleur de paille et noir, bonnet carré, comme les hulans blancs; fourrure noire. — Jeune homme de vingt-deux ans, traits réguliers, teint hâlé, de la fermeté dans le regard, même un peu de fierté.

6. Ligne perspective qu'occupoit le centre de l'armée russe, toute couverte de morts, de mourans, de fusils, sabres, schakos, havresacs.'

'8. Colonne de Russes faits prisonniers le 9, pendant la poursuite sur la route de Koenigsberg: ils traversèrent le champ de bataille, tandis que l'Empereur l'observoit.'

'13. Bivouacs français sur le champ même de bataille. Le ciel nébuleux: il neige dans le lointain.'

Il n'est pas nécessaire de faire remarquer que chacun de ces numéros se rapporte à un numéro semblable, sur le croquis: si l'on considère à présent que ce croquis n'est pas un simple plan du théâtre de l'action, mais que les groupes et les personnages y sont tracés; que c'est une véritable esquisse de la composition demandée, il semble que jamais on n'avoit indiqué plus clairement à des artistes ce qu'ils devoient faire. Il restoit cependant un embarras: le programme propose un tableau historique du genre pittoresque, à personnages au moins de grandeur naturelle; la notice et le croquis indiquent en termes précis, et qui semblent impérieux, une multitude de détails qu'on ne pouvoit faire entrer que dans un plan orné de figures, à la manière des tableaux de Vander-Meulen ou de M. Lejeune. Dans le doute, les concurrens se sont décidés pour le parti le plus conforme à leur goût; presque tous ont traité leur sujet à la manière des tableaux d'apparat: ce qui les a obligés à sacrifier un grand nombre de détails.

Ils ont bien conservé l'action principale, les personnages les plus importans, la disposition générale, et même les masses indiquées; aucun n'a manqué de déterminer le lieu de l'action, et la saison rigoureuse durant laquelle elle se passe; mais il ne leur est pas resté assez de place dans les fonds pour les détails topographiques, à cause de l'importance de l'action, du nombre et de la forte proportion des personnages des premiers plans.

APPENDIX B

Paintings, drawings, and prints of Eylau

Without further research in French provincial museums and private collections, the reassembling of competition sketches for Eylau will remain very incomplete. The following notes summarize what is presently known.

1. Baron Gros. The sketch is often reproduced (e.g. McCoubrey, see above, n. 36); private collection, Toulouse.

2. Charles Meynier. The sketch is in Versailles, illustrated and discussed by Ziesseniss, see above, n. 37. The drawing (Pl. 31) agrees with the sketch in all major features.

3. J. B. Debret. The engraving by Allais (Pl. 30) is after a 'croquis lavé' which must echo the missing oil sketch, but need not be identical with it.

4. Artist unknown (Pl. 32). This work is at present known only by virtue of an unidentified photograph in the Louvre's Service de documentation, kindly communicated by Jacques Foucart. One assumes that it is one of the competition sketches, but this may not be the case. By collating the reviews of the exhibition of May 1807, we know enough of the lost sketches by H. Roehn and Charles Thévenin to eliminate them, at least, as authors of this composition.

5. Baron Lejeune. Lejeune was not one of the competitors for the commission, but did two compositions of the visit to the Eylau battlefield. One seems to be the oil in the Prefecture of Rouen (known through the kindness of Jacques Foucart), attributed to Lejeune, which is clearly within the family of Eylau sketches; it shares many of the features of the others. From Saint-Chamans, p. 60 (see above, n. 40) we know that Lejeune was working on the Eylau subject in the period March to April 1807, but his own memoirs are silent on the subject (Mrs. Arthur Bell, ed., *Memoirs of Baron Lejeune* (London, 1897)). Lejeune did a view of the Eylau subject that was engraved by Lameau and Misbach, 'Dessiné sur les lieux par LeJeune' (Chalcographie du Louvre, no. 1151). It shares characteristics of the group but is not the same as the Rouen oil. Lejeune was a prolific military artist and could easily have studied the Eylau site after the battle, but the exact date of the engraving is not presently known.

6. Benjamin Zix. Zix did not enter an oil in the May competition, but his drawing (Pl. 29) was exhibited *hors concours*. He was also a military artist, but seems not to have been at the Eylau battle. See B. Druène, 'L'Alsacien Zix, témoin de l'épopée impériale', *Revue historique de l'Armée*, IX (1953), 58–64.

Popular prints and other works. In the Cabinet des Estampes, Bibliothèque Nationale, both in the De Vinck and the 'Histoire de France' collections, there are a large number of broadsides of the Eylau subject (including Pls. 33 and 34). The customary references to the relevant army bulletins and to the Denon programme dated 17 March (hence the error in the caption of Pl. 34), plus the relationships to the guide-drawing, support the

assumption that many were made that spring and early summer. One print that seems not to be in the Bibliothèque Nationale is the anonymous mezzotint of Napoleon's visit to the Eylau field signed 'chez Galle' (46 × 62 cm), a pendant to another of the battle of Friedland (June 1807) and therefore after the May exhibition.

There are other Eylau prints which are mere derivations of Gros's composition and probably date from 1808 and later, when the large canvas had been shown. The actual battle, as distinct from Napoleon's visit, was done by J. Swebach-Fontaine (engraved by Bovines), probably in 1807–8, and much later by many artists and print-makers.

VI

STENDHAL AND DELÉCLUZE AT THE *SALON* OF 1824

David Wakefield

FOR the greater part of his life Stendhal was occupied with the fine arts. He began his literary career as an art historian with an erratic but, in places, brilliant account of Italian art and spent the end of it composing guide-books and travelogues. He assumed the role of critic of contemporary French painting for a short period in the 1820s, first with the *Salon* of 1824, Stendhal's only full-length review, and in 1827 a shorter essay entitled 'Des beaux-arts et du caractère français'.[1] These two works are of great interest since they mark Stendhal's only incursion into the genre of art criticism and, together with the pamphlet *Racine et Shakespeare*,[2] made a significant contribution to the French Romantic movement. Here, as in all his work, Stendhal liked to pose as the adversary of established tradition and the champion of originality. With characteristic truculence, he warns his reader in advance in the introduction to the *Salon* of 1824: 'Mes opinions, en peinture, sont celles de l'extrême gauche.' Despite the flippant manner and tone of studied indifference to contemporary opinion, Stendhal always hoped that his voice would carry some weight and that his comments might influence the course of French art. But how far can Stendhal claim to be a critic of the *avant-garde*? Certainly, he had a clear idea of the kind of art which had to be eliminated: the vast historical and mythological compositions vaguely derived from the example of J.-L. David no longer held any meaning for the modern Frenchman. Yet although Stendhal sides with Romanticism as the party of opposition, and offers the younger artists his support in their revolt against the older generation, he was by no means certain of the form modern Romantic art should take. He only knew that he was on the side of innovation, and it is the militant tone, rather than the actual judgements, of Stendhal's criticism which makes it important in the context of the 1820s. The leading spokesman for the

[1] Both these reviews were published with other essays by Henri Martineau in the volume *Mélanges d'art* (Le Divan, 1932). The *Salon de 1824* first appeared as a series of seventeen anonymous articles in the *Journal de Paris*. All quotations from this *Salon* are taken from the Le Divan edition. Quotations from the corresponding *Salon* by Delécluze are taken from the bound folio volumes of his articles from the *Journal des Débats*, preserved in the Bibliothèque Historique de la Ville de Paris.

[2] *Racine et Shakespeare*, published in two parts, 1823 and 1825 respectively.

opposite point of view at this time was E. J. Delécluze (1781–1863),[3] art critic of the *Journal des Débats*, scholar, humanist, and pupil and biographer of David. Delécluze consistently defended the principles of his master's art, and waged a relentless war against Romanticism in painting. He had, moreover, a very low opinion of Stendhal's competence in artistic matters, and in his Journal wrote of the latter's review of the *Salon* of 1824: 'Avec plus d'esprit que Thiers il a cependant trouvé moyen d'étaler autant d'ignorance.'[4] It was Stendhal, however, who had launched the critical offensive, and all the attacks on the *Journal des Débats* in his own *Salon* are directly aimed at his opposite number. The two critics, therefore, make an interesting contrast. The aim of this essay is to compare their respective aesthetic theory and criticism, and, from the encounter, to define Stendhal's own critical position. It is hoped to show that while Stendhal's theory, first elaborated in the *Histoire de la peinture en Italie* (1817), made a vital contribution to nineteenth-century aesthetics, his practical criticism is in some respects still marked by conservative attitudes.

As a past master in the art of polemics, Stendhal knew that the best way to establish his own claims to originality was first to demolish the opposition. He deals summarily with the leading critics of rival newspapers, among others Thiers in *Le Constitutionnel*, with his fine-sounding but rather vacuous phrases, and Hazlitt, who had recently published a strong denunciation of French painting in the *Morning Chronicle*.[5] His first *bête noire*, however, was the *Journal des Débats*, and he begins the verbal skirmish with a parody of Delécluze's viewpoint: 'La guerre est déjà commencée. Les Débats vont être classiques, c'est à dire ne jurer que par David, et s'écrier: Toute figure peinte doit être la copie d'une statue, et le spectateur admirera, dût-il dormir debout.' And as an example of the kind of art he wanted to banish from the repertory, he quotes a work entitled *Romains rendant les derniers devoirs aux ossements laissés dans une vallée de la Westphalie par les légions de Varus*[6] — 'Voilà un tableau qui sera loué par le *Journal des Débats*.' Canvases of this sort, either by pupils of David himself or by other artists trained on classical principles, with crowds of semi-naked warriors all drawn in correct anatomical outline, were a conscious anachronism and therefore irrelevant to men of his own generation. Stendhal believed that French Romanticism had to make a clean sweep of the classical tradition, just as in *Racine et Shakespeare* he had argued in favour

[3] The standard study of Delécluze is by Robert Baschet, *E.-J. Delécluze, témoin de son temps, 1781–1863* (Boivin, 1942).

[4] *Journal de Delécluze 1824–1828*, ed. R. Baschet (Grasset, Paris, 1948), entry for 2 Dec. 1824.

[5] Stendhal writes of 'un manifeste sanglant' by a M.W.H., and taxes the English critic with excessive chauvinism. The reference is clearly to a series of essays in the *Morning Chronicle* of the same year by Hazlitt, entitled *Notes on a Journey through France and Italy*. In the article of 22 Oct. Hazlitt makes some particularly strong criticisms of paintings by Girodet, David, and Guérin in the Luxembourg Gallery. These articles were reprinted in the *Complete Works of Hazlitt* (ed. P. P. Howe, 1930), Vol. X.

Attacks on Stendhal by critics other than Delécluze were numerous. To name only two, the review by Coupin in the *Revue Encyclopédique* entitled *Notice sur l'Exposition des tableaux, en 1824*, and an anonymous review in *Le Drapeau Blanc* dated 29 Sept. 1824 ('Beaux-Arts. Exposition de 1824').

[6] Identifiable as a painting by Abel de Pujol, now in the Palais de Justice at La Rochelle. Unfortunately I have been unable to obtain a photograph of this work.

of a new, historical theatre, freed from the shackles of the unities and conventional rhetoric. At the end of the eighteenth century a similar break with the immediate past had been made by J.-L. David, whom Stendhal acknowledged as 'ce génie audacieux' for his courage in ridding French art of late Rococo mannerism. 'Je dirai fort sérieusement que je regarde M. David comme ayant surpassé de bien loin les Mengs, les Battoni, les Solimène, les Reynolds, les West et tout ce que le dix-huitième siècle a de peintres renommés.' The late-eighteenth-century passion for classical antiquity which had inspired David to produce his early masterpieces, notably the *Horatii* (1784) and the *Brutus* (1789) (both of which held a strong appeal for Stendhal), had by 1820 given rise to a new orthodoxy, and in the hands of his less inspired followers the respect for classical sculpture became rigid dogma. The result was, inevitably, imitation of imitations. But, in associating the name of Delécluze with this kind of art, Stendhal did his fellow critic less than justice, for in his biography of David[7] and elsewhere, Delécluze himself denounced these anonymous 'Praticiens classiques'. Nevertheless Delécluze continued to defend the principles of his master's teaching, namely the primacy of draughtsmanship over colour and the supremacy of plastic, formal beauty derived from classical sculpture, all of which had grown out of Winckelmann's definition of Greek art as 'Edle Einfalt, stille Grösse'.

Stendhal, on the other hand, is convinced that *le beau idéal antique* has had its day:

Nous sommes à la veille d'une révolution dans les beaux-arts. Les grands tableaux composés de trente figures nues, copiées d'après les statues antiques, et les lourdes tragédies en cinq actes et en vers, sont des ouvrages fort respectables sans doute; mais quoi qu'on en dise, ils commencent à ennuyer... Et que me fait à moi le bas-relief antique? Tâchons de faire de la bonne peinture moderne.

The key to this debate on classical versus modern beauty was David's picture of the *Sabine Women* (1799) (Pl. 39), in which the artist had set out in search of the Greek purity of Etruscan vases. For Stendhal, this controversial painting was David's most unfortunate lapse: blatant neglect for the realities of war, stiff stylized figures, and a hero who, instead of fighting for his life and throne, can only think of striking an impressive attitude. He considered that this work exemplified David at his most pedantic and unnatural, and in a passage entitled "Procès de l'École de David', which earned him notoriety, he claims that the painter exerted a despotic influence on other artists, and that his teaching methods were responsible for the current lack of painterly talent.

Pendant les trente années qu'a duré le gouvernement tyrannique de David, le public a été obligé de croire, sous peine de mauvais goût, qu'avoir eu la patience nécessaire pour acquérir la science exacte du dessin, c'était avoir du génie. Vous souvient-il encore des beaux tableaux de figures nues de madame***? Le dernier excès de ce système a été la *Scène du Déluge* par M. Girodet, que l'on peut aller voir au Luxembourg. (Pl. 40)

Stendhal then writes that if a man in the street were thrown into prison, but promised his freedom once he had mastered the principles of David's draughtsmanship, the man

[7] *David, son école et son temps* (1855).

would be free again after two or three years; but if told to paint a lover's despair on losing his mistress, he would find himself condemned to life imprisonment. With considerable arrogance, Stendhal claims that drawing from the antique as taught by David is a purely mechanical technique which can be acquired without the least spark of genius. He sums up his charge as follows: 'L'École de David ne peut peindre que les corps; elle est décidément inhabile à peindre les âmes.'

Such deliberate provocation did not fail to draw a rejoinder from Delécluze, always ready to defend what he considered to be 'sane doctrine' against the attacks of the pro-Romantic critics. In his biography of David he repeatedly emphasized that the painter, far from being the despotic monster of Stendhal's parody, was in fact the most liberal of all teachers and prepared to encourage talent even in pupils like Girodet with whom he disagreed. Delécluze had intended to publish his reply to Stendhal, but for some reason never did so. The draft, however, of his counter-argument remains in manuscript form among his papers at the Bibliothèque Historique de la Ville de Paris, and the passage was obviously intended as an appendix to his review of the *Salon* of 1824 in the *Journal des Débats*.[8] Delécluze begins by coming to the defence of Girodet, stating that Stendhal would have served the interests of French painting better if he had tried to refute the artist's doctrines by intelligent argument rather than uninformed prejudice:

Le même écrivain a parlé avec encore plus d'ignorance et non moins d'amertume des ouvrages de l'École de M. David. Je dois citer les propres paroles de l'auteur: elles donneront à la fois la mesure de ses connaissances dans les arts, et feront juger du désordre et de l'anarchie qui règnent dans toutes les théories individuelles qui se sont fait jour depuis quelque temps, puisqu'on ne craint pas d'imprimer des extravagances semblables dans un journal quotidien. Voici le passage...

Delécluze then quotes the passage in Stendhal's *Salon* already mentioned, and strongly rejects the latter's assertion that drawing as taught by David was a mindless routine. He denies that David exerted a tyrannical influence on French painting, and finds proof of the fertility of his master's teaching methods in the number of distinguished pupils who emerged from his studio, including Drouais, Girodet, Gérard, Gros, Fabre, Ingres, Granet, Cochereau, and Rouillard. David always encouraged his pupils to develop their own individual aptitudes, and never tried to impose his own manner.

This quarrel between Stendhal and the most prominent art critic of the old school might easily be dismissed as a minor squabble, or imputed to mutual jealousy, especially since in other respects the two men had a good deal in common. They were both passionate admirers of Italian art and the country's way of life,[9] and at Delécluze's house in the rue Chabanais (where Mérimée, Ampère, Stapfer, Rémusat, and others were frequent visitors), they exchanged views amicably on Byron, Shakespeare, and the latest

[8] R. Baschet mentions this passage in his biography of Delécluze (p. 281), but does not reproduce it *in toto*.

[9] Delécluze wrote an account of his Italian journey in the *Carnet de route d'Italie, 1823–1824. Impressions Romaines*, ed. R. Baschet (Boivin, Paris, 1942), a book similar to Stendhal's own travel literature, *Rome, Naples et Florence, Promenades dans Rome*, etc.

literary fashions. But in fact this difference between them reveals a radical divergence of aesthetic attitudes, and already in the early 1820s opinion had begun to divide into the two camps, Classicism and Romanticism. In Stendhal's terminology the word classicism is used bluntly as a term of abuse, synonymous with boring and out-of-date—a definition which he had formulated in *Racine et Shakespeare*, in the section 'Ce que c'est que le Romanticisme':

Le romanticisme est l'art de présenter aux peuples les œuvres littéraires qui, dans l'état actuel de leurs habitudes et de leurs croyances, sont susceptibles de leur donner le plus de plaisir possible.
Le classicisme, au contraire, leur présente la littérature qui donnait le plus grand plaisir possible à leurs arrière-grands-pères.

Because each new age demands new art forms appropriate to it, the conventions of seventeenth-century tragedy must be swept away and replaced by a modern, national drama inspired by Shakespeare. The same process of historical change must be applied to the fine arts. In the *Histoire de la peinture en Italie* he had already drawn the contrast between the *beau idéal antique* and the *beau idéal moderne* and shown that the Greek conception of beauty derived from the physical strength of the naked warrior no longer held good in the nineteenth century; the cult of physique had given way to a demand for psychological intensity: 'C'est donc par une peinture exacte et enflammée du cœur humain que le dix-neuvième siècle se distinguera de tout ce qui l'a précédé.'[10] The idea of applying the concept of historical relativity to the evolution of the arts was not, of course, new to the nineteenth century. It had already been clearly stated during the Quarrel of the Ancients and the Moderns, and frequently reappears in eighteenth-century writers on aesthetics.[11] But at the end of the century, under the hegemony of Winckelmann and Neo-Classicism, Greek art was once again reinstated as the exclusive canon of perfection, a doctrine which continued to be upheld well into the nineteenth century, notably by Quatremère de Quincy, the formidable Secrétaire Perpétuel de l'Académie des Beaux-Arts from 1816 to 1839.[12] Stendhal, as we should expect, was resolutely opposed to this absolutist school of aesthetics. He dismissed Quatremère out of hand,[13] and instinctively saw the flaw in Winckelmann's cult of the Greeks: 'Winckelmann me semble aussi avoir ce défaut; il n'a pas regardé la nature, et puis les Grecs, — mais les Grecs, et la nature ensuite, qu'il n'a trouvée admirable que dans les points imités, pris par les statuaires grecs.'[14] The mistake of these writers was in attempting to impose a norm of beauty, regardless of time and circumstance, and in judging works of art according to a pre-established ideal. In retrospect Stendhal can

[10] *Histoire de la peinture*, p. 405.
[11] W. Folkierski, *Entre le classicisme et le romantisme: étude sur l'esthétique et les esthéticiens du XVIII^e siècle* (Champion, Paris, 1925), pp. 409–24.
[12] See R. Schneider, *Quatremère de Quincy et son intervention dans les arts* (Paris, 1910).

[13] In a letter to Adolphe de Mareste, 7 Dec. 1818, Stendhal writes: '*Le Jupiter Olympien* de M. Quatremère est d'un ridicule outré, par exemple.'
[14] Stendhal, *Journal*, 1811. In *Œuvres intimes*, ed. H. Martineau (Édition de la Pléiade, Paris, 1955), pp. 1134–5.

perhaps be seen as the first of the real Moderns, in the sense that he rejects all appeal to classical precedent and firmly identifies himself with the present moment.

Delécluze, by contrast, remained faithful to the *beau idéal antique* of Winckelmann and Quatremère de Quincy. He consistently maintained the priority of form over colour, and the superiority of sculpture to painting as the embodiment of plastic, formal beauty. His passion for Italian painting and literature, especially Raphael and Dante, and his preference for Florentine art taught him to regard painting as a supremely intellectual activity, a means of projecting order on chaos. And as an austere, high-principled liberal in politics, he believed in the value of art as edification ('l'instruction morale ou intellectuelle d'un peuple'). A critic with such a firm faith in the Ancients as established models of perfection understandably feared the implications in Stendhal's statements about the variability of critical and artistic standards. Thus he warns his readers against Stendhal's *Histoire de la peinture* in the bibliography to his own *Précis d'un traité de peinture* (1828): 'Ouvrage sophistiqué quant au fond, mais plein de remarques fines et d'aperçus vrais dans les détails. C'est le Koran des peintres dits romantiques.' In the same work Delécluze gives his own definition of the terms Classic and Romantic:

Depuis quelques années, en France, on désigne par le mot classique tout peintre sans imagination qui fait profession d'imiter machinalement les ouvrages de la statuaire antique ou ceux des maîtres du seizième siècle. On va même jusqu'à donner ce nom à ceux qui exécutent leurs travaux d'après la théorie et la pratique des anciens. Enfin on stigmatise particulièrement de ce nom les imitateurs maladroits du peintre David. On dit l'École classique, par opposition à l'École romantique.

Thus Delécluze, himself a classicist by training and inclination, admits that by the late 1820s the term had already lost its original sense of a model of excellence and become synonymous with uninspired hack work.[15] It suggests further that Delécluze was reluctantly prepared to concede that Stendhal's attacks were not undeserved. But this did not make Delécluze any more sympathetic to the Romantic cause, for in the same *Traité* he wrote:

On ne sait pas encore ce que l'on entend à présent par la peinture romantique. Toutefois, par l'inspection comparative des ouvrages faits par les artistes dits romantiques on peut juger que, dans leur théorie, le coloris et l'effet sont placés en première ligne parmi les moyens d'imiter et d'agir sur les spectateurs, tandis que l'expression des formes est négligée comme un accessoire presque insignifiant.... On peut considérer les peintres romantiques comme une secte d'artistes spiritualistes qui oublient que, sans la connaissance des modifications de la matière, il est bien difficile d'exceller dans un art d'imitation. Les épithètes de romantique ou de classique que se donnent les peintres ne sont pas précisément des compliments.

Delécluze, who was only one of several like-minded critics, based his critique of Romanticism on several counts. First of all he feared that the new sense of aesthetic

[15] Dr. Jon Whiteley gave a paper at a symposium held at the Warburg Institute (Nov. 1971) on the various uses of the term classicism in the early 19th cent. I am very grateful to him for allowing me to read his paper.

liberation, by which painters were virtually free to choose their style and subject-matter at random—and which Stendhal and Thiers had so strongly advocated—would lead to complete anarchy. Henceforward artists would be deprived of the guidance of tradition, and in his opening article on the *Salon* of 1824 in the *Journal des Débats*, Delécluze clearly foresaw the dangers of the new multiplicity of taste and aesthetic doctrines: 'Proprement dit, il n'y a pas d'école, puisque chaque artiste suit aveuglément la manière qu'il s'est faite, soit d'après ses sensations particulières, soit, ce qui est beaucoup plus commun, en imitant le faire des maîtres qui lui plaisent davantage.' Allowing for the tone of hostility, it must be admitted that these strictures were not unjustified. For, apart from Delacroix, the French Romantic movement failed to produce a single painter of stature because it never managed to evolve a distinctive historical style. Painters like Scheffer and Sigalon, who seemed to hold out great promise in 1824 and 1827, either vanished from the scene entirely, or else went over to a meaningless eclecticism. Ary Scheffer was a typical case: hailed in 1824 on the strength of his *Mort de Gaston de Foix* by Stendhal, Thiers, and the pro-Romantic critics as a pioneer, by 1846 he deserved no better than to be dismissed by Baudelaire as one of 'Les Singes du Sentiment'. This lack of a clear sense of artistic direction was only one of the flaws Delécluze detected in the Romantic painters. Less justifiably, he accused them of making a deliberate cult of ugliness (as critics were to write of Courbet twenty years later) and of gratuitous revelling in morbid and horrific effects. The two main culprits here were Sigalon's *Locuste* and Delacroix's *Massacre at Chios* (Pl. 41). Of the latter he wrote: "Non seulement la disposition de la scène est effroyable comme on en peut juger, mais il semble qu'on ait pris à tâche de la rendre plus hideuse encore par le choix des formes ignobles, et par une teinte cadavéreuse étalée sur le tableau.' To Delécluze both these works seemed designed to pander to the depraved tastes of a generation in search of new sensation at all cost. He found evidence of this moral flaw in the rapid, careless brush-strokes of these painters—'le libertinage du pinceau'—a slovenliness of execution for which he holds the Englishmen, Lawrence and Constable, largely responsible. The ideal of 'la peinture soignée' taught by David had been swept away, and replaced by a disrespect for the antique which seemed to him nothing better than a revival of the Rococo mannerisms of Boucher and Vanloo. Another criticism levelled by Delécluze at the Romantics was their excessive realism: 'La recherche de la verité exacte et démontrée est le défaut que la nouvelle école de peinture doit redouter. Ce système d'imitation lui a été évidemment innoculé par les doctrines littéraires qui règnent aujourd'hui.' Whereas Delécluze admired simple, idealized forms and reticence in the expression of emotion, as in classical tragedy, the Moderns never left anything to the spectator's imagination; all the physical details had to be elaborated. Thus, while recognizing Scheffer's talent in his *Gaston de Foix*, he deplored the fact that the artist had encumbered his picture with so much useless ironmongery, and turned the dead hero into 'un cadavre bardé de fer'. Historical costume also presented another insuperable obstacle to the classically trained critic, and he considered that Gérard had tackled an impossible

subject in his large work showing *Louis XIV presenting his grandson to the Spanish Ambassador* (Pl. 42). In his view the naked human figure was the only worthwhile subject because it revealed the essential man and not his accessories. Finally, the Romantics, seduced by the expressive powers of literature, had sacrificed external, plastic beauty ('le beau visible') in favour of inward emotion ('le beau invisible')—a dangerous temptation again exemplified by Ary Scheffer in his later works inspired by Goethe. This, according to Delécluze, was the major defect of Romantic art: poetry had taken the place of sculpture at the top of the artistic hierarchy, and for this new division of allegiances he coined the terms Homeric and Shakespearian (partly to avoid the controversial overtones of Classic and Romantic). In this new scheme the leading artist in the Homeric tradition was Ingres, in whose *Vœu de Louis XIII* Delécluze recognized a worthy successor to Raphael and the Ancients. The so-called Shakespearians, Delacroix and Horace Vernet, on the other hand, sought movement rather than sculptural immobility, colour at the expense of form—in short all the dramatic effects which Delécluze considered to belong to the sphere of literature, and not to that of the fine arts.

While Stendhal's theory is opposed to the classical aesthetics of Delécluze on nearly every point, it is curious to find that their reactions to the pictures at the *Salon* of 1824 are not dissimilar. The difference is essentially one of tone. From the start Stendhal makes it plain that his sympathies lie with the honest, aspiring young artist—'les jeunes peintres qui ont du feu dans l'âme, de la franchise dans l'esprit, et qui n'attendent pas, en secret, leur fortune et leur avancement futur des soirées ennuyeuses qu'ils vont passer chez madame une telle, ou de la partie de whist qu'ils ont quelque fois l'honneur de faire avec monsieur un tel.' The aim, he writes, of his articles, is to cure artists of copying David and Horace Vernet; thus, by ridding French art of imitation, to help painters discover their own artistic personalities. And since art must be in tune with the times, the paintings which earn his approval are those which contain a vivid portrayal of contemporary events, or else moving personal dramas with which the public at large can instinctively sympathize, such as Prud'hon's *La Famille malheureuse* (*Salon* of 1822) or Léopold Robert's *Mort du Brigand*. In intention, at least, and in his demand for intensity of expression, Stendhal is a thoroughgoing Romantic. But, in front of the paintings at the exhibition, he was not entirely satisfied by any, and his reaction of cautious reservation towards Delacroix's *Massacre at Chios* is not very different from the attitude of Delécluze. Stendhal was equally hostile to the *mal du siècle* kind of Romanticism, and he disliked the picture's morbid sentiment and its cadaverous quality: 'Il y a un Massacre de Scio de M. Delacroix, qui est en peinture, ce que les vers de MM. Guiraud et de Vigny sont en poésie, l'exagération du triste et du sombre.' Stendhal frequently complains that the exhibiting artists show an aversion for beauty and a predilection for ugliness; notably Sigalon in his *Locuste*, who, instead of giving us a youth of Apollonian beauty, made his slave a miserable wretch. 'En méprisant le beau, M. Sigalon a partagé l'un des torts des peintres de 1824.' Stendhal rarely found the balance between formal beauty and passionate psychological realism that he sought, except in

a single figure in Girodet's *Le Déluge* (Pl. 40): 'Il y a une femme noyée dans le Déluge de M. Girodet qui toujours m'a fait le plus vif plaisir; c'est qu'elle est fort belle, et la beauté ôte l'horreur à ma sensation...' Here the painter had managed to extract the maximum pathos from his subject, and Stendhal, always generous with emotion, sent out his heart to the beauty in distress. He remained a strong enough adherent of the classical *beau idéal* to believe that idealization and transposition were a natural part of the creative process, and he reminds his reader that all Raphael's Madonnas were only idealized self-portraits. The slightly old-fashioned, eighteenth-century approach to painting is also revealed in Stendhal's habit of judging works by the facial expressions of the characters, as if they were prizes for the *tête d'expression*. The peak of achievement in this respect seemed to him the soulful, abstracted look of Corinne as she bursts into song on Cape Miseno in Gérard's famous picture (Pl. 43) representing an episode in Madame de Staël's novel: 'Je vois dans les yeux de Corinne le reflet des passions tendres telles qu'elles se sont révélées aux peuples modernes; je sens quelque chose qui tient à l'enthousiasme sombre de Werther; j'entrevois en un mot que cette femme inspirée marche à la mort par un chemin de fleurs.' Nowhere is the unconsciously classical bias of Stendhal's criticism more apparent than in his reaction to Constable's *Haywain*, which he praises for its truth to nature—'vrai comme un miroir'—but complains that the artist has no 'idéal', no sense of grandeur; instead of painting a stagnant corner of English countryside, Constable ought to have portrayed a magnificent site, like the Valley of the Grande Chartreuse near Grenoble! Stendhal remains a partisan of 'le grand goût', believing in a hierarchy of subject-matter graded according to its intrinsic human interest. When it came to the business of practical criticism he shared perhaps more of the traditional attitudes to art than he might have cared to admit.

One last passage, however, in which Stendhal again attacks Delécluze and the *Journal des Débats* reminds us of the difference between the two critics, and provides him with the opportunity to restate his definition of Romanticism. The pretext is a battle scene by Horace Vernet, *La Bataille de Montmirail* (Pl. 44), acclaimed by Stendhal as the best example of Romanticism on the grounds that it portrayed modern warfare in a realistic manner:

Un critique, grand ennemi du romantisme, affuble de l'étrange épithète de shakespearien le tableau de M. H. Vernet, tandis qu'il appelle homériques les tableaux de Raphael et de David. Il est plus simple de dire: J'appellerai romantique tout ce qui n'est pas excellent. Par cet artifice fort simple, peu à peu le mot romantique deviendrait aux yeux du public le synonyme du mauvais.

Thus Stendhal rejects Delécluze's terminology, with its implication that Homeric Greece was the only possible source of plastic beauty. In place of this false literary analogy, he takes up the equation of Romanticism with modernity from *Racine et Shakespeare* and applies it to painting: 'Le romantique dans tous les arts, c'est ce qui représente les hommes d'aujourd'hui, et non ceux de ces temps héroïques si loin de nous, et qui probablement n'ont jamais existé.' According to Stendhal, Vernet's paint-

ing has all the truthfulness of an eye-witness account, and for this reason he rates it more highly than Delacroix's *Massacre at Chios* (Pl. 41), which he criticized partly on the grounds that it had evidently been painted from a newspaper report and visibly lacked the authenticity of first-hand experience. Vernet also possessed the immense advantage of popularity and, success for Stendhal being the best index of an artist's worth, he is proclaimed the Romantic painter *par excellence*.

As far as it goes, Stendhal's logic is a model of arbitrary simplicity; but it fails to take any account of artistic quality. While his aesthetic theory and general pronouncements are astonishingly clear-sighted, his judgement of individual pictures is often cursory and disappointing. To have ranked Vernet above Delacroix would have seemed outrageous to Baudelaire, who unleashed some of his most violent diatribes against the military painter's slick execution and philistine contempt for the higher values of art. To pursue the comparison with Baudelaire, Stendhal shows very little sensuous appreciation of painting and seems hardly aware of the emotive possibilities of colour; all the physical ingredients of painting he regarded simply as the means to an end.[16] Instead he directs his attention straight to the moral or psychological content of a painting, and rates the artist according to his success in rendering the subject. Baudelaire clearly saw the ideological basis of Stendhal's criticism, for in the *Salon* of 1846 he repeats a typical lapidary formula: 'La peinture n'est que de la morale construite.'[17] As a result, Stendhal shows an almost anatomical concern with correct gesture, action, and expression, all of which testifies to the persistence of visual habits ultimately derived from Lebrun and the French Academy; for Stendhal's art criticism is a paradoxical mixture of old-fashioned prejudice and far-sightedness. In the end, of course, the second aspect was the more important, and in his rejection of classical precedent, his pleas for the artist to obey his own temperament instead of authority, and in his alliance of Romanticism with modernity, Stendhal set a critical example which others, notably Baudelaire, were to follow with profit. In spite of his reservations about French painting as it developed in the 1820s, Stendhal emerges clearly as one of the first critics to ally himself wholeheartedly with his own times and to support the aspirations of contemporary artists.

[16] *Histoire de la peinture en Italie* (Édition Calmann Lévy, Paris, 1892), p. 90: 'Les peintres doivent sans doute posséder le coloris, le dessin, la perspective, etc.; sans cela l'on n'est pas peintre. Mais s'arrêter dans une de ces perfections subalternes, c'est prendre misérablement le moyen pour le but, c'est manquer sa carrière.'

[17] Quotation from the *Histoire de la peinture*, Chap. CLVI, p. 338.

VII

ART CRITICISM AND THE AUTHORSHIP OF THE *CHEF-D'ŒUVRE INCONNU:* A PRELIMINARY STUDY

Jerrold Lanes

ALTHOUGH the *Chef-d'œuvre inconnu* has always been considered one of the handful of works essential to an understanding of Balzac's conception of the artist,[1] it has traditionally posed a problem. The novella exists in two basic versions: that which appeared in *L'Artiste* in the summer of 1831 and was republished, with some small changes, in volume form later that year as part of the *Romans et contes philosophiques*, and the version published in 1837 among the *Études philosophiques*. To this last version certain passages were added, few in number but in some cases long, which, as everyone agrees, constitute the principal interest of the work, since it is in them that the painter Frenhofer expounds his views. As the novella's most intensive student, Laubriet, has shown, what in the 1831 versions had been simply a *conte fantastique*, with the emphasis on décor and the picturesque, was in the 1837 version transformed into a tale of ideas and an exposition of the technique by which these ideas might best be expressed, with a corresponding increase in the drama of the story as attention shifted from the props to the actors themselves.[2]

But since the end of the last century the authorship of, or at least the inspiration behind, these additions has been problematical.[3] Gautier and Delacroix have most

I wish to thank Edward Sullivan, who initially encouraged my study of this subject, and James Rubin, who helped me to shorten my text.

[1] For example, by V.-L. Saulnier, *La Littérature française du siècle romantique* (7th edn., Paris, 1964), p. 61; and P.-G. Castex, *Nouvelles et contes de Balzac* (*Études philosophiques*) (Paris, n.d. [1961?]), p. 36.

[2] Pierre Laubriet, *Un Catéchisme esthétique: le 'Chef-d'œuvre inconnu' de Balzac* (Paris, 1961), 3ᵉ partie. Hereafter referred to as 'Laubriet'. The same author's *thèse principale*, *L'Intelligence de l'art chez Balzac* (Paris, 1961), will be referred to as 'Laubriet, *Intelligence*'.

[3] It is typical that Laubriet begins his *thèse complémentaire* by raising the question of 'un collaborateur de Balzac', whether what is involved is 'une possible collaboration' or 'même... l'authenticité balzacienne du texte' (pp. 15–16). So far as is known, debate on this subject began with a newspaper story by Jules Claretie, who wrote that, while the phrasing of Frenhofer's remarks might be Balzac's, the ideas were Gautier's (*L'Indépendance belge*, 5 jan. 1879). Claretie said he had his information from Gautier himself, but his account has been doubted—convincingly, in my opinion—by Laubriet, pp. 99–100. A more serious claim for the same thesis was made by Lovenjoul, who for the first time pointed out the changes that had been made in successive versions of the novella (Charles Spoelberch de Lovenjoul, *Études balzaciennes: autour de Honoré de Balzac* (Paris, 1897), chap. I). Lovenjoul's comparison was fairly complete, but he did not analyse the differences

often been proposed as either author or inspirer, but the trend of criticism has been to reject them, and the most thorough of the recent discussions, those by Laubriet and by Castex, have inclined to ascribe the whole work to Balzac's own hand.[4] What I hope to show is that there are sound reasons for doubting this. My study has been based on a reversal of the method previous students have followed in treating this question. It has seemed to me more logical to ask whether Balzac *could* have written the passages in question than whether anyone else *might* have written them—in other words, I focused my study not on other, hypothetical, authors but on Balzac himself. If this is done I believe that a very strong case can be made for the view that Balzac did not write the added passages. In developing my argument I have proceeded in the following way: First, the essential parts of the additions are presented, with a commentary that I hope will bring out their salient characteristics. Next, the attitudes and doctrines to be found in the press and in *Salon* booklets of the time are reviewed; comparison of them with the additions to Balzac's novella suggests that there is little resemblance between the two. Now it might be thought that, since Balzac could not have taken the content of the added passages from the sources to which he might have been expected to turn for documentation, this is an argument in favour of his own authorship; for who else would have written these unusual passages? But if one studies Balzac's own knowledge of art one sees that it was very slight—rudimentary, in fact, and quite inadequate to deal with the novel aesthetic and the precise points of technique that form the subject of Frenhofer's discourse. Still, it might be felt that Balzac's tastes were such that they led him, despite his ignorance and as it were spontaneously, to the views he gives to Frenhofer. Balzac's tastes will, however, be seen to conflict strikingly with what is advocated in the added passages.

between the texts, saying only that in his view the additions betrayed the 'style si magistral, si personnel et si coloré de Théophile Gautier'; he then traced the friendship between Balzac and Gautier, which was, in fact, close at that time. There matters stood until François Fosca ('Les Artistes dans les romans de Balzac', *Revue critique des idées et des livres*, mars 1922) suggested that Delacroix was the author of the passages in question: Fosca felt that they did not reflect Gautier's taste or opinions while, on the other hand, they were close to most of Delacroix's basic ideas. He has been followed by Mary Wingfield Scott (*Art and Artists in Balzac's 'Comédie Humaine'*, Chicago, 1937), who prudently writes: 'My own surmise is that the insertions and changes in the editions of 1831 and 1837 are not the connected work of Gautier or Delacroix or of any third person so far unsuspected, but that they are the outcome of conversation between Balzac and some critic or painter. . . . As we have seen, Gautier's critical writings bear far less resemblance to the speculations of Frenhofer than do those of Delacroix' (pp. 41–2). The most complete summary of the case for Delacroix's responsibility is given by Georg Hirschfell, *Balzac*

und Delacroix: Streiflichter auf den Roman 'La Fille aux Yeux d'Or' (Basel, 1946), pp. 145–59. Georges Matoré, *Le Vocabulaire et la société sous Louis-Philippe* (Genève–Lille, 1951), accepts Lovenjoul's view without further examination.

[4] Castex is rather guarded in his position, writing typically, 'A la vérité, les opinions professées par Frenhofer ne portent pas expressément la marque de Delacroix et peuvent bien venir d'une autre origine. Il convient pourtant d'admettre...' (p. 59). Laubriet is more decided. For him, the similarities between Delacroix and Frenhofer 'portent essentiellement sur des idées, et ne comportent que quelques rencontres de style, qui s'expliquent facilement par la nécessité d'employer le même vocabulaire technique pour exprimer les mêmes choses' (p. 103). The same holds true for Gautier, since 'n'est-il pas bien difficile, quand on touche aux mêmes sujets, d'échapper aux rencontres de pensée et même de forme?' (p. 110). Laubriet concludes (p. 113) that 'l'addition consacrée à l'exposé des théories esthétiques de Frenhofer... est trop dans la ligne des idées esthétiques de Balzac lui-même pour qu'il ait eu recours à un autre qui l'écrivît'.

If this line of reasoning makes sense, then it seems most unlikely that Balzac is responsible for the new portions of the tale; and if this is so, then the search for another author or, in some sense, for a 'source' must be begun again, but now with a firmer knowledge than has been had heretofore that we cannot fall back on Balzac. The purpose of this paper is to clear the ground for such a search, and it is in this sense that it is offered as a 'preliminary' study. My analysis of the additions themselves is perhaps not as long as it might be: in the form in which Laubriet presents them—he prints the texts of 1831 and 1837 in adjacent columns—they stand out very clearly; I try only to point out their basic elements. The discussions of Balzac's interests in art and of the art criticism contemporaneous with the novella are longer; since, to tell the truth, it seemed to me that the authorship of the additions is of less importance than are the ideas and techniques discussed in them, and that an understanding of them is best served in this way. From a great mass of material I have had at every point to choose.

The additions of the final version, of 1837, are not entirely consistent in tone. Once or twice a phrase, for all its apparent sophistication, has no real substance and seems to have been put down primarily to impress: for instance, a brief mention of 'la dégradation aérienne'. Other lines are routinely rhetorical: 'Il ne suffit pas pour être un grand poète de savoir à fond la syntaxe... Non, mon ami, le sang ne court pas sous cette peau d'ivoire'. Still others suggest sources that are often considered to be characteristic of Balzac, but in fact their influence was so general at that time that we can conclude little from them. When we read, 'Une main ne tient pas seulement au corps, elle exprime et continue une pensée qu'il faut saisir et rendre', we *may* feel that the writer was thinking of Diderot;[5] he was more certainly thinking of Swedenborg when he wrote, 'Toute figure est un monde, un portrait dont le modèle est apparu dans une vision sublime'.

But two basic qualities of the additions may be remarked. The first is that even such commonplace statements as those just cited are always led back to and integrated into discussions of pictorial technique; the additions are predominantly technical in nature.[6]

[5] In the *Essai sur la peinture* Diderot wrote, 'Ce n'est pas dans l'école qu'on apprend la conspiration générale des mouvements; conspiration qui se sent, qui se voit, qui s'étend et serpente de la tête aux pieds. Qu'une femme laisse tomber sa tête en devant, tous ses membres obéissent à ce poids; qu'elle la relève et la tienne droite, même obéissance du reste de la machine' (*Œuvres complètes*, ed. Assézat and Tourneux (Paris, 1876), X.465). This particular passage seems to me closer to Balzac's text than those, immediately preceding it, cited by Margaret Gilman in her article, 'Balzac and Diderot: *Le chef-d'œuvre inconnu*', *PMLA*, LXV (1950), pp. 644–8. Jean Pommier has called attention to other possible connections between Balzac and Diderot in 'Notes balzaciennes', *RSH*, avril-sept. 1951, pp. 161–6, and material contemporaneous with our novella is discussed by Jean Seznec in 'Diderot et Sarrasine', *Diderot Studies*, IV

(1963), pp. 237–45; see also the work by Stephen Gendzier cited there.

[6] The principal exception to this statement is the passage to be found in Laubriet, pp. 211–12. Since the technicality of the additions is of such great importance, it may be interesting to review previous students' opinions on this point. At one end of the spectrum is Miss Scott, who finds in Frenhofer's statements 'pages of the most profound theory on the technique of painting' and considers that 'nothing elsewhere in [Balzac's] work leads one to expect such a deep and even clairvoyant understanding' (pp. 29 and 31). Adhémar agrees with her: 'Ces idées fulgurantes et nouvelles sur le dessin, sur l'absence de la ligne, sur l'expression, tout cela ne se trouve qu'une fois sous sa plume', and he draws the conclusion: 'ce qui prouve bien une collaboration dans la rédaction du livre, et on rencontre au contraire dans toutes les

The other is that they are consistent: Frenhofer's critique of Pourbus's painting agrees with the remarks he makes during lunch in his own house, and these fit very well with the descriptions we are given of Frenhofer's way of working, both when he is amending Pourbus's painting and when Pourbus and Poussin stand before his. We can conclude that the additions are the product of an expertly informed intelligence and one with a guiding point of view. Of the two principal schools of painting at the time—they were often described as the followers of Ingres on the one hand and of Delacroix on the other, but more usually they were called classicists and romantics or conservatives and progressives—Frenhofer is a militant partisan of the second faction. His is a style based on 'colour' rather than 'contour' (the two basic categories of style since the quarrel between the Poussinists and the Rubenists), on brush-work and individual brush-strokes rather than on outline drawing and, especially, continuous outlines—forms are broken, not integral; in Wölfflin's terms, this kind of work is 'painterly' not 'linear', 'recessional' not 'planar'.[7] It is characteristic that Frenhofer, in his opening remarks about Pourbus's painting, emphasizes effects of depth, of atmosphere, of three-dimensionality: to him Pourbus's saint seems 'collée au fond de la toile... on ne pourrait pas faire le tour de son corps. C'est une silhouette qui n'a qu'une seule face... Je ne sens pas d'air entre ce bras et le champ du tableau; l'espace et la profondeur manquent'. It is consistent, too, that Frenhofer says over lunch that to find 'le moyen de réaliser sur une toile plate le relief et la rondeur de la nature' he has studied 'à fond les grands maîtres du coloris'; and that 'le corps humain ne finit pas par des lignes... c'est en modelant qu'on dessine... Aussi n'ai-je pas arrêté les linéaments'. Depth, colour, and a preference for modelling over outline are inextricably united in this approach, as they are in the additions to Balzac's text.

It is worth noting that while the basic difference between these two styles is adumbrated in the second of the 1831 versions, Balzac's understanding of it there is badly muddled; the linear school is oddly, in fact unintelligibly, designated the 'école italienne' but contrasted, none the less, with Titian and Correggio. We shall see that this is typical of Balzac's understanding of art, even in a case such as the present one, where

[autres] œuvres le même idéal, trop différent' (Jean Adhémar, 'Balzac et la peinture', *RSH*, avril–juin 1953, p. 161). Castex's opinion is more qualified, but in the end not irreconcilable with Miss Scott's. He says of the 1837 version that 'toutes les considérations techniques sur la peinture... lui donneront... tant de prix' and that, whoever may have been the source of these ideas, they represent 'un parti-pris moderniste, d'ailleurs fort intelligemment raisonné, qui... fait apparaître le romancier comme l'un des témoins et des interprètes les plus lucides de l'expérience et des aspirations de toute une époque' (pp. 37 and 60). Laubriet is at the other end of the spectrum. He notes that 'les premières éditions sont très pauvres en dissertations techniques' and that 'une tâche essentielle reste à faire, expliquer pourquoi Frenhofer est un

génie de la peinture... elle sera accomplie avec l'édition de 1837' (p. 85). But when he comes to analyse the passages added to the later edition he concludes that 'Ils n'offrent aucun caractère de nouveauté, et l'on ne peut dire que le peintre mis en scène par Balzac apparaisse comme un exceptionnel génie de la peinture par ses principes techniques... ses notions se limitent... aux éléments de l'art de la couleur et de l'histoire de la peinture. Il semble que sa documentation, malgré son apparence sérieuse, se soit limitée aux rudiments; il a appris ce qu'il fallait pour produire une suffisante illusion' (pp. 97–8).

[7] The English translation of Heinrich Wölfflin's classic book is called *Principles of Art History*; it was made by M. D. Hottinger from the 7th German edition, of 1929, and itself exists in many editions

the matter was perfectly common in the thinking and writing of the time. Six years later, while Pourbus is still confused, the author of Frenhofer's critique of his work is not:

Tu as voulu imiter à la fois Hans Holbein et Titien, Albrecht Durer et Paul Véronèse... Mais qu'est-il arrivé? Tu n'as eu ni le charme sévère de la sécheresse, ni les décevantes magies du clair-obscur. Dans cet endroit, comme un bronze en fusion qui crève son trop faible moule, la riche et blonde couleur du Titien a fait éclater le maigre contour d'Albrecht Durer où tu l'avais coulée. Ailleurs, le linéament a résisté et contenu les magnifiques débordements de la palette vénitienne. Ta figure n'est ni parfaitement dessinée, ni parfaitement peinte, et porte partout les traces de cette malheureuse indécision.

This summary characterization of the two schools of painting is as lucid and articulate as any to be found in the art criticism of the time.

As significant as the understanding of basic principles of which the additions give evidence is an acquaintance with particular details of technique. These are numerous, precise, and, once again, of a striking coherence. Twice Frenhofer describes his method of rendering a figure. The highlights are laid on in a thick impasto, the darks in thin transparent glazes; between, instead of an unbroken gradation of a single tone, is a series of *demi-teintes*:

j'ai... ébauché ma figure dans un ton clair avec une pâte souple et nourrie, car l'ombre n'est qu'un accident, retiens cela, petit. Puis je suis revenu sur mon œuvre, et au moyen de demi-teintes et de glacis dont je diminuais de plus en plus la transparence, j'ai rendu les ombres... j'ai répandu sur les contours un nuage de demi-teintes blondes et chaudes qui fait que l'on ne saurait précisément poser le doigt sur la place où les contours se rencontrent avec les fonds.

Regarde la lumière du sein, et vois comme, par une suite de touches et de rehauts fortement empâtés, je suis parvenu à accrocher la véritable lumière et à la combiner avec la blancheur luisante des tons éclairés; et comme par un travail contraire, en effaçant les saillies et le grain de la pâte, j'ai pu, à force de caresser le contour de ma figure, noyé dans la demi-teinte, ôter jusqu'à l'idée de dessin... et lui donner l'aspect et la rondeur même de la nature.

In effect Frenhofer's practice follows the doctrine—for it was virtually that—of painting an *ébauche* as this was taught in the schools. Since Boime has described it very clearly there is no need to repeat it here.[8] And when the surface of the canvas has been built up in this way, Frenhofer finishes Pourbus's *Égyptienne* in what also seems to have been the prescribed fashion:

Tout en parlant, l'étrange vieillard touchait à toutes les parties du tableau: ici deux coups de pinceau, là un seul, mais toujours si à propos qu'on aurait dit une nouvelle peinture, mais une

[8] Albert Boime, *The Academy and French Painting in the Nineteenth Century* (London and New York, 1971); most relevant for our purposes are pp. 36–41, from which the following citations are taken. On highlights and shadows: 'Dans tous les livres il est dit: empâtez les clairs; peignez légèrement les ombres' (Paillot de Montabert, *Traité complet de la peinture* (Paris, 1829), IX.37); and 'empâtez largement et grassement toutes vos plus belles lumières' (P. L. Bouvier, *Manuel des jeunes artistes et amateurs en peinture* (2nd edn., Paris, 1832), p. 239). On *demi-teintes*: 'le précepte qui oblige à appliquer chaque ton, chaque teinte juste, et à ne les fondre entr'eux que par d'autres tons et teintes justes et intermédiaires, déposés aussi sans mélange avec les tons voisins' (Montabert, p. 40): and 'évitez de les passer [colours] l'une dans l'autre avec la brosse... c'est en posant avec discernement une filiation de teintes presque insensible les unes à côté des autres, que vous devez obtenir leur liaison' (Bouvier, p. 241).

peinture trempée de lumière... Pon! pon! pon! disait-il en réchauffant les parties où il avait signalé un défaut de vie...[9]

Since these procedures were described in students' manuals, we may anticipate subsequent discussion by asking if Balzac might have owed the additions to sources such as these. Here I only note that these particular passages are of a very technical, as well as a practical, nature; we shall see that nothing would lead us to expect Balzac to understand questions of this sort, or even to be directly interested in them. At present it is perhaps more important to stress the novelty of those additions which are technical; for, along with their technicality and coherence, novelty is the striking characteristic of the added passages. One element of this novelty lies in a basic principle: if Frenhofer does indeed adopt the basic methods by which an *ébauche* was usually made, he applies them not to a sketch but to a finished painting. This is not a small fact. At a time when the difference was so great between an *ébauche* and a painting that was considered suitable for public exhibition (as Pourbus's is explicitly said to be by Frenhofer when he finds it worthy of being signed), it is fundamental: this change in the role of certain techniques amounts to a subversion or inversion of the values on which serious painting was based, changes that were to be effected as the century advanced. Despite the fact that central elements of Frenhofer's practice can be found in artists' handbooks, his aesthetic is radically different from that which prevailed in Balzac's time.

In addition to its basic novelty, Frenhofer's approach includes some specific innovations, of which it may be useful to single out one, his way of treating shadows. This is especially interesting in the light of later developments in painting, and it affords a particularly clear instance of the rightness of the individual element in the over-all scheme of additions to the novella. Usually, at that time, shadows were rendered in a kind of bituminous brown, having ochre or sienna as its base; in fact this was the basic tone of the entire canvas, which was orchestrated in what one writer described as 'un simple clair-obscur au bistre, d'un ton plus ou moins chaud'.[10] Frenhofer on his part colours his shadows blue—the 'petit glacis bleuâtre' he applies when he begins to retouch Pourbus's painting in order to 'faire circuler l'air autour de la tête de cette pauvre sainte qui devait étouffer et se sentir prise dans cette atmosphère épaisse'. As he indicates, this method is consistent with his style, colouristic and striving for effects of depth: the contrast between cool blue shadows and the warm browns of the figure causes the figure to seem to stand out and away from the ambient areas in a true atmospheric depth;

[9] Cf. Bouvier, p. 239: 'revenir ensuite rehausser le centre de ces mêmes lumières avec une teinte encore plus brillante...; mais pour cela vous attendrez que toute votre tête soit couverte et comme achevée: alors vous attaquerez en dernier lieu le centre de ces lumières très-vives et reluisantes, afin d'ajouter plus de relief au tout par ces touches vives.'

[10] M. Boutard, *Dictionnaire des arts du dessin* (Paris, 1838), p. 233; I owe this citation to Albert Boime. Boime points out that Couture also writes of 'un ton composé de noir et de brun rouge' (T. Couture, *Méthode et entretiens d'atelier* (Paris, 1867), p. 32). Laubriet is quite mistaken in saying (p. 94), 'sans doute Pourbus avait-il procédé comme tous les peintres académiques en employant pour ses ombres des teintes froides, c'est à dire à base de noir et de bleu'.

in this way it is a corollary of Frenhofer's abandonment of outline as a means of distinguishing figure from ground. The artist himself underscores the importance of his procedure, and its uniqueness, for while many painters of the thirties were moving in the direction articulated by Frenhofer, to my knowledge none had carried their practice as far as he:

car les ombres des peintures ordinaires sont d'une autre nature que leurs tons éclairés; c'est du bois, de l'airain, c'est tout ce que vous voudrez, excepté de la chair dans l'ombre. On sent que si leur figure changeait de position, les places ombrées ne se nettoieraient pas et ne deviendraient pas lumineuses. J'ai évité ce défaut où beaucoup[11] entre les plus illustres sont tombés, et chez moi la blancheur se révèle sous l'opacité de l'ombre la plus soutenue![11]

In fact one of the most remarkable characteristics of the additions of 1837 is that even at their most extreme they are not rhetorical—their boldness is based on sense and knowledge. I am thinking of such statements as 'l'ombre n'est qu'un accident'; 'le corps humain ne finit pas par des lignes... Rigoureusement parlant, le dessin n'existe pas... La ligne est le moyen par lequel l'homme se rend compte de l'effet de la lumière sur les objets; mais il n'y a pas de lignes dans la nature, où tout est plein: c'est en modelant qu'on dessine... la distribution du jour donne seule l'apparence au corps'; or, 'Peut-être faudrait-il ne pas dessiner d'un seul trait, et vaudrait-il mieux attaquer une figure par le milieu en s'attachant d'abord aux saillies les plus éclairées...' To sum up: what Frenhofer has to say in the version of 1837 is not vague or commonplace but both highly technical and very advanced; it is not the work of an amateur, or of a man with conventional views on the subjects it concerns. How greatly it differs in these respects from the statements about art of Balzac himself we shall see, but first we may look at the ideas of contemporary art critics.

Their writing, on the basis of which Balzac might normally have formed his own knowledge of art, has three principal characteristics: whether by conservatives or progressives it is preponderantly moralizing in tendency; partly as a result of this it lacks any very technical quality, confining itself mostly to generalities; and by the 1830s it had come to lack even a point of view, except in reflecting a kind of eclecticism that could find a place for all schools.

Of the tendency toward moralizing a remark of one of the conservatives, Charles Farcy, may be taken as typical: in defending academic values Farcy said he spoke 'au nom du beau, du bon et du sens commun'.[12] What is significant is the fact that he makes his defence of the Academy not in terms of a certain technique, linear and rather

[11] It is interesting to relate this passage to a change in Delacroix's thinking. As late as 1830 Delacroix was noting, 'Mettre dans l'ombre des tons de feuille morte (Van Dyck), bruns' (*Journal*, ed. P. Flat (3 vols., Paris, 1893–5), I.143); but his first trip to Africa taught him to break with this practice: 'L'ombre des objets blancs très reflétée en bleu', as he wrote in a sketch-book of 1832 (*Journal*, ed. A. Joubin (3 vols.,

Paris, 1960), I.130). However, Delacroix does not seem to have used this method in his oil paintings of the thirties.

[12] Cited without reference by Pontus Grate, *Deux critiques d'art de l'époque romantique: Gustave Planche et Théophile Thoré* (Stockholm, 1959), p. 20. In the following section of this paper I have drawn largely on Grate's very competent work.

monochrome in means and bas-relief in effect, but of certain moral values. It was the same with Delécluze, the leading spokesman of conservative taste. Delécluze was perfectly capable of recognizing in restrospect certain weaknesses in Davidian painting, but he does not conceive them in pictorial terms: 'Il faut le reconnaître, il a manqué à David, à ses élèves, ainsi qu'à tous leurs contemporains, une *idée mère*, qui, comme une étoile, les guidât...' Although their works were in many cases 'fort remarquables sous le rapport de l'art', their moral deficiency—they 'distraient les esprits au lieu de les... instruire'—was in the end decisive.[13] And if Delécluze blames Delacroix, it is, again, not because he finds his colour or his handling of paint chaotic or his drawing weak, but because of his subjects and the *values* which these imply: the damage done by Delacroix's *Dante et Virgile* and *Les Massacres de Scio* was for Delécluze that 'au lieu du beau, qui jusqu'alors avait été le but qu'on se proposa d'atteindre, se fut substitué la vérité sans sélection qui chercha à ennoblir l'insignifiant par le contraste piquant avec le laid'.[14]

The progressives expressed their position in analogous language. To a conservative charge that they 'semblent avoir secoué toute règle' and only 'vise[nt] à l'effet',[15] romantic art critics replied that 'Le besoin de la nouveauté s'est fait sentir à toutes les époques, mais jamais aussi impérieusement qu'à la nôtre'.[16] Yet when it came to defining this 'nouveauté' they offered nothing more precise than the classical 'beau' of Farcy and Delécluze: 'Les sociétés sont tourmentées d'un mal que l'on voudrait rendre secret, quoique chacun le sente...'[17] In the same way a fictitious interlocutor in Auguste Jal's review of the Salon of 1824 calls Delacroix's *Massacres de Scio* 'le plus beau tableau de l'exposition, parce que c'est le plus expressif',[18] but he makes no attempt to characterize this expressiveness or to analyse the means by which it was achieved. It is worth noting that such moralistic criticism prevailed far into the century. Even in 1865 Gonzague Privat, who, as one of the first to recognize Manet, must have had a strong interest in technique, wrote that 'Delacroix nous émeut par la pensée, par l'idée',[19] a judgement whose terms are very similar to those used by Delécluze about David and his following.

Why did these critics, unlike Frenhofer, have such trouble in finding for their preferences reasons of technique, in basing their positions on analyses of *métier*? There were, of course, many reasons;[20] but perhaps the most pertinent for our purposes is that, at about the time when Balzac was writing the *Chef-d'œuvre inconnu*, the opposed

[13] E.-J. Delécluze, *Louis David, son école et son temps* (Paris, 1855), p. 324.

[14] Idem, *Les Beaux-arts dans les deux mondes en 1855* (Paris, 1856), p. 199. Grate, pp. 36–9, has shown that it was this moralizing concern that lay behind critical reaction to Constable and then to other English painters when they were shown in Paris, not the difference between their technique and what was usual in French painting.

[15] By an anonymous critic in the *Lettres champenoises*, cited by Grate, pp. 31–2.

[16] F. Flocon and M. Aycard, *Salon de 1824* (Paris, 1824), pp. 16–17.

[17] Ibid.

[18] A. Jal, *L'Artiste et le philosophe: entretiens critiques sur le Salon de 1824* (Paris, 1824), p. 47.

[19] G. Privat, *Place aux jeunes! Causeries critiques sur le Salon de 1865* (Paris, n.d.), p. 126.

[20] An important one is the nature of the majority of the reading public; see Ch.-M. des Granges, *Le Romantisme et la critique: la presse littéraire sous la Restauration, 1815–1830* (Paris, 1907).

schools of painting that Frenhofer describes in such categorical terms did not, in fact, exist. In 1833 Lenormant wrote that the arts had 'perdu leur vieux cris de guerre de classique et de romantique';[21] in the following year another critic felt that these were 'mots surannés, qui bientôt ne présenteront plus de sens',[22] while Jal predicted that 'du romantisme, il restera M. Delacroix, qui est un grand artiste; du ingrisme, il restera M. Ingres, très grand artiste aussi; le reste changera de route ou se fera tout-à-fait oublier'.[23] And in fact Ingres was at that time working in relative isolation in Rome, while Delacroix was always very careful to keep his distance from the painters of whom he was the nominal leader.

What one found instead of these two was a thoroughly amalgamated style of very broad appeal. It is not unusual to find Landon, the leading conservative critic after Delécluze, noting that a *Saint Vincent de Paul* by the romantic Delaroche 'paraît concilier les suffrages des diverses classes d'amateurs, dont les goûts sont les plus opposés... On ne résiste point à l'attrait du bon et du vrai'.[24] In the same way everyone liked Devéria's *Naissance d'Henri IV* when it was shown at the Salon of 1827: 'romantiques, classiques, coloristes, dessinateurs... tout s'incline respectueusement devant la composition de M. Devéria'.[25] And why? Because his painting showed that, as Vitet put it, 'tout en recherchant par-dessus tout cette vivacité de couleur, ce naturel de pose et de composition, ce je ne sais quoi de vivant et d'expressif que M. Delacroix essaie de répandre dans ses ouvrages, on peut conserver quelque noblesse de style, un dessin correct, une touche fine et moelleuse'.[26] We can see that the stylistic lines of battle had become so blurred as no longer to exist; and alongside this eclectic painting there developed a kind of criticism which represented what Grate has aptly called the 'triomphe du juste-milieu'.[27] It is ironic that Thiers, who began as the most aggressive spokesman of the progressives and, when he became a minister, was responsible for some of Delacroix's most important commissions, was the most lucid exponent of this view: 'Je repousse autant l'esprit exclusif de ceux qui s'appellent classiques que le délire des nouveaux romantiques', he wrote.[28] He sought instead a 'liberté sage', and this is why he hoped of Delacroix that 'la force de son esprit le ramenèra bientôt au point juste, et il distinguera entre les conventions ridicules et les règles raisonnables'.[29]

These citations are perhaps enough to suggest the interest of this large body of material for the student of the *Chef-d'œuvre inconnu*; only by reading it can one appreciate how very different are the passages on painting which were added to the 1837

[21] C. Lenormant, *Les Artistes contemporains* (2 vols., Paris, 1833), II.171.
[22] A. Coquerel, cited by Grate, p. 51.
[23] Ibid., pp. 59–60.
[24] C.-P. Landon, *Salon de 1824* (Paris, 1824), pp. 25–6.
[25] Cited by Grate, pp. 43–4.
[26] Ibid., p. 44.
[27] Pp. 44–7.
[28] A. Thiers, *Salon de 1822* (Paris, 1822), p. 41.
[29] Cited by Grate, p. 39, n. 5. Frenhofer's views

may seem still more anomalous if it is remembered that, at the time the *Chef-d'œuvre inconnu* was being revised, what Rosenthal has called the 'réaction abstraite' was already developing—that movement back to neo-classical linearism which was to be ratified by Ingres's triumphal return from Rome in 1841 (L. Rosenthal, *Du romantisme au réalisme: essai sur l'évolution de la peinture en France de 1830 à 1848* (Paris, 1914), Chap. IV). Frenhofer's views go against this renascent neo-classicism as much as against the prevalent eclecticism.

version of our novella. These show no concern for moralizing (excepting their Sweden-borgian element, and as it happens this is not to be found in the art criticism of the thirties, widespread though it was in other spheres), are relatively, and sometimes very, technical in nature, and advance a point of view that is neither eclectic nor synthetic but is categorical, even militant.

But if Frenhofer's ideas owe little to the art criticism of Balzac's time, we have seen that in crucial ways they resemble certain points to be found in artists' handbooks that were in current use and themselves reflect current practice. Hence we must ask if Balzac's interest in art could have led him to such sources and enabled him to use them in formulating the additions himself. The question has two aspects, one involving Balzac's tastes in art and the other his knowledge of it. It is clear that Balzac actually was interested in art, and not only because he thought he ought to be: in his fiction, and especially his fiction during the years with which we are concerned, artists figure very prominently and similes of works of art are frequent. But it is certain that he knew very little about these objects. At about the time of the final version of the *Chef-d'œuvre inconnu*, for instance, Balzac in a letter to Mme Hanska refers to the *Maddalena Doni* in the Pitti Palace, one of Raphael's most famous portraits, as the '*Margherita*' *Doni*.[30] Of course this might have been a slip of the pen, but one finds too many such errors: on the same trip the novelist went to see what he calls the 'triglyphes', presumably for 'triptyches', in San Miniato. He begins by calling them 'superbes', which is at most a stock epithet, and then confesses, 'Je n'ai rien vu de tout cela'; he begs his correspondent not to think him a 'commis-voyageur... à cause de cet aveuglement'.[31] Yet it is in just this spirit that he asks for a Roman itinerary that will enable him to see, 'en huit jours, tout ce qu'il y a de réellement beau, de bien, de capital',[32] as elsewhere he writes spontaneously of 'œuvres à voir' or which 'valent le voyage'.[33] We know that Balzac frequented the Salons and *salons* after the mid-thirties, but it would not seem that he learned much from his exposure to them; for in these remarks we are far closer to the *Guide Michelin*[34] than to Frenhofer.

Even these few citations allow one a glimpse of another important quality of Balzac's mentions of artists or works of art: his characterizations of them are facile stereotypes

[30] *Lettres à l'étrangère*, ed. M. Bouteron (4 vols., Paris, 1906–50), I.387; hereafter referred to as 'L.E.'

[31] *L.E.* I.435.

[32] Ibid., p. 153.

[33] See Laubriet, *Intelligence*, p. 397.

[34] Laubriet suggests the possible importance for Balzac of the so-called *Manuel Roret* and of Stendhal's *Écoles italiennes de peinture* and *Histoire de la peinture en Italie* (pp. 117–18 and 121, n. 229). Incidentally, Stendhal's tastes were similar in many ways to what we shall see Balzac's to have been. In 1824 he put Sigalon and Léopold Robert at the head of the advanced movement, along with Schnetz and Saint-Évre

(*Mélanges d'art et de littérature* (Paris, 1867), p. 205); not only Delacroix but even Delaroche were placed lower on his list, although by 1827 he was complimenting Delaroche (*La Minerve français* (Paris, 1919), p. 330). In fact Stendhal thought that Delacroix's *Massacres de Scio* were 'en peinture ce que les vers de MM. Guiraud et de Vigny sont en poésie, l'exagération du triste et du sombre' (*Mélanges*, p. 150); cf. the references in nn. 14 and 15, above. To me it seems unlikely that Balzac read Jal's *Salons*, as Castex (pp. 53–4) conjectures; Jal wrote popular surveys, too, and it is quite possible that Balzac at some time knew his *Visites au Musée Royal du Luxembourg; ou, coup d'œil critique de la galerie des peintres vivants*.

phrased in generalities or clichés.[35] Balzac is prodigal in his references to artists: Laubriet has found mention in his novels of 133 painters, 28 sculptors, 13 draughtsmen, and so on.[36] But this is a large and very catholic assortment, and for this reason we can wonder what the nature of his interest in these artists was. If preferences do emerge, the first point to be made about them is that they appear to be banal: Raphael is cited 80 times (according to Laubriet; 102 according to Miss Scott), Titian 28, Leonardo 13...[37] There is little sign in these numerous mentions of an intense or personal interest; one finds instead the same eclecticism that, as we have seen, was such a marked feature of art criticism at that time. So in 1831 Balzac groups Ingres, Devéria, Schnetz, Vernet, and Delacroix as the glories of French painting, as though for him, as for the Salon critics we examined, they belonged in a single category;[38] at the end of the decade he extols in *Pierre Grassou* a similarly heterogeneous group consisting of Ingres, Delacroix, Devéria, and Sigalon, who, as he says in a characteristically uncommunicative phrase, 'apprenaient au monde l'existence de palettes jeunes et ardentes'.[39] At about the middle of the decade he both calls David 'colossal' (while comparing him with Titian)[40] and particularly draws Mme Hanska's attention to an *Intérieur d'Algérie* by Delacroix.[41] During these same years he was interested in still another kind of painting, one that was unlike the work of all the artists we have just named: that meticulous seventeenth-century Netherlandish painting of everyday life with which *La Recherche de l'absolu* is permeated. 'C'est toujours les tableaux de Meiris ou de Terburg, moins les plumes rouges sur les chapeaux gris pointus', he writes of a scene in Douai,[42] as three years earlier in *La Peau de chagrin* he had evoked 'le plus délicieux tableau de cette nature modeste si naïvement reproduite par les peintres flamands'.[43] Perhaps Balzac's interest in it was due to the vogue of Meissonier, which he followed to its source; for Meissonier 'recommence l'école flamande', as he tells Mme Hanska.[44] We have seen that such apparent inconsistencies were not peculiar to Balzac, and indeed their significance in this connection is that the novelist was merely following the eclecticism of his day. His taste or tastes, which we have noted throughout the decade of the thirties, are hard to reconcile with Frenhofer's views.

Béatrix, which also contains an enthusiastic reference to Dutch realistic painting,[45] includes a mention of a very different kind of art, to which, it would seem, Balzac's preference went, in so far as he had a preference: it is to the qualified neo-classicism of Guérin.[46] In the same spirit the *Corinne au cap de Misène* by Guérin's contemporary Gérard is mentioned in *Louis Lambert*,[47] as is his *Daphnis et Chloé* in *Ferragus*;[48] but

[35] This has been said also by Laubriet (*Intelligence*, p. 397) and Miss Scott (p. 6).

[36] *Intelligence*, p. 382, n. 10.

[37] Laubriet, *Intelligence*, pp. 397–8 and n. 161; Miss Scott, p. 15.

[38] *Lettres sur Paris*, XXXIX.114. The reference here and subsequently for Balzac's novels and tales is to the Conard edition.

[39] XVI.436–7. [40] *L.E.* I.437.

[41] Ibid., p. 155. [42] XXVIII.199.

[43] XXVII.131. [44] *L.E.* I.539.

[45] V.9. [46] V.115–16.

[47] XXXI.59–60.

[48] XIII.69. G. Franceschetti ('Un quadro di Gérard fonte probabile dello "Chef-d'œuvre inconnu"', *Studi francesi*, XXXIII (sett.-dic. 1967), pp. 407–25) has proposed that Gérard's *Madame Récamier* provided the prototype of Frenhofer's painting. To

Balzac was especially enthusiastic about Girodet, whom he seems to have rated very highly—he mentions him far more often than Delacroix and even more often than Leonardo.[49] It is not easy to know just why Balzac admired him so much: Girodet's style, in respect of colour, drawing, and handling of paint, is consistently hard and dry, and in this sense may be called 'neo-classical', but the range of his subjects, and of the emotional register in which these subjects are conceived, gives his work quite a varied character. Evidently one quality Balzac saw in it was 'poetry', since in *La Femme de trente ans* 'une Vierge de Raphaël luttait de poésie avec une esquisse de Girodet'[50] and *Béatrix* dressed herself like the spirits 'si poétiquement peints par Girodet' in his *Ossian*.[51] Girodet was also, for Balzac, 'gentil'—'gentil comme un Girodet' is a phrase we find in both *Les Illusions perdues* and *La Cousine Bette*.[52] But whatever it was that drew Balzac to Girodet, it is true that, as Gautier said in 1835, 'Son peintre était Girodet. Quelques-unes de ses premières nouvelles portent les traces de cette admiration arriérée'.[53] 'Arriérée' is an important word; for the persistent academicism of Girodet's style as well as the renascent rococo of his pretty and often erotic themes look in the opposite direction from the experimental boldness of Frenhofer's work.

I think, then, that a dominant note does emerge from Balzac's tastes in painting; but it is heard much more clearly in sculpture. As Laubriet in an important article[54] has reviewed this question, I need give only a few examples here. So far as Balzac considers, in sculpture, technique and style, the kind of work he admires is linear: it should 'traduire la volupté des lignes',[55] as we read in the preface to *La Peau de chagrin*. But technique and style were very far from providing the basis for Balzac's taste in this medium—he was much more concerned with a statue's theme, and he sought in this regard an extreme of idealization. For him sculptors are 'des hommes sublimes qui

me his argument seems very weak. Part of its difficulty is that, as Franceschetti recognizes (on p. 419, for instance), Gérard's painting does not correspond to Balzac's description, which is clear, of Frenhofer's: Gérard's does have a cord, but one attached to a cushion and not a curtain-pull; it lacks the tripod or brazier; and the figure in it is not 'couchée sur un lit de velours, sous des courtines'. Balzac's description resembles David's painting of Mme Récamier as closely as it does Gérard's, and it is not far removed in certain respects from Prud'hon's portrait of Josephine. The other salient weakness of Franceschetti's thesis, then, is that it has not been given a historical foundation. The pose and motifs with which we are concerned were common and traditional. My guess is that many paintings of the time correspond more or less closely to Balzac's description of Frenhofer's, and it would be necessary first to review them, at least on the basis of the lists in Salon catalogues, in order to determine which paintings Balzac might have been thinking of—if indeed he was thinking of some particular painting, and if it was contemporary.

[49] See above, n. 37. [50] VI.186.

[51] V.278. [52] XII.149, and XVII.457.

[53] T. Gautier, *Honoré de Balzac: sa vie et ses œuvres* (2nd edn., Paris, 1859), p. 89, cited by Laubriet, *Intelligence*, p. 383, n. 25. Laubriet (ibid., p. 398, n. 161) has made the attractive suggestion that Balzac's friend Latouche played some part in the novelist's predilection for Girodet, as indeed for Canova, who will be discussed below. Latouche, in a way that was characteristic of many of his contemporaries and as much as anyone, combined a strong retrospective taste for the purest neo-classicism with a marked penchant for rococo revival. His neo-classical interests are best discussed by F. Ségu, *H. de Latouche et son intervention dans les arts* (Paris, 1931), esp. pp. 59–80 (on Canova) and 99–107 (on Quatremère de Quincy). Latouche considered Canova to be exemplary not only for sculptors, but for painters as well.

[54] P. Laubriet, 'Balzac et la sculpture', *Gazette des beaux-arts*, 6th series, LVII (mai 1961), pp. 331–58.

[55] In *L'Œuvre de Balzac*, ed. A. Béguin and J. Ducourneau (Paris, 1950-3), XV.65, cited after Laubriet, art. cit., p. 344.

s'expriment avec du marbre'[56] and a statue is 'une sorte de méditation matérielle'.[57] What kind of sculpture does Balzac look to for this quality? Filippo, in *Sarrasine*, is compared to the *Antinous*,[58] while in the same year Balzac writes in *La Peau de chagrin* of the *Venus of Milo*;[59] in *Massimilla Doni* the Duchesse Cataneo is Niobe,[60] as Mme de Beauséant had already been in *Le Père Goriot*.[61] In *Splendeurs et misères* we read of Diane de Maufrigneuse's 'corps blanc, aussi parfait que celui de la Vénus de Canova'.[62]

Balzac was able to find French counterparts of these illustrious prototypes. One was Étex, although Balzac does not mention him before the early forties; at that time he found Étex's *Léandre disant adieu à Héro* 'sublime', writing to Mme Hanska that there was not 'une grande différence entre ça et les chefs-d'œuvre de l'Antiquité'.[63] With Bra he had been friendly since about 1833. Typical of this sculptor's work, which was remarkably abstract and exalted in content, was a projected Musée de la Paix, to consist of such motifs as 'La synthèse absolue, parfaite'—it is not surprising that Balzac got from Bra the first idea for *Séraphita* and that he hoped to have her assumption carved in marble.[64] But he admired above all David d'Angers, with whom he became acquainted about 1836–7, it appears; 'David, c'est le roi de la sculpture, lui et Bosio. Voilà', he writes to Poland.[65] David, unlike his namesake in painting, was a writer of unusual articulateness, and he has left clear statements of his views. For him 'les arts ne doivent rendre que la passion, les vertus de l'humanité'; to be a sculptor one has to 'comprendre la morale de l'art'; as Balzac's Sarrasine carved a 'méditation matérielle', so for David a statue is 'une idée impressionnée dans la matière' and sculpture 'la représentation de l'âme'.[66] We have noted that there is something of Swedenborgian idealism in what Frenhofer says; nevertheless, his language is in an altogether different register from this.

To sum up: There is almost nothing in Balzac's taste in art that might have led him to formulate Frenhofer's positions. Therefore he would have had to find them in writings about art that were contemporaneous with his revision of the novella; but we have seen that these bear little resemblance to Frenhofer's views either in general or in particular. An exception must be made for certain technical handbooks; but the level of Balzac's understanding of art, as it appears in his mentions of works of art and of artists, makes it unlikely that he used or even could use sources of this kind. Thus, the additions to the version of 1837 must have been the responsibility of someone else, at least in large part. For, as Regard has shown in the case of *Gambara*,[67] and as Miss

[56] *Séraphita*, XXXI.260.
[57] *Sarrasine*, XVI.414.
[58] Ibid., p. 394.
[59] XXVII.117.
[60] XXVII.432.
[61] See Laubriet, art. cit., p. 344, n. 19.
[62] XVI.227.
[63] *L.E.* III.27, after Laubriet, art. cit., p. 346.

[64] *L.E.* I.355, after Laubriet, ibid., pp. 345–6; see also Adhémar, p. 155.
[65] *L.E.* II.84, after Laubriet, ibid., p. 340.
[66] All this is cited after Laubriet, ibid., p. 341.
[67] Maurice Regard, 'Balzac est-il l'auteur de "Gambara"?', *RHLF*, oct.–déc. 1953; see also the introduction to his edition of *Gambara* (Paris, 1964), and Appendices II and IV.

Scott suggests for the *Chef-d'œuvre inconnu*,[68] the forms such collaboration or authorship might have taken are many, so many that it might be hard to know whether to speak of collaboration or authorship. Without the discovery of new documents from the hand of Balzac himself or of galleys from his printer, we shall never know for certain; the material in the present paper is not offered as proof. But given the fact that we must work as it were at one remove, I think it does add up to a very strong case against Balzac's unaided authorship and in favour of at least a very active collaboration, if not of actual authorship, by someone else.

[68] Miss Scott's approach, although based on what she herself calls 'surmise' (see above, n. 3), is most commonsensical. She suggests, pp. 41–2, that a collaborator 'talked over' the first version with Balzac, 'making suggestions here and there', and that before the third edition Balzac 'might have been struck by some discussion among his artist-friends and have definitely addressed himself to this same critic to come and help him with a story whose technicalities had passed beyond his competence. Here his mysterious friend may have sat beside him, proofs on the table, telling him what to change or add, possibly writing the longer paragraphs of insertion.'

VIII

DE THOMAS COUTURE À JEAN VALJEAN: UNE LETTRE DE CHARLES HUGO À SON PÈRE, VICTOR HUGO (1843)

Pierre Georgel

Lundi soir, 7 Août[1]

Mon bon petit père,

Henri[2] m'a remis ta lettre, en me montrant celle que tu lui as écrite.[3] Elle est charmante et lui a fait le plus grand plaisir. Je lui lu [*sic*] celle qui m'était adressée, et il a été également profondément touché de ce que tu me dis de lui. C'est un bon jeune homme qui sent bien ce qui va au cœur. Je ne pourrai jamais que profiter dans sa société, crois-le bien, mon bon père.

J'ai une foule de choses à te dire et je ne sais par où commencer. D'abord, notre départ pour le Hâvre[4] est retardé jusqu'au vingt à cause des mille petits préparatifs qu'il nécessite pour Julie.[5] Nous devons être embarqués dans les Messageries Royales qui elles-mêmes voyageront en chemin de fer jusqu'à Rouen. Tu connais cette manière. On met les diligences sur

[1] Charles Hugo (1826–71), fils aîné de Victor Hugo, a dix-sept ans en 1843. C'est un adolescent studieux, d'une sensibilité vive et inquiète. Il fait d'excellentes études au lycée Charlemagne, et a même obtenu, en 1840, le premier prix de thème latin au Concours général. Il est resté à Paris, cet été 1843, dans l'institution où il est pensionnaire, tandis que sa mère, son frère Victor et sa sœur Adèle sont allés rejoindre au Havre l'aînée des enfants, Léopoldine, mariée depuis février à Charles Vacquerie (on est à un mois de la catastrophe de Villequier). Hugo voyage dans les Pyrénées avec Juliette Drouet.

[2] Henry-Paul-Marie Didier (1823–68), à ne pas confondre avec Henry-Gabriel Didier (né en 1807), autre homme politique de la IIème République et du Second Empire. Ami des fils Hugo. Il est souvent question de lui et de ses visites dans les correspondances de la famille. Hugo le recommande à Victor Cousin pour le baccalauréat. Il devient par la suite avocat, député en 1852, puis en 1857 et en 1863. En 1868, il a une crise d'aliénation mentale en prononçant un discours à la Chambre. Voir la lettre de Mme Hugo que nous avons publiée dans *Revue des Sociétés savantes de Haute-Normandie*, 1967, 'Lettres', nº 45,

p. 88. La présente note complète les indications dont nous accompagnions alors ce texte.

[3] Le 31 juillet, Hugo écrivait à Charles de Saint-Sébastien: 'C'est avec bien du plaisir, mon Charlot, que je tiens la promesse que je t'ai faite d'écrire à M. Henri Didier. M. Didier est un digne et noble jeune homme qui a du cœur, de l'âme et de l'esprit, les trois rayons de l'intelligence. J'ai toute confiance en lui, et je l'aime parce qu'il t'aime. C'est lui qui te remettra cette lettre.' (Édition chronologique des *Œuvres complètes* de Hugo, publiée sous la direction de Jean Massin, VI.1237; nous nous référons ci-dessous à cette édition par l'abréviation 'éd. Massin'.) La lettre à H. Didier ne semble pas avoir été conservée.

[4] Charles s'apprête à rejoindre sa mère au Havre, en compagnie de sa tante Julie. Le voyage aura lieu le 20 août. Voir P. Georgel, *Léopoldine Hugo* (2e éd., Paris, 1967), p. 251 (il convient de corriger ainsi les lignes 5–7; 'Charles et Julie Foucher quittent Paris pour Le Havre, etc.').

[5] Julie Foucher (1822–1905), sœur cadette de Mme Hugo et tante des enfants Hugo. Elle était alors institutrice à la Maison royale de la Légion d'Honneur, à Saint-Denis (voir J.-L. Mercié, *Victor Hugo et Julie Chenay* (Paris, 1967), pp. 37 sq.).

des espèces de wagons disposés à cet effet et lorsqu'elles sont arrivées à leur destination, on les repose sur leurs roues. Voilà comment nous voyagerons depuis 6 heures du soir jusqu'à 10½. Nous aurons trois heures de jour. A dix heures et demie nous continuerons notre voyage sur les routes et trainés par des chevaux. Nous arriverons au Hâvre vers deux ou trois heures du matin. Bien entendu l'on nous attendra. Nos places sont retenues dès à-présent. Nous avons pris les numéros 1 et 3 afin de nous trouver en face l'un de l'autre et d'avoir chacun une fenêtre pour respirer et regarder. C'est cet excellent bon papa[6] qui s'est chargé de tout cela.

Tu me demandes des détails sur les résultats de fin d'année. Nous sommes toujours à peu près aussi avancés, c'est à dire que nous ne savons rien du tout. J'ai composé Mercredi dernier en Thême Grec. Ma composition a été trouvée par tout le monde bonne et même très-bonne. Elle a été jugée la meilleure de toute notre division. Nous saurons notre sort dans quelques jours, mon bon père; et je m'empresserai de te l'annoncer, avec joie si c'est un succès, avec résignation si c'est un insuccès. J'aurai toujours la consolation de me dire: J'ai fait ce que j'ai pu; le bon Dieu a fait ce qu'il a voulu. Voilà tout.

J'ai été, ces jours ci, dans l'atelier de Couture. Il y a à là de belles peintures. Tu verras tout cela à ton retour, car je lui ai dit que tu désirais le voir et le connaître. Il a été joyeux comme un homme qui verrait un de ses beaux rêves s'accomplir. Je suis sûr que te connaître, t'entendre et te voir, pour cet homme, c'était un rêve. Il a fait un tableau qu'il appelle L'Amour de l'or.[7] C'est grand comme la moitié de la Messaline.[8] L'idée est un avare qui, assis devant sa table et presque couché dessus, retient avec ses ongles et ses doigts crispés un tas de pièces d'or et de bijoux de toutes sortes; il a de l'or devant lui, à foison, sous ses mains, sous sa robe; on en devine encore plus qu'on n'en voit. Et c'est là, il me semble, un des grands talents du peintre, de faire deviner encore plus que de faire voir. Autour de cette table, recouverte d'une vieille tapisserie en lambeaux, sont rangées toutes les voluptés de ce monde, des femmes, de belles femmes, blondes et brunes, l'une montre sa chevelure, l'autre son sein à l'avare dont l'œil pétille. Derrière l'Avare est un Satan, un beau Satan avec un air moqueur et malignement souriant. Il est vêtu en cardinal.[9] Ce que je te dis là de ce tableau est très-incomplet. Je ne te parle pas, parce que ces choses ne se disent pas mais se voient, de la couleur étourdissante de ce tableau. Quand je l'ai vu pour la première fois, cela a été pour moi comme un éblouissement. Ajoute encore dans ta pensée un dessin d'une régularité parfaite, des poses d'un naturel étonnant, une richesse de costume extraordinaire et tu auras à peu près l'aspect de ce tableau.

[6] Pierre Foucher (1772–1845), père de Mme Hugo.

[7] Pl. 45 (Toulouse, musée des Augustins). Ce tableau, qui figura au Salon de 1844, est daté 1844. La lettre de Charles permet de le faire remonter avec certitude à 1843. Il en existe plusieurs versions, et on l'a parfois confondu avec le Timon d'Athènes. Voir Bertauts-Couture, 'Thomas Couture, sa technique et son influence sur la peinture française de la seconde moitié du XIXe siècle', Études d'Art, n° 11–12 (Alger, 1955–6), p. 187; et la mise au point la plus récente dans le catalogue de l'exposition Thomas Couture: Paintings and Drawings in American Collections, University of Maryland Art Gallery, 1970, p. 53, n. 3.

[8] Sans aucun doute La Mort de Messaline de Louis Boulanger, tableau refusé au Salon de 1843, dont la composition nous est connue par une lithographie de L'Artiste, 1843, 12e livraison, p. 192. D'après le registre inédit d'enregistrement des œuvres présentées au Jury (Archives du musée du Louvre), ce tableau mesurait H. 3,50 m. sur L. 4,50 m. (enregistrement n° 2607). Les dimensions de L'Amour de l'or sont: H. 2 m. sur L. 2,40 m. On sait les relations très amicales de Boulanger avec la famille Hugo.

[9] Il est intéressant de confronter cette description-interprétation avec celle que Couture donnera lui-même du tableau: 'Auri sacra fames — c'est cette faim toujours inassouvie qui fait que tous viennent à l'or. Ici deux femmes s'offrent à celui qui en possède et semblent lui dire: 'Voici nos charmes, ils seront à toi si tu veux bien nous donner de l'or.' Le courtisan, le flatteur, placé derrière elles, fait l'office du renard devant le corbeau, et un poète misérable, vaincu par la misère, chantera volontiers l'avarice pour avoir du pain. Mais l'avare aime l'or pour lui-même... il conserve ce dont ces femmes, ce flatteur, ce poète ne sauraient jamais se passer mais qu'il est seul à posséder.' ([Bertauts-Couture], Thomas Couture (1815–1879). Sa vie, son œuvre, son caractère, ses idées, sa méthode, par lui-même et son petit-fils (Paris, 1932), pp. 12–13.)

Il va en faire un second aussi grand que le Naufrage de la Méduse. C'est une orgie Romaine.[10] Ce sera plein de fantaisie et de grandeur. Du reste son atelier est peuplé de volumes de toi Hernani, Le Roi s'amuse les Voix Intérieures etc. Il y a aussi un faust[11] dans quelque coin. Je voyais cela hier. C'est un garçon plein de poésie, que Couture. Tu l'aimeras.

Il vient d'arriver ce matin dans notre Rue Culture[12] un événement assez grave que tu liras probablement dans les journaux, si tu lis les journaux. Tu sais que *la Force*[13] est voisine de notre rue. Ce matin donc, Monsieur Jauffret[14] entend un tapage atroce de voix, de cris, de: *Au voleur, à l'assassin*. Il pouvait être 6 heures et demie. Il descend, va dehors, et voit quantité de bourgeois peu habillés courant après deux hommes qui fuyaient vers l'extrémité de la rue. On les prit. L'un d'eux supplia qu'on le laissât partir; mais on cria: Il vient de blesser deux personnes. Ne le lachez pas!

Depuis près de huit jours, des prisonniers de la Force, des détenus pour accusations d'assassinats et de meurtres creusaient secrètement sous leur cachot, où ils étaient réunis au nombre de trente, un souterrain dont il n'avait [*sic*] pas calculé l'étendue mais qui pouvait aller fort loin. Ce matin donc, vers quatre heures du matin, seize des détenus, armés de stylets, descendirent dans leur souterrain. Arrivés à l'extrémité, ils se mirent à creuser la terre au dessus d'eux afin de se livrer passage au dehors, car leur souterrain n'avait pas d'issue. Or, il se trouvait que la mine qu'ils avaient creusée s'était arrêtée sous un établissement de bains — à l'emplacement même d'une cave. Ces bains, ce sont les bains Ste Catherine. Les détenus, qui n'avaient probablement pas de montre, car ils se la seraient volés [*sic*] mutuellement, et qui d'ailleurs se trouvaient là dans une profonde obscurité, les détenus croyaient qu'il pouvait être quatre heures du matin et s'attendaient à trouver tout le monde endormi. Ils avaient mal calculé: il en était six et demie. Le hazard [*sic*] voulut que, précisément au dessus de l'endroit où s'arrêtait le souterrain, un chauffeur de l'établissement de bains fût occupé à mettre du bois dans son poêle. Tout à coup, pendant qu'il travaillait ainsi, il sentit que la pierre où posait le poêle se levait insensiblement. Il se recula et vit alors une tête d'homme, barbue, ébouriffée, hideuse, immonde (car ils [*sic*] leur avait fallu traverser deux fosses de lieux d'aisance). Le chauffeur, revenu de son premier étonnement, lui demanda d'où il venait, qui il était. L'autre lui avoua franchement leur évasion. Le chauffeur voulut le renfoncer dans son trou, mais il vit alors plusieurs têtes effrayantes de détenus qui s'avançaient presque au dehors. Il eut peur et s'enfuit en criant: au voleur, fermez la grille! La baigneuse qui rangeait tranquillement son linge, entendant ces cris, crut qu'on venait lui voler ses serviettes et se mit à les prendre en tas pour les cacher, tout en criant: au voleur! Elle fut bientôt forcée de se taire. Deux ou trois voleurs entrèrent dans sa cabine, lui mirent la main sur la bouche — et quelles mains! — et la maltraitèrent. Cependant le temps pressait. Ils abandonnèrent donc la baigneuse et s'enfuirent

[10] Les futurs *Romains de la Décadence* (Pl. 46), dont es dimensions seront: H. 4,66 m. sur L. 7,75 m. Celles du *Radeau de la Méduse* (Pl.47) sont: H. 4,91 m. sur L. 7,16 m. Couture semble avoir longtemps hésité entre le titre *L'Orgie romaine* et le titre définitif. De l'année 1843 date une petite *Orgie romaine* (Pl. 48), datée (Londres, Wallace Collection, cat. 1968, n° P.340), qu'il faut probablement rattacher à la préparation du grand tableau.

[11] Une peinture de Couture représentant Faust et Méphistophélès a figuré à la vente Williams, American Art Association, New York, 3–4 fév. 1915. Voir un dessin préparatoire, qu'on situait 'vers 1844' dans une annonce publicitaire du *Burlington Magazine*, nov. 1966, p. liii. Signalons une autre peinture à sujet

littéraire, *Don Quichotte et Sancho Pança*, repr. ibid., jan. 1971, p. xxvi (il est difficile, sur une simple photographie, de se prononcer sur l'attribution de ce tableau à Couture).

[12] Rue Culture-Sainte-Catherine, aujourd'hui rue de Sévigné, où se trouvait l'institution Jauffret (voir p. 14).

[13] La prison de La Force, aujourd'hui détruite, s'élevait entre la rue Pavée et la rue du Roi-de-Sicile. L'évasion des prisonniers de La Force fit grand bruit dans les journaux du temps. Voir par exemple *L'Illustration*, n° 25, 19 août 1843, t. I, pp. 386–7.

[14] Le directeur de l'institution où Charles est pensionnaire. Voir le catalogue de l'exposition *Maturité de Victor Hugo*, Paris, Maison de Victor Hugo, 1953, pp. 134 sq.

tous dans le jardin des bains. La grille, un moment fermée, se rouvrit tout-à-coup, et cinq ou six robustes bourgeois du quartier, un marchand de vin, un menuisier, un charbonnier d'une force herculéenne, s'élancèrent tout-à-coup à la rencontre des détenus. Il y eut alors une lutte acharnée. Le charbonnier s'adressa au plus effrayant de la bande, le prit à la gorge, et allait le terrasser quand plusieurs arrivèrent sur lui, le couteau levé. A cette vue, le charbonnier lâcha prise. Cependant les prisonniers, se voyant entourés de bourgeois, et ne sachant comment se faire jour, se mirent à donner au hazard [*sic*] des coups de stylet et parvinrent ainsi à s'échapper dans la rue. Mais là une autre lutte les attendait. Ils avaient à peine fait quelques pas qu'un détachement des pompiers de la caserne voisine arriva en toute hâte l'arme au bras. Plusieurs alors s'enfuirent à toutes jambes dans la rue, d'autres disparurent plus prudemment. Mais sur seize qui étaient sortis dix furent saisis. Ce fut à ce moment qu'arrivèrent les patrouilles de toutes les couleurs, les sergents de ville, la police secrète, le commissaire presque en chemise, Mr de [un mot illisible] lui-même. Les sergents de ville se mirent en campagne et en saisirent trois autres. Treize de pris sur seize. C'est alors que nous passâmes dans la rue pour aller au collège. Les bains étaient remplis de soldats. Une foule de spectateurs encombraient la rue. On disait même que quelques uns des détenus, plus adroits que les autres, étaient parvenus à se glisser dans la foule, et demandaient avec un air de curiosité simulé, "qu'y a-t-il donc? Pourquoi ces soldats?" etc. etc. Trois des échappés sont encore dans Paris. Du reste plusieurs personnes ont été blessées et dangereusement. L'une a reçu un coup de stylet au-dessous des côtes, très près du poumon. L'autre a été blessée dans les reins; une autre à la cuisse.

Voilà, mon bon père, ce que Monsieur Jauffret nous a raconté hier, à moi et à bon papa qui était venu me voir. Cela a mis en révolution tout le quartier et toute la pension. On ne parlait que de cela.

Je t'envoie cette lettre à Pau,[15] mon bon père. Je pense qu'Henri doit t'écrire aussi. Il me l'a dit du moins. Je lui ai donné cette adresse.

Quand tu verras arriver le seize, songe que c'est la distribution du Concours. Le bruit court que j'ai le premier prix de thème grec. Monsieur Jauffret croit ce bruit sans le moindre fondement et moi aussi.

Sans adieu, mon bon père. Ecris moi.

Ton fils qui t'aime et te respecte

Charles.

De la visite à Thomas Couture que relate ici Charles Hugo,[16] on retiendra surtout les signes multiples des affinités du peintre avec le romantisme. Une déclaration d'amour à Victor Hugo,[17] ses livres 'peuplant' l'atelier, le grand œuvre à venir placé sous le signe du *Radeau de la Méduse*: de quoi surprendre, à première vue, le lecteur de *Méthode et entretiens d'atelier*, où Couture, vingt-cinq ans après, exécute avec tant de superbe les romantiques, ces 'pygmées'.[18]

Couture a tout fait pour s'acquérir une réputation d'opportunisme.[19] Il est donc

[15] Hugo s'y rendra le 14 août.

[16] Lettre conservée à la Maison de Victor Hugo, Paris (cote: α549).

[17] On verra comment Hugo apparaît, aux yeux des artistes de son temps, comme la figure même du romantisme, dans P. Georgel, 'Le Romantisme des années 1860, Correspondance Victor Hugo–Philippe Burty', *Revue de l'art*, n° 20 (1973), p. 13.

[18] Th. Couture, *Méthode et entretiens d'atelier* (2e éd., Paris, 1868), p. 151.

[19] On le verra successivement, en 1848 peintre officiel de la République, en 1856 favori de la cour et commensal des 'meilleurs souverains du monde', puis sous la Troisième République, victime déclarée de l'ingratitude impériale. Voir A. Boime, 'Thomas Couture and the evolution of painting in nineteenth century France', *Art Bulletin*, LI (1969), 48–56. A. Boime apporte quelques nuances à son analyse de l'attitude de Couture envers le Second Empire, dans sa préface au catalogue de l'exposition *Thomas Couture* au Musée départemental de Beauvais, 1972.

tentant de voir dans ces indices étalés devant un jeune homme crédule une simple flagornerie à l'égard de son père. Reste qu'en 1843, et sans préjuger de son évolution future, les préoccupations du peintre, son imagination, semblent se porter avec prédilection vers le romantisme. Redevable à la tradition classicisante par sa technique — Charles souligne à juste titre le dessin 'd'une régularité parfaite' de *L'Amour de l'or* —, il cherche à la renouveler par des lectures qui lui procurent des sujets, un climat, différents. Si vous voulez 'orner votre esprit', écrira-t-il dans ses *Conseils à un jeune peintre*, 'les anciens, nos classiques français sont bons à connaître. Mais *pour vous, peintre*, il est certains ouvrages que je tiens à vous signaler et qui vous seront d'un grand profit: Homère, Virgile, Shakespeare, Molière, Rousseau, Bernardin de Saint-Pierre'.[20] Cet éloge de l'inspiration littéraire, la liste même des auteurs, relèvent bien d'un programme romantique, et d'ailleurs, un peu plus loin,[21] Couture présente Shakespeare comme le romantique par excellence.

Au moment, donc, où il commence à concevoir la fête orgiaque des *Romains de la Décadence*,[22] Couture garde à portée de main ce *Roi s'amuse* de 1832 qui précisément s'ouvrait sur une scène de fête ayant, écrit Hugo, 'un peu le caractère d'une orgie'.[23] Est-ce par hasard? On ne peut s'empêcher d'observer une ressemblance entre le décor du *Roi s'amuse* ('salles magnifiques... flambeaux, musique, danse... Dans l'architecture, dans les ameublements, dans les vêtements, le goût de la Renaissance') et celui des Romains, qui, malgré leur sujet et leurs costumes antiques, procèdent à l'évidence des *Noces de Cana*, la 'source' même dont le décorateur du *Roi s'amuse*, Châtillon, s'était inspiré au dire du *Victor Hugo raconté*.[24] Puis on pense à d'autres pièces de Hugo: à *Lucrèce Borgia* (1833), autre fête ayant pour décor un palais vénitien, autre image d'une société décadente qui achève de s'étourdir dans le plaisir et le crime; aux *Burgraves*, surtout (1843), où le rideau se lève sur le tumulte de l'orgie mêlé au 'bruit des fers'.[25] Couture pouvait d'abord trouver dans ces spectacles un système dramatique d'une efficacité éprouvée. C'est par leur intermédiaire, autant que par une fréquentation directe, qu'il dut assimiler les modèles vénitiens communs. Des *Noces de Cana*, des grandes compositions de Tiepolo, les *Romains* donneront, jusques dans leurs vastes dimensions, une version à l'échelle du théâtre. L'absence de profondeur réelle et le mouvement de long en large propres à l'espace d'une scène, les proportions des personnages par rapport au décor donnent bien l'impression d'assister à un tableau vivant dans le goût de l'époque, ceux-là même dont la photographie devait tirer, selon Baudelaire, d''étranges abominations'.[26] Il faut insister sur cette idée de *tableau*, d'une dramaturgie en quelque sorte plastique, directement transposée du théâtre à la peinture. Non seulement elle offre à l'artiste un riche répertoire visuel, mais elle substitue à la représentation classique de l'action à son point culminant (comme dans les *Horaces* de David) l'image plus

[20] *Méthode et entretiens d'atelier*, pp. 36–7.
[21] Ibid., p. 151.
[22] Une thèse inédite a été consacrée à la genèse des *Romains* par Francine L. Klagsbrun (New York University, 1958). Voir le catalogue de l'exposition de Maryland, déjà cité.
[23] Éd. Massin, IV.535.
[24] Éd. Massin, IV.1207.
[25] Éd. Massin, VI.578.
[26] Baudelaire, *Salon de 1859* (Pléiade, p. 770).

confuse, plus étalée dans la durée, plus ambitieusement 'totale' qui est propre au drame romantique.[27]

Couture n'a pas seulement demandé au théâtre romantique des effets de spectacle, des procédés de composition. S'il a probablement assisté à des représentations de drames de Hugo (il habite Paris depuis 1826), la lettre de Charles nous apprend surtout qu'il les lit, et avec eux, les recueils poétiques de la même époque, 'les Voix intérieures etc.' Il peut y trouver une matière qui rejoint sa propre inspiration, la nourrit et lui donne forme: cette pensée inquiète, caractéristique des années 1830-40, qui traduit le désarroi des consciences assistant à la désagrégation de la Société, à l'effondrement des valeurs morales.[28] Nul ne l'a exprimée plus fortement que Hugo dans son théâtre d'*Hernani* aux *Burgraves*. Les mêmes images d'orgies, de banquets, reviennent chez le Balzac de *La Peau de Chagrin* (1831), le Musset de *Rolla* (1833) et de *Lorenzaccio* (1833-4), la George Sand de *Lelia* (1833), le Vigny de *Daphné* (1837),[29] le Hugo des *Chants du crépuscule* (1835).[30] Un poème de ce dernier recueil[31] fait du Festin de Balthasar, cher aux admirateurs de John Martin, le symbole de la société contemporaine. Deux thèmes s'y entrelacent: celui de la fête insolente, étalage effronté de luxe et de puissance, satiété des voluptés, étourdissement de l'ivresse, et celui du 'morose alchimiste', du 'sombre amphitryon' qui vient demander compte aux repus: le Destin. C'est à la fois la figure du peuple souffrant et celle d'un passé mythique où se cristallise la nostalgie d'une époque de grandeur et de vertu. La statue du Commandeur, 'La pâle mort, debout, comme un muet esclave',[32] se confondent avec les portraits des ancêtres, contemplant de leurs yeux fixes la dégradation de leur descendance. Du poème de 1832 aux *Burgraves*, la signification de ce mythe est devenue explicite. Dans la salle des portraits du burg de

[27] M. Fried a étudié cette métamorphose de la dramaturgie dans la peinture française de la fin du XVIIIe et du début du XIXe siècles ('Thomas Couture and the theatricalization of action in 19th century French painting', *Artforum*, juin 1970, pp. 36-46). Nous souscrivons dans l'ensemble au schéma qu'il propose: passage d'une action calquée sur le théâtre à une action 'théâtralisée' de l'intérieur; mais cette distinction le conduit à des subtilités un peu spécieuses. L'étude comparée de la dramaturgie romantique et de l'œuvre de Couture, entre lesquelles le présent article établit l'existence de relations de fait, devrait conduire à des observations plus concrètes et plus sûres. L'alliance 'de fantaisie et de grandeur' dont Couture parle à son visiteur nous semble notamment issue de la synthèse du 'grotesque' et du 'sublime' propre au drame romantique.

[28] Voir. A. Bellesort, *Dix-huitième siècle et romantisme* (Paris, 1941), et, en ce qui concerne Hugo, J.-B. Barrère, *Hugo, l'homme et l'œuvre* (Paris, 1952), pp. 73 sq.

[29] *Daphné* ne sera publié qu'en 1912. Le livre resta inachevé, mais la partie rédigée avait été écrite pour l'essentiel en 1837. Nous ne pensons évidemment pas

au 'banquet' platonicien de Libanius, mais à l'émeute orgiaque de *Fin de Daphné*. L'assimilation entre 'les Barbares du VIIe siècle' et 'les barbares de Paris du XIXe siècle' est clairement dégagée dans les dernières pages (Vigny, *Les consultations du docteur Noir*, p.p. F. Germain (Paris, 1970), pp. 382-3).

[30] On n'oubliera pas les œuvres picturales qui sont, à la même époque, les antécédents des *Romains*. Thoré indique l'une d'elles dans son *Salon de 1847*: *Antoine et Cléopâtre après la bataille d'Actium* de Gigoux (1837, aujourd'hui au Musée des Beaux-Arts de Bordeaux). Il fait même un rapprochement précis: 'A la manière de Plutarque, qui entremêle son récit de sages réflexions, Gigoux avait placé au coin de la scène quelques Gaulois indignés, protestation vivante en faveur de l'avenir. De même, aux deux angles de sa grande épopée, Couture a symbolisé, comme deux vers brûlants de Juvénal, la philosophie et la poésie qui contemplent tristement les excès d'un monde condamné.' (*Salons de Thoré* (Paris, 1868), p. 425.)

[31] *Noces et festins* (1832), éd. Massin, V.405-7.

[32] *Le Repas libre*, poème de 1823 où le 'pompeux banquet' des maîtres corrompus a déjà la Rome antique pour décor (éd. Massin, II.489-90).

Heppenheff, sanctuaire d'un grand passé que vient souiller la rumeur de l'orgie, Job a décroché, retourné, les portraits de ses ancêtres:

> Je les ai retournés tous contre la muraille
> Pour qu'ils ne puissent voir la honte de leurs fils.[33]

Couture recueille cette inspiration toujours vivante (*Les Burgraves* ont été représentés quelques semaines à peine avant la visite de Charles). Dans ses envois au Salon se succèdent un *Jeune Vénitien après une orgie* (1840), dont le sujet et le climat évoquent Musset, *Le Fils prodigue* (1841), *L'Amour de l'or* (1844)[34] — n'oublions pas, en 1843, la petite *Orgie romaine* de la collection Wallace, qui est sans doute une des toutes 'premières pensées' pour les *Romains*. La même pensée, les mêmes images se retrouvent dans ce tableau. Gautier reconnaît clairement dans les statues 'aux physionomies sévères, aux attitudes solennelles' les ancêtres 'des époques glorieuses, [qui] assistent, témoins impassibles, du haut de leur piédestal, aux débauches de leurs descendants dégénérés'.[35] D'autre part l'arrière-pensée contemporaine est commune à Hugo et à Couture. Quand celui-ci donne pour épigraphe à son tableau, dans le livret du Salon de 1847, les vers suivants de Juvénal:

> ... Saevior armis
> Luxuria incubuit victumque ulciscitur orbem[36],

ne suggère-t-il pas d'identifier le Bas-Empire romain et la France de Louis-Philippe, pacifiste et corrompue? Les *Romains* ont été peints, pour l'essentiel, dans les crises finales du régime de Juillet. L'affaire Pritchard, en 1844–5, vient de surexciter le patriotisme belliqueux des Français, et l'année 1847, où le tableau paraît au Salon, est celle de la grande série de scandales (affaires Teste-Cubières, Choiseul-Praslin) qui achève de discréditer moralement la classe dirigeante. Par sa signification séditieuse, le triomphe des *Romains* semble faire écho aux applaudissements qui avaient fait interdire *Le Roi s'amuse* en 1832. A l'âge d'or de la caricature, quand le sublime est passé de saison, Couture s'obstine à prolonger la satire romantique, de type héroïque. Les *Romains* en sont une manifestation bien tardive, déjà anachronique.[37] Conçus dans le temps où *Les*

[33] Éd. Massin, VI.605.

[34] Rapprochons par exemple ce dernier tableau et l'interprétation qu'en donne Couture (voir n. 9) des lignes de 1844 (l'année même où *L'Amour de l'or* paraît au Salon) où Sainte-Beuve stigmatise les écrivains éconduits par la *Revue des Deux Mondes*, 'race d'airain qui veut de l'or' (cité par A. Cassagne, *La Théorie de l'art pour l'art en France chez les derniers romantiques et les premiers réalistes* (Paris, 1905, réimp. en 1959), p. 27).

[35] Th. Gautier, *Salon de 1847* (Paris, 1847), p. 10.

[36] Juvénal, *Satire VI*. Jean Seznec fait observer que Hugo paraphrasera ce passage de Juvénal dans un poème de *L'Année Terrible*, *Lettre à une femme* (J. Seznec, "The Romans of the Decadence and their

historical significance', *Gazette des beaux-arts*, oct. 1943, p. 222).

[37] A cet égard, *l'Olympia* de Manet se situera exactement à l'opposé des *Romains*. Tandis que Couture reprend à son compte l'image de la débauche et le jugement moral caractéristiques du romantisme, Manet représentera avec une sorte de détachement cynique l'apothéose d'une courtisane. Nous avons suggéré ailleurs que le titre même d'Olympia pouvait contenir une allusion à Olympio, le double imaginaire de Hugo, et viser ironiquement à travers lui la tradition romantique, sentimentale et moralisante (P. Georgel, 'Le Romantisme des années 1860', *Revue de l'art*, n° 20 (1973), p. 34, n. 28). Cf. aussi, de Couture luimême, *La courtisane moderne* de 1873.

Burgraves échouaient, exécutés alors même que le poète a provisoirement renoncé à se faire entendre, ils reprennent le message moral de Hugo et sa vision grandiose.

Le caractère grandiose du style est en effet inséparable du contenu moral: les modèles plastiques des *Romains* en témoignent autant que leurs modèles littéraires. Le jeune peintre voulait un art à la fois chargé d'une haute signification et situé dans ce qu'on appelait alors, d'une formule vague, 'la grande tradition'. Cette volonté, que rendent manifeste les références parfois indiscrètes des *Romains* à Véronèse, à Rubens, à Ingres, aux sculptures du Parthénon,[38] est commune à beaucoup d'artistes des années 1845–50, mais la plupart d'entre eux cherchent à l'accomplir en recourant aux sujets et aux procédés conventionnels de la peinture d'histoire plutôt que par un renouvellement proprement plastique.[39] Les *Romains* n'échappent nullement à cette ambiguïté, avec leur sujet antique, leurs poses d'atelier, leurs réminiscences des maîtres; et il est facile de déceler dans les œuvres antérieures et contemporaines de Couture les signes d'une indécision, d'un éclectisme fondamental, que son développement ultérieur ne viendra que trop confirmer. Pourtant, dans une peinture comme *L'Amour de l'or*, où nous reconnaissions volontiers aujourd'hui le fade mélange habituel au 'Juste-Milieu', les critiques du temps trouvèrent de la vigueur, de l'éclat.[40] L'homme qui venait de peindre ce tableau était habité par un rêve de 'grandeur'. Il se référait explicitement, et en quelque sorte se mesurait, au modèle épique de Géricault.

Celui-ci est certainement le peintre du dix-neuvième siècle le plus souvent cité par Couture dans ses écrits, avec une admiration sans réserve.[41] Non seulement, à ses yeux, Géricault a poursuivi la *grande tradition* française,[42] mais, avec David et Gros dans

[38] Voir Seznec, art. cit., p. 221.

[39] J. C. Sloane a analysé ce phénomène dans le chapitre préliminaire de *French painting between the past and the present: artists, critics and traditions, from 1848 to 1870* (Princeton, 1951). C'est probablement la partie la moins contestable de ce livre, que M. Schapiro a soumis à une critique sévère et justifiée (*Art Bulletin*, XXXVI (1954), 163–5).

[40] Voir les textes recueillis par L. Rosenthal, *Du romantisme au réalisme* (Paris, 1914), p. 253.

[41] Voir en particulier [Bertauts-Couture], op. cit., 1932, pp. 144–5; *Méthode et entretiens d'atelier*, pp. 317–18 et 335–7. Pages 317–18, Couture dégage la signification politique et sociale de la *Méduse*, témoignage symbolique sur la France contemporaine. En cela aussi, le tableau de Géricault a pu servir de modèle aux *Romains*, qui auraient voulu être pour la société de la Monarchie de Juillet l'équivalent de ce que la *Méduse* avait été, selon Couture, pour la société de la Restauration. — D'après M. Fried ('Manet's sources, aspects of his art, 1859–1865', *Artforum*, mars 1969, p. 77, n. 195), 'the *Romans of the Decadence* ... is involved far more closely with the *Raft of the Medusa* than may at first appear. Figure after figure can be seen to have its equivalent in Géricault's painting.' Il est regrettable que M. Fried ne soit pas plus précis. Il nous semble surtout que c'est dans le

modèle épique et dans les dimensions grandioses que se trouve la référence des *Romains* à Géricault. D'autre part, Fried suggère, en citant d'excellentes sources (p. 55 et p. 76, n. 163), que la fortune de Géricault est surtout due à son réalisme. C'est même en partie contre Courbet qu'on exaltera Géricault vers 1860: d'après Chesneau, Courbet aurait 'usurpé le drapeau' du réalisme 'dressé par Géricault'. Nous pensons cependant que l'intérêt de Couture pour Géricault, comme son admiration pour Hugo, est un aspect de son orientation romantique. — Dans son article de 1970 (cité *supra*, n. 27), Fried fait des rapprochements bien plus convaincants entre la *Méduse* et l'une des peintures décoratives de Couture à Saint-Eustache, *Stella Maris*. En revanche, nous ne le suivons pas du tout quand il cherche à démontrer, dans son article sur Manet (p. 61) que les *Romains* sont 'based ... on an earlier painting, or projected painting ... David's unfinished *Tennis Court Oath*'.

[42] Dans son étonnante argumentation sur les références à la peinture française que l'œuvre de Manet contiendrait entre 1859 et 1865 ('Manet's sources...'), M. Fried décrit longuement cette recherche d'un art national *français* dans les écrits et l'œuvre de Couture. Il propose notamment de reconnaître dans les idées de Couture l'influence de l'enseignement de Michelet vers 1840. Dans l'ensemble, son analyse nous

leur période impériale, il en a fondé une lui-même, caractérisée par la 'grandeur'. C'est ce que Couture appelle 'l'art moderne'[43] (quelques semaines avant sa mort, il écrira encore qu'avec la *Méduse*, 'l'art moderne était trouvé').[44] Quand il explique à Charles que son tableau futur sera 'aussi grand que le Naufrage de la Méduse', il ne veut sans doute pas parler de 'grandeur' matérielle seulement. Celle-ci ne se suffit pas à elle-même; elle est le signe d'une autre grandeur: elle donne l'échelle d'un art à la mesure des 'gloires de la Révolution et de l'Empire', ces 'colosses'[45] dont Couture rêve de retrouver la 'belle peinture interrompue'.[46] Par l'éclat de son court destin, devenu légendaire, par la pureté de son œuvre, dont ni le doute ni le vieillissement n'avaient eu le temps d'altérer la véhémence, Géricault, mieux que David et que Gros,[47] incarnait par excellence le génie héroïque à opposer aux gentillesses et aux facilités des 'peintres qui produisent encore pour la satisfaction de petits appétits bourgeois'.[48] Tel nous apparaît bien aujourd'hui dans son ampleur le véritable programme romantique en peinture; mais Couture, comme presque tous les hommes de son temps,[49] identifiait le romantisme avec l'art de ses 'singes' (pour reprendre l'expression contemporaine de Baudelaire).[50] Il est significatif que dans son livre il situe 'la fièvre romantique' 'vers 1832',[51] souscrivant ainsi à ce mythe de 1830, d'une médiocre valeur historique, auquel les années 1860 ont donné corps pour satisfaire leur propre nostalgie de grandeur.[52] De fait, en se voulant le continuateur de Géricault contre une imagerie pittoresque heritée de ce que la peinture 'romantique' avait de plus fragile, comme en puisant son inspiration dans la dramaturgie hugolienne, dont le grandiose et les ambitions totalitaires étaient devenus si démodés, Couture prouvait sans le savoir que c'était lui, le romantique. Quand, à son tour, incapable d'accomplir ce programme, il multipliera à satiété ses arlequinades désenchantées, ses lendemains d'orgie, ses 'soupers après le bal masqué', ses clowns tristes,[53] il lui restera du moins, à défaut de la 'grandeur' dont la peinture

paraît suggestive, mais nous pensons qu'elle exagère l'importance du concept de 'frenchness'. Couture parle bien de renouer avec 'l'art national' de Gros et de Géricault, mais il n'attache probablement pas à cette expression toute la valeur nationaliste que lui donne Michelet. Par 'national', il entend surtout: à l'échelle de la nation, populaire — et par là, rejoignant cette fois Michelet (et Hugo): gigantesque, à la mesure de l'Histoire contemporaine et du vaste génie anonyme du peuple. Ce génie 'national' s'oppose, plutôt qu'aux génies locaux d'autres écoles, aux 'petits appétits bourgeois' (voir n. 48).

[43] Il va de soi que cette expression n'a pas le même sens pour Couture et pour nous. Ce serait une grossière erreur de croire qu'il voyait, comme nous le faisons, un maître de 'l'art moderne' dans son élève Manet, par exemple.

[44] Texte de 1878, cité dans [Bertauts-Couture], op. cit., 1932, p. 144.

[45] *Méthode et entretiens d'atelier*, p. 151.

[46] Ibid., p. 362.

[47] 'Peut-être [Gros] sentait-il que Géricault était allé plus loin que lui dans l'expression moderne, qu'il

y avait là un tempérament d'exception', etc. (texte de 1878 cité dans [Bertauts-Couture], op. cit., 1932, p. 144).

[48] *Méthode et entretiens d'atelier*, p. 362.

[49] Et trop encore du nôtre. Sur l'impropriété du terme 'romantisme' appliqué aux années 1830, voir (1) en matière de littérature: Cl. Pichois, 'Surnaturalisme français et romantisme allemand', dans *Connaissance de l'étranger, mélanges dédiés à la mémoire de Jean-Marie Carré* (Paris, 1964), pp. 385–96; (2) en matière de peinture: P. Georgel, 'Le Romantisme des années 1860', p. 10.

[50] Voir l'ensemble du *Salon de 1846*, qui est, dans la littérature de l'époque, le texte le plus approfondi et le plus clairvoyant sur le concept d'art romantique.

[51] *Méthode et entretiens d'atelier*, p. 150.

[52] Voir P. Georgel, 'Le Romantisme des années 1860', pp. 10–11.

[53] Sur ce thème, sa fortune, ses relations avec la littérature du Second Empire, voir F. Haskell, 'The sad clown: some notes on a 19th century myth', dans (U. Finke, éd.), *French Nineteenth Century Painting and Literature . . .* (Manchester, 1972), pp. 2–16.

de Géricault et le théâtre de Hugo lui avaient donné l'exemple, quelque chose du romantisme tardif mais authentique de sa jeunesse. A l'échelle menue du 'genre', et avec toutes les facilités et toutes les ambiguïtés réclamées par une clientèle bourgeoise, ces peintures garderont quelque chose du contenu moral, et parfois un peu de la vigueur plastique que les *Romains* avaient cherché — et peut-être en partie réussi? — à orchestrer sur le mode de l'épopée.

La deuxième partie de la lettre de Charles n'aurait qu'un intérêt anecdotique, si le récit qu'elle contient ne suscitait dans la mémoire du lecteur une analogie frappante. Cette histoire de prison, d'évasion, suffit à rappeler les nombreux textes de Hugo sur les thèmes du crime et de la justice;[54] mais une ressemblance plus précise s'impose: entre l'événement relaté par Charles et les pages célèbres des *Misérables*[55] où Jean Valjean, portant Marius, s'échappe de la maison de Corinthe à travers l'égoût de Paris.

Ces pages n'ont pas été écrites avant l'ultime révision de 1861–2, mais l'évasion-sauvetage étant un des moments essentiels à la structure narrative et symbolique du roman, il est probable que Hugo l'avait prévu, au moins sous une forme vague, avant d'entreprendre la rédaction suivie en 1845.[56] Le 'reliquat' des *Misérables* contient d'autre part deux pages de notes sur les égoûts de Paris, qui semblent dater de 1837 environ.[57] Cependant rien ne permet de rapprocher ceci de cela et de conclure que Hugo avait d'emblée conçu la scène dans son décor définitif.

La lettre de Charles peut apporter un point de repère. Son récit n'a sûrement pas laissé indifférent celui qui avait déjà écrit *Le Dernier Jour d'un condamné* et *Claude Gueux*, qui dès 1827 assistait avec David d'Angers au ferrement des galériens à Bicêtre,[58] qui venait, en 1839, de visiter le bagne de Toulon. On ne saurait dire s'il a pensé à son roman futur en lisant la lettre de son fils. Du moins a-t-il dû l'enregistrer dans sa mémoire à toutes fins utiles, comme il fait de toute chose. Le fait qu'elle lui soit parvenue au cours du mémorable voyage de 1843 où il apprit la mort de sa fille est une raison de plus pour qu'il ne l'ait pas oubliée.

Le souterrain fétide traversant 'deux fosses de lieux d'aisance', la 'tête d'homme, barbue, ébouriffée, hideuse, immonde', l'évasion dans les ténèbres qui finit par l'irruption de la police: tout engage à supposer que la lettre de Charles, relue ou remémorée, est la 'source' principale de l'épisode des *Misérables*. Source modeste, d'une médiocre valeur littéraire, mais qui a pu fournir le point de départ d'un développement profondément original, ou plutôt qui a pu en cristalliser les thèmes. Que la Descente aux

[54] Voir P. Savey-Casard, *Le Crime et la peine dans l'œuvre de Victor Hugo* (Paris, 1957).

[55] V, II et III (éd. Massin, XI.873–902).

[56] R. Journet et G. Robert situent plusieurs notes et ébauches de la Ve partie avant février 1848 (*Le Manuscrit des 'Misérables'* (Paris, 1963), p. 23).

[57] Ibid., pp. 16–17. Observons toutefois que la note 'chemin de J.V.' (=Jean Valjean) inscrite par Hugo

en marge de la *Statistique des égoûts de la ville de Paris* ne peut être antérieure à 1860, date à laquelle 'Jean Tréjean' prend le nom de 'Jean Vlajean' (il ne devient 'Jean Valjean' qu'en 1861).

[58] Voir le lettre de David d'Angers à Victor Pavie citée par Y. Gohin, *Les Réalités du crime et de la justice pour Victor Hugo avant 1829*, éd. Massin, III.xxv.

Enfers de Jean Valjean, qui est aussi sa Montée au Calvaire,[59] l'épreuve décisive du grand roman initiatique, ait pu prendre corps autour d'une donnée aussi mince, rien de plus conforme aux habitudes créatrices de Hugo. Il est même probable que celui-ci, près de vingt ans après, a repris tels quels, ou peu s'en faut, les éléments du récit de son fils dans un passage du Livre V: celui où il imagine Jean Valjean égaré dans le labyrinthe noir de l'égoût, puis surgissant 'en plein jour sur le point le plus peuplé de Paris':

Peut-être aboutirait-il à quelque cagnard de carrefour. Stupeur des passants de voir deux hommes sanglants sortir de terre sous leurs pieds. Survenue des sergents de ville, prise d'armes du corps de garde voisin. On serait saisi avant d'être sorti. Il valait mieux s'enfoncer dans le dédale, se fier à cette noirceur, et s'en remettre à la providence quant à l'issue.[60]

[59] Voir P. Albouy, *La Création mythologique chez Victor Hugo* (Paris, 1968), pp. 302–3.

[60] Éd. Massin, XI.886.

IX

FLAUBERT AND SOME PAINTERS OF HIS TIME

Alison Fairlie

'Sɪ j'avais été peintre, j'aurais été rudement embêté...' wrote Flaubert in a letter. He had just been trying to capture in words the countless extraordinary colours shifting on the surface of the sea, and it came naturally to think of the painter's problem, since exact reproduction of this 'truth' is impossible, and if it could be achieved would produce a false effect (*C* II.210).[1] He often disclaimed any technical knowledge as an art critic, but he reacted strongly and individually to works of art; his responses are perhaps of three main kinds. First, in the context of his reflections on aesthetic problems in general, and of the paradoxes of representation and suggestion in particular, he compares and contrasts the dilemmas of writer and painter. Second, there is what might nowadays be called the sociological approach: his fascinated contemplation of the details which reveal the Taste of the Times, whether he searches for the atmosphere of a past age transfigured by the great masters, or is provoked to a creative 'horreur sacrée' by the spectacle of contemporary adulation for the second-rate. Of course, the terms aesthetician and sociologist would have been anathema to Flaubert;[2] it is his third response which matters most, and was evident, as with Baudelaire, from early childhood: his reaction to pictures as a means of extending and crystallizing his own inherent aspirations and projects.[3]

[1] Page references below are to the Conard edition unless otherwise stated: I use the following abbreviations: *C*: *Correspondance* (9 vols., 1926–33); *CS*: Four supplementary vols. of *Correspondance inédite*, ed. R. Dumesnil, J. Pommier, Cl. Digeon, 1953; *ES*: *Éducation sentimentale*; *BP*: *Bouvard et Pécuchet*.

For Flaubert's manuscript notes taken in the 1860s, I have consulted, in the Bibliothèque Historique de la Ville de Paris, the Carnets de Lecture (CL) and the Carnets de Voyage (CV); and, in the Bibliothèque municipale de Rouen, the eight dossiers g 226^{1-8}. A debt is owed to the work of many scholars who have provided analyses of these documents, or published important material from them. I give here references to the originals.

[2] Cf. below, p. 113, his apology for using the word

esthéticien in the Chesneau letter, and his summing-up of Pellerin as 'un esthétiqueur qui fait le portrait d'un enfant mort' (*CS* II.172). Cf. also below, p. 122, on the 'chaire d'esthétique'. Cf. his use of *esthéticien* to Fromentin, *C* VII.322.

[3] Cf. Jean Seznec, *La Source de l'épisode des dieux dans 'La Tentation de saint Antoine'* (Vrin, 1940), on the important fact that the visual stimulus may be less an initial source than a means to 'cristalliser des pensées et des rêves encore flottants' (p. 12), and on how it is after he has created his own 'idée d'ensemble' that Flaubert searches for its exemplification in detail (p. 24). Cf. also the same author's *Nouvelles Études sur 'La Tentation de saint Antoine'* (London, Warburg Institute, 1949), and his other studies mentioned below. On some other aspects of Flaubert's reaction

The wide and varied discoveries, penetrating analyses, and seminal suggestions of Jean Seznec have shown both how rewarding it can be to examine the ways in which Flaubert shaped his initial responses so as to give them suggestive value in his own creative works, and how much new material awaits investigation. I propose here to add two small contributions: by looking first at Flaubert's letter to the art critic Ernest Chesneau in 1868, then at a few of his manuscript notes on artists of the 1840s, notes which he compiled in the 1860s, in preparation for *L'Éducation sentimentale*.

Flaubert thanked other writers, notably Fromentin and Taine, for their books on art.[4] I have chosen his letter to Chesneau for three reasons: first, the previously published versions of the text contain many errors; second, beneath the informal tone and the appearance of taking up Chesneau's views just as they come, Flaubert has initially picked out three basic points of principle, then proceeded to agreement or disagreement on specific artists or problems; finally, to follow his allusions, one needs the kind of commentary provided for the Taine letter in the Supplement to the *Correspondance*, and Chesneau's volume is not easy to come by.

First, the text:

<div style="text-align: right">

Croisset.

Dimanche

</div>

[fo. 1ʳ] Non! mon cher ami, votre livre ne "contrarie en rien mes goûts" loin de là! J'ai même été ravi de voir ce que je sens, ce que je pense formulé d'une telle façon.

Votre morceau sur l'École anglaise est à lui seul une œuvre. Et d'abord vous avez très bien signalé son trait saillant, l'absence de composition — (si vous aviez tenu à noircir du papier
5 vous auriez pu faire un rapprochement entre la Peinture & la littérature britannique)

Bien que j'aie lu l'ouvrage de Milsand voilà la première fois que je trouve enfin une définition nette du Préraphaelisme! — La manière dont l'Absolu & le contingent doivent être mêlés dans une œuvre d'art me semble indiquée nettement p. 62. Je pense comme vous.
"dès qu'il y a interprétation dans l'œuvre d'un peintre, l'artiste a beau s'en défendre, il fait
10 fonction d'idéaliste" (94) Bref, on n'est idéal qu'à la condition d'être réel & on n'est vrai qu'à force de généraliser. [fo. 1ᵛ] Du reste vous concluez fort bien, en montrant l'inanité des théories par l'exemple des deux écoles Anglaise & Belge arrivant à des résultats divers bien qu'elles soient parties du même principe (89–90)

La limite de la peinture, (ce qu'elle peut et ce qu'elle ne peut pas) est montrée avec une

l.7. 'contingent' is written above a crossed-out word which I have not deciphered but which may simply be an initial mis-spelling.
l.9. the same is true of 'fait'.
l.14. 'montrée' is written above 'exprimée', crossed out; 'une' has been inserted above the line between 'avec' and 'évidence'; probably in the course of writing Flaubert changed 'exprimée avec évidence' to the stronger 'montrée avec une évidence qui crève les yeux'.

to the visual arts, cf. Jean Bruneau, 'Les deux voyages de Gustave Flaubert en Italie', in *Connaissance de l'Étranger*, Mélanges offerts à la mémoire de J.-M. Carré (Paris, Didier, 1964), pp. 164–80, and Irma B. Jaffé, 'Flaubert—the novelist as art critic', *Gazette des Beaux-Arts*, May–June 1970, pp. 335–70.

[4] *C* VII.321–2 to Fromentin, for *Les Maîtres d'autrefois*; *CS* II.86–90, to Taine for *Voyage en Italie, II, Florence et Venise*, and *CS* II.160–2 for *Philosophie de l'art dans les Pays-Bas*.

évidence qui crève les yeux, à propos d'un tableau de Pauwels et d'un autre de Comte. 15
Enfin, je n'ose trop vous louer de vos idées parceque ce sont les miennes Donc sur la Religion
nous sommes d'accord

Quant aux appréciations particulières (question de nerfs & de tempérament autant que
de goût) je vous trouve parfois un peu d'indulgence — Comme pr mon ami H. Bellangé
entr'autres. Cela tient peut-être à ce que vous savez beaucoup et que vous êtes sensible à 20
des mérites que je ne vois pas? Cependant j'applaudis sans réserve à tout ce que vous dites
sur Ingres & Flandrin (215) Gérôme (221) le sculpteur italien Vela (378) bien d'autres
encore! & je vous remercie d'avoir rendu justice à Gustave Moreau — que beaucoup de nos
amis n'ont pas selon moi suffisamment admiré. (mais prquoi dites-vous *le* sphinx. C'est, ici,
la sphinx — [fo. 2r] Cette infime remarque vous prouvera que je vous ai lu attentivement. 25
Aussi p 124 il y a une faute. "les récits d'hist. romaine d'Augustin Thierry." vous avez voulu
dire "les récits *mérovingiens* d'A. Thierry. les récits d'hist. romaine sont d'Amédée Thierry.

Mais je ne suis nullement de votre opinion quand vous prétendez que "Decamps nous fit
un Orient imaginaire" Son Orient n'est pas plus imaginaire que celui de Lord Byron — ni
par la brosse ni par la plume personne encore n'a dépassé ces deux là comme *vérité* 30

Vous m'avez souvent remis sous les yeux des tableaux que j'avais oubliés. La description
des portraits de l'empereur & de Mme de Ganay sont des pages du meilleur style, achevées,
excellentes. — votre article sur l'art Japonnais est d'un critique supérieur où l'on sent le
Praticien sous l'esthéticien (pardon du mot) à preuve: vos observations sur les surfaces
courbes, la perspective, 420. — cela est creusé. Vous êtes entré au cœur de l'art Japonais il 35
me semble.

Une chicane, cependant. êtes-vous bien sûr que ce soit "le rationalisme étroit & sec de
la Chine" qui lui ait fait repousser toute tentative de Progrès Le rationalisme seul en est-il
la cause? Je n'en sais rien.

[fo. 2v] En résumé, mon cher Chesneau, votre livre m'a fait grand plaisir & je vous remercie 40
de m'avoir envoyé. Je vous remercie également de l'aimable lettre qui l'accompagnait.
Mon nom répété deux fois dans votre volume m'a prouvé votre sympathie. — Croyez bien à
la mienne

Je vous serre les deux mains
& suis votre 45
Gve Flaubert

Si vous voyez les De Goncourt priez les donc de m'envoyer leur adresse.
rappelez-moi au souvenir de votre patron —.
Enfin, si cela n'est pas inconvenant, présentez tous mes respects à la Princesse —[5]

l.28. A word or beginning of word has been crossed out before 'Mais'. Possibly 'Un'?
l.38. After 'Progrès' a phrase of four or five words has been crossed out: it ended 'et que' and led on: 'et
 que le rationalisme seul en soit la cause?' This has been changed to 'Le rationalisme seul en est-il la cause?'.
l.41. *sic*, for 'de me l'avoir envoyé'.

[5] I am glad to express here warm thanks to Professor G. Donnay, Conservateur, Musée de Mariemont, for his kindness in letting me have excellent photo-copies of the manuscript and for authorization to publish a corrected version.

The letter appears (without its postscript and with a number of misreadings) in the Conard *Correspondance*, V.379–81. It was exhibited in 1967; see Paul Culot's notes on it in *Trésors inconnus du Musée de Mariemont*, Aut. 366/1. In Dec. 1968 J.-M. Paisse

produced in the Bulletin of the *Amis de Flaubert* No. 33, pp. 27–8, a version which restored the postscript and made some other corrections, but cf. below.

Other observations: I have inserted some missing accents, but otherwise followed Flaubert's text exactly. Apart from details of spelling, punctuation, and paragraphing, the following are the main corrections to the Conard version, affecting the sense of the letter:

Chesneau's book: *Peinture — Sculpture. Les Nations rivales dans l'art*, with its voluminous sub-title,[6] was a survey of contemporary art in many lands as seen at the Paris Exposition Universelle of 1867. If Flaubert, in a list of those obligatory subjects for cliché-conversation which infuriated him, included 'Les Expositions Universelles',[7] yet, with his customary interplay of encyclopedic appetite and wry criticism, he did attend them, from his journey to the London Exhibition of 1851 onwards,[8] and he had made at least two visits in 1867 (*C* V.299). He presumably knew Chesneau through their common Rouen connections[9] as well as through the circle of Princess Mathilde; the tone of the letter is clearly that of a polite acquaintance rather than a close friend. Chesneau later sent him others of his many works; there survives,[10] inscribed 'A Gustave Flaubert — Bien affectueux hommage — de son constant et fidèle admirateur', a copy of *La Chimère* of 1879, a strange lyrical prose tale, dedicated to Gustave Moreau, so admired by himself and by Flaubert, and with as frontispiece, to symbolize intense aspirations and temptations, a work by Moreau. Chesneau's career had been unconventional; on his parents' refusal to let him train as a painter he joined the army and spent four years in the ranks; after an unsuccessful venture at founding a newspaper in 1857, he gradually won a reputation for articles of art criticism in a variety of periodicals. By 1868 he had published a number of works on French and English painters, was

Restoration of quotation marks indicating that Flaubert is citing Chesneau: ll. 1 and 9–10.*

Corrections to page references: l. 8, 62 *not* 60*; l. 13, 89–90 *not* page 550; l. 22, 215 *not* 315*.

Other corrections: l. 15, Pauwels *not* Pamvels; l. 25, prouvera, *not* prouve*; l. 26, Aussi *not* Ainsi; l. 26, vous avez voulu dire, *not* vous avez bien voulu dire*; l. 31, remis *not* mis*; l. 35, insert, 420 *after* perspective; l. 37, insert & sec *after* étroit*; l. 41, m'avoir *not* me l'avoir*; l. 45, *insert at end* et suis votre G^ve Flaubert; *at end add postscripts*.

On the points indicated by asterisks, J.-M. Paisse's version produced the same corrected readings. But it dislocated the order of Flaubert's comments by placing fo. 2^r before instead of after fo. 1^v, left some errors uncorrected, and introduced misreadings (l. 13, par. 990 *for* 89–90; l. 26, je sais [qu'] *for* p. 124; l. 27, André Thierry *for* Amédée Thierry; l. 35, etc. *for* 420).

[6] *Peinture—Sculpture. Les Nations rivales dans l'art.* Angleterre – Belgique – Hollande – Bavière. Prusse – États du Nord – Danemark – Suède et Norwége – Russie – Autriche – Suisse – Espagne – Portugal – Italie – États Unis d'Amérique – France. L'Art Japonais. De l'Influence des Expositions Internationales sur l'Avenir de l'Art. Par Ernest Chesneau. Paris. Librairie Académique. Didier et Cie. 1868. Dedicated to Princess Mathilde, Chesneau's book was listed in the Bibliographie de la France on 1 Aug. 1868. I have found no exact evidence for the date of Flaubert's letter of thanks, though it is not likely to be between mid-July and mid-August, when he was

away from Croisset on visits to Dieppe, Fontainebleau, Saint-Gratien, and Paris.

[7] 'Choses qui m'ont embêté, alias: scies'. BMR g 226¹ fo. 277 (quoted by a number of scholars).

[8] Cf. Jean Seznec, *Flaubert à l'Exposition de 1851* (Oxford, Clarendon Press, 1951). The notebook which Professor Seznec so impeccably deciphers, and illuminates with his introductory comments, appears to me to be Flaubert's 'fair copy', in more coherent form, of Carnet de Lecture 4, BHVP (where most pages are diagonally crossed out as was Flaubert's habit when he had rewritten). This latter, often very illegible, *carnet* would be the one used on the spot. To set the two versions side by side is to discover an interesting development of 'variants' even in such brief notes. CL 4, fo. 70^v, suggests that in Seznec p. 32 l. 22 *moutons* should read *montans*. The editors of the Club de l'Honnête Homme *Œuvres* have recently published in Vol. VII the *Carnets de lecture.* As with previous volumes of this edition, the presentation of important material is marred by some serious misreadings. Mme Durry's indispensable volume of material from particular *carnets* is of course familiar to all scholars.

[9] Ernest Chesneau (1833–90) was born in Rouen (twelve years after Flaubert); he was at school in Rouen (after Versailles) in 1848.

[10] Cf. L. Andrieu's list of books inscribed to Flaubert (*Les Amis de Flaubert*, No. 24 (mai 1964), pp 3–23) and *C* VIII.332. Chesneau also sent Flaubert his *Peintres et statuaires romantiques* of 1880.

'rédacteur au Louvre' and 'chargé du rapport officiel du jury des classes des beaux-arts pour l'exposition de 1867'; in 1869 he was to become inspecteur des beaux-arts. His long sequence of books was to continue throughout the 1880s, including his major contribution in *L'Œuvre complet de Delacroix* of 1885.

Flaubert is clearly conscious of producing a *modèle du genre* in the art of the polite thank-you letter, with its balance between wide principles and detail, between disclaimers of expert knowledge and suggestion of good grounds for his own views, between shared enthusiasm and occasional vigorous objection. He no doubt had more reservations about Chesneau's book than he cares to express: one wonders about his reactions to Chesneau's leisurely and repetitive style, and to the obvious gap, at times, between those rational arguments which reject trite conventions and those instinctive preferences in subject-matter where clearly bullfight-watchers or cruel landlords are at a disadvantage as compared to a sweet girl with a dead dove (e.g. pp. 55–6). But Chesneau was seen by others discussing him in the context of his times as eschewing both rigid general theories and cramping specialized technicalities; this approach, and his genuine if not always sustained or informed desire for breadth and variety of vision, gave Flaubert grounds for agreement.

Les Nations rivales opens with an article on contemporary English painters, and recalls the shock to all French standards when some of their works were originally exhibited in Paris in 1855: a shock caused first by violent crudity of colour, then by 'l'absence de toute composition. Ici, pas de centre, une action principale noyée dans l'accessoire' (p. 2; cf. pp. 9, 29, 50). On the other hand, Chesneau stresses that they have a kind of national originality unknown in France since David[11] (except for caricaturists), and that the French, 'trop portés à généraliser', could profit from their meticulous respect for detail. Flaubert, himself so often (and so wrongly) accused of subjecting structure to accessory detail, goes immediately to the importance of *composition*, his initial and lasting preoccupation in each of his novels[12]—and at once draws an analogy with English literature. His letter gives no evidence as to his direct knowledge of English painting—and Chesneau himself had significant difficulties over seeing many pictures: he points out that Rossetti's works have never been exhibited in France and are hard to see in England (p. 40) so must be reported on at second hand;[13] and that it is a pity nothing is known in France of Madox Brown or Jones Burne (*sic*, p. 47). But Flaubert's pleasure at finding in Chesneau a clear definition of Pre-Raphaelitism, after attempting in vain to extract one from Milsand, is neither empty compliment nor name-dropping; among his manuscript notes there exist two foolscap pages of

[11] Cf. Flaubert on the Empire painters, e.g. in *Voyage en Orient: Italie*, ed. L'Intégrale II.682, 'Peinture à faire périr d'ennui... il gèle à 36° dans cette école'.

[12] Cf. also to Caroline (*C* VIII.290), 'Quant à tes études picturales, tu devrais t'exercer à la composition', and compare with VII.373, 'tu me dois un

Vénitien, quelque chose de royal et *d'archicoloré*'. Construction and colour are central to his reactions.

[13] Chesneau speaks of a Rosetti exhibition at Russels place [*sic*] in 1857, and of how Georges Pouchet, a friend of Flaubert, on a visit to Darwin, saw a Rosetti painting (pp. 72–3).

efficient summary and quotation from Milsand's *L'Esthétique anglaise: étude sur John Ruskin*.[14] Chesneau's central point about this school is that 'par un système d'analyse microscopique poussé jusqu'au vertige... ils voulaient réaliser, épouser étroitement le Vrai, principe et fin de toute morale'; even if this culminates in a 'création quasi-monstrueuse' it is a 'noble erreur' (pp. 14, 26). The sense of 'vertige' inherent in the pursuit, at two related extremes, of abstract truth and concrete exactitude no doubt held Flaubert's attention, as perhaps did the account (p. 22) of Holman Hunt's five years of study and travel in Judaea while preparing his *Finding of Christ in the Temple*.

Flaubert moves immediately to his second conviction: the falsity of the simplified arguments, so rife at the time, around the ill-defined terms 'realism' and 'idealism'. On p. 62 Chesneau had discussed the way in which the old masters combined the general and the specific; Flaubert relates this to Chesneau's attack (pp. 94 ff.) on Courbet's dogmatic theories of realism, and quotes the clinching sentence: 'Dès qu'il y a interprétation dans l'œuvre d'un peintre...' His own summing-up, in its lapidary expression of potential paradox: 'Bref, on n'est idéal qu'à la condition d'être réel & on n'est vrai qu'à force de généraliser', points forward to the puzzlement of Bouvard and Pécuchet in their study of aesthetic theories: 'L'application trop exacte du Vrai nuit à la Beauté, et la préoccupation de la Beauté empêche le Vrai. Cependant, sans idéal pas de Vrai; c'est pourquoi les types sont d'une réalité plus continue que les portraits' (*BP*, ed. Cento, p. 411).[15] And indeed here his conclusion, over-vigorously attributed to Chesneau, is, typically, that of 'l'inanité des théories'.[16]

He then takes up a third fundamental conviction: that of the essential separation between the different arts; one remembers his famous refusal to allow illustrations of his novels, since these would limit to one particular angle of vision the author's deliberate and suggestive appeal to the creative imagination of individual readers' responses. Chesneau was frequently concerned with the problem of the anecdotal or the allusive in painting, and with distinguishing between works where gesture and facial expression adequately convey the central suggestion, and those which unjustifiably demand out-

[14] BMR g 226¹ fo. 165ʳ⁻ᵛ. These careful notes show Flaubert's choice of central problems relating to his own basic preoccupations and would deserve close analysis. They end with: 'Les penseurs qui s'occupent des artistes les engagent sous prétexte de se relever à se dégrader. L'interêt humain, pathétique, moral, philosophique sont précisément ce que cherche et aime dans un tableau la foule ignorante et les lettrés qui lui demandent les mérites d'un récit ou d'un roman' and also include: 'les lettrés sont incapables d'apprécier les qualités en quelque sorte musicales qui distinguent les tableaux des œuvres peintes'. Joseph Milsand's *L'Esthétique anglaise*, étude sur M. John Ruskin (Paris, 1864), appeared at the time when Flaubert was embarking on his documentation for *L'Education sentimentale*. Milsand's other works bear on philo-

sophy, religion, politics, education, rather than art. Chesneau mentions his *Esthétique anglaise* on pp. 20, 22, 27. The CHH notes to *ES*, p. 468 (cf. above, n. 8), mention notes by Flaubert on Pre-Raphaelites without including his own reference to Milsand.

[15] Cf. Alison Fairlie: 'Flaubert et la conscience du réel', *Essays in French Literature*, IV (Nov. 1967), 1–12. On the supposed dichotomy between *Le Vrai* and *La Beauté*, cf. Baudelaire, *Notes nouvelles sur Edgar Poe*, passim.

[16] For Chesneau's milder expression of the problem, cf. pp. 88–90 where he sees both the Pre-Raphaelites and the Neo-Germanists as a theoretical return to primitivism but stresses the inferior execution of the former. Cf. also p. 327 on the difference between system and result.

side knowledge or commentary: on pp. 98–100 he gives detailed examples from three pictures by Pauwels (how, for example, can a picture convey that the woman giving her jewels is doing so in order to save by her heroic magnanimity the populace who had murdered her husband?); much later (pp. 252–3) he looks into the problems involved by Charles Comte's attempt to depict in *Seigni Joan* the anecdotal and verbal complexities of an incident from Rabelais. Flaubert's grouping of these observations shows that he has indeed 'lu attentivement'. And his interest in this problem, as in his notes on Milsand, shows how strongly he thinks of literature as calling on special resources for selection and interpretation.

Contact with the unfamiliar history or traditions of other nations has suggested the dangers of counting on a shared response to the painter's subject: Chesneau, however, holds that 'la légende biblique et chrétienne échappe seule dans l'ordre historique aux inconvénients que nous venons de signaler', for here the artist is using material familiar to all civilized societies (p. 101). But he also attacks (with all due respect for moral intentions) the stultifying conventions imposed on contemporary painters of church frescoes by well-meaning ecclesiastics who 'se préoccupent beaucoup plus de l'idée religieuse que de l'idée esthétique' (pp. 211–16). Hence Flaubert's 'sur la Religion nous sommes d'accord'.

With the polite formula 'Je n'ose trop vous louer de vos idées parceque ce sont les miennes',[17] Flaubert turns from theory to appreciation of particular works, stressing that this depends not just on criteria of taste, but on individual and physical response— that of 'nerfs et tempérament'.[18] His comments are skilfully grouped to lead from artists about whom he has reservations to those he wholeheartedly admires, and at the same time to place his queries concerning Chesneau's judgements between passages in which he can stress his partial or complete agreement.

First, a polite doubt. The space and the praise (with only gentle reservations) which Chesneau gives to Hippolyte Bellangé (pp. 228–40), immensely popular in his day (along with Charlet and Raffet) for the combined 'realism' and nostalgia of his paintings and prints of military life in the epic age of Napoleon (his vignettes of the Old Guard—his battle paintings where *Les Deux amis* fall touchingly across each other on the field, each clutching the ribbons given by his beloved; his last rendering of the famous theme, *La Garde meurt*—both exhibited in 1867), these seem excessive to Flaubert. His polite deference to Chesneau's specialized knowledge suggests perhaps not just Chesneau's technical equipment as an art critic, but the personal reactions produced by four years in the army; Flaubert's own friendship with the late Bellangé does not inhibit his doubts.[19]

[17] Cf. the self-mocking marginal note on political views in a periodical, BMR g 226⁴, fo. 117ᵛ: 'Idées fort sages (c'est à dire les miennes)'.

[18] Both terms—*nerfs* and *tempérament*—recall Baudelaire's stress on individual physical response to the work of art. Cf. Alison Fairlie, 'Aspects of expression in Baudelaire's art criticism' in *French Nineteenth Century Painting and Literature*, ed. U. Finke (Manchester University Press, 1972), pp. 40–64.

[19] Flaubert refers to Bellangé as 'mon ami', and must certainly have known him closely. Joseph-Louis-Hippolyte Bellangé (1800–66) was Conservateur au Musée de Rouen from 1837 to 1854; he published a catalogue of the collection in 1846 (O. Popovitch,

Chesneau's criticism of Ingres and Flandrin (pp. 215 ff.) comes in a discussion of religious painting; he sees them as 'esprits intelligents mais limités', marking the culmination of past traditions and devoid of any new stimulus. One remembers Flaubert's derogatory recalling of Ingres's *Roger délivrant Angélique*,[20] or his reaction to *Françoise de Rimini*: 'Détestable, sec, pauvre de couleur; le col du jeune homme qui va pour embrasser Françoise n'en finit';[21] but also his appreciation of Ingres's portraits, when in the moment of intense delight produced by the encounter with a beautiful 'passante' in Rome he dreamed of having her portrait done by a painter summoned from Paris, and the painters he thought of were Ingres and Lehmann.[22] As for Flandrin, Flaubert did more than once remember details from the fresco of Christ's entry into Jerusalem, which he saw in Saint-Germain-des-Prés the day before he left for his journey to the Middle East in 1849.[23]

Chesneau makes Gérôme the occasion for an analysis (pp. 220–3) of how the contemporary public, determined to have value for its money, likes to see each detail minutely rendered, 'prendre le tableau sur ses genoux, l'étudier point par point à la loupe'. On the positive side, he provides an evocative page on Gérôme's skill in rendering the suppleness and substance of folds of material, the fragility and transparency of crystal, the rich touches of gold and silver on the hilt of weapons—sensuous impressionistic effects very close to those which Flaubert captures verbally in *L'Éducation sentimentale*; on the negative side, he attacks Gérôme's trite following of a now outmoded fashion for the caricaturing of antiquity, which 'vient après-coup, comme *Orphée aux Enfers* ou la *Belle Hélène*'. Flaubert was likely to agree with both sides of this appraisal.[24] As for Vincenzo Vela's statue of *The Last Days of Napoleon* (pp. 377–8), one can imagine Flaubert's mesmerized and ironically reflective contemplation of this masterpiece of *trompe-l'œil* in all the glory of its 'realistically' rendered woollen blanket and intricate lace-work.

Catalogue du Musée des Beaux-Arts de Rouen (Paris, Arts et Métiers Graphiques, 1967), p. 4). Chesneau (quoted in Jules Adeline, *Hippolyte Bellangé et son œuvre*, Paris, A. Quantin, 1880) was at school with his son Louis who died young, and describes Bellangé's picturesque studio which Flaubert presumably knew (Adeline, pp. 14–17). Flaubert recalls how, when he left for Egypt in October 1849, the farewell party included 'le jeune Louis Bellangé qui est mort pendant ma visite' (*Voyage en Orient: Égypte*, ed. L'Intégrale II.550; cf. II.559 where the child is recalled). Cf. M. Mespoulet in *Images et romans* (Paris, Belles Lettres, 1939), p. 108, for Bellangé's representation of a Normandy wedding procession (dating from well before *Mme Bovary*)—this, and a Bellangé portrait of Achille Flaubert, are reproduced in the *Album Flaubert*, ed. Jean Bruneau and A. Ducourneau (Pléiade, 1972), pp. 107 and 69.

Cf. Jean Seznec, 'Flaubert and the Graphic Arts', *Journal of the Warburg and Courtauld Institute*, VIII (1945) (p. 182, n. 1 remarks how Callot and Bellangé are juxtaposed in a note by Flaubert). Were those prints of Napoleonic battles, dear to Henry's bourgeois father in the first *Éducation* (Seznec, p. 176) works by Bellangé? Early in his career, Bellangé had even produced scenes for the decoration of popular china (cf. Jean Seznec, '*Madame Bovary* et la puissance de l'image', *Médecine de France*, VIII (1949), for the china plates with the Louise de la Vallière story which had so influenced Emma). On Bellangé, cf. below, n. 35 and n. 44.

[20] *Voyage en Orient: Italie et Suisse*, ed. l'Intégrale, II.463.

[21] Ibid., *Italie*, II.682.

[22] Ibid., II.698.

[23] *Voyage en Orient: Égypte*, ed. l'Intégrale, II.566; cf. *C* II.228.

[24] Cf. *C* V.241 'Le Chic... admirer *Orphée aux Enfers*', and *C* IV.371 on Gluck's *Orphée*: 'une des plus grandes choses que je connaisse'.

But Flaubert's admirations, as so often, outpace his hatreds. Here he chooses one painter who had meant much to his own generation, Decamps, and one who seems to promise much for the future, Gustave Moreau.[25] Decamps, who has obviously been a long-standing stimulus to his own way first of imagining, then of directly experiencing, the Middle East,[26] is defended, in general terms, and with an immediate literary parallel, for the fundamental insight of his vision (once again, it is not superficial accuracy of representation which is the criterion).

Although only two of Gustave Moreau's pictures appeared in the 1867 Exhibition, and he there received no award, Chesneau, considering him 'la personnalité la plus haute parmi les peintres vivants et militants', gave Moreau pride of place (pp. 179–207) and quoted at length his own past discussions of other paintings shown in the *Salons* of 1864, 1865, and 1866. Much of what he says would fit with Flaubert's own temperament and preoccupations: for example, Chesneau's stress on how Gustave Moreau's sudden rise to fame in 1864 was the result of long years of effort and of waiting (against all the arguments of his friends) until he considered his work ready; or on how, out of elements chosen from reality, the painter constructs a compelling unity of effect, intense, haunting and suggestive. Detailed evocations and analyses are given to *Œdipe et le Sphinx*, *Jason*, *Le Jeune Homme et la Mort*, *Diomède dévoré par ses chevaux*, and *Orphée* (for the last, the theme of the severed head is related in detail to that of John the Baptist);[27] there is also a mention of an enamel exhibited in the *Salon* of 1867, based on Gustave Moreau's *La Chasse*. Worried perhaps by the idea that these enigmatic paintings may appear to contradict his strictures on the over-allusive or over-literary, Chesneau insists that their value does not depend on precise interpretation of detail, compares their effect with the kind of suggestion to be found in Shakespeare, sees them as representing 'le droit d'échapper à la terre par le rêve, l'imagination', and stresses that they transform any impetus given by fact, idea, emotion, or sensation into its purely pictorial equivalent. Flaubert's enthusiasm for Gustave Moreau (his physical, emotional, and intellectual reactions to problems of the stylization of suffering, represented through intense colour and through a sharp and strange precision where detail is at once hyper-realistic and hyper-symbolic, would deserve further discussion) certainly found here an eloquent advocate for the defence.[28]

Flaubert says nothing of his own reactions to Cabanel's portraits of Napoleon III and Mme de Ganay (Chesneau, pp. 173–5);[29] what he praises is Chesneau's way of

[25] As regards the future, Flaubert makes no comment on the passages where Chesneau uneasily combines reproof and real effort at explanation around the startling works of Manet. (Cf. the refusal to pronounce in *C* VIII.279 to Zola: 'Comme je ne comprends goutte à sa peinture, je me récuse'.)

[26] Cf. in J. Seznec, art. cit., *Jnl. Warburg and Courtauld Inst.* p. 175, and M. Mespoulet, op. cit., p. 68, references to L. Hourticq's discussion, in *La Vie et les images* (1927), of Decamps in relation to *Salammbô*. Cf. below, n. 35.

[27] Cf. also Flaubert's comments on pictures representing Judith and Holophernes.

[28] Cf. above, p. 114, for Chesneau's *La Chimère*.

[29] Both pictures date from 1865. Alexandre Cabanel (1824–89) won fame in his day particularly for his portraits of society women: he contributed to the decoration of the pre-1870 Hôtel de Ville, and of the Panthéon and the Tuileries. Contemporary critics frequently select, along with the portrait of Mme de Clermont-Tonnerre, the two mentioned here. Flaubert's long-standing attack on the merely 'realistic' portrait painter (cf. the satirical apotheosis of Ternande in the first *Éducation*) now finds an analysis which stresses the suggestive function in portraiture. He knew Cabanel personally; *C VIII*. 236.

writing about them. The merely 'realistic' portrait had always seemed to Flaubert the temptation of the bad painter; what interests him here is the attempt to sift out from peripheral detail certain significant suggestions. Chesneau centred his discussion on what he held to be the 'modernity' of these portraits, where, instead of using the obligatory conventions (Emperor in military accoutrements or mantle of imperial purple; society beauty fashionably corseted), the painter, rejecting the pompous and the prettifying, had chosen to convey the epitome of aristocratic dignity in the man and of complex sensitivity in the woman, not through picturesque symbolic accessories, but through the simple and subtle suggestions of their mere physical appearance as arranged and interpreted by the artist. Late in the day, and beneath a good deal of initial verbiage, Chesneau is here formulating something akin to Baudelaire's ideas on 'le peintre de la vie moderne', 'le dandy', the hyper-civilized woman; Flaubert is perhaps half-ironically praising his 'tour de force' in extracting such ideas from the exigencies of official portraiture. And one thinks ahead to how, on the contrary, Flaubert's aspiring and dismally unsuccessful painter Pellerin, in *L'Éducation sentimentale*, will set out to produce the master-portrait of all time, not by seeking to combine the suggestively representative and the specifically individual in his model, but by surrounding the unfortunate Rosanette with a concatenation of derivative, romanesque, and caricatural accessories.

Flaubert, who commented only on what he had himself looked at, left out some sections of Chesneau's work. But, like others in the late nineteenth century, he turns to Japanese art. Chesneau's final article, on 'L'art japonais', once again raised the question of supposedly 'realist' art and of varying conventions, and sought to show that what to French eyes might appear primitive or barbaric was the product of a deliberate and sophisticated technique. The Flaubert who is so drawn to playing in every way on geometrical patterns (whether in plot, in relations between characters, or in description of landscapes), and on suggestive shifts in point of view, has picked out Chesneau's comments both on how the curve of a vase and the angle from which it is seen may affect decorative stylization and on the differences between linear geometrical perspective and 'la perspective du sentiment' (pp. 420–1).

But he objects vigorously to Chesneau's generalizations contrasting Japan and China (pp. 416–17); here the Flaubert in whom some critics of today over-stress the potential absurdist or nihilist refuses to see rationalism qualified as 'étroit et sec' or made an obstacle to progress.[30]

[30] One or two further details from the letter deserve brief comment:
 (i) In his remark on the gender of 'sphinx' Flaubert is thinking of the female figure in the picture, though the title followed grammatical usage, *Orphée et le Sphinx*.
 (ii) The correction of the confusion between the two Thierrys recalls his own lifelong reading of historians.

 (iii) The two references to Flaubert in Chesneau's book occur on p. 65 (where a water-colour by Lamont recalls 'l'ennui de Mme Bovary, analysé dans un chef-d'œuvre de Gustave Flaubert') and p. 90 (where Leys's historical paintings are compared with 'l'archaïsme savant et cependant animé, presque vivant' through which Leconte de Lisle and Flaubert restore past civilizations).

'Vous m'avez souvent remis sous les yeux des tableaux que j'avais oubliés': this is part of Flaubert's thanks to Chesneau. At a period when reproductions as we now know them were unobtainable, and travel to see the originals was much more difficult, the ability of the art critic to give in words either a purely factual, or a physically evocative, description of a painting had an important function, sometimes overlooked today in derogatory remarks on 'descriptive' critics of the nineteenth century. Flaubert's own notes on the paintings which at different stages of his life he contemplated so closely have often a purely mnemonic purpose, designed simply to resuscitate before his own mental vision the slightest detail of the picture, details on which he will later work as he selects and transforms for his own evocative purposes.[31]

He had, however, special reasons in 1868 for being interested in Chesneau's panorama of painters. For at least four years he had been systematically compiling his documentation for *L'Éducation sentimentale*, in which the hero's early, and sporadically renewed, ambition is to be a painter, while the significant figure of Pellerin provides a richly detailed evocation, both sardonic and serious, of the ambitious and contradictory succession of aesthetic theories throughout the period, and that of Arnoux an epitome of the trivializing compromises inherent in the commercial pressures imposed by the popularization of art.

From about 1864 he set out to re-create in his own mind the atmosphere of the years 1840–51, through reading and annotating an encyclopedic range of books and periodicals.[32] Many of course he read primarily for their political background, but the fine arts hold an important place, in several ways.

For the treatment given in this period to the treasures of the past, there is the grim or gleeful study of pompous theoretical aspiration set by the side both of the details of commercial double-dealing, deliberate fraud and forgery, and, still more ironically, of the damage caused to great works of art in State museums whether by

(iv) In the postscript, 'votre patron' is presumably Nieuwerkerke, directeur des musées impériaux, who furthered Chesneau's career. In *C* V.421 Flaubert wonders whether the Goncourts are still at Trouville; he has had no news of them since before August.

[31] The process can already be seen if one compares the chapter summaries for *Par les champs et par les grèves* with the developed passages, or the *Notes de voyage* with parallel passages in the *Correspondance*.

[32] Much of this documentation subsists in the BMR dossiers g 226[1-8]. See Alberto Cento's careful analysis, made with a view to determining which sections of these dossiers belong to the preparation of *L'Éducation sentimentale*, in his critical edition of *Bouvard et Pécuchet* (Paris, Nizet, 1964), pp. lxiii–iv, and especially his *Il Realismo documentario nell' 'Éducation sentimentale'* (Naples, Liguori, 1967), pp. 73 ff. A few other sections should probably be added to his list, and his dating by the type of paper used (in general

useful and valid) may need further investigation in relation to MSS. in other collections. The following are the notes on art (not necessarily for the *ES*) not mentioned in his lists: g 226[1] fos. 125–36 (notes on Winckelman and Lessing); fo. 165 (notes on Milsand, cf. above, p. 115); g 226[5], fos. 233–355 (notes on great painters of different schools and nationalities); g 226[7], fos. 230[v]–233 (notes on *Revue des Deux Mondes*, including *Salon*; cf. those in g 226[4], fo. 105). Many of these notes can be dated through cross-references from the *Correspondance*.

The CHH edition (cf. n. 8 above) published for the first time (in Vol. III) an important selection from this material, but it must be used with caution in view of many misreadings and omissions.

When undertaking his systematic reading of the periodicals of the 1840s, Flaubert often appended to his notes the shelfmark in the Bibliothèque Impériale [Nationale] where he read many of them; cf. *C* V.142, 144, 211, etc.

the inertia of neglect or by the ill-conceived initiative of clumsy restoration. From *L'Artiste* Flaubert copies a project for a Chair of Aesthetics (to be coveted by the unfortunate Pellerin) as a means of enlightenment in this age of lack of criteria, when mankind is 'égaré par le positivisme': this Chair should be given to one who possesses 'l'entraînement passionné vers l'idéal uni à un sentiment profondément naturel du plastique... un philosophe ému dont l'éloquence comme celle d'Abélard au Moyen Age parvienne à grouper la multitude éparse...'.[33] On the commercial dealings that influence reputations or corrupt taste, and on the official failure to preserve the great works, he collects material from many books and articles. His very detailed investigations will be sifted out to give in his novel the brief but virulent suggestions on the one hand of Arnoux's profiteering from Pellerin's ability to paint 'dessus de porte, genre Boucher', of the machinations round Rosanette's portrait or Pellerin's dangerously revolutionary Christ on a Railway Engine, and on the other hand of Pellerin's strictures on some of the damage inflicted in the Louvre.[34]

For the artists of the present, Flaubert takes systematic notes on each year's *Salon*. In these, whether from the eight annual pieces of leisurely gossip by Jules Janin in *L'Artiste* or from the more compressed and forthright two annual articles by Planche in the *Revue des Deux Mondes*, he selects out of a vast number of names the main painters of the year: obviously he has the benefit of hindsight in his choice; obviously too he concentrates, though not exclusively, on the early pages of each series where the critic picks out those who count most at the time; but in any case Flaubert is here concerned not just with choosing his personal preferences, but with pin-pointing the artists who formed the talking-points of the year, destined for representative and allusive use, as in the first scene at Arnoux's where the up-to-date subject is the much-contested Ingres portrait of Cherubini.[35]

The notes on the *Salons* are mainly lists of names—again a simple means of recalling

[33] Cf. Flaubert's notes in BMR g 226⁴, fo. 106, and *L'Artiste*, July–Oct. 1847, pp. 1–2, article by Édouard L'Hote, 'De l'enseignement des beaux-arts en France'. Flaubert's hatred of the confusion between philosophy and art, and his insistence on the importance of the individual talent separated from the stereotypes of the crowd, must have made him leap on this passage. The precise sections he quotes are marked by a pencil line in the BN copy of *L'Artiste*; perhaps Flaubert's own marking? (Cf. n. 32, above, for his reading of periodicals there.)

[34] Cf. the notes (BMR g 226¹, fos. 153–67), on Henri Rochefort, *Les Petits Mystères de l'Hôtel des Ventes*; Horsin Déon, *De la conservation et de la restauration des tableaux*; Ch. Blanc, *Le Trésor de la curiosité*. Attacks on neglect or restoration in the Louvre were frequent in periodicals: Flaubert takes particularly full notes on examples from *Les Guêpes* by Alphonse Karr (G 226⁴, fo. 111) and from *L'Alliance des Arts* of June 1849 (g 226¹, fo. 148). He also notes at intervals paeans of praise to Daguerre, suggesting Pellerin's final career as photographer. For some aspects of Pellerin's significance in *ES*, see Alison Fairlie, 'Pellerin et le thème de l'art', *Europe* (Sept.–Nov. 1969), pp. 38–49.

[35] This figures in his notes on *L'Artiste* of 1842 (BMR g 226¹, fo. 160ᵛ, in a list which also includes Bellangé's *Maréchal Ferrant*). To give one example of the kind of choice made: from Planche's two *Salon* articles, *RDM* 1847, he picks out the much-discussed *Portrait de Louis-Philippe et de ses cinq fils* by Horace Vernet (for Flaubert the sadly popular equivalent of Béranger in poetry), Ziegler's *Judith*, Isabey's *Cérémonie dans l'église de Delft au XVIᵉ siècle*, Gérôme's *Combat de coqs*, Pradier's *Pietà*, one or two busts—and joyously copies Planche's scandalized comments on Clésinger's *Femme piquée par un serpent* (g 226⁴, fo. 105). Works by Delacroix and Decamps are specially noted whenever they occur.

material familiar to Flaubert, and part of the atmosphere he wished to re-create. But there are other notes which bring alive his immediate and personal response as he looks at some of the engravings in which periodicals either reproduced the pictures of the year or provided other examples of popular taste. And if the majority of the notes on the *Salons* are taken from *L'Artiste*, it is no doubt because its two plates for each week provided a visual means of recalling the paintings from twenty-five years earlier. Sometimes there is a brief analysis of pleasure, as for the four charming colour-plates of fancy-dress costumes by Gavarni in *L'Artiste* of 1840: one in particular is 'charmant de grâce et de mouvement'.[36] But the most expressive passages come from the Flaubert 'nauseated and fascinated at the same time' by the taste of contemporaries 'who take delight in the bad with edifying tenacity'.[37] *L'Artiste* of 1841 produced an engraving by Perronel of Cassel's *Nina attendant son bien-aimé* (Pl. 49) and flanked it with a lyrical description of the elevated grace and charm of this admired painting; the *Salon* article in an earlier issue had seen it as 'noble, gracieux', evincing a 'tristesse de bon goût'. To Flaubert it is 'hideux de mauvais goût', and he contemplates the tiniest details of the clichés which contribute to its fearful effect: 'en marquise Pompadour, le coude appuyé sur un rocher, un mouchoir à la main — bouffotte au soulier, rubans au corsage, mantelet à dentelles — rêvant — un clocher à l'horizon'.[38] Other works of pious sentimentality—in particular Bourdet's *Une Petite Fille d'Eve* (Pl. 50),[39] with its mournful maiden poised in melancholy between a grisly demon and an improbable angel, and Compte-Calix's sugary *Les Sœurs de lait* (Pl. 51)[40]—rouse the same stupefaction at the spectacle of the *Salon* including works that exemplify 'ineptitude pushed to this degree'.[41]

But there are occasional reflections of another kind—and one in particular proves that Flaubert finds it natural for a painting or engraving to stimulate a literary work. Looking at '*L'Enlèvement*, lithographie par M. Alfred de Dreux. Première pensée du tableau — Salon de 1840' (Pl. 52), he notes: 'A peut-être inspiré la jolie romance dans Eviradnus. Les deux jeunes gens se baisent à la bouche [.] celles des chevaux se cherchent. Crinières au vent — elle s'appuie sur son bras. Les deux chevaux galoppent'.[42]

As always with Flaubert, his documentation was to be sifted and re-sifted. Jean Seznec has shown how[43] in *Madame Bovary* details of the engravings in the Rouen hotel room of Emma's and Léon's last meetings were sacrificed in the final version of the novel; engravings which were at the same time savorously representative of popular

[36] g 226¹, fo. 159. On Gavarni, cf. M. Mespoulet, op. cit., p. 68 (also p. 54). In g. 226⁴, fo. 116 there are notes on costumes for *Bals masqués* by Gavarni from *Le Charivari*, 1841, mingling, as at Rosanette's ball, the most incongruous and picturesquely wild contrasts —'un général étranger', 'les débardeurs', 'un insulaire de n'importe où, une tête suspendue à la ceinture'.

[37] Jean Seznec, art. cit., *Jnl. Warburg and Courtauld Inst.*, p. 178.

[38] g 226¹, fo. 160. Cf. *L'Artiste*, Jan.–June 1841, pp. 255, 280. P.-A.-V.-F. Cassel, born Lyons 1801, exhibited in *Salons* 1824–48. *Nina attendant* is quoted by

Bénézit, Thieme and Becker, and others among his representative successful works.

[39] g 226¹, fo. 159. Cf. *L'Artiste*, 25 May 1840, p. 372. Joseph Bourdet, 1799–1869, exhibited in *Salons* from 1833 onwards.

[40] g 226¹, fo. 160ᵛ. Cf. *L'Artiste*, 1841, p. 397. François-Claudius Compte-Calix exhibited in *Salons* from 1840 and was represented in the 1867 Exhibition.

[41] J. Seznec, art. cit., *Jnl. Warburg and Courtauld Inst.* (see above, n. 19).

[42] g 226¹, fo. 159. Cf. *L'Artiste*, 8 Mar. 1840. p. 180.

[43] J. Seznec, art. cit., *Médecine de France*, pp. 37–40.

taste, and deeply suggestive, through ironical parallel or contrast, of the fundamental patterns of impulse underlying the two characters and their situation. We do not know what the huge first manuscript of *L'Éducation sentimentale* may have contained or what may have been deleted from it later. In that country inn beyond Fontainebleau where Frédéric and Rosanette dined by the river in the evening, in a privileged moment of isolated and illusory delight, did Flaubert originally place on the walls those engravings which he noted in his *carnet* when he selected the auberge 'A la bonne matelotte' at La Plâtrerie for this key scene?—engravings comprising a Bellangé caricature and portraits of the men of 1830? They would have given a finely allusive ironical touch as background to the central figures' moment of careless escape from the battles of 1848.[44]

Alfred de Dreux at all events survives in the final version of *L'Éducation*. Frédéric's multiple purchases from Arnoux's shop, displayed in the room he shares with Deslauriers, include, beside views of exotic cities (Venice, Naples, Constantinople), 'des sujets équestres d'Alfred de Dreux'.[45] Suggestive enough of Frédéric's aspirations to the world of aristocratic fashion (where Alfred de Dreux's elegant works found a long and steady sale) and of the modish background of Jockey Club and races on the Champ de Mars; but did Flaubert also have at the back of his mind a more specific allusion to *L'Enlèvement*, as evoking Frédéric's dreams of Mme Arnoux, dreams held in common with other lovers borne 'dans un délire parallèle / Vers le paradis de mes rêves'?[46]

[44] BHVP, CL[12], fos. 32[v]–35. Many critics have discussed the Fontainebleau episode in the novel by the side of these notes, and copious extracts have been published; a complete and accurate version is still needed (A. Dubuc's complete transcription, along with other Carnets, in *Les Amis de Flaubert*, XXXIV, May 1969, did not make use of the more correct readings in the extracts given by R. Dumesnil, Belles Lettres edition of *ES*, 1942, I.lxxxix ff., but the latter are incomplete even in relation to the passages discussed, and are conflated with another set of notes from the Conard edition. Cf. n. 8 above for the CHH edition).

In his long mid-day pause at the inn at La Plâtrerie, 'A la bonne matelotte—Bertaud', Flaubert had already in mind the central functions of this key scene in his novel—Frédéric's moments of delight with Rosanette by the river in the evening form a deliberate pendant to his dreams of shared joy with Mme Arnoux on the river-steamer at the beginning ('La Plâtrerie rappelle à Fr. le voyage de Montereau'). For the combined delight and irony of this idyll of the everyday Flaubert then selects each detail of physical sensation to contribute to his effects, swiftly brushing in one of those potential paintings of the kind noted by Jean Seznec (art. cit., *Jnl. Warburg and Courtauld Inst.*, p. 182) among his immediate and characteristic reactions:

en face: rideau ⟨clair⟩ d'arbres, ⟨prairie⟩ mamelon boisé — a g[auche] sur l'autre rive Héricy [.] église

à toit de tuile bouquet de futaie sur la même rive Maisons ⟨au loin⟩ une à toit rouge se mire dans l'eau. Au Ier plan la Seine joncs, nénuphars bachots, boutiques à poisson — baigneurs ⟨hommes et fem.⟩ 2 ou 3. Filets sur des bâtons,

then notes the real pictures on the walls: 'Dans la salle de l'auberge, caricature de Bellangé, portraits de 1830. Lamennais Odilon Barrot.' (BHVP CL 12, fos. 34, 33[v].)

There is a nice coincidence in that this very view from la Plâtrerie, opposite Valvins, was to be the scene of Mallarmé's long summers and later retreat only a few years afterwards.

[45] The views of exotic cities, which initially hung in the hotel room where Emma and Léon met in Rouen (cf. Jean Seznec, art. cit., *Médecine de France*, p. 40), have been transferred to Frédéric's room. For Alfred de Dreux, and his function as suggesting frustrated aspirations, social or emotional, cf. the passage from *Par les champs* quoted by Jean Seznec, art. cit., *Jnl. Warburg and Courtauld Inst.*, p. 180, n. 1, 'les sujets équestres d'Alfred de Dreux qu'on trouve chez les filles entretenues'.

[46] Cf., in Baudelaire's art criticism, three brief remarks on the worth and limitations of Alfred de Dreux. For an interesting suggestion comparing another of Alfred de Dreux's paintings with a passage in *Madame Bovary*, cf. Jean Pommier, in *Les Amis de Flaubert*, Nos. 2–3 (1951), p. 3.

I have ended with a question. And the main purpose of this brief article has been to indicate how much remains to be investigated by those to whom Jean Seznec's sensitive scholarship has offered a new and lasting stimulus. To Flaubert 'la plastique, mieux que toutes les rhétoriques du monde, enseigne à celui qui la contemple la gradation des proportions, la fusion des plans, l'harmonie enfin!' (*Par les champs*, p. 299), and he has followed his own counsel (C V.302): 'Emplissez-vous la mémoire de statues et de tableaux.'

X

IMAGES OF FLAUBERT'S QUEEN OF SHEBA IN LATER NINETEENTH-CENTURY ART

Theodore Reff

IN Flaubert's attitude toward the visual arts there was, as Professor Seznec has shown, a fundamental ambivalence: no writer of his time was more deeply interested in works of art than he, yet none was more strenuously opposed to the illustration of his own works.[1] That he was fascinated by all forms of art, from ancient monuments and Renaissance paintings to the popular prints of his day; that he often depended on pictures, book illustrations, church windows and sculpture, and other objects as sources of information or stimulation; that he could achieve equally vivid effects in his own descriptions, composed and rendered with a painter's eye for colour and atmosphere—all this testifies to the essentially visual character of his genius. Nevertheless, it did not prevent him from despising the illustrations he found in contemporary books or from stating categorically that none would appear in his own. 'Toute illustration en général m'exaspère,' he informed his publisher, 'à plus forte raison quand il s'agit de mes œuvres, et de mon vivant on n'en fera pas.'[2] For he was convinced not only of the low level of commercial illustration, but of the harmful effect any visual image would have on his own imagery by making it explicit and thus limiting its power to evoke or suggest: 'Ce n'était guère la peine d'employer tant d'art à laisser tout dans le vague, pour qu'un pignouf vienne démolir mon rêve par sa précision inepte.'[3]

With these ambivalent attitudes in mind, it is instructive to examine the works of art inspired by *La Tentation de saint Antoine*, a book so thoroughly dependent on visual experiences or documents and so brilliantly pictorial in its descriptions of real or imaginary events that it can well be called 'le délire visuel de Flaubert'.[4] Although other episodes within it—the Sphinx and the Chimera, Simon and Helen (Ennoia)—particularly appealed to the Decadent and Symbolist writers of the time, it was the episode

[1] 'Flaubert and the Graphic Arts', *Journal of the Warburg and Courtauld Institutes*, VIII (1945), 175–90.
[2] Letter to Georges Charpentier, 16 Feb. 1879, his *Correspondance* (Paris, 1926–33), VIII.207.
[3] Letter to Jules Duplan, 10 June 1862, ibid., V.23.
[4] Introduction by the Société des Études Littéraires Françaises, in the Club de l'Honnête Homme edition (Paris, 1972), pp. 24–5.

of the Queen of Sheba that captured the imagination of artists. And not surprisingly, since it contains some of the most vividly descriptive passages in the book, passages ranging in style from beautiful word-pictures reminiscent of the Parnassians to evocative flashes of imagery anticipating the Surrealists, which were therefore capable of attracting artists of the most varied stylistic tendencies.[5]

From the time of its first publication, among the fragments of *La Tentation de saint Antoine* that appeared in the magazine *L'Artiste* in 1856–7, the extraordinarily pictorial quality of the Queen of Sheba episode has been acknowledged by critics both friendly and hostile to the work as a whole. On this issue, if on no other, Baudelaire and the Avocat Impérial who condemned *Madame Bovary* could agree, the former singling out among the 'morceaux éblouissants' published in *L'Artiste* 'la merveilleuse apparition de cette petite folle de reine de Saba, miniature dansant sur la rétine d'un ascète',[6] the latter unwittingly praising the same hallucinatory intensity in declaring: 'Je ne crois pas qu'il soit possible de donner plus de vivacité à l'image, plus de trait à la peinture.'[7] When the book was finally published in 1874, the Parnassian poets were equally enthusiastic about this aspect. Coppée was reminded by 'l'intensité de la couleur et la netteté du dessin' simultaneously of Rembrandt and Dürer.[8] Banville, more knowledgeable in his choice of art-historical models, was convinced that 'Rubens ou Paul Véronèse n'auraient pas mieux qu'il ne la fait costumé la Reine de Saba avec une galanterie fastueuse et triomphale.'[9] Even critics such as Fournel and Saint-René Taillandier, who attacked every other feature of *La Tentation de saint Antoine*, were forced to admit that it contained 'nombre de vignettes d'une précision de traits et d'une intensité de couleur saisissantes',[10] more specifically that the Queen of Sheba and the other embodiments of deadly sins were 'scènes fantastiques, magiques, éblouissantes, [qui] ont passé tour à tour dans la lanterne du montreur d'images'.[11] Only Barbey d'Aurevilly insisted that Flaubert had ruined what was potentially 'un cul-de-lampe magnifique' in depicting the Queen of Sheba and her procession 'avec le détail chinois de sa manière, avec ce pointillé exaspéré qui veut faire tout voir'.[12]

Despite the intensely visual character of *La Tentation de saint Antoine*, its author's opposition to all forms of illustration seems to have prevented any from appearing in the numerous editions published during his lifetime and for many years thereafter. It was only in 1895 that the first illustrated edition came out, but none of its small, rather routinely dramatic woodcuts, based on designs by one S. Gòrski, depicted the

[5] On its place in the whole, see A. Chastel, 'L'Episode de la Reine de Saba dans la *Tentation de saint Antoine* de Flaubert', *Romanic Review*, XL (1949), 261–7.

[6] *Œuvres complètes*, ed. Y.-G. Le Dantec and C. Pichois (Paris, 1964), pp. 656–7, from *L'Artiste*, 18 Oct. 1857.

[7] Indictment by Ernest Pinard, 31 Jan. 1857, in the Conard edition of *Madame Bovary* (Paris, 1910), p. 574.

[8] Letter to Flaubert, spring 1874, in A. Albalat, *Gustave Flaubert et ses amis* (Paris, 1927), p. 157.

[9] Review in *Le National*, 4 May 1874.

[10] Review by Fournel in the *Gazette de France*, 28 Apr. 1874.

[11] Review by Taillandier in the *Revue des Deux Mondes*, XLIV (1874), 215.

[12] Review in *Le Constitutionnel*, 20 Apr. 1874.

Queen of Sheba.[13] And if in the following edition, published in 1907 with larger, more colourful reproductions of water-colours by Georges Rochegrosse, she and her exotic retinue were shown in dazzling detail (Pl. 53), it was precisely the kind of literal detail that Flaubert had sought to avoid.[14] No longer the mysteriously provocative figure he had conjured up, but an oriental version of the fashionable Parisienne of Rochegrosse's own era, she seemed designed expressly to illustrate the writer's statement: 'Une femme dessinée ressemble à une femme, voilà tout. L'idée est dès lors fermée, complète, et toutes les phrases sont inutiles, tandis qu'une femme écrite fait rêver à mille femmes.'[15] What remains to be seen is whether other artists, more subtle and original than Rochegrosse, who were independently attracted to the same episode, could translate it effectively into another medium.

The earliest picture that has been connected with it is Isabey's *Tentation de saint Antoine* (Pl. 54), painted in 1868 and shown at the *Salon* the following year. A large composition, dramatic in its contrasts of line and tone and its hordes of agitated figures, it was discussed by most reviewers of the *Salon*.[16] Yet none mentioned the Queen of Sheba episode, not even Gautier, who had been responsible for its publication in *L'Artiste* twelve years earlier; instead he saw in Isabey's picture 'une armée de diablesses sous forme de Vénus, de nymphes, de bacchantes, [qui] assaillent le saint ermite'.[17] It was in an auction catalogue of 1909 that 'la Reine de Saba, entourée d'une cohorte d'esclaves,' was first mentioned,[18] whereas a similar catalogue of 1900 referred simply to 'un groupe de femmes nues et de démons'.[19] Was this because Flaubert's text had been published twice—in the *de luxe* edition illustrated by Rochegrosse and in Bertrand's edition of the *Première Tentation*[20]—shortly before 1909? In any event, if Isabey's conception recalls Flaubert's in its exotic and opulent elements, its extensive display of treasures and retinue of Negro servants, it differs in many other respects. The wild and mountainous landscape, the angels comforting St. Anthony or assaulting his tempters, and the groups of voluptuous nudes among the latter have no counterparts in the text. In them Isabey seems rather to continue the Romantic tradition of Delaroche and Tassaert, in whose numerous versions of the Temptation of St. Anthony or St. Hilarion similar hordes of female nudes appear.[21] And these, painted about 1850 and hence contemporary with Flaubert's first version, only show how effective was his concentration of every form of sensual and material appeal in the provocative yet royal figure of the Queen of Sheba.

[13] Published by Nichols, London; English translation by D. Hannigan.

[14] Published by Ferrould, Paris; the illustration faces p. 32.

[15] Letter to Ernest Duplan, 12 June 1862, *Correspondance*, V.25–6.

[16] For example, E. Chesneau, in *Le Constitutionnel*, 27 June 1869, and H. Fouquier, in the *Revue internationale de l'Art et de la Curiosité*, I (1869), 475.

[17] *Tableaux à la plume* (Paris, 1880), pp. 316–17, from *L'Illustration*, May–June 1869. See also his review in the *Journal Officiel*, 27 June 1869.

[18] Sale, Collection Rosenberg Père, Hôtel Drouot, 21 May 1909, lot 26.

[19] Sale, Collection M. [Otlet], Hôtel Drouot, 17 Dec. 1900, lot 13.

[20] Actually the second (1856) version; published by Fasquelle, Paris, 1908.

[21] Reproduced in A. Lombard, *Flaubert et saint Antoine* (Paris, 1934), Pl. 5, and O. Prost, *Octave Tassaert* (Paris, 1886), pp. 53, 86.

In contrast to Isabey's picture, skilfully executed but shallow in conception, Cézanne's (Pl. 55) is more awkward in certain details but more authentic in expressing a mood of anxiety and dramatic tension. Like his other erotic subjects of *c.* 1875—*L'Éternel Féminin, La Lutte d'Amour*, etc.—his *Tentation de saint Antoine* is charged with his own hermetic fantasies and fears; and "therein lies the strong flavor of his compositions: they betray his repressed eroticism and his consciousness of sin'.[22] This would also explain his initial attraction to the subject *c.* 1869, before he had read Flaubert's text, and his subsequent return to it *c.* 1877, in a water-colour directly inspired by its description of St. Anthony standing outside his cabin.[23] More important, Cézanne's emotional involvement in the subject would explain his relative independence from that text even while drawing on it for certain aspects of his later painting of the Temptation. In fact, he seems to have combined elements from both the Queen of Sheba episode and the episode of the gods, particularly the description in it of Venus Anadyomene. The retinue of smaller figures accompanying her, the ape holding the train of her robe, and, in some of the preparatory studies,[24] the bird hovering near her identify the female figure in his composition as the Queen of Sheba. But her appearance—voluptuously nude rather than elegantly dressed, with flowing blond hair rather than an elaborate blue coiffure, and an expression of languorous sensuality rather than coquettish gaiety—identify her more closely with Venus Anadyomene. So, too, do the little cupids surrounding her, though they do not appear in the text and may instead be based on older pictures of the Worship of Venus, such as the one by Rubens.[25] Probably also derived from a pictorial source, in this case one of the numerous versions of the Temptation by Teniers the Younger, is the Devil leaning over St. Anthony in the guise of a procurer and urging him to look at the woman who stands before him.[26] There is, however, a similar motive in Flaubert's text, directly before the appearance of Venus: disguised as Hilarion, the Devil coaxes and compels the hermit, who has turned away (exactly as in Cézanne's studies), to admire the beauty of the Greek pantheon. Similarly, St. Anthony's energetic gesture of rejection, in the final version of the composition, corresponds to that in the Queen of Sheba episode; for when she attempts to embrace him, 'il la repousse à bras tendus'. Thus Cézanne, although inspired by some of the bizarre or dramatic features in Flaubert's book, makes the image of carnal temptation peculiarly his own.

The artist who, far more than Cézanne, would have found its exotic elements, its vivid evocations of a world of oriental splendour and decadence, congenial to his own art was Gustave Moreau. Some of its descriptions, such as those of the Hindu Trimuiti and Artemis of Ephesus, have rightly been called 'verbal anticipations of pictures by

[22] J. Seznec, 'The Temptation of St. Anthony in Art', *Magazine of Art*, XL (1947), 91.

[23] T. Reff, 'Cézanne, Flaubert, St. Anthony, and the Queen of Sheba', *Art Bulletin*, XLIV (1962), 116–19, 122; see also pp. 119–22 on the version of *c.* 1875.

[24] Reproduced ibid., Pls. 4, 5.

[25] Reproduced in *P. P. Rubens, L'Œuvre du maître* (Paris, 1912), p. 324.

[26] See Museo de Arte de Ponce, *Catalogue, Paintings of the European and American Schools*, ed. J. S. Held (Ponce, 1965), pp. 172–3, with reproduction.

Moreau'.[27] But if his library did include *La Tentation de saint Antoine*, his only representations of that subject, a water-colour of *c.* 1890 and an oil sketch of unknown date, are not in any way specifically related to it.[28] And what is more to the point here, even his image of Salome, whose perverse eroticism, like her royal manner and elaborately jewelled costume, makes her a 'sister of the Queen of Sheba', is no more directly related to Flaubert's book.[29] Apart from the chronological discrepancy—the edition Moreau owned dated from 1878, his picture from 1876 or earlier—the two images have few elements in common. The more numerous ones that seem to emerge when the description of the Queen of Sheba is compared instead with Huysmans's celebrated description of *Salomé* in *A Rebours* are misleading, since the latter actually relied on Mallarmé's *Hérodiade*, a more appropriate text which he borrowed for that purpose.[30] With Ari Renan, the first writer whom Moreau's fantastic imagery and wealth of exotic detail reminded irresistibly of *La Tentation de saint Antoine*, we can only conclude then: 'Il n'y eut, entre les deux artistes, aucun échange direct d'influence; mais il y a souvent parité dans leur optique, dans la percée qu'ils ouvrent sur le passé reculé.'[31]

If Moreau's pictures were not directly influenced by the episode of the Queen of Sheba, they were nevertheless instrumental in stimulating other artists of the 1880s to discover in it an image of the *femme fatale* perfectly suited to their Decadent taste. Probably the first to do so was the Belgian Fernand Khnopff,[32] whose remarkable drawing and painting of 1883 (Pl. 56) show Flaubert's royal figure overwhelming the half-naked hermit standing helpless before her solely by means of her stature and seductive gaze, with no indication of her fabulous retinue and treasures and little indication of her elaborate costume; only the hypnotic power of her jewellery, a familiar Decadent theme, is suggested by the brilliant light she seems to radiate into the darkness engulfing the two figures.[33] The drama is thus concentrated entirely in her gaze, as it is in her ultimate appeal to St. Anthony, at once royal and diabolical, in Flaubert's text: 'Préfères-tu un corps froid comme la peau des serpents, ou bien de grands yeux noirs, plus sombres que les cavernes mystiques? regarde-les, mes yeux!' Although an earlier passage, in which she offers a magic shield and other precious gifts, was quoted when the preparatory drawing for this picture was exhibited in 1906, presumably by the artist himself,[34] it is clearly the later one that corresponds more closely.

[27] M. Praz, *The Romantic Agony*, trans. A. Davidson (New York, 1956), p. 391, n. 7.

[28] Musée Gustave Moreau, *Catalogue sommaire des peintures* (Paris, 1904), no. 204 (unpublished), no. 525 (reproduced in Museum of Modern Art, *Odilon Redon, Gustave Moreau, Rodolphe Bresdin* (New York, 1962), p. 135).

[29] Reproduced in *Odilon Redon*, p. 116. See Praz, op. cit., pp. 292–3, quoting Huysmans's description of Moreau's picture.

[30] R. Baldick, *The Life of J.-K. Huysmans* (Oxford, 1955), p. 85.

[31] 'Gustave Moreau', *Gazette des Beaux-Arts*, XXII

(1899), 67, and ibid. XXI (1899), 14. But see L. Hourticq, *La Vie des images* (Paris, 1927), pp. 218, 222 on the influence of Moreau's *Salomé* on Flaubert's *Hérodias*.

[32] On Moreau's influence here, see F.-C. Legrand, 'Fernand Khnopff—Perfect Symbolist', *Apollo*, LXXX (1967), 284.

[33] In a sheet of studies, reproduced in L. Dumont-Wilden, *Fernand Khnopff* (Brussels, 1907), facing p. 15, she seems to wear a jewelled halo.

[34] Art Gallery of the Corporation of London, *Catalogue of the Exhibition of Works by Flemish and Modern Belgian Painters* (London, 1906), no. 132.

Many of Khnopff's colleagues in the Belgian *avant-garde* were equally enthusiastic about *La Tentation de saint Antoine*. In 1885, during the second annual exhibition of Les Vingt, it was the subject of a featured lecture by the poet Émile Sigogne;[35] in 1887, of campaigns by Huysmans and Verhaeren designed to bring about its publication in a *de luxe* edition, with Redon's lithographs as illustrations.[36] In this atmosphere, it was almost inevitable that Ensor, whose fascination with the perverse and the grotesque had already drawn him to older images of the Temptation, would also turn for inspiration to Flaubert's book. Whether this can be seen in his well-known painting *The Tribulations of St. Anthony* is uncertain, for the monstrous forms he shows polluting the hermit's environment recall those in Northern Renaissance and Baroque art as well as those described in the closing pages of the book.[37] In any event, the Queen of Sheba is not among them, whereas she does appear in another version of the Temptation (Pl. 57), one whose dependence on that source is far more certain. A drawing of extraordinary complexity, rendered in minute detail on a very large sheet made up of seventy-two pages from a sketch-book, it conveys more fully than any other illustration the nightmarish, Surrealist quality of Flaubert's endless processions and infinite panoramas, yet imposes on them a compositional schema of almost iconic symmetry.[38] Curiously, neither Ensor himself, when he exhibited the drawing with Les Vingt in 1888, nor his friend Verhaeren, when he discussed it in a monograph twenty years later, mentioned Flaubert's work, on behalf of which Verhaeren had campaigned; instead, both quoted a passage from a *Vie des saints* by the popular Catholic writer Alban Stolz.[39] That *La Tentation de saint Antoine* was the more likely literary source becomes evident once we recognize in the drawing such features as the face of Christ radiating from the disc of the sun, the many-breasted figure of Diana of Ephesus at the left, and the human-headed bird Simorg-Anka hovering in the sky. Hence the tiny female figure on the central axis, crowned and surrounded by a large retinue, must be the Queen of Sheba, though she appears naked and frontal, more like an icon of lechery than the exotic personage Flaubert had portrayed.

What seems to be an invention of striking originality in Ensor's drawing, its bizarre combination of religion and mythology with modern urban life, mixing the Last Judgement and gods of Olympus with top-hatted creatures selling 'frites', was in fact common at that time.[40] In the very years that he was making and exhibiting this drawing in Brussels, Henri Rivière was producing at the Chat Noir café in Paris a shadow-play in which the characters and scenes described by Flaubert were freely combined with those of contemporary society. As Fénéon observed in his review, 'les tentations

[35] M. O. Maus, *Trente années de lutte pour l'art* (Brussels, 1926), p. 31.

[36] *Lettres... à Odilon Redon*, ed. A. Redon and R. Bacou (Paris, 1960), pp. 111–12, 170–2; see also p. 157, letter from Edmond Picard.

[37] J. Kaplan, 'The Religious Subjects of James Ensor, 1877–1900', *Revue Belge d'Archéologie et d'Histoire de l'Art*, XXXV (1966), 192–4 and Pl. 10.

[38] Ibid., pp. 194–6 and Pl. 11.

[39] P. Haesaerts, *James Ensor* (New York, 1959), p. 342, Pl. 1; and E. Verhaeren, *James Ensor* (Brussels, 1908), pp. 67–9.

[40] For example, in the work of his countryman Félicien Rops; see C. Brison, *Pornocrates* (London, 1969), pp. 39–43 and Pls. 46, 104, etc.

sont de fabrication actuelle qui obsèdent le saint', and the settings include 'les Halles-Centrales dans une lumière hyaline où glisse l'ombre de M. Zola'.[41] Some months later, Rivière preserved the appearance of this 'féerie à grand spectacle' in an album of forty colour prints, many of them accompanied by quotations from *La Tentation de saint Antoine*. In both cases, the longest episode by far, the one that provided material for the most colourful effects, was that of the Queen of Sheba.[42] But unlike Ensor's conception, Rivière's stresses the purely pictorial value of her fabulous procession and dazzling treasures, dwelling on them in scene after scene; and unlike Khnopff's, it makes even her ultimate physical appeal a theatrical tableau with a cast of hundreds behind her (Pl. 58). Appropriately, her costume is no longer the one Flaubert had described, its jewels and embroidered patterns evoking a mood of mystery and splendour, but the loose, transparent veil of an oriental dancer. The final effect, then, is of a Hollywood film *avant la lettre*, not only technically, in the extent to which the shadow-play anticipates the cinema,[43] but conceptually, in the type of theatrical statement it is employed to make. But the latter is already implicit in Flaubert's text, in which some of the descriptions, it has been suggested, are 'de pures exhibitions picturales qui ne diffèrent pas beaucoup des "reconstitutions" bibliques ou impériales du cinéma américain. L'arrivée de la reine de Saba en grande tenue de courtisane du temps de Théodora est un produit typique de cette vulgarité documentaire qui est une des faiblesses de Flaubert.'[44]

Whether or not we accept this judgement, which curiously resembles those pronounced by Fournel and other hostile critics in 1874,[45] it is evident that the most impressive illustrations of *La Tentation de saint Antoine* are precisely the ones that show the least interest in its 'pures exhibitions picturales', namely those by Redon. Although he later recalled that on first reading it he was enchanted 'par la partie descriptive de cet ouvrage, par le relief et la couleur',[46] these qualities play a minor role in the series of lithographs he published in 1888, 1889, and 1896. What he dwelt on instead were its images of a suggestive rather than a sensuous character, images of nightmarish creatures, legendary figures, and primitive organisms, through which he could evoke the awe and mystery of a world shrouded in the darkness of his famous 'noirs'. By then such images were 'already part of his mental world', so that the text could act on him 'almost like an agent of self-revelation'.[47] By the same token, his are probably the only illustrations that Flaubert himself would have accepted, despite his outspoken opposi-

[41] *Œuvres plus que complètes*, ed. J. Halperin (Geneva, 1970), II.721–2, from *La Revue Indépendante*, Jan. 1888.

[42] *La Tentation de saint Antoine* (Paris, 1888), pp. 42–65; the illustration is on p. 63. See the review in Fénéon, op. cit., I.128–30, from *La Cravache*, 4 Aug. 1888.

[43] W. Ritter, 'Henri Rivière', *Die graphischen Künste*, XXII (1899), 112–16.

[44] See above, n. 4. The idea already appears in Lombard, op. cit., pp. 97–9.

[45] 'M. Flaubert est le dernier des Byzantins. Il s'est composé... un magasin d'accessoires et de costumes où rien n'est oublié,' etc. See above, n. 10.

[46] Letter to André Mellerio, 21 July 1898, his *Lettres, 1878–1916* (Paris and Brussels, 1923), p. 32.

[47] J. Seznec, 'Odilon Redon and Literature', *French Nineteenth Century Painting and Literature*, ed. U. Finke (Manchester, 1972), pp. 281–2.

tion to all forms of visual translation of his prose. In view of Redon's interests, which drew him quite naturally to such figures as Oannes, the Sphinx and the Chimera, and Buddha, it is surprising to discover that two of his lithographs depict so clearly theatrical a figure as the Queen of Sheba.[48] In both the earlier and the later versions of this subject, however, he avoided the temptation of explicitness, to which Rivière had succumbed; and ironically, he did so by means of another compositional device later to be exploited in the cinema, the close-up view. Omitting any indication of the Queen of Sheba's exotic retinue and treasures, or even of her elaborately costumed body, he represents her head alone, which becomes all the more disturbing in its proximity and brooding expression. The earlier print (Pl. 59) shows the moment when her magic bird Simorg-Anka, its human face full of a nameless terror, alights in her hair; the later one (Pl. 60), the moment when she withdraws, pouting yet still coquettish, at the end of the scene. Here she wears a bizarre, helmet-like head-dress, reminiscent of a type found in Renaissance pictures of the Temptation.[49] But in the other print, the 'chaîne d'or plate [qui,] lui passant sous le menton, monte le long de ses joues, s'enroule en spirale autour de sa coiffure..., puis, redescendant, lui effleure les épaules,' follows Flaubert's description exactly.

Redon's illustrations were the last of those produced by artists spontaneously attracted to *La Tentation de saint Antoine*, and within it to the episode of the Queen of Sheba, without the obligation of a commission. Those that followed in the twentieth century, beginning with Rochegrosse's in 1907, were almost always disasters of the type that Flaubert had predicted.[50] That Redon's were also the most restricted in scope of those we have considered seems equally appropriate; for in reviewing them we discover a progressive contraction of the field, corresponding to a shift from the notion of a narrative composition to that of a symbolic or expressive vignette, as we proceed chronologically from the Isabey to the Cézanne, then to the Khnopff and the Redons, although the Ensor is inevitably an exception. Implicit in this contraction was a decline in the importance of literary inspiration as such, so that the authentic images of carnal temptation in the early twentieth century no longer depicted the Queen of Sheba, but rather the Demoiselles d'Avignon.[51]

[48] On the character of his choices, see S. Sandström, *Le Monde imaginaire d'Odilon Redon* (Lund, 1955), pp. 139–42.

[49] For example, that of Gossaert, reproduced in E. Castelli, *Il Demoniaco nell'arte* (Milan and Florence, 1952) Pl. 73.

[50] Lombard, op. cit., pp. 99–104, 107–8. The most successful illustrated edition, published by Vollard, Paris, 1933, simply uses Redon's lithographs and designs.

[51] Reff, art. cit., p. 125. For help in obtaining photographs, I am indebted to Mme G. Ollinger-Zinque, Musées Royaux des Beaux-Arts de Belgique, and to Professor Julius Kaplan, University of California, Los Angeles.

XI

TWO MASTERS OF THE ABSURD: GRANDVILLE AND CARROLL

Mario Praz

THERE have been written in the last few years many books on the art of the bizarre, on the demoniacal in art, on surrealism (to mention only a few: René de Solier's *L'Art fantastique*, 1961, Roger Caillois's *Au cœur du fantastique*, 1965, Enrico Castelli's *Il Demoniaco nell'arte*, 1952), but one only, *The Grand Eccentrics* (a collection of essays edited by Thomas B. Hess and John Ashbery, New York, 1971), lays stress on Grand-ville's lithographs, of which no less a critic than Baudelaire had written in an essay, later included in *Curiosités esthétiques*, 1868: 'With superhuman courage this man devoted his life to refashioning creation. He took it in his hands, wrung it, rearranged it, explained it and annotated it; and Nature was transformed into a fantasmagoria. He turned the world upside down. Did he not, in fact, compose a picture-book called *Le Monde à l'envers*?' (The actual title is *Un Autre Monde*, 1844.) 'There are some super-ficial spirits who are amused by Grandville; for my part, I find him terrifying... When I open the door of Grandville's works, I feel a certain uneasiness, as though I am enter-ing an apartment where disorder was systematically organized.'

Possibly this method in his madness, this logical organization of the absurd (e.g. a rabbit and a panther exchanging their heads, an owl with a bulldog's head and a mouse with the head of a screech-owl, a frog with a goose's head, a sergeant and his female companion exchanging attributes, people transfigured by distorting mirrors, and so on) has caused Grandville to appear too mechanical, too easy to be foreseen, like the rest of a phrase overleaf, or the paradoxes of Oscar Wilde. Therefore he has been denied a privileged altar next to Bosch, Brueghel, Goya, Fuseli, and, one may add, Arcimboldi, who painted human faces composed of still-life objects, Jesse de Momper who repre-sented the seasons in the shape of anthropomorphic mountains, or Franz Xavier Messerschmidt who twisted faces into frightful grimaces. At the 1957 Bordeaux exhibi-tion called 'Bosch, Goya et le fantastique', Grandville was present with *Les Méta-morphoses du jour* and *Les Fleurs animées*, defined as 'of a surrealist taste *avant la lettre*', perhaps because these works were considered his masterpieces in Charles Blancs's preface to the 1854 edition of *Les Métamorphoses du jour*, whereas Grandville's fame, rather than on the pretty but conventional flower-girls (Pl. 61), and the therianthropic

metamorphoses in a taste which can be traced back at least to the Pompeian caricature of Aeneas and his children with dogs' heads, rests mainly on *Un Autre Monde*, which, among other things, anticipates electronic music with its orchestra of inexplosible steam musical instruments (Pl. 62). Only Hans Sedlmayr, in *Verlust der Mitte* (1948), has seen in Baudelaire's words on Grandville a foretaste of the chief peculiarities of modern art, and has found that the change of scene in Strindberg's *Dream* follows the principles of Grandville's dream image. It would then seem that Grandville should be mentioned among the holy fathers of surrealism, as Sedlmayr maintains; André Breton, however, does not even mention him in his *Surréalisme et la peinture*.

Grandville, like many other bizarre artists, faced the consequences of his freaks, for he died insane in 1848, but the domestic misfortunes which befell him (deaths of his children and his first wife)—and he was very much of a family man—were likely to upset the mind also of other Biedermeier artists as shy and childlike as he was. However, we can hardly credit Michael Benedikt's hypothesis, advanced in his essay on 'The Visionary French' in the volume on *The Grand Eccentrics*, that 'despite the playfulness of his [politico-satirical] attack, his light-hearted representation of literary fantasies and his popularity, Grandville's spiritual isolation during this particular period must have been formidable.'

So little must Grandville have been an isolated phenomenon, in an age alive to the taste for caricature, that beyond the Channel, shortly after his death, there blossomed a kindred spirit, no doubt more complex than his: the Revd. Charles Dodgson, the author of *Alice's Adventures in Wonderland* (1865) and *Through the Looking-glass* (1871), Lewis Carroll. Though Tenniel's illustrations have a typical Victorian flavour, what matters in *Alice* is the text, whereas in Grandville the text is disappointing—a weak libretto for the music of the illustrations: Alphonse Karr, Taxil Delord, and count Foelix are extremely vapid librettists. However, the same spirit of methodized absurdity controls both works. Thackeray defined Grandville 'that Swift of the pencil', The process by which Swift achieved the astonishing surprises of *Gulliver's Travels* is nothing else but Voltaire's *complexe de Micromégas*, that is, looking now from one end, now from the other, of a field-glass. *The Rape of the Lock* exploited the proportion from great to small as a source of wit, obtaining the most astonishing effects through a mere juxtaposition of maxima and minima, as in the famous lines:

> Here files of pins extend their shining rows,
> Puffs, powders, patches, bibles, billets-doux.

Here lies also the foundation of the whole system on which both Grandville and Carroll ring their changes, simple enough variations in the French artist, complex ones in the English story-teller, so complex indeed as to have anticipated modern scientific theories. Moreover we read in the sixth chapter of *Through the Looking-glass*: '"That's just what I complain of", said Humpty Dumpty. "Your face is the same as everybody has—the two eyes, so——" (marking their places in the air

with his thumb) "nose in the middle, mouth under. It's always the same. Now if you had the two eyes on the same side of the nose, for instance—or the mouth at the top— that would be *some* help."' We cannot help exclaiming: 'Picasso!' And when in *Les Métamorphoses du joir* we see a swan's head inserted into the body of a lady with a lyre, we think of De Chirico's brother, the painter Alberto Savinio.

To Grandville, however, the mirror suggests no more than the superficial deformations which are akin to those of the Micromégas: instead of the relation bigger:smaller, the other couple of opposites longer–thinner:shorter–fatter. But Carroll causes Alice actually to get through the looking-glass, beyond which we are in another world where all relations are reversed, a world, so to say, inverted like Leonardo's handwriting. Grandville imagines a battle of playing-cards (Pl. 63): an angel develops out of the shape of the heart, his wings being modelled on its curves; the shape of the *trèfles* suggests a lady dressed in black according to the fashion of 1830, with a small-size cornette and leg-of-mutton sleeves, the *carreaux* become large gaily-coloured cashmere shawls worn by other ladies after the fashion of copes; the *piques* are turned into gloomy confessionals with a monk inside; but Grandville is incapable of inventing a *jeu de cartes* like the game of chess which Carroll unfolds beyond the mirror, controlling after its moves the motions of Alice and the other imaginary characters.

Carroll adds the humour of logical contradiction to that of inversion. Dry biscuits are eaten in order to slake thirst; a messenger whispers shouting at the top of his voice; Alice runs at breakneck speed in order to keep in the same place. One of Carroll's acquaintances related having heard him speak of a friend whose feet were so big that he was obliged to put on his trousers from his head. The March Hare offers Alice a wine which does not exist; Alice wonders where is the flame of a candle when the candle is not lit; for the King of Hearts it is unusual to write letters to nobody: this way of treating non-existent things as if they were existing provides another copious source of Carroll's nonsense, in comparison with which Grandville has to offer only an interminable and inflexible iron bridge, complete with gas standards, joining the re- volving planets of the universe; its three hundred and thirty thousandth pier rests on Saturn (Pl. 64). The White King congratulates Alice for having such good eyes that they can see nobody at a great distance along the road; a cake is handed round before being cut into slices; the White Knight has a queer-shaped little deal box fastened across his shoulders, upside-down, and with the lid hanging open: an invention to prevent the rain from getting in. Grandville humanizes the flowers: they all become like the pretty and silly angel-like women who were congenial to contemporary taste. Carroll invents the Garden of Live Flowers and writes the parody of one of the lyrics in Tennyson's *Maud*, which is found entertaining even today: '"She's coming!" cried the Larkspur. "I hear her footstep, thump, thump, along the gravel-walk!"' (cf. 'She is coming, my dove, my dear . . . / The larkspur listens: "I hear, I hear"; / And the lily whispers: "I wait."'). On the other hand, the text of the little tales which accompany Grandville's coloured lithographs is, as I said, of such vapidity that one wonders how it could pass

muster with his contemporaries. If these were amused by the weak pleasantries of Grandville's text, we must confess that whatever flavour they possessed has vanished with the years, whereas Carroll's puns, his fictitious language *Jabberwocky*, have been so vital that Joyce has drawn inspiration from them for his diabolical contaminations: two or more words are telescoped, creating a new one whose meaning may be guessed from the sound which is sufficient to give a clue to the sense. *Fuming* and *furious* combine in *frumious*; a contamination of *gallop* and *triumphant* yields *galumphing*. Later on in the century Rimbaud indulged in similar combination (e.g. *sangsuel*). Carroll's, commentator (Martin Gardner) wonders whether Carroll's interest in logic and the mathematics is enough to explain the logical distortions and the most hazardous equations in which he delighted. Or did there exist coercions at an unconscious level which pushed him to a continuous twisting and distorting, compressing and inverting, turning upside-down the everyday world? Is an adequate explanation to be found in the hypothesis that he may have been born left-handed, and was forced to use the right hand? Did the fact that he had an asymmetrical and pleasant aspect contribute to his interest in reflections in a mirror? Certainly Carroll's life plays into the hands of the psychoanalyst. He is known to have doted on Alice Liddell, the girl who was the living protagonist of his story, and to have been fond of drawing or photographing little girls naked (with their mothers' permission), but this should not lead us to the conclusion that he was a Victorian Humbert Humbert in chase of Lolitas. For Gardner the thing that distinguishes Carroll from other writers who had a sexless life (Thoreau, Henry James, and so on), as well as from writers who felt a strange attraction for teenagers (e.g. Poe, Ernest Dowson), was his curious combination, almost unique in the history of literature, of a total sexual innocence and a passion that one can only describe as totally heterosexual. His *furor mathematicus* ended in nonsense, his *furor eroticus* in non-sex.

Grandville has been defined an isolated man, and Carroll may seem a unique case; but in England Edward Lear, the author of the *Book of Nonsense*, was his contemporary, and there existed in France other caricaturists who cultivated the absurd. The sleep of reason produces monsters, Goya had said; but is it not rather the bourgeois climate, so rational, conventional, standardized, monotonous, that is apt to produce them? The end of *Through the Looking-glass*, when Alice says to the kitten: 'Now, Kitty, let's consider who it was that dreamed it all . . . You see, Kitty, it *must* have been either me or the Red King. He was part of my dream, of course—but then I was part of his dream', with the conclusion in the final little poem: 'Life, what is it but a dream?' reminds us of Calderón's drama, with the difference that behind the same sentence there was in one case the belief in a true and better world, and in the other only the desire to escape, from the pale light of common day, anywhere out of the world, even if through a looking-glass.

XII

'MODERNITÉ' IN BAUDELAIRE'S ART CRITICISM

David Kelley

IN the final chapter of his *Salon de 1846* Baudelaire insists that the moral decadence of the nineteenth century need not necessarily imply the decadence of painting, and encourages artists to face up to the task of extracting from the apparent spiritual and physical ugliness of their civilization its paradoxical heroism and beauty, and thus to play their part in the creation of a new artistic tradition which will replace the lost tradition of the masters of the past. And the researches of Yoshio Abe have shown that, in this respect if in no other, the prophetic intentions expressed much earlier in the same essay were fulfilled, since these pages probably played an important part in the evolution of Courbet towards the 'realism' of his *Enterrement à Ornans*.[1]

The exceedingly rich theoretical development which the poet gives to these ideas in *Le Peintre de la vie moderne* appears to go further still in liberating painting from traditional assumptions concerning subject-matter. For if in 1846 his assertion that 'la beauté absolue et éternelle n'existe pas' (p. 950)[2] represents a clear rejection of any universally valid norm for deciding what is beautiful and thus fit for inclusion in a painting, it is nevertheless specifically the 'coté épique' of modern life that he urges the painter to seek out, precisely those heroic and mysterious qualities that are exemplified by the literary characters of Balzac:

La vie parisienne est féconde en sujets poétiques et merveilleux. Le merveilleux nous enveloppe et nous abreuve comme l'atmosphère; mais nous ne le voyons pas.

Le *nu*, cette chose si chère aux artistes, cet élément si nécessaire de succès, est aussi fréquent et aussi nécessaire que dans la vie ancienne — au lit, au bain, à l'amphithéâtre. Les moyens et les motifs de la peinture sont également abondants et variés; mais il y a un élément nouveau qui est la beauté moderne.

Car les héros de l'Iliade ne vont qu'à votre cheville, ô Vautrin, ô Rastignac, ô Birotteau, —

[1] '*Un Enterrement à Ornans* et l'*habit noir* baudelairien', *Études de langue et littérature françaises, Bulletin de la Société de langue et de littérature françaises au Japon*, No. 1, Tokyo, Hakusuisha, 1962. See also, by the same critic, 'Baudelaire et la peinture réaliste', *Cahiers de l'Association internationale des études françaises*, No. 18 (1966), 204–14.

[2] References to Baudelaire's works are to *Œuvres complètes*, éd. Y.-G. Le Dantec, édition revisée, complétée et présentée par Claude Pichois (Paris, Gallimard (Pléiade), 1961); for the Poe essays and the correspondence, to the Conard edition, edited by Jacques Crépet and Claude Pichois (abbreviations: *NHE, Nouvelles Histoires extraordinaires*; *CORR.: Correspondance générale*).

et vous, ô Fontanarès, qui n'avez pas osé raconter vos douleurs sous le frac funèbre et convulsionné que nous endossons tous; — et vous, ô Honoré de Balzac, vous le plus héroïque, le plus singulier, le plus romantique et le plus poétique parmi tous les personnages que vous avez tirés de votre sein. (p. 952)

Moreover, these examples suggest that, far from thinking of the relationship between the subject represented on the canvas and the meaning of the picture in any radically new way, Baudelaire is here fundamentally concerned with the adaptation of the traditional iconography of painting to the social and moral conditions of the nineteenth century, and more particularly with the adaptation of traditional Romantic literary and dramatic themes to the physical realities of modern life. In *Le Peintre de la vie moderne*, he is no less preoccupied with the problem of the artistic intensification of what he sees as the banality and triviality of modern urban civilization, but considers the matter in different terms. Guys is not the painter of the epic and heroic aspects of the nineteenth century whom Baudelaire had sought in vain in his early art criticism, but 'le peintre de la *circonstance* et ce qu'elle suggère d'éternel' (p. 1156). What he is attracted to in the artist is specifically his capacity to suggest vitality and universality by the very nature of his representation of what is most banal and ephemeral.

In *Le Peintre de la vie moderne* detailed descriptions of individual pictures are relatively rare. But the terms in which Baudelaire describes Legros's *Angélus* in the *Salon de 1859* (pp. 1046–7) clearly relate his commentary to these preoccupations, and here he draws a very clear distinction between the humble nature of the poor inhabitants of the faubourgs represented by the artist and the implicit significance with which he has managed to endow his picture. Similarly, in his discussion of Armand Gautier's *Sœurs de Charité*[3] which immediately follows this commentary, he emphasizes the painter's achievement in suggesting the eternal precisely through his evocation of monotonous banality:

Il faut une véritable puissance pour dégager la poésie sensible contenue dans ces longs vêtements uniformes, dans ces coiffures rigides et dans ces attitudes modestes et sérieuses comme la vie des personnes de religion. Tout dans le tableau de M. Gautier concourt au développement de la pensée principale: ces longs murs blancs, ces arbres correctement alignés, cette façade simple jusqu'à la pauvreté, les attitudes droites et sans coquetterie féminine, tout ce sexe réduit à la discipline comme le soldat, et dont le visage brille tristement des pâleurs rosées de la virginité consacrée, donnent la sensation de l'éternel et de l'invariable, du devoir agréable dans sa monotonie. (p. 1048)

If the nature of the 'pensée principale' is clearly of great importance in attracting the poet's attention to this picture, the abstract or emotive meaning is conveyed to him, not by any allegorical, dramatic, or even anecdotal means, but through the corres-

[3] Baudelaire's enthusiasm for this picture has surprised some critics, notably Wolfgang Drost ('Kriterien der Kunstkritik Baudelaires. Versuch einer Analyse', *Beiträge zur Theorie der Künste im 19. Jahrhundert* (Frankfurt am Main, 1971), I.270). For an interesting analysis of the poet's commentary on it, see Alison Fairlie, 'Expression in Baudelaire's art criticism', *French Nineteenth Century Painting and Literature*, ed. Ulrich Finke (Manchester, 1972), pp. 54–5. Miss Fairlie compares Baudelaire's evocation of the picture to his own *Les Petites Vieilles*.

pondence between the visually suggestive quality of the figures and *décor* represented and the austerity of the formal terms in which the representation is achieved.

Moreover, the specific contrast which Baudelaire draws between the same painter's *Hôpital de folles* and the 'méthode philosophique et germanique' according to which Kaulbach has treated a similar subject suggests that his use of the term 'poésie sensible' implies a conscious reflection at the time of writing on the characteristic terms in which painting and literature can convey meaning. For Kaulbach's *Maison des fous* is also referred to in the notes for *L'Art philosophique* (p. 1100) in the context of the well-known distinction between 'l'art pur suivant la conception moderne', in which subjective expression and objective representation, meaning and form, are simultaneously and synthetically fused in space, and the allegorical, 'literary' painting of Chenavard and the Germans, in which the relationship between visual representation and abstract meaning is perceived analytically and consecutively (p. 1099).

It is known, however, that in Baudelaire's critical practice at this period the role of subject-matter in painting and the distinctions between literature and the visual arts are less clear-cut than the introductory paragraphs of *L'Art philosophique* would suggest. Indeed, in spite of my remarks above concerning the development of Baudelaire's thought away from the search for literary and dramatic subjects, he tends in the *Salon de 1859* to look at paintings in more obviously literary terms than in his early *Salons*.[4]

For although in 1846 he begins by offering a definition of the critic's role which implies that 'le meilleur compte-rendu d'un tableau pourrait être un sonnet ou une élégie', such a method is specifically rejected for his present purpose in favour of 'la critique proprement dite'—that is a criticism which is 'partiale, passionnée, politique...', faite à un point de vue exclusif, mais au point de vue qui ouvre le plus d'horizons'. And I have tried to show elsewhere[5] that however deeply rooted in the tradition of 'la grande peinture' Baudelaire's definitions may remain, the tendency of the point of view in question—defined as 'l'individualisme bien entendu', or 'la naïveté et l'expression sincère de son tempérament, aidée par tous les moyens que lui fournit son métier' (p. 877)—is to emphasize the importance of painterly rather than literary qualities and to break down the traditional hierarchy of genres, since it implies that the true subject of any picture, whether it be a still life or a crucifixion, is the particularity and the coherence of the artist's personal vision, expressed not only through what he chooses to represent, but also through the formal means which he employs. Nor is such an emphasis on the artist's individuality the excuse for a series of randomly excentric

[4] In the article referred to in the previous note, and in 'De la critique d'art baudelairienne', *Actes du Colloque de Nice sur Baudelaire* (Minard, 1968), pp. 79–88, Wolfgang Drost emphasizes the importance of 'suggestiveness', and more particularly the suggestiveness of the subject, in Baudelaire's criticism, but he does not consider this in relation to the poet's chronological evolution. In her article referred to in the previous note, Alison Fairlie examines very sensitively the literary qualities of Baudelaire's commentaries.

[5] In 'Deux aspects du *Salon de 1846* de Baudelaire: la dédicace aux bourgeois et la couleur', *Forum for Modern Language Studies*, Vol. V, No. 4 (Oct. 1969), and in the edition of the *Salon de 1846* shortly to be published by the Clarendon Press.

personal impressions of painters and pictures,[6] since in the *Salon* in question it implies an attempt on the part of the critic to evaluate the quality of the artist's projection of his own inner universe and to situate him on this basis in relation to his predecessors and contemporaries in such a way as to disengage from the apparent confusion of styles and tendencies a coherent modern French school.

There are in Baudelaire's *Salon de 1846* examples of detailed poetic evocations of the imaginative response triggered off by a particular painting—for example, the remarks on Tassaert's *Marchand d'esclaves* referred to by Wolfgang Drost, or the reaction to Manzoni's *Rixe nocturne* (pp. 902, 909)[7]—but these are relatively rare. Far more typical of Baudelaire's method in this essay and of his real critical preoccupations at this period is his commentary on the works of Théodore Rousseau. Here there is no reference to any specific painting, but rather the attempt to suggest, by reference to certain characteristic visual themes which are in part evoked by appeals to the reader's memory of the works of other painters—Delacroix, Rubens, Rembrandt, and the English landscapists—and by a brief suggestion of the quality of his use of colour, what one might call the moral atmosphere of his work as a whole. And the references to other artists, combined with the concluding remark, 'c'est un naturaliste sans cesse entraîné vers l'idéal' (p. 941), serve also to situate Rousseau's painting within the historical and stylistic categories of landscape painting outlined a few pages earlier (pp. 936–7), as well as within the related aesthetic categories defined much earlier in the work (pp. 892–3)—categories which provide the basis for the poet's synthetic survey of the situation of contemporary French painting, and thus for the structure of his *Salon* as a whole.[8]

The *Salon de 1859* is also underpinned by a series of aesthetic categories; indeed, Baudelaire divides the painters exhibiting into 'les imaginatifs', 'les soi-disant réalistes', and 'les hommes qui par leur impuissance ont élevé le poncif aux honneurs du style" (p. 1045). Nevertheless, if one excepts the extremely rich theoretical chapters, in which he offers the most comprehensive definition to be found in his critical works of the nature and functioning of the artistic imagination, the essay as a whole seems to imply an acceptance of the terms of his commission: '"Soyez bref; ne faites pas un catalogue, mais un aperçu général, quelque chose comme le récit d'une rapide promenade à travers les peintures"' (p. 1025).[9] That is to say that it reads very much like the philosophical wandering of a 'flâneur' or 'homme des foules' round the ephemeral trivialities of the exhibition, in search of the nervous shock of surprise, of the painting or sculpture which will trigger off his own imaginative processes. And the works which achieve this

[6] As has been suggested by Anita Brookner, 'Art Historians and Art Critics: Charles Baudelaire', *Burlington Magazine* (June 1964), p. 269.

[7] 'De la critique d'art baudelairienne', p. 81.

[8] See the edition of the *Salon de 1846* referred to in n. 5, I (4).

[9] Baudelaire's claim never to have visited the exhibition, and his subsequent admission that he did look round, but very briefly (*CORR.* II.313, 317), are well known.

are very often those which are able to suggest, in some way or other, his own literary preoccupations, and his own current reading.

Even in the commentary on Legros's *Angélus*, Baudelaire continues the remarks referred to above by an explicit literary analogy and by a moral reflection induced by that analogy:

Par une association mystérieuse que les esprits subtils comprendront, l'enfant grotesquement habillé, qui tortille avec gaucherie sa casquette dans le temple de Dieu, m'a fait penser à l'âne de Sterne et à ses macarons. Que l'âne soit comique en mangeant un gâteau, cela ne diminue rien de la sensation d'attendrissement qu'on éprouve en voyant le misérable esclave de la ferme cueillir quelques douceurs dans la main d'un philosophe. Ainsi l'enfant du pauvre, tout embarrassé de sa contenance, goûte en tremblant, aux confitures célestes. (p. 1047)

And this tendency is frequent in this essay, although the reference is not always an explicit one. It seems likely, for example, that Baudelaire's interest in military subjects (rejected outright in the *Salon de 1846*), and more particularly his enthusiasm for Tabar's *Guerre de Crimée. Fourrageurs*, are influenced, like the chapter on 'Le Militaire' in *Le Peintre de la vie moderne*, by his reading of Paul de Molènes, who was to have figured in the article on literary dandies (pp. 1059–60).[10] Similarly, his adverse criticism of Gérôme's *Le Roi Candaule* is clearly made with Gautier's treatment of the same subject in mind (p. 1058, cf. p. 694). He also quotes extensively from Chateaubriand (also one of the literary dandies); however, in order to evoke the specific atmosphere of Delacroix's *Ovide chez les Scythes* (p. 1052) he reproduces a line of Wordsworth— probably borrowed in fact from his reading of Gautier (p. 1083)[11]—and a fragment from Hugo's *Voix intérieures*, in order to suggest the nature of his response to Meryon's views of Paris, and refers to Fromentin's own literary works as providing a commentary on his paintings (p. 1067), as well as quoting a long passage from Hood, in order to ridicule the eternal Cupid of the academic painters (pp. 1055–6).

Indeed, it would seem that the definition of a criticism which is 'amusante et poétique', of which the best example might be a sonnet or an elegy, is more applicable to the *Salon de 1859*. For, in addition to quoting the lines of Hugo referred to above, Baudelaire uses the first part of his own poem *Danse macabre*, inspired by a statuette by the sculptor Ernest Christophe, in order to explain rather than illustrate the subtle pleasure afforded by the work in question. Moreover, a comparison of his commentary on the other statuette by Christophe, referred to in the essay *La Comédie humaine*, with the poem *Le Masque* suggests that it represents the first stage in the process by which the suggestive impressions produced by a work of art are worked on by the imagination

[10] See J. Léthève and Cl. Pichois, 'Baudelaire et les illustrateurs des fastes napoléoniens', *Bulletin du Bibliophile* (1965), No. 5, for Baudelaire's interest in military subjects at this period. Paul de Molènes appears to have shared Baudelaire's enthusiasm for Chateaubriand. The relationship between his conception of military life and the Baudelairian conception of the dandy is clear from the following remarks on the 'gardes mobiles' of 1848: 'Le détachement de la vie est la première condition de la vie spirituelle et de la vie élégante. C'est par là que les bandits touchent aux raffinés et aux saints', *Histoires et récits militaires, Œuvres diverses* (Paris, 1885), I.9.

[11] See Henri Lemaitre's edition of the *Curiosités esthétiques. L'Art romantique et autres textes critiques* (Paris, Garnier [1962]), p. 379 n.

until they are transformed into a work of art in an entirely different medium, endowed with a specific and very personal significance (pp. 1094–6).[12]

Clearly the examples I have given are not identical in their implications. It is perfectly excusable to judge Gérôme's rendering of a literary theme in relation to Gautier's version of the same theme. Tabar's *Fourrageurs* on the other hand does not appear to have been either an allegorical or an anecdotal work; and if it evokes in the poet's imagination the qualities of military life as described by Paul de Molènes, this is very largely through its visual contrasts, and more particularly through the contrast of red and green, so important to Baudelaire. The case of the Christophe statuettes is, however, rather different. He is led into a discussion of these works, neither of which was actually on show in the exhibition, by his fascination for a statuette by Hébert entitled *Jamais et Toujours*, which clearly falls into the category defined by Baudelaire himself—perhaps the sign of his own awareness of the equivocal nature of his position in this respect—as works in which the artist is seeking to capture the imagination by resources situated at the extreme limits of, if not beyond, the possibilities of his medium (p. 1064).

The Christophe statuettes themselves are explicitly described as 'allegories', and clearly relate in Baudelaire's sensibility not only to the thematic preoccupations of the *Fleurs du Mal* and Baudelaire's search for a suitable frontispiece,[13] but also to the consecutive, literary art considered in *L'Art philosophique* as a monstrosity, and to his well-known comment on Penguilly-l'Haridon's *Petite danse macabre*:

Les artistes modernes négligent beaucoup trop ces magnifiques allégories du moyen âge, où l'immortel grotesque s'enlaçait en folâtrant, comme il fait encore, à l'immortel horrible. Peut-être nos nerfs trop délicats ne peuvent-ils plus supporter un symbole trop clairement redoutable. (p. 1069)

And the extent to which an allegorical reading of works of art which themselves contain no such implications is a natural reaction for Baudelaire is suggested by his facetious interpretation of Fremiet's *Cheval de Saltimbanque*—strangely enough, in the context of an attack on those artists who disobey the principle of 'l'art pur' by resorting to a means of expression alien to their medium (p. 1092).

Baudelaire's attitude tends to be similarly equivocal in relation to the importance of subject-matter in general. The concept of the creative imagination which is at the centre of his theoretical considerations in the *Salon de 1859* would in many ways appear to imply, no less than the aesthetic of 'naïveté' elaborated in the *Salon de 1846*, the relative unimportance of the nature of the objects or figures represented, in comparison with the artist's capacity to create, out of whatever materials, a coherent visual unity. But if he

[12] The poem *Le Masque* appeared in *La Revue contemporaine* of 30 Nov. 1859. See also Wolfgang Drost's interesting remarks on the relationship between Baudelaire's commentary on Liès's *Les Maux de la guerre* and the word 'gouge' used in 'Danse macabre' ('Kriterien der Kunstkritik', p. 269).

[13] See *CORR.* II.316–17, 397; III.69, 91, 95, 149, 172, 176–80, 185. The poet was originally thinking of Célestin Nanteuil or Penguilly-l'Haridon for this work, finally given to Braquemond.

himself is careful to make this clear, it is only as a qualification to the emphasis which he gives to what is basically a very traditional conception of the hierarchy of the genres:

Bien que ces deux méthodes absolument contraires puissent agrandir ou amoindrir tous les sujets, depuis la scène religieuse jusqu'au plus modeste paysage, toutefois l'homme d'imagination a dû généralement se produire dans la peinture religieuse et dans la fantaisie, tandis que la peinture dite de genre et le paysage devaient offrir en apparence de vastes ressources aux esprits paresseux et difficilement excitables. (p. 1044)

Elsewhere in the same essay, he explicitly states that, barbarous as it may seem, he cannot avoid considering the subject of a painting to be of vital significance (p. 1084).[14]

Such an attitude manifests itself both in the structure of the essay, which is far more clearly organized round the different genres than had been the *Salon de 1846* or the *Exposition universelle de 1855*, and in the poet's critical judgements—in particular the severity of his treatment of some of the leading landscapists of the period, and notably Daubigny, Th. Rousseau, and Corot (pp. 1077–9),[15] and the indulgence which he shows for Chenavard, one of the 'douteurs' of 1846, as he does for the *petits-maîtres* of the Romantic period, whom he had been concerned to put firmly in their place in his early criticism. But, strangely enough in the light of my opening remarks, this conception of the relative importance of different kinds of subject-matter is also reflected in *Le Peintre de la vie moderne*. For, in a passage which seems to be directly associated with the thinking behind the text just quoted from the *Salon de 1859*, Baudelaire affirms quite explicitly that Guys's concern with the transient and the ephemeral makes of him the practician of a minor genre, hardly comparable, whatever his genius, with a painter of religious or heroic subjects:

On a justement appelé les œuvres de Gavarni et de Daumier des compléments de la *Comédie humaine*. Balzac lui-même, j'en suis très-convaincu, n'eût pas été éloigné d'adopter cette idée, laquelle est d'autant plus juste que le génie de l'artiste peintre de mœurs est un génie d'une nature mixte, c'est-à-dire ou il entre une bonne partie d'esprit littéraire. Observateur, flâneur, philosophe, appelez-le comme vous voudrez; mais vous serez certainement amené, pour caractériser cet artiste, à le gratifier d'une épithète que vous ne sauriez appliquer au peintre des choses éternelles, ou du moins durables, des choses héroïques et religieuses. (pp. 1155–6)[16]

The paradoxes and ambiguities of the evolution of Baudelaire's critical practice correspond fairly closely to the modifications which occur in his own moral and social

[14] It should, however, be noted that in the article on Asselineau's *La Double Vie* (published in *L'Artiste* of 9 Jan. 1859) he writes (p. 662): 'Le choix des sujets, c'est l'homme'. This very clearly relates the choice of subject-matter to the personal vision of the artist (cf. *Salon de 1846*, p. 898).

[15] Compared with the *Salons* of 1845 and 1846, in which both Corot and Rousseau are given considerable importance (pp. 849–50, 938, 941).

[16] This has been insufficiently noticed by critics, although Wolfgang Drost ('Kriterien der Kunstkritik', p. 280) and L. B. and F. E. Hyslop ('Baudelaire and Manet: a re-appraisal', *Baudelaire as a Love*

Poet and Other Essays, ed. Lois B. Hyslop (Pennsylvania State University Press, University Park, Pa., and London, 1969), p. 93) draw attention to these remarks. The Hyslops quite rightly suggest that they show the extent to which Philippe Rebeyrol's attack on Baudelaire for seeing in Guys rather than in Manet the painter of modern life is based on a misunderstanding (Philippe Rebeyrol, "Baudelaire et Manet', *Les Temps modernes*, Oct. 1949). But they, like Wolfgang Drost, see the poet's comments above all as a judgement of Guys's talent, rather than as a modification of the concept of modernity.

attitudes, and with the development of French painting between the mid-1840s and the period around 1859. I have tried to show elsewhere that the aesthetic of 'naïveté' developed in the *Salon de 1846* is formulated in relation to a moment in Baudelaire's intellectual career at which the fundamental dualisms which create the central tensions of the poet's work as a whole—unity and multiplicity, Good and Evil, spirit and matter—appear reconcilable within the synthetic scheme of an amoral but dynamic and ultimately purposeful Nature, conceived of as the sum of all complementary contrasts. In these terms, the unity and the harmony which the artist creates within his work of art are pre-existent in reality, and his function is less to extract the spiritual from the material than to express the fusion of the two which is embodied in nature. And the desire for an attempt to renew the grand tradition of painting by rendering the heroism of modern life is based on a similarly almost pantheistic notion of the relationship between variety and unity, and on an optimistic conception of the organic and progressive interaction of the individual and society, the artist and his public.

By 1859, however, Baudelaire has left behind him such a potentially optimistic view of personal and social conflicts and tensions. The duality of spirit and matter, unity and multiplicity, Good and Evil, tends to be considered in terms of what is basically a Christian, albeit extremely unorthodox, conception of an irreparable Fall—hyperbolically associated in a text from the *Journaux intimes* (p. 1283) with the fall from spiritual unity into multiplicity and matter that is divine creation. In such terms social Progress is an impossible concept, born of spiritual laziness; it is replaced, at best by a static conception of the displacement of spiritual vitality, at worst, by the conviction that the whole world is committed to universal decadence (pp. 958–60, 1262–4). The interaction of the individual and society can only lead to the absorption of the unity of the formers' personality. The unity and intensity of the work of art are supernatural rather than natural, and the poet tends to see the artist's task as a fundamentally spiritual one, the creation of the impression of the infinite within the finite world in which he is exiled—the only problem being the definition, within such a finite world, of the term 'spiritual'.[17]

If the Realism of the 1850s can be seen as representing one of the possible developments of the aesthetic of 'naïveté' proposed by Baudelaire in his early *Salons*, it is probably not precisely what the poet himself was thinking of when attempting to define the terms in which Romantic painting could renew itself, but it is even more clearly opposed in some of its theoretical implications to the development that his own thought took. For the more extreme theoreticians of the movement react very forcibly, not only

[17] Thus, in *L'École païenne*, for example (published in January 1852), Baudelaire attacks the materialist implications of neo-pagan preoccupation with physical and formal beauty, whereas later, in the Poe essays and the articles on Gautier and Banville, the non-utilitarian implications of formal beauty give it a 'spiritual' value.

The account given here of Baudelaire's aesthetic and intellectual development is necessarily extremely oversimplified. The most detailed and nuanced discussion of the evolution of Baudelaire's thought so far available is to be found in F. W. Leakey's *Baudelaire and Nature* (Manchester, 1969).

against the academic conception of a static norm of beauty and against the exotic trappings of much Romantic painting, but also against any form of idealism, including the 'sentimentality' implicit in any conception of 'correspondances', whether it be seen in 'pantheistic' or 'spiritualist' terms.[18]

In the *Salon de 1859*, the 'realistic' tendencies which Baudelaire sees as being the dominant ones in the painting of the period are associated, by virtue of their concern for the technical aspects of painting and for physical reality, as well as on account of their democratic implications, with the immersion in materialism which is the symptom of the continued effect of the Fall:

et cependant je leur demanderai à mon tour s'ils croient à la contagion du bien et du mal, à l'action des foules sur les individus et à l'obéissance involontaire, forcée, de l'individu à la foule. Que l'artiste agisse sur le public, et que le public réagisse sur l'artiste, c'est une loi incontestable et irrésistible; d'ailleurs les faits, terribles témoins, sont faciles à étudier; on peut constater le désastre. De jour en jour l'art diminue en respect de lui-même, se prosterne devant la réalité extérieure, et le peintre devient de plus en plus enclin à peindre, non pas ce qu'il rêve, mais ce qu'il voit. (p. 1036)

Aussi admirons avec quelle rapidité nous nous enfonçons dans la voie du progrès (j'entends par progrès la domination progressive de la matière), et quelle diffusion merveilleuse se fait tous les jours de l'habileté commune, de celle qui peut s'acquérir par la patience. (pp. 1032–3)

It is such an equivalence between preoccupation with the visual world and with the technical aspects of the painter's craft and the progressive domination of matter that appears to lead him often to associate, by reaction, spirituality with abstract meaning and to give excessive emphasis to the transcending of the physical realities of painting in favour of the latter, rather than, as the definition of 'l'art pur' in *L'Art philosophique* would suggest, creating a fusion of the two in which meaning is contained within the evocation of the material world. It is certainly this which determines his more favourable attitude towards Chenavard, who in the *Salon de 1846* had been dismissed as a 'douteur' (p. 935), and who in the *Salon de 1859* is counted as one of the few painters whose conversation makes him the worthy companion of a poet:

Disons tout de suite que Chenavard a une énorme supériorité sur tous les artistes; s'il n'est pas assez animal, ils sont beaucoup trop peu spirituels. (p. 1102)

Chenavard est un grand esprit de décadence et il restera comme signe monstrueux de son temps. (p. 1104)

It is not of course Chenavard who is at the centre of the *Salon de 1859*, but Delacroix. And it is unnecessary to indicate the extent to which the poet's discussion of the Romantic colourist, and of the theory of the imagination which is here specifically attributed to him, reiterate the main points of the chapters concerned with his work and with colour theory in the *Salon de 1846*. Nevertheless the text referring to Chenavard quoted above

[18] See, for example, H. Rognairol, 'A quoi sert donc Charenton?', *Le Réalisme*, No. 2 (15 Dec. 1856), or the review of Toussenel's *L'Esprit des hêtes: le monde des oiseaux* and Michelet's *L'Oiseau* in *Le Réalisme*, No. 5 (15 Mar. 1857).

is not entirely irrelevant to Baudelaire's attitude towards Delacroix in 1859. For, in the context of the conflict between colour and line of the 1840s, the latter had been seen as the champion of 'progressive' art, the ally of landscape painters such as Th. Rousseau, opposed to Ingres, now adopted by the academic reaction. In 1859, on the other hand, the landscapists are linked in the poet's mind, by the very nature of their interest in external reality, with the positivism of the more aggressive Realists (p. 1044); his enthusiasm for Delacroix is set against this movement, and related with a nostalgia for the Golden Age of Romanticism, now seen in a historical perspective as the last great moment in the grand tradition of French painting (p. 1027), and the concept of the imagination, in essence a theory of artistic perception and creation, associated with the characteristic subject-matter of that tradition:

L'imagination de Delacroix! Celle-là n'a jamais craint d'escalader les hauteurs difficiles de la religion; le ciel lui appartient, comme l'enfer, comme la guerre, comme l'Olympe, comme la volupté. Voilà bien le type du peintre-poëte! (p. 1048)

The painter represents, like the dandy defined in *Le Peintre de la vie moderne*, 'le dernier éclat d'héroïsme dans les décadences' (p. 1179). He unremittingly asserts the unity and individuality of his personality in face of the general tendency for the artist to be absorbed by the degenerate taste of the public—and Baudelaire explicitly suggests that Delacroix is even greater than the artists of the past whose values he alone maintains, since he has managed to achieve as much as they, but in a social climate hostile to art (p. 1050).

This helps perhaps to define more closely the evolution of the concept of 'modernité' in Baudelaire's thought, and its relationship with the ideas of the *Salon de 1859*. For Guys also partakes of the nature of the dandy (p. 1160), although in a sense he would appear to be diametrically opposed to this last aspect of Delacroix in so far as his art is born of his immersion in the multiplicity of the urban crowd. But his relationship with the crowd is very different from that mutual interdependence between the artist and society which in 1846 had provided the basis for the poet's conception of artistic progress, and thus for the importance which he attributed to modern subject-matter— an interdependence which in 1859 can only be seen as fatal for art. Guys is 'un *moi* insatiable du non-moi', for whom immersion in the crowd becomes a means of augment- ing and intensifying the personality by domination of the crowd, by assimilating and appropriating imaginatively the vital energy dispersed among the individuals which constitute the mass, and the projection of this 'spiritual' intensity on to the paper makes of his art a reaction against that very debasement out of which it is created (pp. 1161–2).

The evolution of Baudelaire's conception of the relativity of beauty has similar implications. In 1846 absolute and eternal beauty had been an almost meaningless con- cept, merely an abstraction skimmed from the top of all of the various fragmentary beauties, themselves the concrete projection of the inner coherence underlying the aspirations of the society of which they were born. In *Le Peintre de la vie moderne*,

however, absolute beauty is a meaningful value, even if it is seen as being intangible and inaccessible in human terms; for in this essay the poet inserts what are fundamentally very similar arguments to those of 1846 concerning the dual nature of beauty into a theological framework. The simultaneous and necessary existence in any work of art of an element of eternal beauty and an element of transient beauty is a function of the duality of soul and body in man, itself the direct and, in Baudelairian terms, irremediable, result of the Fall. So that Guys's attempt to extract the invariable, the eternal, from the relative, the circumstantial, and the ephemeral is a function of the impossibility of absolute beauty in a sullied creation (pp. 1153–4; cf. p. 950).

This is reflected in the significance within the structure of the *Fleurs du Mal* of the 'Tableaux parisiens', inserted into the work as a separate section in the second edition of 1861, that is in the middle of the period of gestation of *Le Peintre de la vie moderne*.[19] For one of the central aspects of the state of Spleen, image of man's exile in the imperfect, and the state to which he is forced consistently to return by the impossibility of realizing in a finite world dominated by evil the aspiration towards the infinite which is the symptom of his divine origin, is the awareness of his own impotence in the face of time, itself the most sinister reminder of his mortal nature. And the 'Tableaux parisiens', which follow immediately the expression of the poet's ironic awareness of the positive potentiality of 'la conscience dans le Mal', are an answer to the challenge issued by the clock in *L'Horloge*:

> Les minutes, mortel folâtre, sont des gangues
> Qu'il ne faut pas lâcher sans en extraire l'or, (p. 77)

the first of the groups of poems expressing in various forms the 'deviation' of the sense of the infinite, that is, in face of the impossibility of attaining the ideal in 'pure' terms, suggested in the section 'Spleen et Idéal', the search to create the impression of infinite intensity through the conscious exploitation of the realities of human exile in imperfection and in evil.

The relationship between the *Salon de 1859* and *Le Peintre de la vie moderne* is thus perhaps analogous to that of the opposite poles of human experience and endeavour as expressed in the *Fleurs du Mal*—or to that of the two forms of cosmetics defined in the essay on Guys itself—the one tending to make the human face resemble the purity and nobility of the statue or of an 'être divin et supérieur', the other emphasizing and intensifying its vitality, but both alike in their common desire to transcend human reality. If Baudelaire no longer in 1859 as in 1845 and 1846 concludes his review of the *Salon* with an appeal for a painter of modern life, but devotes a whole long essay to Constantin Guys, it is not because he feels that he has found in the latter the artist he had been looking for, but because he no longer sees in contemporaneity a possible means of regenerating the great tradition of art. The art of the *Salons* is one in which

[19] *Le Peintre de la vie moderne* appears to have been written for the most part between Nov. 1859 and Feb. 1860. It was published in *Le Figaro* of 26 and 29 Nov., 3 Dec. 1863.

'le peintre des choses éternelles ou du moins durables, le peintre des choses héroïques et religieuses', is, or should be, seeking to create beauty in absolute terms. But in face of the progressive immersion in matter to which the poet refers in the text quoted above, equivalent to a progressive aggravation of the symptoms of the Fall, such a search is progressively more impossible, so that the importance which he gives to what he himself suggests to be a minor art form, to the search for beauty through the ephemeral and the transient, is perhaps in direct relation to the sense of the bankruptcy and decadence of the 'serious' art of the period which he expresses in the *Salon de 1859*.[20]

In a previous article I have already discussed the existence in Baudelaire's mature criticism of such an aesthetic dualism,[21] suggesting, however, that what appear to be two complementary but contrasting series of aesthetic principles correspond to some extent at least to the different possibilities of expression afforded by literature and painting, since, when speaking of the former, and particularly in his essays on Poe, the poet tends to value qualities of abstraction, purity, concision, and conscious elaboration, whereas when talking of painting he continues to emphasize, as he had in his defence of the colourist art of Delacroix against the draughtsmanship of Ingres in 1846, the importance of vitality, of an epic and dramatic vision encompassing the totality of life, of grandeur of proportions and spontaneity. I also emphasized of course, that such categories are by no means watertight—that on the contrary Baudelaire is constantly striving throughout his criticism to arrive at a comprehensive and unified aesthetic formulation, and the comparison which he attempts to establish between Delacroix and Poe is perhaps a symptom of this. But the extreme difficulty of defining the terms in which such comparisons between artists working in different art forms can be made, and, more specifically, the problems he encounters in applying ideas formulated in a literary context to an aesthetic of the visual arts worked out in its essentials a number of years before, and to a critical context in which the issues are rather different from those of his literary essays, perhaps contribute towards the creation of the ambiguities I have referred to here in Baudelaire's thought concerning the subject-matter of painting.

The chronological development I have outlined here is closely bound up with this; for, with Joseph de Maistre and the poet's disillusionment with the failure of the 1848 revolution, Poe is probably one of the factors which influenced his increasingly pessimistic view of life.[22] In particular, it appears to be in the essays on the American writer that the concept of 'absolute' Beauty becomes important in his thought. It is here that he begins to use the Cousinian conception of the separation of the Good, the True, and the Beautiful in order to attack the 'heresy' of didacticism in literature, and to suggest the existence of a hierarchy of literary genres. The highest form of writing is

[20] See in particular, pp. 1025–30.

[21] 'Delacroix, Ingres et Poe. Valeurs picturales et valeurs littéraires dans l'œuvre critique de Baudelaire', *Revue d'Histoire littéraire de la France* (July–Aug. 1971), pp. 606–14.

[22] See p. 1266. For the importance attached by Baudelaire to *coup-d'état*, see Jacques Crépet and Georges Blin's edition of the *Journaux intimes* (Paris, Corti, 1949), pp. 334–6.

the short lyric poem, the exclusive product of what Baudelaire variously terms 'l'idéa-lité', 'le goût', and 'le sens du beau', and endowed with the exclusive function of creating in the spectator that enthusiasm of the soul which is the manifestation of an aspiration towards a higher Beauty,[23] whereas drama and the novel are relegated to a secondary rank by their mixed, impure, nature, and more particularly by their simultaneous preoccupation with Beauty, Truth, and Passion (p. 686 and n.).

Such an insistence on the isolation in the lyric poem of the purely aesthetic, defined above all in terms of the effect produced on the reader's sensibility, corresponds with precisely those aspects of Baudelaire's own creative practice which have caused him to be seen as a significant precursor of modern developments in poetry, since it tends to imply a conception of the poem as a series of interrelated images, purified of all narra-tive, discursive, and rhetorical elements, in which the surface subject-matter is virtually irrelevant; and its closest equivalent in the poet's art criticism would seem to be 'l'art pur suivant la conception moderne' which, in the passage from *L'Art philosophique* already referred to, he opposes to the allegorical painting of Chenavard and the Ger-mans. Indeed, on the page following this definition, he speaks of 'la beauté pure et désintéressée', attacking the heresy of didacticism in terms rather similar to those of the Poe essays (p. 1100).

In fact, however, Baudelaire tends, when applying these ideas to his art criticism, to associate them with equivalent traditional concepts in the visual arts which lead in a quite different direction. The pure Beauty of the Poe essays has, for example, little connection with the idea of a universally valid norm of Beauty derived from classical sculpture upheld by the theorists of neo-classical painting. Yet it is specifically to sculpture that he compares lyric poetry:

De même que la poésie lyrique ennoblit tout, même la passion, la sculpture, la vraie, solennise tout, même le mouvement; elle donne à tout ce qui est humain quelque chose d'éternel et qui participe de la dureté de la matière employée. (pp. 1087–8)

And the emphasis that he places on the capacity of sculpture to eternalize movement suggests that these remarks may not be unconnected in his mind with the definitions of absolute and eternal beauty, and ephemeral and circumstantial beauty, in *Le Peintre de la vie moderne*:

Cet élément transitoire, fugitif, dont les métamorphoses sont si fréquentes, vous n'avez pas le droit de le mépriser ou de vous en passer. En le supprimant, vous tombez forcément dans le vide d'une beauté abstraite et indéfinissable, comme celle de l'unique femme avant le premier péché. (p. 1164)[24]

[23] *NHE*, pp. xv–xxi; cf. *Œuvres*, pp. 690, 711–12, 736.

[24] It is interesting to compare this text with Baude-laire's definition of the lyric mode in his essay on Banville (pp. 736–7): 'Ensuite, nous observons que tout mode lyrique de notre âme nous contraint à considérer les choses non pas sous leur aspect par-ticulier, exceptionnel, mais dans les traits principaux, généraux, universels... La femme est non-seulement un être d'une beauté suprême, comparable à celle d'Ève ou de Vénus... mais encore faudra-t-il doter la femme d'un genre de beauté tel que l'esprit ne peut le concevoir que comme existant dans un monde supérieur.'

Moreover, in the *Salon de 1859*, Baudelaire's invocation of the autonomy of the Good, the True, and the Beautiful is not directed, as in the Poe essays, against the admixture of the Good and the Beautiful in moralizing literature, but against the confusion of Truth and Beauty:

Chez nous le peintre naturel, comme le poëte naturel, est presque un monstre. Le goût exclusif du Vrai (si noble quand il est limité à ses véritables applications) opprime ici et étouffe le goût du Beau. Où il ne faudrait voir que le Beau (je suppose une belle peinture, et l'on peut aisément deviner celle que je me figure), notre public ne cherche que le Vrai. Il n'est pas artiste, naturellement artiste; philosophe peut-être, moraliste, ingénieur, amateur d'anecdotes instructives, tout ce qu'on voudra, mais jamais spontanément artiste. (p. 1033)

The final sentence in this text recalls the definition of the 'peintre de mœurs' in the Guys article, and indeed, the poet has just been attacking the French public's predilection for anecdotal genre painting. Since, however, the passage also serves as a means of leading into an equally savage attack on the current taste for photography, clearly associated in Baudelaire's mind with the Realist tendencies that he considers to be the biggest threat to aesthetic values in the visual arts, he seems to be associating the concept of Truth, which in the *Notes nouvelles sur Edgar Poe* is clearly intellectual truth, with fidelity to visual reality.

Thus, the hierarchy of literary genres in which the noblest form is the short lyric poem tends to become fused, in Baudelaire's art criticism, with the traditional hierarchy of genres in painting, with its emphasis on heroic and religious subjects. For the comparison of the 'peintre de mœurs' with the novelist or the moralist, and the suggestion that his genius is inevitably 'd'une nature mixte', relate the assertion that he is the practitioner of a secondary genre to the 'hierarchie du Beau' outlined in the 1859 article on Gautier, and it is specifically in terms of subject-matter that he is opposed to the painter of eternal things, 'des choses héroïques ou religieuses'. If it is evident that in the passage quoted above the pure search after Beauty is represented by Delacroix rather than by any exponent of 'une beauté abstraite et indéfinissable', it seems likely that it is his rejection of triviality through the nature of his subjects as much as the visual intensity of his painting that is implied. For those qualities which, in the *Notes nouvelles sur Edgar Poe*, characterize the state of perception of Beauty, 'enthousiasme' and 'enlèvement d'âme' are used, at the beginning of the chapter of the *Salon de 1859* in which Baudelaire pays tribute to Delacroix's creative imagination, as a justification for the importance he attaches to religious subject-matter—strangely enough employing a literary analogy drawn, not from lyric poetry, but from a form whose impurity relegates it to a secondary place in the 'hierarchie du Beau', drama:

Ainsi le personnage de Polyeucte exige du poëte et du comédien une ascension spirituelle et un enthousiasme beaucoup plus vif que tel personnage vulgaire épris d'une vulgaire créature de la terre, ou même qu'un héros purement politique. (p. 1045)

My remarks have not been intended as a general attack on Baudelaire's judgement as an art critic; they have been limited to a single aspect of the evolution of his aesthetic

thought. And if so sophisticated a mind as his should have become entangled in the problems considered, this suggests perhaps above all the extreme difficulty involved in making comparisons and equivalences between different art forms, as well as the extent to which creative involvement in one of the arts can be a positive hindrance in considering others. For the mature Baudelaire's art criticism is more obviously informed by his preoccupation with the specific problems of his own literary medium, and more clearly related to the actual sources of his own creative imagination than are his early *Salons*, while the latter are not only more positively and dynamically involved in the development of French painting, but also, in the case of the *Salon de 1846*, more coherent in their aesthetic formulations.[25]

Even here qualifications must be made. Baudelaire's nostalgic pessimism as to the future of painting in France, and the theoretical inconsistencies I have drawn attention to here, both derive to a large extent from a quite justifiable reaction against the limitations, not so much of the painting of Courbet, to whose artistic vitality and energy he continued to pay tribute long after the parting of their aesthetic ways, but of the more extreme expressions of Realist theory—limitations of which the immediately succeeding generations of painters were to be well aware. Looking ahead no further than the impressionists, what might appear to be some of the more retrograde aspects of his aesthetic can also be seen to be prophetic, as, for example, his emphasis on painting from memory in the studio, rather than working in the open air, which is based precisely on that rejection of a positivist attitude towards external nature implied by the Impressionists' attempt to paint the retinal image. And if, in the section on landscape painting in the *Salon de 1859*, he applauds the Romantic visions of Paul Huet, he also expresses his fascination for the 'prodigieuses magies de l'air et de l'eau' of Boudin (pp. 1080-2).

[25] See the introduction to my edition of the *Salon de 1846* and F. W. Leakey, 'Les Esthétiques de Baudelaire: Le 'système' des années 1844-1847', *Revue des Sciences humaines* (July–Sept., 1967), pp. 481–96.

XIII

MALLARMÉ CRITIQUE D'ART

Lloyd Austin

MALLARMÉ partage avec son père spirituel Baudelaire et son fils spirituel Valéry le goût de tous les arts, musique, peinture, sculpture, arts décoratifs. Mais la place qu'occupe la critique d'art proprement dite dans l'œuvre de Mallarmé est beaucoup plus restreinte que chez les deux autres poètes de sa lignée, cet œuvre même, tragiquement inachevé, étant d'ailleurs plus bref dans sa densité de diamant. Baudelaire se place au premier rang des critiques d'art du dix-neuvième siècle en France et dans le monde. Valéry a laissé un riche ensemble de réflexions sur les arts visuels. On a pu faire de beaux albums illustrés de *Baudelaire critique d'art* et des *Écrits sur l'art* de Paul Valéry.[1]

Rien de pareil chez Mallarmé. S'il suivait avec assiduité salons et expositions, il n'a jamais songé à les décrire ou à les juger dans des articles ou des monographies, à l'exception de la préface qu'il fit pour l'exposition Berthe Morisot en 1896. Le seul autre article de quelque étendue qu'il ait publié sur la peinture parut en traduction dans une revue anglaise. Il faut chercher les remarques de Mallarmé sur la peinture dans de petites notules éparses (dont plusieurs furent publiées anonymement dans une autre revue anglaise), dans des articles qui passèrent inaperçus, ou dans sa correspondance avec les artistes de son temps. Recueillis, ces éléments ne feraient pas un livre. Ils suffisent largement, toutefois, pour révéler en Mallarmé un connaisseur très averti, respectueux, certes, des grands représentants d'une peinture plus traditionnelle, mais doué d'un coup d'œil très sûr pour discerner les véritables valeurs d'avenir. Novateur des plus hardis lui-même, il avait une sympathie divinatoire pour tout ce qui était d'avant-garde. Il avait au plus haut degré le sens de son époque. Par là, il reprend sur Baudelaire et sur Valéry un avantage certain. Car Baudelaire, malgré son goût de la modernité, et son exaltation de l''héroïsme de la vie moderne', a célébré surtout, comme le grand peintre de son époque, un artiste de la génération antérieure à la sienne, Delacroix, dont *La Barque de Dante* fut exposée au Salon de 1822, alors que Baudelaire avait un an à peine. Je ne reprendrai pas le reproche mal fondé, dirigé trop souvent contre Baudelaire, d'avoir méconnu Manet (Mallarmé le louera à juste titre de l'avoir défendu): encore moins, de ne pas avoir prévu l'imminent essor de l'Impressionnisme et l'aurore

[1] Publiés par le Club des Libraires de France en 1956 et en 1962 respectivement, textes de Baudelaire présentés et rassemblés par Bernard Gheerbrandt, textes de Paul Valéry réunis et présentés par Jean-Clarence Lambert.

d'une des plus riches époques de la peinture française.[2] Un accident historique a fait qu'il n'y avait pas une grande génération de peintres contemporains de Baudelaire (il est cependant significatif que Baudelaire éprouvera de la sympathie, malgré une opposition diamétrale de doctrine, pour Courbet, son aîné de deux ans seulement). Ses grandes admirations iront à deux artistes sensiblement plus âgés que lui: Delacroix, né en 1799, et Constantin Guys, né en 1805. De même pour Valéry, qui semble avoir hérité de Mallarmé ses grandes admirations artistiques: Manet (né en 1832), Degas (1834), Berthe Morisot (1841). Valéry fait preuve de beaucoup de réticence à l'égard de l'art contemporain, qu'il condamne en termes généraux, sans jamais parler en détail des artistes du vingtième siècle proprement dit.

Mallarmé, lui, vit d'emblée dans le plein courant de l'art de son temps.[3] Si Manet a neuf ans de plus que lui, et Degas et Whistler huit ans, cet intervalle n'empêche pas des rapports fraternels entre le poète et les peintres. Mais Sisley et Cézanne n'ont que deux ans de plus que lui; Monet, Odilon Redon et Rodin, un an seulement, comme d'ailleurs Émile Zola; Renoir et Berthe Morisot sont ses contemporains exacts. Avoir vingt ans à peu près au même moment crée un premier lien qui peut être plus fort que des querelles de doctrine ou des différences de métier ou de mode d'expression. Il peut être plus difficile de comprendre les générations plus jeunes. Mais Mallarmé avait l'esprit ouvert aux expériences nouvelles, et il a salué le génie de Van Gogh et travaillé activement en faveur de Gauguin. Il a déploré la mort de Seurat. Dans le milieu de *La Revue Blanche*, il a connu et estimé Toulouse-Lautrec et Vuillard. Il comptait Jacques-Émile Blanche parmi ses amis. Il a collaboré avec Raffaëlli, et célébré Puvis de Chavannes. Il était en relations amicales ou cordiales avec bien d'autres artistes de valeur inégale et de destin posthume varié, tels Mary Cassatt, Anquetin, Chéret, Besnard, Blache, Roll, John Lewis Brown.[4] Beaucoup de ces relations, attestées par des billets ou des lettres, relèvent du domaine anecdotique, échanges d'invitations, de vœux de nouvel an, démarches auprès des autorités pour l'achat par l'État de tableaux à titre honorifique ou parfois charitable. Leur nombre est cependant impressionnant, et met en lumière la place importante que Mallarmé tenait dans la vie artistique de son temps, ainsi que la place considérable que l'art et les artistes occupaient dans la vie du poète.

Les artistes recherchaient sa compagnie et sa conversation, car ils se sentaient compris. Qu'ils le fussent, c'est ce dont on se rend compte si l'on examine quelques-uns de ses

[2] L'article de Philippe Rebeyrol, publié dans *Les Temps Modernes* d'octobre 1949, a été réfuté plus d'une fois; voir par exemple Lois Boe Hyslop et Francis E. Hyslop, dans 'Baudelaire and Manet: a re-appraisal', dans *Baudelaire as a Love Poet and Other Essays*, éd. Louis B. Hyslop (Pennsylvania State University Press, 1969), pp. 87–130.

[3] Voir L. J. Austin, 'Mallarmé and the visual arts', dans *French Nineteenth Century Painting and Literature*, éd. Ulrich Finke (Manchester University Press, 1972), pp. 232–57, pour quelques aspects de la question (la

note 5, p. 254, donne quelques indications bibliographiques). Sur un plan anecdotique, voir Henri de Régnier, 'Les Portraits de Mallarmé', et 'Mallarmé et les peintres', dans *Nos rencontres* (Paris, Mercure de France, 1931), pp. 183–92 et 195–214.

[4] Pour tous ces détails, et bien d'autres, voir la *Correspondance* [*Corr.*] *de Mallarmé*, éd. H. Mondor et J.-P. Richard, t. I (1862–71), 1959, éd. H. Mondor et L. J. Austin (Paris, Gallimard), t. II (1871–85), 1965, t. III (1886–89), 1969, t. IV (1890–91) 1973, et les tomes V, VI, VII et VIII (en préparation).

propos, brefs ou étendus, qui ont été préservés. Il voit dans Van Gogh 'l'un des rares'.[5]
A l'exposition des toiles rapportées de Tahiti par Gauguin, Mallarmé affirme: 'Je n'ai
jamais vu tant de mystère dans autant de joie!'[6] Il avait, on le sait, favorisé le retour
de Gauguin à Tahiti au moment de la vente de février 1891, en obtenant de son ami
Octave Mirbeau des articles retentissants dans l'*Écho de Paris* et même dans le *Figaro*
philistin et réticent. En s'adressant à Mirbeau, Mallarmé avait insisté sur la volonté
de renouvellement chez Gauguin, mettant ainsi en lumière les mobiles profonds de
ce recours au primitivisme; Mirbeau reprendra d'ailleurs presque textuellement ces
paroles de Mallarmé:

Cet artiste rare, à qui, je crois, peu de tortures sont épargnées à Paris, éprouve le besoin de se
concentrer dans l'isolement et presque la sauvagerie. Il va partir pour Taïti, y construire sa
hutte et y vivre parmi ce qu'il a laissé de lui là-bas, y retravailler à neuf, se sentir.

Mallarmé demandait à Mirbeau 'un article, pas sur la vente, rien de commercial; mais
attirant simplement l'attention sur le cas étrange de ce transfuge de la civilisation; et
comme vous pourriez faire cela! au *Figaro*, quelque matin.. L'aventure est poignante.'[7]
Mallarmé ramassa sa pensée en des formules plus denses, dans le toast qu'il prononça
peu après au dîner d'adieu offert à Gauguin: 'Messieurs, pour aller au plus pressé,
buvons au retour de Paul Gauguin; mais non sans admirer cette conscience superbe qui,
en l'éclat de son talent, l'exile, pour se retremper, vers les lointains et vers soi-même.[8]
 Dans la correspondance assez étendue échangée entre Mallarmé et Monet, les lettres
de Monet qui ont été conservées sont plus nombreuses que celles de Mallarmé.[9] Mais
à plusieurs reprises Mallarmé donne, en des formules lapidaires, une appréciation aiguë
et pénétrante des œuvres de Monet qu'il venait de voir. Ainsi pour les *Dix Marines
d'Antibes* de 1888: 'Je sors ébloui ce votre travail de cet hiver; il y a longtemps que je
mets ce que vous faites au-dessus de tout, mais je vous crois dans votre plus belle heure.
Ah! oui, comme aimait à le répéter le pauvre Édouard, Monet a du génie.'[10] De même
pour les *Meules*: 'Vous m'avez ébloui récemment avec ces *Meules*, Monet, tant! que
je me surprends à regarder les champs à travers le souvenir de votre peinture; ou plutôt
ils s'imposent à moi tels.'[11] Enfin, Monet, n'ayant pu faire l'illustration du poème en
prose 'La Gloire' qu'il avait promise à Mallarmé pour *Pages*, offrit à Mallarmé une

[5] Lettre à Robert Picard, du 25 février 1890
(*Corr.* IV. 71–72).
 [6] C'est la version donnée par P. N. Roinard, dans
Belles-Lettres, septembre 1923, p. 61. Roinard écrit:
'... je veux ici répéter cette pure parole qu'il m'adres-
sait naguère, au cours d'une visite à l'exposition du
peintre Paul Gauguin, devant ses toiles rapportées de
Tahiti'. On cite d'autres versions de ce mot, mis en
épigraphe à l'édition de *Noa-Noa* publiée par Charles
Morice (l'épigraphe n'exista pas dans le manuscrit de
Gauguin): 'Il est extraordinaire qu'on puisse mettre
tant de mystère dans tant d'éclat'; 'Comment est-il
possible de mettre autant de mystère dans tant d'éclat?'

Quelle est la version authentique, et quand Mallarmé
a-t-il dit ce mot?
 [7] Lettre de Mallarmé à Mirbeau du 5 janvier 1891.
Citée partiellement par H. Mondor, *Vie de Mallarmé*
(Paris, Gallimard, 1941–2), pp. 589–90; le texte in-
tégral inédit dans *Corr.* IV. 176–7.
 [8] Cité dans le *Mercure de France* de mai 1891,
p. 318; voir aussi *Vie de Mallarmé*, p. 604.
 [9] Voir *Corr.* III.212, n. 1.
 [10] Voir ibid., et Gustave Geffroy, *Claude Monet*
(Paris, Crès, 1924), II.186.
 [11] Lettre du 9 juillet 1890, citée par Gustave
Geffroy, op. cit., et reprise dans *Corr.* IV. 119.

toile. C'est au cours d'une après-midi passée à Giverny, en compagnie de Berthe Morisot, que Mallarmé reçoit ce cadeau:

N'osant pas choisir sa toile préférée, [Mallarmé] y est poussé par Berthe Morisot: un paysage de la région de Giverny où l'on voit la fumée d'un train. Et Mallarmé revient radieux, le tableau sur ses genoux: 'Une chose dont je suis heureux, dit-il dans la carriole, c'est de vivre à la même époque que Monet'.[12]

Il remercia Monet huit jours plus tard:

On ne dérange pas un homme en train d'une joie pareille à celle que me cause la contemplation de votre tableau, cher Monet. Je me noie dans cet éblouissement, et estime ma santé spirituelle du fait que je le vois plus ou moins, selon mes heures. Je me suis peu couché la première nuit, le regardant; et, dans la voiture, Madame Manet était humiliée que je ne craignisse les incartades du cheval, parmi le bruit de la fête, qu'au point de vue de ma toile...[13]

Gustave Geffroy rapporte un mot significatif de Mallarmé sur ce tableau: 'Il y avait autrefois chez Stéphane Mallarmé une toile de Claude Monet, un paysage comme entrevu, et pourtant d'une précision délicieuse, un méandre de rivière, une arabesque d'eau à travers la campagne, que Mallarmé comparait au sourire de la *Joconde*.'[14]

Chose curieuse, il est très peu question de peinture dans la volumineuse correspondance échangée entre Whistler et Mallarmé, sauf sur un plan purement extérieur.[15] On y voit surtout Mallarmé épousant les querelles de l'irascible peintre ou favorisant ses ambitions. Il remercie cependant Whistler de l'envoi d'une lithographie, *The Dancing Girl*: 'Quelle merveille! et pourtant, je ne sais si ma joie d'y jeter les yeux, pendue au mur de la petite salle que vous connaissez, ne vient pas, autant de l'attention exquise, vraiment, que de la beauté de votre œuvre; laquelle ainsi porte à double titre la signature de Whistler.'[16] Il s'enthousiasme à propos d'une autre lithographie, reproduite dans *The Whirlwind*, où il publiera bientôt son 'Billet à Whistler': il s'agit cette fois du *Chapeau à ailes* (Pl. 65): 'La lithographie m'enchante, vous la traitez en maître absolu, du premier coup, comme l'eau-forte: et quel dessin, mon cher Whistler! mordant et élégant, de charme suprême. Merci.'[17] Sur son portrait par Whistler (encore une lithographie) (Pl. 66), qui figura en frontispice à son 'florilège' *Vers et prose*, il ne dira qu'une phrase, mais décisive: 'Ce portrait est une merveille, la seule chose qui ait été jamais faite d'après moi, et je m'y souris.'[18] Enfin, Whistler ayant fait un portrait de la fille du poète, portrait resté à Paris, Mallarmé lui écrit de Valvins: 'Geneviève a hâte de revoler du côté de son image; elle se sent très belle, et captive, autre part. Quelle munificence, Whistler, et aussi la bonne affection, d'avoir pris les devants, avec cette merveille,

[12] *Correspondance de Berthe Morisot* [*CBM*], documents réunis et présentés par Denis Rouart (Paris, Quatre chemins—Editart, 1950), p. 154.
[13] G. Geffroy, op. cit. II.187, lettre du 21 juillet 1891 (reprise dans *Corr*. IV. 123-4.).
[14] G. Geffroy, op. cit. II.95. Pour le sourire de la *Joconde*, et la place symbolique que lui assignait Mallarmé dans l'évolution de l'art, voir *Corr*. I.246.

[15] Voir *Correspondance Mallarmé-Whistler* [*CMW*], recueillie, classée et annotée par Carl Paul Barbier (Paris, Nizet, 1964). Les lettres sont reprises dans *Corr*., *passim*.
[16] *CMW*, p. 47; *Corr*. IV. 24(5/1/90).
[17] *CMW*, p. 74; *Corr*. IV. 157 (31/10/90).
[18] *CMW*, p. 188; à paraître dans *Corr*. V. (5/11/92).

sur un souhait secret!'[19] Peu de chose, en somme; mais le triple retour du mot 'merveille' résume l'attitude constante de Mallarmé envers le peintre. Et Mallarmé burinera lui-même une saisissante image de Whistler pour les *Portraits du prochain siècle*, soulignant le contraste entre l'homme et l'œuvre et définissant avec subtilité les rapports qui les unissaient: 'l'enchanteur d'une œuvre de mystère close comme la perfection' y est évoqué dans son aspect physique et moral, 'un Monsieur rare, prince en quelque chose, artiste décidément', avec sa 'stature, petite à qui la veut voir ainsi, hautaine, égalant la tête tourmentée', et sa 'furie de bravoure', l'homme paraissant comme le dragon tutélaire de l'œuvre qui 'joue au miracle et nie le signataire'. La phrase finale résume la pensée de Mallarmé en une synthèse analogique unissant l'aspect extérieur et la disposition morale de Whistler:

Cette discrétion affinée en douceur, aux loisirs, composant le maintien, pour peu, sans rien perdre de grâce, éclate en le vital sarcasme qu'aggrave l'habit noir ici au miroitement de linge comme siffle le rire et présente, à des contemporains devant l'exception d'art souveraine, ce que juste, de l'auteur, eux doivent connaître, le ténébreux d'autant qu'apparu gardien d'un génie, auprès comme Dragon, guerroyant, exultant, précieux, mondain.[20]

Les relations entre Berthe Morisot et Mallarmé appellent la même constation que celles qui existaient entre Mallarmé et Whistler. C'est de vive voix que Mallarmé parlait de leur art à ses amis peintres, qu'il voyait presque quotidiennement; et ici encore une correspondance[21] nourrie ne contient que peu d'allusions précises à la peinture de Berthe Morisot. Mais la préface que rédigea Mallarmé pour le catalogue de l'exposition rétrospective des œuvres de Berthe Morisot,[22] plus développée, certes, que le portrait en miniature de Whistler, mais brève et dense aussi, fait également la synthèse de la personne physique et morale de l'artiste et de son œuvre. Poème en prose qui défie toute analyse et tout commentaire, depuis l'évocation initiale de 'Tant de clairs tableaux irisés, ici, exacts, primesautiers', à travers celle de la 'figure de race, dans la vie et de personnelle élégance extrêmes' qui porta avec un 'charme extraordinaire' le nom de Berthe Morisot, 'cordiale et railleuse', intimidante au point de suggérer à Mallarmé le terme hardi d''amicale méduse', jusqu'à ces passages où l'impressionnisme littéraire s'égale à l'impressionnisme pictural:

Toujours, délicieusement, aux manifestations pourchassées de l'impressionnisme — la source, en peinture, vive — un panneau... limpide, frissonnant empaumait à des carnations, à des vergers, à des ciels, à toute la légèreté du métier avec une pointe du XVIII^e siècle exaltée de présent, la critique, attendrie pour quelque chose de moins péremptoire que l'entourage et d'élyséennement savoureux...

Mallarmé s'interrompt pour signaler l'erreur de cette interprétation, et propose une analogie subtile entre la vitre protectrice de la toile et l'art magistral du peintre, vitre

[19] *CMW*, p. 266 (25/10/97); voir p. 264, reproduction du portrait de Geneviève.

[20] Stéphane Mallarmé, *Œuvres complètes* [*OC*], éd. H. Mondor et G. Jean-Aubry (Paris, Gallimard (Bibliothèque de la Pléiade), 1951), pp. 531–2.

[21] Recueillie dans *CBM* (voir *supra*, n. 12).

[22] Voir *OC*, pp. 533–7, où se trouvent tous les passages de cette préface cités *infra*.

transparente cependant pour ceux qui savent comprendre cet art: 'Toute maîtrise jette un froid: ou la poudre fragile du coloris se défend par une vitre, divination pour certains.' Mallarmé, un des 'certains', suggère pour nous ce 'spectacle d'enchantement moderne', par une magie congénère:

Loin ou dès la croisée qui prépare à l'extérieur et maintient, dans une attente verte d'Hespérides aux simples oranges et parmi la brique rose d'Eldorados, tout à coup l'irruption à quelque carafe, éblouissamment du jour, tandis que multicolore il se propage en perses et en tapis réjouis, le génie, distillateur de la Crise, où cesse l'étincelle des chimères au mobilier, est, d'abord, d'un peintre. Poétiser, par art plastique, moyen de prestiges directs, semble, sans intervention, le fait de l'ambiance éveillant aux surfaces leur lumineux secret: ou la riche analyse, chastement pour la restaurer, de la vie, selon une alchimie, — mobilité et illusion. Nul éclairage, intrus, de rêves; mais supprimés, par contre, les aspects commun ou professionnel.

Les vrais orangers du verger évoquent les Hébrides, la vraie brique rose des maisons, l'Eldorado, la lumière réfractée par une carafe et répercutée par les couleurs prismatiques des tentures et des tapis, fait surgir des reflets chimériques sur les 'meubles luisants, polis par les ans': on croirait que c'est le décor lui-même qui crée ses effets magiques, alors que c'est l'alchimie de l'art, fondée sur l'analyse savante des vertus de la lumière pour restaurer, dans une nature morte, la mobilité et l'illusion de la vie. 'Nul éclairage, intrus, de rêves': on songe au 'Toast funèbre', où Mallarmé exaltait chez Gautier la même transfiguration du réel par la seule magie de l'art, sans recours au surnaturel métaphysique:

> C'est de nos vrais bosquets déjà tout le séjour,
> Où le poète pur a pour geste humble et large
> De l'interdire au rêve, ennemi de sa charge.

Après les décors et les natures mortes, Mallarmé évoque les personnages de Berthe Morisot, 'les chairs de préférence chez l'enfant', ou 'la créature de gala':

à miracle, elle, la restitue, par quelle clairvoyance, le satin se vivifiant à un contact de peau, l'orient des perles, à l'atmosphère: ou dévêt, en négligé idéal, la mondanité fermée au style, pour que jaillisse l'intention de la toilette dans un rapport avec les jardins et la plage, une serre, la galerie. Le tour classique renoué à ces fluidité, nitidité.

Et Mallarmé résume enfin l'essence de l'art de Berthe Morisot, avec une dernière évocation d'un de ses thèmes de prédilection:

Féerie, oui, quotidienne — sans distance, par l'inspiration, plus que le plein air enflant un glissement, le matin ou après-midi, de cygnes à nous; ni au-delà que ne s'acclimate, des ailes détournée et de tous paradis, l'enthousiaste innéité de la jeunesse dans une profondeur de journée.

Mallarmé peut alors conclure en situant fermement Berthe Morisot parmi les grands peintres originaux de son temps et en affirmant que 'son œuvre, achevé... se lie, exquisement, à l'histoire de la peinture, pendant une époque du siècle.'

Jusqu'ici, nous n'avons pas eu d'exemple de Mallarmé commentant dans le détail

un tableau spécifique. Odilon Redon lui inspire plusieurs descriptions ou évocations précises, et cela dans des lettres (il n'a pas consacré d'article ou d'étude à Redon, malgré la sympathie profonde et les étroites affinités qui existaient entre les deux hommes et leurs œuvres).[23] Ces descriptions, comme le dédicataire de ces pages l'a démontré dans une étude pénétrante et profonde,[24] tombaient parfois à côté des intentions de Redon, comme par exemple les commentaires que consacra Mallarmé à deux lithographies appartenant à la seconde suite inspirée à Redon par la *Tentation de saint Antoine* de Flaubert. Parfois aussi, Mallarmé se bornait à une évocation générale des œuvres de son ami qu'il venait de recevoir, comme pour l'album *Songes*. Mais qui lui en voudrait, quand il s'exprime ainsi?

Vous agitez dans nos silences le plumage du Rêve et de la Nuit. Tout dans cet album me fascine, et d'abord qu'il vous soit personnel, issu de vos seuls *Songes*: l'invention a des profondeurs, à l'égal de certains noirs, ô lithographe et démon; et, vous le savez, Redon, je jalouse vos légendes.[25]

Il y a toutefois une lettre, la première, où Mallarmé commente avec ampleur, sinon avec précision, chacune d'une suite de six lithographies, celles qui constituent l'album *Hommage à Goya*. Il se peut que, ici encore, l'imagination du poète l'entraîne loin des intentions de Redon et qu'il attribue à l'artiste ses propres hantises. Voici l'autre face de Mallarmé, la face tournée précisément vers le rêve. Plutôt qu'une page de critique d'art, il faut voir ici peut-être une suite de poèmes en prose sur des thèmes suggérés par l'artiste. Mallarmé ne suit pas l'ordre de Redon, mais celui d'une progression qui nous mène jusqu'au cœur de ses propres ambitions les plus secrètes: la recherche d'un 'mystère qu'il sait ne pas exister', mais qui, s'il existait, 'eût été la Vérité', recherche symbolisée par plusieurs personnages, surtout le 'grand Mage inconsolable' et 'l'étrange jongleur'. Et ici, c'est 'la déesse de l'Intelligible' qui est refusée, car elle 'nous sort à regret du cauchemar', ce rêve que Mallarmé, maintenant, accepte et exalte. On voit ici l'aspect nocturne et tragique de 'ce pays' lumineux qui, dans la 'Prose pour des Esseintes', 'n'exista pas', mais reste le seul pays habitable pour 'un homme au rêve habitué'. Que le lecteur juge lui-même, en comparant le texte de Mallarmé avec les lithographies de Redon (Pls. 67–72) et avec leurs légendes; les descriptions de Mellerio, dans leur sobriété, peuvent servir de point de comparaison ou de contrôle:

Comme vous me gâtez! et venez au-devant d'un de mes souhaits, qui était de regarder longuement une œuvre de vous. Voilà deux jours que je feuillette cette suite extraordinaire des six lithographies, sans épuiser l'impression d'aucune, tant va loin votre sincérité dans la vision, non moins que votre puissance à l'évoquer chez autrui. Une sympathie bien mystérieuse vous a fait portraiturer dans ce délicieux hermite fou le pauvre petit homme que du fond de mon

[23] Voir Roseline Bacou, *Odilon Redon* (Genève, Pierre Cailler, 1956), I.9, 88–97, et *Lettres... à Odilon Redon* [*LOR*], présentées par Arï Redon, textes et notes par Roseline Bacou (Paris, J. Corti, 1960), pp. 131–46. Voir aussi *Corr.* II.279, n. 1.

[24] Jean Seznec, 'Odilon Redon and literature', in *French Nineteenth Century Painting and Literature* (voir *supra*, n. 3), pp. 280–98.

[25] *LOR*, p. 141; *Corr.* IV. 326 (10/11/91). Les 'légendes' sont, naturellement, les titres brefs et suggestifs que Redon donnait à ses lithographies.

âme j'aimerais être; et je suspends ce dessin à part à quelque mur de ma mémoire, pour juger les autres d'une façon plus désintéressée. La tête de Rêve, cette fleur de marécage, illumine d'une clarté qu'elle connaît seul et qui ne sera pas dite, tout le tragique falot de l'existence ordinaire; et quelle synthèse cruellement abrégée, sans étiolement là, mais presque satisfaite de la face intérieure de beaucoup, dans la planche IV. L'étude de femme, que vous appelez si justement la déesse de l'Intelligible, nous sort à regret du cauchemar; mais mon admiration tout entière va droit au grand Mage inconsolable et obstiné chercheur d'un mystère qu'il sait ne pas exister, et qu'il poursuivra, à jamais pour cela, du deuil de son lucide désespoir, car *c'eût été* la Vérité! Je ne connais pas un dessin qui communique tant de peur intellectuelle et de sympathie affreuse, que ce grandiose visage. Mon autre préféré est, dans le même ordre de songes salomoniques, cet 'étrange jongleur' à l'esprit dévasté par la merveille au sens profond qu'il accomplit, et si souffrant dans le triomphe de son savant résultat.

J'adore aussi votre légende d'un mot ou deux, mais d'une justesse qui montre à quel point vous pénétrez avant dans l'arcane de votre sujet.[26]

Libre à nous de contester la fidélité de ces interprétations: Redon, lui, voyait dans Mallarmé 'un allié d'art d'une sûreté absolue';[27] il fut bouleversé par sa mort.

Mais l'artiste que Mallarmé a le plus abondamment commenté, et avec peut-être le plus de pertinence au point de vue de la critique d'art, c'est Manet. Il écrit un article vengeur sur 'Le Jury de Peinture pour 1874 et M. Manet',[28] lorsque ce jury refuse deux sur trois des tableaux envoyés par le peintre. Il consacre à Manet trois des notes les plus importantes qu'il envoie en 1875-6 à *l'Athenaeum* de Londres, pour être insérées sous la rubrique 'Fine Art Gossip'.[29] Il envoie à une autre revue anglaise, *The Art Monthly Review*, numéro du 30 septembre 1876, un article substantiel sur 'Les Impressionnistes et Edouard Manet'.[30] Il consacre enfin à Manet (comme à Whistler et à

[26] *LOR*, pp. 132-3; *Corr.* II.279-80. La suite des six lithographies de *l'Hommage à Goya*, album tiré à cinquante exemplaires, est reproduite et décrite par André Mellerio, *Odilon Redon* (Paris, Société pour l'étude de la gravure française, 1913), sous les nos 54 à 59 de son catalogue, p. 97 et planche XIII. Voici l'ordre du commentaire de Mallarmé:

1. Pl. III, intitulée par Redon UN FOU, DANS UN MORNE PAYSAGE et décrite ainsi par Mellerio: 'Dans un site désert, auprès d'un arbre fendu, se tient un homme chauve, à longue barbe, vêtu d'une robe, et croisant ses bras sur sa poitrine.'
2. Pl. II: LA FLEUR DU MARÉCAGE UNE TÊTE HUMAINE ET TRISTE ('Au milieu d'un paysage plein d'une immensité obscure, resplendit au bout d'une tige végétale une tête exsangue et glabre, aux yeux élargis, à l'air profondément navré').
3. Pl. IV: IL Y EUT AUSSI DES ÊTRES EMBRYONNAIRES ('A gauche s'élève une colonne massive. Puis dans l'air flotte, émergeant d'une coque, une tête à l'œil agrandi et bête. Plus bas une face petite et blanchâtre').
4. Pl. VI: AU RÉVEIL J'APERÇUS LA DÉESSE DE L'INTELLIGIBLE, AU PROFIL SÉVÈRE ET

DUR ('La physionomie est dure, le regard triste. Dans les cheveux quelques fleurs').
5. Pl. I: DANS MON RÊVE, JE VIS AU CIEL UN VISAGE DE MYSTÈRE ('Une figure allongée et triste, la main fermée contre les lèvres dans un geste de songerie. L'Horizon est traversé diagonalement par un rais de clarté et d'ombre').
6. Pl. V: UN ÉTRANGE JONGLEUR ('Une figure aux yeux démesurément dilatés. A droite une circonférence grise entourée d'un anneau plus sombre. Tout en haut, un astre opaque, cerclé de rayons clairs').

[27] *LOR*, p. 132.
[28] *OC*, pp. 695-700.
[29] Voir *Les 'Gossips' de Mallarmé. Athenaeum 1875-1876* [GM]. Textes inédites, présentés et annotés par H. Mondor et L. J. Austin (Paris, Gallimard, 1962), pp. 42-3, 49, 70-1, 72, 91, 101.
[30] Voir *OC*, pp. 1623-4, pour un admirable résumé en français; *La Nouvelle Nouvelle Revue Française*, 1er août 1959, pp. 375-84, traduction en français par Marilyn Barthelme (malheureusement tronquée, sans avertissement); *Documents Stéphane Mallarmé* [DSM], présentés par Carl Paul Barbier, Paris, I, 1968, pp. 66-86 (texte anglais complet), pp. 61-5 et 87-91 (commentaires).

Edgar Poe) un des *Portraits du prochain siècle* de 1894.[31] De tous ces écrits, l'article de 1876 est le plus riche et le plus significatif.

L'original français de cet article sur 'Les Impressionnistes et Edouard Manet' n'a pas été retrouvé; la traduction anglaise, malgré le jugement généreux de Mallarmé ('à part quelques contre-sens faciles à redresser — ceci bien entre nous! — son excellente traduction fait honneur à ma prose, et rend ce travail passable'),[32] nous laisse nécessairement insatisfaits, en ce qui concerne l'expression. Mais il semble que Mallarmé ait adopté un style relativement simple, comparé au style nettement expérimental qu'il avait employé quelques mois plus tôt, dans sa 'Préface à *Vathek*'.[33] Et le fond de l'article révèle un critique d'art fort avisé, admirablement au courant du mouvement artistique de son temps.

Mallarmé part de l'avènement du Réalisme de Courbet (qu'il place un peu tardivement vers 1860), pour aboutir au moment où il écrit, alors que l'Impressionnisme, qui avait reçu ce nom en 1874, se dégageait et s'imposait comme le mouvement dominant. Au seuil de son étude, il rend hommage à Baudelaire et à Zola, premiers défenseurs de Manet. L'article traite surtout de Manet tel qu'il était en 1876, peintre de la vie contemporaine et peintre du 'plein air'; mais Mallarmé rappelle ses débuts chez Couture, son recours à Velasquez et aux peintres flamands pour dégager sa 'première maniére'; il évoque *l'Olympia* et en souligne l'inspiration baudelairienne, ainsi que la recherche de la vérité dont témoignait ce nu non traditionnel, non conventionnel; il écarte le reproche superficiel alléguant que Manet peignait naguère la laideur et, maintenant, la vulgarité; il rappelle les grandes toiles jalonnant le développement de Manet jusqu'au *Linge*, qui venait d'être refusé au Salon de 1876, et qu'il décrit comme 'un répertoire complet et définitif de toutes les idées courantes et de leurs moyens d'exécution'. Il rapporte des propos d'atelier de Manet, propos d'un grand intérêt et qu'il reprendra vingt ans plus tard en évoquant Manet dans les *Portraits du prochain siècle*.[34] Mallarmé ne se borne pas à parler de Manet: il passe en revue les autres peintres impressionnistes, Monet, Sisley, Pissarro, Degas, Berthe Morisot, Renoir, en consacrant à l'art de chacun une vignette évocatrice.[35] Il cite Eva Gonzalès comme élève de Manet; nomme Whistler comme apparenté au groupe; et mentionne en passant Cézanne ('L'intrépide M. de Césane', nom saisi sans doute oralement) comme ayant poussé encore plus loin les tentatives et les efforts divers du groupe. Il salue au passage son ami Henri Régnault et ses 'effets décoratifs hardis';[36] il nomme Gustave Moreau et Puvis de Chavannes comme de grands talents dont l'art relève plutôt du passé; il cite Fantin-Latour et Chintreuil comme ayant été influencés par Manet sans appartenir à l'Impressionnisme. Il conclut en affirmant que l'Impressionnisme es le principal, le vrai mouvement de la

[31] Voir *OC*, pp. 532–3.
[32] *Corr.* II.129–30 et 129, n. 1.
[33] *OC*, pp. 549–68.
[34] Cf., par exemple, ce qui est dit dans l'article (*DSM*, I.68–9) sur les rapports entre la main et l'œil

du peintre, avec le raccourci saisissant, cité *OC*, p. 532: 'L'œil, une main...'.
[35] Voir *DSM*, I.79–82, et la traduction de Marilyn Barthelme.
[36] Sur Henri Régnault, mort pour la France à Buzenval en janvier 1871, voir *Corr.*, I.337–8.

peinture contemporaine; il rapproche ce mouvement de l'avènement de la démocratie, affirmant que 'la participation d'un peuple jusqu'ici ignoré à la vie politique de la France est un fait social qui honorera toute la fin du XIX^e siècle'; et il termine par une définition de l'Impressionnisme, qui vise, non pas à imiter la nature, mais à la 'recréer touche par touche'. Il fait parler le peintre impressionniste dans une magnifique prosopopée, dont voici la péroraison:

Je laisse la solidité massive et tangible à son moyen plus apte, la sculpture. Je me contente de refléter, sur le miroir clair et durable de la peinture, ce qui vit perpétuellement mais qui meurt à chaque instant, ce qui n'existe que par la volonté de l'Idée, mais qui constitue dans mon domaine le seul mérite authentique et certain de la nature — l'Aspect. C'est par la peinture que, brutalement jeté, à la fin d'une époque de rêves, devant la réalité, j'ai pris à celle-ci seulement ce qui est propre à mon art, une perception originale et exacte qui distingue pour elle-même les choses qu'elle voit avec le regard ferme d'une vision rendue à sa plus simple perfection.[37]

Baudelaire en 1846, Mallarmé en 1876, avaient chacun 25 ans. Ainsi à trente ans d'intervalle — l'espace d'une génération — l'auteur des 'Impressionnistes et Edouard Manet' prenait, dans le domaine de la critique d'art, comme par ailleurs dans le domaine de la poésie, la relève de l'auteur du *Salon de 1846*, de celui qu'il appelait 'notre dernier grand poëte: Charles Baudelaire'.[38]

[37] *DSM*, I.86 (traduction M. Barthelme, avec quelques retouches).
[38] *DSM*, I.67; *OC*, p. 1623. Soulignons la fidélité de Mallarmé à la mémoire de Baudelaire, et cet hommage renouvelé à sa grandeur.

XIV

PROUST ET LES PATINS DE GOETHE

Annie Barnes

NOUS sommes en février 1895. Proust a 23 ans. Il y a moins de deux mois que Reynaldo Hahn a présenté son nouvel ami chez les Daudet où le jeune Proust va être reçu fréquemment et où il va se lier avec les fils de l'écrivain, Léon et Lucien. En ce moment les deux frères sont sur le point de rentrer d'un voyage en Scandinavie, 'tous deux émerveillés de ces paysages hyperboréens' — notera Edmond de Goncourt dans son *Journal*, — et pour fêter ce retour Proust est invité à dîner. Le 22 février il écrit à Alphonse Daudet:

... Je me réjouis beaucoup de venir jeudi prochain et d'entendre les récits de vos fils. Je chercherai si je peux les retrouver une vieille photographie de Goethe patinant à Frankfort et aussi deux pages des *Confidences* de Lamartine pour illustrer les souvenirs de patinage de Monsieur Lucien. Mais probablement il a l'une et l'autre.[1]

Philip Kolb qui le premier a publié cette lettre en entier[2] cite en note les deux pages de Lamartine. C'est un passage admirable sur le patinage, 'cet exercice du Nord', auquel nous reviendrons. Quant à la 'vieille photographie de Goethe' (Pl. 73), elle reste sans note explicative. Nous voudrions proposer une solution, sans prétendre établir plus qu'une forte probabilité. Mais rappelons d'abord que la documentation visuelle a toujours beaucoup compté pour Proust. Vers la fin de cette même année 1895, ayant invité Lucien Daudet à venir le voir, il lui écrira: 'Venez, je vous ai préparé quelques photographies de gens célèbres, des actrices, des écrivains, des artistes, cela vous amusera peut-être...'[3] et une lettre de janvier 1908, qui demande à Auguste Marguiller, le secrétaire de la rédaction de la *Gazette des Beaux-Arts*, 'des gravures anglaises' sera, selon Philip Kolb, la première indication que Proust travaille à *Contre Sainte-Beuve*.[4]

Lucien Daudet, dans ses souvenirs, ne fait nulle mention de la vieille photographie de Goethe patinant à Francfort. Il s'agit vraisemblablement du *Goethe in Frankfurt* de Wilhelm von Kaulbach (1805–74) qui fait partie d'une série de dessins publiés à

[1] *Correspondance de Marcel Proust*, Vol. I (Plon, 1970), lettre 225.

[2] Lucien Daudet en a publié le second paragraphe dans l'introduction à *Autour de soixante lettres de Marcel Proust, Les Cahiers Marcel Proust*, 5 (Gallimard, 1929), p. 13.

[3] Ibid., p. 14.

[4] 'Le "Mystère" des gravures anglaises recherchées par Proust', *Mercure de France*, Vol. 327 (août 1956), p. 754: 'Il avait accumulé une collection de gravures et de reproductions de toutes sortes qu'il faisait apporter près de son lit lorsqu'il voulait les consulter...'

partir de 1862 sous le titre *Goethe-Gallerie*. La collection a joui d'une immense popularité en Allemagne dans le dernier tiers du dix-neuvième siècle, et l'éditeur munichois Fr. Bruckman en a varié le format et la qualité afin de l'adapter à toutes les bourses.[5] Les dessins de Kaulbach illustrent des scènes choisies dans les œuvres de Goethe, en faisant la plus belle part aux héroïnes des romans et des drames, — d'où le sous-titre *Goethes Frauengestalten*, — et chaque reproduction est accompagnée d'un commentaire d'une ou deux pages dont l'auteur est le romancier et critique bien connu à l'époque, et grand admirateur de Goethe, Friedrich Spielhagen (1829–1911). La première phrase de sa courte introduction nous rappelle qu'il écrit à l'époque de Bismarck: 'Wir Deutschen haben einem Ausländer den Ruhm, die beste Lebensbeschreibung Goethe's geschrieben zu haben, überlassen müssen'.

Cet éloge qu'arrache au patriote Spielhagen le célèbre *Life and Works of Goethe* (1855) fait vite place à la jubilation: Kaulbach, selon son commentateur, représente l'équivalent allemand de G. H. Lewes.[6] Les sentiments patriotiques de Spielhagen s'exprimeront aussi à plusieurs reprises dans ses commentaires.

La photographie qu'aurait possédée Proust en 1895 est l'avant-dernière de la collection. L'artiste s'est inspiré du récit à la fin du seizième livre de *Dichtung und Wahrheit*, et Spielhagen cite le passage au début de son commentaire:

Ein sehr harter Winter hatte den Main völlig mit Eis bedeckt und in einen festen Boden verwandelt. Der lebhafteste notwendige und lustig gesellige Verkehr regte sich auf dem Eise. Grenzenlose Schlittschuhbahnen, glattgefrorne, weite Flächen wimmelten von bewegter Versammlung. Ich fehlte nicht vom frühen Morgen an und was also, wie späterhin meine Mutter, dem Schauspiel zuzusehen, angefahren kam, als leicht gekleidet wirklich durchfroren. Sie saß im Wagen in ihrem roten Samtpelze, der, auf der Brust mit goldenen Schnüren und Quasten zusammengehalten, ganz stattlich aussah. ,,Geben Sie mir, liebe Mutter, Ihren Pelz!'' rief ich aus dem Stegreife, ohne mich weiter besonnen zu haben, ,,mich friert grimmig''.

Auch sie bedachte nichts weiter; im Augenblick hatte ich den Pelz an, der, purpurfarbig, bis an die Waden reichend, mit Zobel verbrämt, mit Gold geschmückt, zu der braunen Pelzmütze gar nicht übel kleidete. So fuhr ich sorglos auf und ab; auch war das Gedränge so groß, daß man die seltene Erscheinung nicht sonderlich bemerkte, obschon einigermaßen, denn man rechnete mir sie später unter meinen Anomalien im Ernst und Scherz wohl einmal wieder vor.

Un hiver rigoureux avait gelé le Mein et en avait fait un sol des plus fermes. Naturellement on se livrait sur la glace à l'animation la plus vive. Dès le matin je m'y rendais, et une fois que ma mère était venue dans la journée pour assister à ce spectacle, étant légèrement vêtu, je me trouvai transi de froid. Ma mère était dans sa voiture enveloppée d'une pelisse de velours rouge, qui, attachée sur son sein avec des glands dorés, avait quelque chose d'imposant. 'Donnez-la moi, chère Maman, votre pelisse, m'écriai-je sur-le-champ sans prendre le temps de réfléchir; j'ai horriblement froid.'' Elle-même ne réfléchit pas davantage. En un instant j'eus la pelisse couleur de pourpre, bordée de zibeline, ornée d'or, qui me descendait jusqu'à mi-jambe, et qui n'allait pas mal avec le bonnet brun en fourrure que je portais. Je continuai

[5] L'exemplaire que j'ai utilisé est sans date, format 22 × 29 cm.

[6] G. H. Lewes allait faire le commentaire à l'édition de Londres in-folio de 1867: *Female Characters of Goethe from the Original Drawings of William Kaulbach.*

à patiner avec insouciance, la foule était si grande, que cette étrangeté ne fit pas scandale;
mais quelques-uns la remarquèrent, car plus tard on la comprit au nombre de mes excentricités
sérieuses ou plaisantes.

 (*Goethe; ses mémoires et sa vie*, traduits et annotés par Henri Richelot (Paris, Hetzel,
 1863), II.11–12.)

C'est Bettina von Arnim qui avait rappelé au poète de soixante ans cet épisode de
sa jeunesse. Dans sa lettre du 28 novembre 1810 elle le lui avait relaté tel qu'elle l'avait
appris de la mère de Goethe. Spielhagen se rend compte que Kaulbach a trouvé dans
cette seconde source quelques détails pour son dessin, et il les cite dans la suite de son
commentaire:

Nach Bettina nämlich hatte Goethe selbst die Mutter an einem hellen, frostigen Wintermorgen
gebeten, auf das Eis zu kommen, „um ihn fahren zu sehen". Die Mutter kommt. Da schießt
nun ihr Sohn wie ein Pfeil durch die Gruppen. „Der Wind hatte seine Wangen gerötet und
den Puder aus seinem braunen Haar geblasen." Folgt die Mantelgeschichte. — „Und da fuhr
er dahin über das Eis wie ein Sohn der Götter. O Bettina, wenn du ihn hättest sehen können!
So was Schönes sieht man heutzutage nicht mehr!" — Und nun des Pudels Kern (ajoute
Spielhagen): „Deine Mutter war auf dem Eise, und das alles geschah, um ihr zu gefallen."[7]

Après ces deux citations, Spielhagen peut expliquer le dessin: la jeune femme à la boule
de neige est Maximiliane Brentano, la mère de Bettina; la sœur de Goethe est à droite de
Frau Rat etc., avec des commentaires qui révèlent l'humour prosaïque du commen-
tateur. Voici ce qu'il dit de la mère de Goethe:

Vielleicht kämpft in diesem Moment die Freude über die ambrosischen Locken mit der Sorge,
daß Apollo-Wolfgang sich einen göttlichen Schnupfen und einen unsterblichen Husten holen
wird, wenn er den Hut, den er in der linken unterschlagenen Hand trägt, nicht bald wieder
auf die olympische Stirn setzt.

En 1895 Proust avait probablement déjà lu *Dichtung und Wahrheit* en traduction
française, mais il est peu vraisemblable qu'il ait connu le commentaire de l'excellent
Spielhagen, car depuis 1870 la *Goethe-Gallerie* de Kaulbach existait aussi en français,
publiée sous le titre *Les Femmes de Goethe*.[8] La librairie Hachette n'avait pas seulement
évité de blesser le public français par une traduction de Spielhagen et de ses ferveurs
patriotiques; elle s'était assuré le succès en joignant aux gravures de Kaulbach les
commentaires, ou plutôt les 'esquisses de plume' comme il les décrit dans son introduc-
tion, du célèbre, du brillant Paul de Saint-Victor, le 'Prince du journalisme', et fervent
admirateur de Goethe par surcroît. La supériorité littéraire du texte français sur celui
de Spielhagen éclate presque partout, et certainement dans le commentaire de *Goethe à
Francfort*. Des deux relations de l'épisode, Saint-Victor ne cite que celle de Bettina,
mais il commence par un portrait bien venu du jeune Goethe à Francfort et cite Jacobi:

[7] Cf. Bettina von Arnim, *Goethes Briefwechsel mit einem Kinde, Werke und Briefe*, éd. Gustav Konrad (Köln, 1959), II.275.

[8] *Les Femmes de Goethe. Dessins de W. de Kaulbach avec un texte de Paul de Saint-Victor* (Paris, lib. Hachette, 1870), in-folio de 132 pages avec 21 planches. Je n'ai pu consulter que l'édition de Bruxelles 1872. Le commentaire au 20e dessin: *Goethe à Francfort. Vérité et Poésie* est aux pages 122–4.

'Il a vingt-cinq ans, il est tout génie.' Il consacre ensuite à cet amour du patinage chez Goethe tout un paragraphe de fort beau style, voyez plutôt:

Il jouissait avec ivresse de ce vol sans ailes, de cette course qui est une danse, de cette naviga-tion fantastique où l'homme, par le simple balancement du corps, par le seul gouvernail de sa volonté, s'imprime à lui-même toutes les évolutions de la barque filant et bondissant sur la mer.

Puis, s'inspirant sans doute du récit au quinzième livre de *Dichtung und Wahrheit* où Klopstock, en visite à Francfort, préfère parler patins plutôt que poésie avec ses jeunes admirateurs, Saint-Victor nous montre les jeunes gens, sur la glace, se récitant l'ode de Klopstock. Il fait une seule allusion à Kaulbach: la jeune femme à la boule de neige du tableau, c'est Maximiliane Brentano. Oubliant son chapeau à plumes et sa robe à volants, Saint-Victor la décrit 'comme une nymphe séduite par un dieu'. Pas trace de rhume divin ou de toux immortelle dans ce texte tout soulevé par l'enthousiasme, mais cette remarque suivie de la conclusion:

Seulement la glace qu'il fend de ses patins agiles nous avertit que nous ne sommes pas sur le bord de l'Ilyssus et de l'Eurotas, mais dans les brumes et sous le ciel froid du Nord. — N'est-ce pas là le symbole complet du génie de Goethe, hellénique et germanique à la fois? N'est-ce pas ainsi qu'on se le représente, les pieds sur la terre allemande qu'il a cultivée et régénérée, le front dans la lumière de la Grèce?

Que Proust en 1895 ait eu dans sa collection l'album de Kaulbach ne serait pas sur-prenant. A cette date, il est déjà familier de Goethe: il est cinq fois question d'Ecker-mann dans ses lettres de l'hiver 1893–4 à Montesquiou, et en se liant avec les Daudet, il vient de pénétrer dans un milieu de goethéens.[9] Et le commentateur l'aurait intéressé aussi bien que l'artiste. Saint-Victor était mort en 1881, mais sa gloire de critique lit-téraire et de critique d'art était encore bien vivante. Les années 1884 à 1889 — les années de Proust à Condorcet, — avaient vu paraître trois volumes dont le premier rassemblait les articles sur Victor Hugo. Quoi qu'il en soit, en 1917, Proust commencera une lettre à Walter Berry par un compliment suivi de la célèbre citation qui figure aussi dans la *Note des éditeurs* au volume Victor Hugo: 'Votre lettre est d'un merveilleux poète. Hugo disait à Saint-Victor:... on composerait un volume pour vous faire écrire une page...'[10] et il a tenu à faire une place à Saint-Victor dans la *Recherche du temps perdu* où le pastiche Goncourt du *Temps retrouvé* le mentionne parmi les critiques d'art desquels les habitués du salon de sa femme parlent à M. Verdurin sans se douter qu'il a été lui aussi un critique d'art distingué avant son mariage.[11]

La lettre du 22 février à Alphonse Daudet annonce également deux pages des *Confi-dences* 'pour illustrer les souvenirs de patinage de Monsieur Lucien'. Que Proust ait placé Lamartine très haut parmi ses poètes préférés ne fait aucun doute.[12] L'époque y

[9] Sur Proust et Goethe, voir mon article dans *Oxford German Studies*, No. 8, 1973–4.
[10] *Correspondance générale* (Plon, 1935), V.39.
[11] Éd. Pléiade, III.709.
[12] Ce n'est pas l'avis de René de Chantal, ni de cette note au *portrait d'Oranthe*, dans les *Plaisirs et les jours*, éd. de la Pléiade, p. 926 du volume *Jean Santeuil*: 'Proust, bien qu'il connût Lamartine (sa correspondance le prouve) ne semble pas l'avoir beaucoup apprécié.'

est peut-être pour quelque chose, — la carrière littéraire de Proust se situe presque entièrement entre deux dates qui ont été dûment commémorées en France: 1890, le centenaire de la naissance du poète, et 1920, le centenaire des *Méditations poétiques*. Mais les jugements littéraires de Proust n'ont jamais dépendu de l'opinion courante, et son amour de Lamartine remonte à l'année où l'écolier achète les *Œuvres* chez Calmann Lévy[13] et a duré toute sa vie. A ses débuts littéraires dans un de ces éloges superlatifs qui resteront sa spécialité, il nomme ensemble Baudelaire, Lamartine et Vigny pour faire d'Henri de Régnier 'le pair de ces grands poètes'.[14] De même, pour exprimer son admiration à la comtesse de Noailles en 1920, il comparera ses vers à ceux de Lamartine.[15] *Jean Santeuil*, au grand regret de sa mère, préférera Verlaine à Lamartine, mais cette préférence sera expliquée par l'immaturité du héros qui n'a alors que treize ans.[16] Le pastiche inédit de Sainte-Beuve sera tout à la gloire de Lamartine par le fait même qu'il est un petit chef d'œuvre de méchanceté à la Sainte-Beuve contre 'l'amant d'Elvire'.[17] Enfin, dans *Sodome et Gomorrhe*, le narrateur à Balbec racontera à sa mère comment Bloch se faisait un devoir religieux d'adopter une orthographe grecque et donnera comme exemple: '...il écrivait un vrai nektar, avec un k, ce qui lui permettait de ricaner au nom de Lamartine.'[18] Tous ces éloges ne sont pas moins clairs pour être indirects. Et Proust n'a pas seulement apprécié le poète. Dans la note aux *Journées de lecture* qui semble annoncer le célèbre article sur Flaubert en parlant déjà de l'imparfait, ce 'temps cruel', il n'en donnera qu'un exemple: une phrase de Lamartine.[19]

A vrai dire, cette fidélité ne devrait pas nous étonner. Entre Proust et Lamartine les affinités sont profondes. Proust devait aimer tout particulièrement ce livre des *Confidences*, où il trouvait partout le souvenir d'une mère adorée et l'amour de la nature, où se trouvent déjà des 'lectures au jardin' et surtout une conception du temps très proche de la sienne. Mais rappelons en plus que Lamartine, à la date de 1895, n'a pu qu'encourager chez Proust la lecture de Goethe. Le souvenir de *Wilhelm Meister* introduit *Graziella*, celui de *Werther* le second roman d'amour, *Raphael*, et à la fin de ces 'pages de la vingtième année', quand il retournera à Aix pensant y retrouver Julie, Raphael n'emportera qu'un livre, qui le fera prendre pour un étudiant suisse: *Werther* en allemand. Surtout, n'oublions pas que Lamartine, dans son *Cours familier de littérature*, a consacré deux *Entretiens* aux *Conversations de Goethe avec Eckermann*, et Proust connaissait bien Eckermann à cette date de la lettre à Alphonse Daudet.

Ces deux *Entretiens* du *Cours familier* ne contiennent guère autre chose que de longues citations empruntées à la traduction de Délerot qui venait alors de paraître (1863). Mais dans les deux tomes de la traduction française, le vieux poète a fait un choix selon ses préférences personnelles. A part les passages où Goethe parle d'écrivains français,

[13] Cf. George Painter, *Marcel Proust* (London, Chatto and Windus, 1959), I.46.

[14] *Tel qu'en songe* (volume *Contre Sainte-Beuve*, éd. Pléiade), p. 354.

[15] *Correspondance générale*, II.208.

[16] Éd. Pléiade, p. 217.

[17] Publié par Philip Kolb et Larkin P. Price dans *Textes retrouvés* (1968), pp. 44–5; cf. *C.S.B.*, éd. Pléiade, pp. 195–6.

[18] *R.T.P.*, éd. Pléiade, II.836.

[19] *C.S.B.*, éd. Pléiade, p. 170.

Lamartine cite presque uniquement ce qui a trait à l'histoire naturelle, conversations sur les oiseaux ou sur les arbres, l'épisode du tir à l'arc, enfin tout ce qui est en harmonie avec son propre amour de la nature, — et qui devait trouver un écho dans celui de Proust. Un exemple suffira. Lamartine cite tout ce qu'Eckermann a noté sous la date du 22 mars 1824 [20] et qui, — à vrai dire, exprime son propre amour de la nature autant que celui de Goethe, et il introduit ces pages de la manière suivante:

Une délicieuse et minutieuse description de la maison des champs de Goethe à la fin de l'hiver vient ensuite, cadre du portrait qui en relève l'originalité pensive. Lisez:

Ne citons que ce passage de la description d'Eckermann:

On se sent plongé dans la paix profonde d'une nature solitaire, car le silence absolu n'est interrompu que par les notes isolées des merles qui alternent avec le chant d'une grive des bois. Mais on est tiré de ce rêve de solitude par l'heure qui vient de sonner à la tour, ou par le cri des paons du parc, ou par les tambours et les clairons qui retentissent à la caserne.

Climat lamartinien, certes, mais aussi climat de *Combray*: ne se sent-on pas tout près des lectures au jardin, les dimanches après-midi, de ces pages auxquelles succède une note militaire avec le passage des cuirassiers? [21]

Il nous reste à montrer que Proust, en rapprochant deux pages des *Confidences* de sa vieille photographie de Goethe patinant à Francfort, a rapproché du même coup deux admirateurs de Goethe, Lamartine et Saint-Victor, qui sont loin d'être sans liens l'un avec l'autre. [22] Le père de Paul de Saint-Victor avait contribué à persuader le libraire Nicole d'imprimer à ses frais les *Méditations poétiques*. Vingt-huit ans plus tard, Lamartine devenu Ministre des Affaires étrangères, paie sa dette de reconnaissance en faisant du fils de son bienfaiteur un de ses secrétaires. Le passage au pouvoir de Lamartine est court, et le secrétaire de vingt-trois ans suit le poète dans sa retraite de Saint-Point, où il devient l'amant d'Alix de Pierreclos, une des nièces adorées de Lamartine et la veuve de son fils naturel. De retour à Paris, le jeune Saint-Victor, rongé d'ambition littéraire, s'exerce déjà à devenir le Prince du journalisme en envoyant à Alix de singulières lettres d'amour. Bernard d'Harcourt a relevé dans ces lettres à Alix nombre passages copiés dans le *Cahier vert*, le manuscrit de Maurice de Guérin que Saint-Victor n'a pu connaître que par Barbey d'Aurevilly qui le lui aura prêté sans se douter à quel usage il allait servir. Mais notons aussi que Saint-Victor envoie à sa maîtresse qui demande des livres pour dissiper l'ennui d'un hiver à Saint-Point, deux volumes de Heine, et les *Poésies* de Goethe. Deux mois plus tard il lui demandera: 'As-tu lu dans les *Poésies* de Goethe le *Nouveau Pausanias* [sic] ce voluptueux dialogue dont chaque strophe est une poignée de roses lancée à la figure de l'amant et de la maîtresse? N'est-ce pas là notre duo épistolaire?' [23]

[20] CXIXe Entretien, *Cours familier de littérature* t. XX (1865), pp. 321–9.

[21] *R.T.P.*, éd. Pléiade, I.83–8.

[22] Voir Alidor Delzant, *Paul de Saint-Victor* (Paris, Calmann-Lévy, 1886), et surtout Bernard d'Harcourt, *Lamartine, Barbey d'Aurevilly et Paul de Saint-Victor en 1848. Documents inédits* (Paris, Calmann-Lévy, 1948).

[23] Op. cit., p. 127. Il s'agit du dialogue de 1797: *Der neue Pausias und das Blumenmädchen*, Pausias étant le peintre amoureux de la bouquetière Glycère chez Pline.

Alix ne semble pas avoir beaucoup goûté ces témoignages de passion par intermédiaire. Le futur auteur des *Femmes de Goethe* et des *Deux masques* n'a guère connu que la passion littéraire, et chez lui les qualités du cœur ne valent pas les qualités de la plume. Désormais Saint-Victor poursuit sa carrière à Paris sans plus se soucier beaucoup de la nièce ni de l'oncle qui commence alors les longues années douloureuses de sa vieillesse. Arrivé au faîte de sa gloire, Saint-Victor est assidu aux dîners Magny et c'est là, le 1er mars 1869, que l'atteint le billet de Girardin annonçant la mort de Lamartine. L'article nécrologique qui paraît le lendemain dans la *Liberté* est éloquent et curieusement impersonnel.[24] La même année, les textes qui vont former les *Femmes de Goethe*, commencent à paraître dans le *Moniteur*.

Et maintenant, ayant longuement préparé notre petit coup de théâtre, citons les 'deux pages des *Confidences*' qu'annonce la lettre de Proust. Lamartine raconte comment à l'âge de dix ans, avec quelques camarades enfants de paysans aisés, il va chaque matin chez le vieux curé de Bussières y apprendre le latin:

Entre Bussières et Milly, il y a une colline rapide dont la pente, par un sentier de pierres roulées, se précipite sur la vallée du presbytère. Ce sentier, en hiver, était un lit épais de neige ou un glacis de verglas sur lequel nous nous laissions rouler ou glisser comme font les bergers des Alpes. En bas, les prés ou le ruisseau débordé étaient souvent des lacs de glace interrompus seulement par le tronc noir des saules. Nous avions trouvé le moyen d'avoir des patins, et, à force de chutes, nous avions appris à nous en servir. C'est là que je pris une véritable passion pour cet exercice du Nord, où je devins très habile plus tard. Se sentir emporté avec la rapidité de la flèche et avec les gracieuses ondulations de l'oiseau dans l'air, sur une surface plane, brillante, sonore et perfide, s'imprimer à soi-même, par un simple balancement du corps, et, pour ainsi dire, par le seul gouvernail de la volonté, toutes les courbes, toutes les inflexions de la barque sur la mer et de l'aigle planant dans le bleu du ciel, c'était pour moi et ce serait encore, si je ne respectais pas mes années, une telle ivresse des sens et un si voluptueux étourdissement de la pensée que je ne puis y songer sans émotion. Les chevaux même, que j'ai tant aimés, ne donnent pas au cavalier ce délire mélancolique que les grands lacs glacés donnent aux patineurs. Combien de fois n'ai-je pas fait des vœux pour que l'hiver, avec son brillant soleil froid, étincelant sur les glaces bleues des prairies sans bornes de la Saône, fût éternel comme nos plaisirs![25]

Nous ne lisons guère les *Confidences* aujourd'hui. Soyons reconnaissants à Proust d'avoir remis sous nos yeux cette page éblouissante comme la glace au soleil, et saluons en Lamartine un précurseur de la phrase proustienne aux quatre épithètes: '... une surface plane, brillante, sonore et perfide'. Quant à ces autres brillants passages, 'par un simple balancement du corps', 'par le seul gouvernail de la volonté', et la comparaison avec la barque sur la mer, nous les reconnaissons: ils se trouvent fidèlement reproduits dans le commentaire de *Goethe à Francfort*. Le Prince de la Critique, en 1870, agit comme agissait vingt ans plus tôt l'obscur amant d'Alix qui s'exerçait au style. En 1850, il dépouillait Maurice de Guérin, à présent il dépouille Lamartine. Mais devenu paon lui-même, qu'a-t-il besoin de se parer des plumes du paon?

[24] D'après les citations qu'en fait Bernard d'Harcourt, op. cit., pp. 244–6.

[25] Les *Confidences*, livre cinquième, V. Je cite l'édition de 1858, Paris, Michel Lévy, p. 94.

Sans essayer de répondre à cette question, revenons à Proust, cause et prétexte de nos digressions. Si Proust possédait la collection *Les Femmes de Goethe*, on aimerait bien savoir s'il a noté le plagiat de Saint-Victor. Selon Alidor Delzant[26] l'album in-folio de 1870, tiré à petit nombre, fut vite épuisé malgré son prix élevé. Proust n'aurait-il connu que la planche *Goethe à Francfort*, trouvée chez un bouquiniste? C'est possible, bien que la phrase à Alphonse Daudet: 'Mais probablement il a l'une et l'autre' semble vouloir dire que cet album bien connu doit se trouver chez des admirateurs de Goethe comme les Daudet. Qu'il s'agisse bien du dessin de Kaulbach n'est pas prouvé non plus. Nos preuves ne sont pas de la dernière certitude, comme dirait Pascal, et ressemblent plutôt à celles que Filleau de la Chaise voudrait attribuer à Pascal. Ajoutons cependant une dernière indication: Proust écrit Francfort avec un k selon l'édition de Philip Kolb. L'orthographe des noms propres chez lui est souvent défectueuse, il est vrai, mais ce k sous une plume française a tout de même de quoi surprendre, et pourrait s'expliquer par un effet de la mémoire visuelle, le titre sur la vieille photographie étant sans aucun doute en allemand: *Goethe in Frankfurt*.

Ce qui est certain, c'est que le motif du patinage a vécu dans l'imagination de Proust pendant bien des années. En 1899, il écrira deux notes, restées inédites jusqu'en 1954, — sur les *Perles rouges*,[27] le recueil de vers de Montesquiou qui venait de paraître. La seconde commence ainsi:

C'est un charme de plus quand les écrivains qui firent plus ou moins grande figure dans l'histoire des lettres, ont été, en plus, de séduisantes, amusantes ou poétiques silhouettes. Ceux-là, nous aimons les voir, et eux du reste ils aiment à se montrer dans leurs livres, Chateaubriand les cheveux au vent, Lamartine suivi de ses lévriers, ou patinant comme Goethe, ou sur un de ses chevaux 'qu'il a tant aimés'. Il serait long d'expliquer, mais il est aisé de sentir, pour ceux qui sentent, que M. de Montesquiou est de la même race.[28]

On s'étonne un peu de voir Proust écrire 'plus ou moins grande figure dans l'histoire des lettres' alors qu'il va nommer Chateaubriand, Lamartine et Goethe. Peut-être pensait-il à Montesquiou.' Ne le chicanons pas non plus d'exprimer ici des sentiments qui sembleraient, à un esprit superficiel, recommander cette méthode biographique si souvent condamnée par l'auteur de la *Recherche du temps perdu*. Ce texte n'est guère qu'un brouillon inachevé. Mais le souvenir de la page des *Confidences* est si vivant qu'il va jusqu'à la citation des 'chevaux même, que j'ai tant aimés...' Et quant à Goethe, il est le maître du patinage auquel on compare le patineur Lamartine. Le motif restera lié dans la mémoire de Proust à la figure de Lucien Daudet, et en 1916 encore, il lui écrira, pour marquer le contraste entre Lucien voyageur et lui-même, sédentaire: 'Je te voyais... partir en patins...'[29]

Arrivés à ce point de notre enquête sur Proust et les patins, interrogeons notre mémoire: l'auteur de la *Recherche du temps perdu* a-t-il utilisé ce motif dans son œuvre?

[26] Op. cit., p. 181.
[27] C'est le recueil qui contient une allusion aux *Affinités électives*; cf. 'Proust et Goethe' (voir *supra* n. 9).

[28] *C.S.B.*, éd. Pléiade, p. 411.
[29] Lucien Daudet, op. cit., p. 178.

La réponse semble devoir être négative. Proust, il est vrai, est le poète de toutes les saisons, et l'hiver, et le brouillard, la neige et le gel ont certainement été chez lui une source d'inspiration. On pense surtout à la description de Paris nocturne pendant la guerre, au *Temps retrouvé*, où la neige au clair de lune est comparée à une prairie paradisiaque, tissue avec des pétales de poiriers en fleurs.[30] On se souvient aussi, vers la fin du *Côté de chez Swann*, des Champs Élysées sous la neige, où le narrateur attend anxieusement Gilberte en allant regarder la Seine prise, où Gilberte arrive en se laissant glisser sur la glace, affectant le maintien d'une patineuse, les bras grands ouverts.[31] Mais la lettre à Alphonse Daudet nous aura surtout invités à lire ou à relire des textes dont nous pourrions faire une anthologie du patinage. En plus de Goethe, de Lamartine et de Saint-Victor, nous aimerions y voir Wordsworth.[32]

Cependant Goethe restera sans aucun doute le poète par excellence du patinage. L'épisode de *Dichtung und Wahrheit* qu'a illustré Kaulbach n'en est pas le seul exemple dans son œuvre. Au livre précédent, au quinzième, le récit de la visite de Klopstock à Francfort contient le passage où Klopstock disserte sur l'étymologie de *Schrittschuh*, et sur le 'noble art de patiner, à l'aide duquel on traverse les mers consolidées sur des semelles ailées comme celles des dieux d'Homère',[33] passage qui a bien pu inspirer Saint-Victor. Mais ces deux récits de ses *Mémoires* n'ont pas suffi au poète. Son imagination amoureuse de l'exercice du Nord' a créé un épisode qui devrait s'appeler l'apothéose du patinage. Il se trouve dans la nouvelle *Der Mann von fünfzig Jahren* que Goethe a conçue à peu près à la même époque, et qu'il a ensuite placée dans *Wilhelm Meisters Wanderjahre*. C'est en parlant de *Wilhelm Meister* que l'impertinent Saint-Victor, — dans le commentaire à la *Mignon* de Kaulbach, — avait écrit que 'Goethe est le Jupiter pluvieux de l'ennui.'[34] Il ne croyait pas si bien dire, à condition de remplacer ennui par poésie.

Nous sommes au château où le beau Flavio et sa cousine, la belle Hilarie qui doit épouser le père de Flavio, sentent grandir en eux une passion irrésistible et non avouée. Pour atteindre à ses fins, notre Jupiter de la poésie crée d'abord des pluies torrentielles qui causent de vastes inondations. A leurs risques et périls les jeunes gens vont en barque distribuer le nécessaire aux chaumières isolées par l'inondation. Survient le gel: l'élément dangereux est transformé comme par magie en une belle surface plane, symbole de l'unité. Le monde entier patine. Les activités charitables de la journée terminées, les deux jeunes gens patinent au clair de lune sous le ciel étoilé. Lamartine n'a probablement pas connu cette scène féérique, mais Proust, — ses pages *Sur Goethe* nous permettent de le penser,[35] — l'a lue dans la traduction de Th. Gautier fils:

... denn das hat die Eislust vor allen andern körperlichen Bewegungen voraus, daß die Anstrengung nicht erhitzt und die Dauer nicht ermüdet. Sämtliche Glieder scheinen gelenker zu werden,

[30] III.736. [31] I.398.

[32] *The Prelude* (1805), I.v.425–73.

[33] Je cite la traduction de la baronne de Carlowitz (1872), moins fidèle et plus élégante que celle de

Richelot, p. 340.

[34] Mignon, cela va de soi, n'est pas visée. Cf. 'Proust et Goethe' (voir *supra*, n. 9).

[35] Cf. 'Proust et Goethe'.

und jedes Verwenden der Kraft neue Kräfte zu erzeugen, so daß zuletzt eine selig bewegte Ruhe über uns kommt, in der wir uns zu wiegen immerfort gelockt sind.

Heute nun konnte sich unser junges Paar von dem glatten Boden nicht loslösen, jeder Lauf gegen das erleuchtete Schloß, wo sich schon viele Gesellschaft versammelte, ward plötzlich umgewendet und eine Rückkehr ins Weite beliebt; man mochte sich nicht voneinander entfernen, aus Furcht, sich zu verlieren, man faßte sich bei der Hand, um der Gegenwart ganz gewiß zu sein. Am allersüßesten aber schien die Bewegung, wenn über den Schultern die Arme verschränkt ruhten und die zierlichen Finger unbewußt in beiderseitigen Locken spielten.

Der volle Mond stieg zu dem glühenden Sternenhimmel herauf und vollendete das Magische der Umgebung. Sie sahen sich wieder deutlich und suchten wechselseitig in den beschatteten Augen Erwiderung wie sonst, aber es schien anders zu sein. Aus ihren Abgründen schien ein Licht hervorzublicken und anzudeuten, was der Mund weislich verschwieg, sie fühlten sich beide in einem festlich behaglichem Zustande.

Alle hochstämmigen Weiden und Erlen an den Gräben, alles niedrige Gebüsch auf Höhen und Hügeln war deutlich geworden; die Sterne flammten, die Kälte war gewachsen, sie fühlten nichts davon und fuhren dem lang daherglitzernden Widerschein des Mondes, unmittelbar dem himmlischen Gestirn selbst entgegen...[36]

... car les courses sur la glace ont cet avantage sur les autres exercices du corps que les efforts n'échauffent pas, et qu'on peut les prolonger sans se fatiguer. Les membres s'assouplissent, l'emploi de la force donne de nouvelles forces, si bien que nous finissons par goûter un calme agité, dans lequel nous sommes tentés de nous bercer sans cesse.

Un soir, notre jeune couple ne pouvait se décider à abandonner la surface glacée; ils arrivaient jusqu'au pied du château brillamment éclairé, où se pressait déjà une nombreuse société, puis ils s'élançaient de nouveau vers la plaine unie; ils ne pouvaient se séparer de crainte de se perdre, ils se tenaient par la main pour être bien sûrs de la présence l'un de l'autre. Quel délicieux mouvement, lorsque les bras entrelacés se reposaient sur les épaules, et que les doigts délicats se jouaient involontairement dans les boucles de cheveux!

La pleine lune monta dans le ciel étincelant, et vint compléter le magique tableau. Ils pouvaient se voir maintenant; ils cherchèrent dans leurs yeux voilés la réponse habituelle, mais elle semblait ne plus être la même. Une étincelle parut briller au fond de leur être, et exprimer ce que leur bouche ne voulait pas dire; ils se sentaient dans une solennelle béatitude.

On distinguait nettement les aulnes et les saules le long des fossés, les étoiles flamboyaient, le froid était devenu plus vif; ils ne le sentaient pas et continuaient à glisser sur le reflet de la lune, comme s'ils allaient au devant de l'astre lui-même.

Éternelle jeunesse du poète! Quand ont paru *Wilhelm Meisters Wanderjahre*, Goethe avait quatre-vingts ans.

[36] *Wilhelm Meisters Wanderjahre*, II.5.

A PERSONAL POSTSCRIPT

Jean Adhémar

UN JOUR il y a vingt-cinq ans, Jean Seznec entendait un grand cri, suivi d'un craquement. Il avait eu l'imprudence de me loger chez lui à Boston, où il m'avait fait venir pour donner des conférences, et je tombais de mon lit que je défonçais parce qu'après de longs entretiens avec Seznec je venais de comprendre l'intérêt des études comparatives littérature-art, et le service que je pouvais lui rendre en mettant à sa disposition les millions d'images du Cabinet des Estampes, et en lui indiquant celles qui pouvaient l'intéresser. Curieux chemin de Damas.

C'est ainsi qu'est né notamment son fameux *Madame Bovary et les images*, dans lequel il a démontré le pouvoir nocif de l'image sur l'esprit de la pauvre Emma, et dans lequel il a reproduit une image impossible à trouver, car elle n'est pas signée, où on voit des hommes en costume de moine boire du champagne en compagnie de jeunes femmes: c'est tout simplement une des estampes que Flaubert accroche dans la chambre où Léon reçoit Emma ('les grosses couleurs de quatre estampes représentant quatre scènes de *la Tour de Nesle*, avec une légende, au bas, en espagnol et en français'). Or, jusque–là, des flaubertistes trop pressés avaient prétendu que Léon possédait *la Tour de Nesle*, fameuse estampe de Callot, d'intérêt topographique (paysage parisien).

Seznec a continué ses découvertes. Une de nos vieilles amies nous avait parlé de la question, Mlle Mespoulet, dont le livre: *Images et romans*, paru à la veille de la guerre, n'avait guère eu que nous pour admirateurs.

En souvenir de ces jours héroïques, je voudrais publier ici quelques estampes dont la fortune littéraire a été assez grande au dix-neuvième siècle. On sera probablement surpris de leur manque de qualité, car aucune n'a de valeur artistique, aucune n'est reproduite ni citée dans les histoires de la gravure, mais elles ont eu sur la sensibilité non seulement des bourgeois, mais des littérateurs une influence déterminante. Il n'est pas absolument nécessaire de voir une œuvre d'art; il est curieux de constater que Dürer et Rembrandt n'ont inspiré que Victor Hugo, pour qui Grandville comptait probablement davantage. Un passage de Flaubert est bien la preuve de ce que nous avançons: Léon pour évoquer Emma recourait à une image niaise vue dans une vitrine de marchand: 'Il y a sur le boulevard, chez un marchand d'estampes, une gravure italienne qui représente une Muse. Elle est drapée d'une tunique, et elle regarde la lune

avec des myosotis sur sa chevelure dénouée. Quelque chose incessamment me poussait là; j'y suis resté des heures entières', et sans doute Flaubert a précédé Léon dans ces stations ferventes.

Envisageons donc une image qui représente un chien aboyant à la mort devant un chapeau de marin. Rien de plus ridicule dans l'expression. L'estampe est banale. Elle a été gravée d'après un tableau du paysagiste Demarne, qui a été exposé au Salon de 1799 (n° 72), sous le titre de: *Marine où l'on voit un chien qui pleure son maître*. Le caractère *sensible* du sujet a retenu les critiques d'alors: l'idée est 'ingénieuse', c'est 'une véritable romance' (*Mercure de France*, p. 232); ce chien qui hurle sur le rivage pauvre animal, te voilà seul maintenant' (ibid., p. 268). Le *Journal du mois* (p. 502) assure que 'notre sensibilité prouve celle du peintre; on se sent ému malgré soi'. Arnault (*Souvenirs d'un sexagénaire*, IV.305–7) a ressenti un tel 'désespoir' devant le tableau que Lenoir, Regnault et d'autres amis ont essayé de le lui offrir. Le sujet est préromantique. A l'époque romantique, on le verra traité sur des paravents, des devants de cheminée, brodé en tapisserie sur des coussins; un collectionneur s'était amusé à en réunir d'innombrables exemples. Et le sujet est entré dans la littérature; considéré comme le symbole du goût bourgeois, il est ridiculisé dans *Le Gendre de Monsieur Poirier* (1854), ce sujet 'ingénieux, simple et touchant' est préféré par Poirier au paysage impressionniste que veut acheter son gendre, le Marquis de Presles.

Une autre image a connu un retentissement littéraire encore plus considérable: une gravure de Paolo Mercuri (1804–84) datant de 1831, et représentant le tableau de Léopold Robert: *Les Moissonneurs dans les Marais Pontins*. Beraldi, qui signale que sa popularité a été immédiate et considérable, en connaît six états, si bien qu'on peut penser qu'elle a été tirée à plusieurs milliers d'exemplaires; Lamartine dit même qu'on en a vendu 'des millions'. Le tableau avait fait sensation; Decamps avait passé huit jours au lit après l'avoir vu, et avait déclaré qu'il ne voulait plus se servir de ses pinceaux; 'je vais renoncer à la peinture', disait-il. (Voir d'autres témoignages dans Grate, *Deux critiques d'art*, pp. 78–80.) Mais la gravure avait rendu l'œuvre encore plus attrayante, elle avait, selon un critique de 1884 (*Monde illustré*, 7 juin 1884), 'exagéré la valeur du tableau. C'est, grâce à elle, un enfant changé en nourrice', et on avait surtout admiré la figure de femme qui domine la composition: 'C'est un vrai type de Raphaël, charme et grandeur' (Lenormant, *Salon de 1831*, p. 102).

Alexandre Dumas la cite dans *Monte–Cristo*, et la jeune italienne que voit Albert de Morcerf au Carnaval à Rome lui ressemble. L'italienne de Robert-Mercuri devient même l'héroïne d'un roman de Balzac, *Pierrette* (1840). Pierrette avait 'cette grâce virginale que Léopold Robert a su trouver pour la figure *raphaélique* qui tient un enfant dans le tableau des *Moissonneurs romains*'.

Balzac connaissait donc l'œuvre; mais connaissait-il la peinture ou la gravure? La question est intéressante, car elle pourrait permettre de savoir si Balzac allait au Salon. En fait, Balzac, le 30 octobre 1834, avait reçu de l'éditeur de livres et d'estampes Ricourt,

un échange du *Colonel Chabert*, une collection du journal *l'Artiste*, et 'une gravure avant la lettre du tableau des *Moissonneurs* par Mercien' (Mercien est une mauvaise lecture pour Mercuri; cf. le texte dans *Les Comptes dramatiques de Balzac*, p. 184).[1]

D'autres images ont-elles eu un tel succès au dix-neuvième siècle? Oui, quelques autres, et de valeur très inégale.

Les premières sont la *Didon* du baron Guérin (1813) et sa *Phèdre* (1802). De la *Phèdre*, David fit les plus grands éloges en 1810, disant qu'elle faisait honneur à l'école de Regnault, à quoi Guérin répondit que 'quiconque tient un crayon ou un pinceau vous reconnaît pour son maître'. Cette *Phèdre* séduisit Stendhal, et on la retrouve dans *Lucien Leuwen*: 'Mme Grandet... resta immobile près d'une heure sur son fauteuil. Son air était pensif, elle avait les yeux tout-à-fait ouverts comme la *Phèdre* de M. Guérin'.

Une source encore plus intéressante pour l'esthétique balzacienne est la *Didon* de Guérin (*Énée racontant à Didon les malheurs de la ville de Troie*, 1813; Salon de 1817). Le tableau fut un moment célèbre; Miel, dans son *Salon de 1817*, lui consacre neuf pages de son compte rendu. Il est gravé. Son succès est durable; au Salon de 1834 est exposé un tableau de porcelaine d'après lui, et Berlioz, surtout, emprunta l'idée de la scène pour *les Troyens* (1857). Or Baudelaire disait en 1855 que 'cette Didon, avec son œil humide, noyé dans les vapeurs du *Keepsake*, annonce presque certaines parisiennes de Balzac'. Il ne s'y trompait pas; Balzac cite à plusieurs reprises Guérin, et donne à ses héroïnes la pose des modèles du peintre. Dans *Les Secrets de la Princesse de Cadignan*, par exemple, l'héroïne a 'l'attitude pleine de nonchalance et d'abandon que Guérin a donné à Didon'; dans *la Bourse*, dans *Beatrix*, dans le *Cousin Pons* on retrouve Guérin.

Autre cas curieux: *La Madone sixtine* de Raphaël, dite *la Madone de Dresde*, parce que conservée au Musée de Dresde. Cette Madone est le sujet véritable de *César Birotteau* pour les historiens de l'image, puisque Birotteau en offre une gravure, celle que tout le monde avait alors, celle de Muller,[2] au chimiste Vauquelin, lequel l'accepte de façon si touchante que Popinot et Birotteau s'essuient les yeux. Tout le monde en avait alors une épreuve (Musset, par exemple, en 1834, Vigny peut-être, Balzac aussi[3] — il

[1] Cf. aussi lettre à Mme Hanska du 16 jan. 1846 montrant que cette gravure a contribué à la décoration du musée constitué dans la maison de la rue Fortunée.

[2] Entreprise par Christien-Frédéric Muller en 1814, inachevée à sa mort (1816), terminée par Bervic et Boucher-Desnoyers, et parue en 1820. Muller y avait travaillé avec une ardeur qui allait lui coûter la vie.

Les premières épreuves se vendaient plus de 600 frs. On en connaît trois tirages.

[3] Balzac, dans les *Petits Bourgeois*, fait allusion au fait que 'beaucoup de paysannes tiennent leurs enfants comme la fameuse *Madone de Dresde* tenait le sien': on cite 14 allusions aux *Madones* de Raphaël dans son œuvre. Mais, lorsqu'il voit le tableau en 1843, il écrit de Dresde à Mme Hanska le refrain de la vieille chanson: 'J'aime mieux ma mie, oh gué'.

la conserve rue Fortunée, parmi les chefs-d'œuvre qu'il a réunis), mais tous ne la voyaient pas de la même façon. Les Romantiques allemands, Novalis, les frères Schlegel en font grand cas. Dostoiewsky l'admirait lui aussi. Dans *l'Adolescent* (p. 95), il raconte que dans le salon de ses parents 'il y avait une admirable gravure de la *Madone de Dresde*'. Cette image le frappa tant qu'il la conserva au-dessus de son sopha: 'vers elle va mon premier regard'. Plus tard, en 1867, il vit l'original à Dresde, mais il ne semble pas avoir ressenti le même choc (*Dostoiewski par sa femme*, Gallimard, 1930, p. 269), et s'il passe alors une heure par jour au musée, il y admirait aussi Titien et Carrache et il rêvait devant Acis et Galathée du Lorrain. Tourgéniev compare encore un des personnages de son *Virgin Soil* à la *Madone Sixtine* (nous devons le renseignement au professeur Robert L. Herbert).

Le retentissement de la *Vierge de Dresde* est-il alors terminé. Sans doute pas, car, dans *Le Collaborateur*, Aragon veut nous montrer un petit enfant, Jacquot, il nous dit qu'il 'ressemblait aux petits anges des images, vous savez, ceux qui sont si drôlement accoudés'.

Tolstoï aussi, en avait une épreuve dans son Cabinet de travail, ce Cabinet dont il existe de nombreuses photographies à des dates successives. Il l'avait achetée après son mariage, parce qu'il trouvait qu'elle ressemblait à sa femme, et que les enfants accoudés au bas lui faisaient penser aux siens. Lorsqu'à l'amour succède l'agacement, on voit sur les photographies les rangées de livres monter devant la gravure, et commencer à la cacher; ce n'est sans doute pas par hasard.

Les images sont donc intimement liées à la vie de ceux qui écrivent; elles les inspirent, et cela parfois à leur insu. C'est ainsi qu'on se rappelle le fameux passage où dans le *Chantecler* de Rostand (1910) le coq, trouvant le soleil levé, se désole, constatant qu'il ne l'a pas fait lever lui-même. Après la première de la pièce, le *Rire* (22 janvier 1910) tint à signaler une idée analogue, trouvée dans un dessin de Roubille paru dans ce journal le 30 avril 1898, avec pour légende: 'Si je ne chantais pas le matin, savoir si le soleil se lèverait'.

* * *

Un autre sujet nous intéresse beaucoup, Seznec et moi, celui de la transposition par les littérateurs qui sont eux-mêmes peintres, ou qui sont ce qu'on appelle des *aime-peinture*, comme Théophile Gautier par exemple, de la langue de la peinture dans celle de la littérature. Rappelons-nous qu'on disait de Loti: 'Il a écrit ses aquarelles.' Zola, lisant *Germinie Lacerteux* (*roman expérimental*) est frappé par la 'langue nouvelle' des Goncourt, donnant aux objets le frisson nerveux de notre âge, allant plus loin que la phrase écrite, et ajoutant aux mots du dictionnaire' 'une couleur, un son, un parfum'.

C'est dans un esprit analogue que le *Paris illustré*, cette belle revue si curieuse de la fin du dix-neuvième siécle, publia en 1889 des *paysages littéraires*, c'est-à-dire des images évoquant le sujet et le style des littérateurs de l'époque, de Hugo à Zola, Theuriet, Loti, et Barbey.

A quoi bon continuer ? j'ai encore de nombreuses histoires de ce genre dans un classeur noir, et Seznec, avec la belle langue qu'il sait si bien employer, serait, lui aussi, capable d'en raconter.

Que celles-ci soient le témoignage et le souvenir de notre amitié. Nous en reparlerons à Vallery et à Montlaur, nous aurons notre retraite pour cela.

INDEX OF NAMES AND PLACES

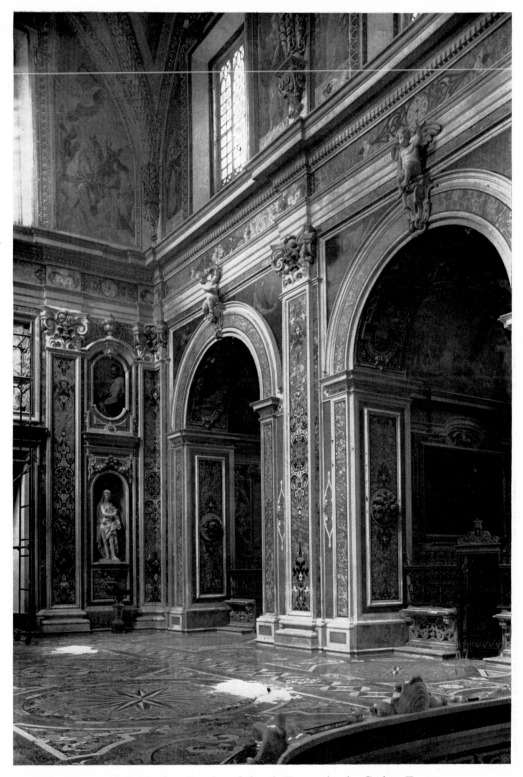

1. Naples. Certosa di S. Martino. Interior of church. Decoration by Cosimo Fanzago

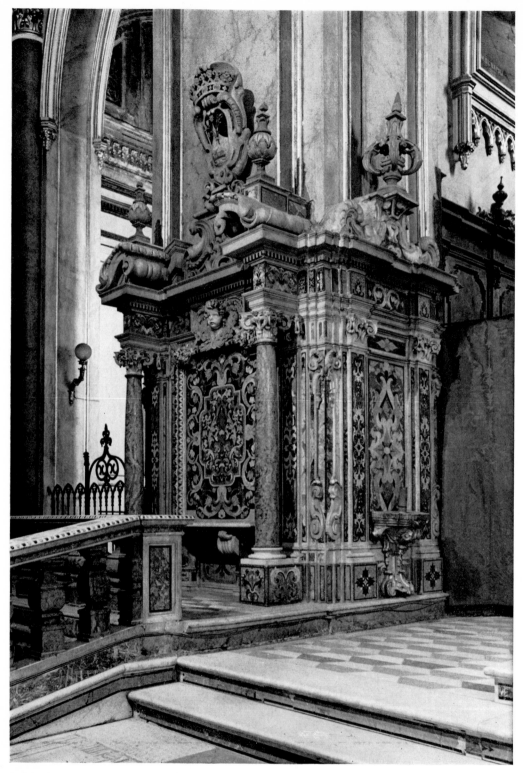

2. Naples. S. Domenico Maggiore. Detail of High Altar by Cosimo Fanzago

3. Naples. Guglia di S. Gennaro by Cosimo Fanzago

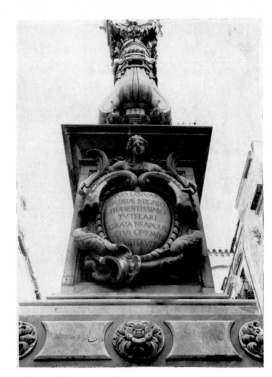

4. Naples. Palazzo di Donn'Anna. Engraving after Hubert Robert, from Saint-Non, *Voyage pittoresque ou description des royaumes de Naples et de Sicile* (Paris, 1781–5)

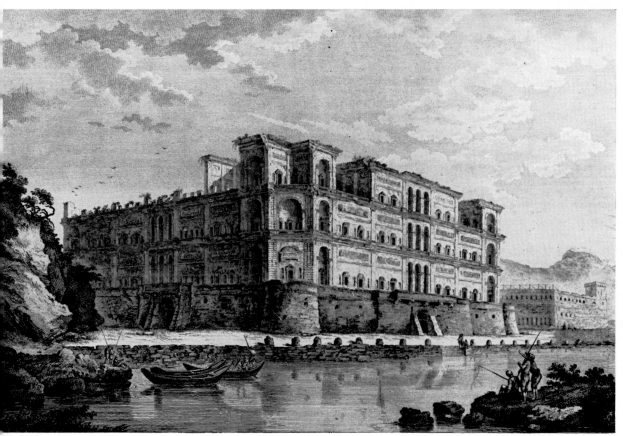

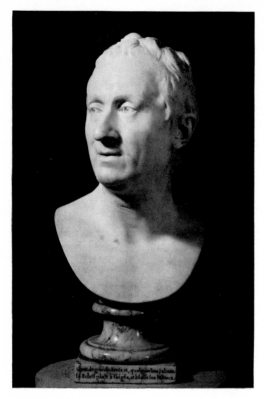

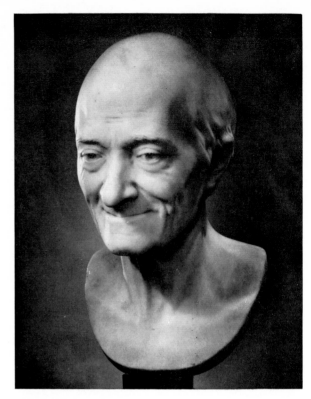

5. Diderot by Houdon 6. Voltaire by Houdon, 1778

7. J.-J. Rousseau and Voltaire (1769–80), signed 'Wedgwood & Bentley'

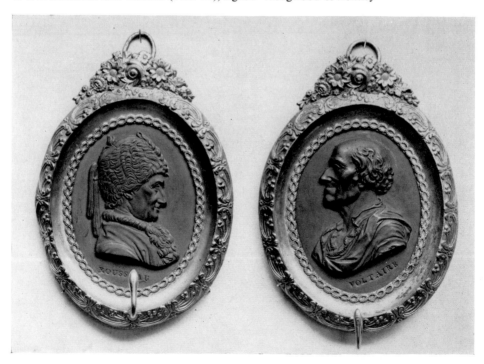

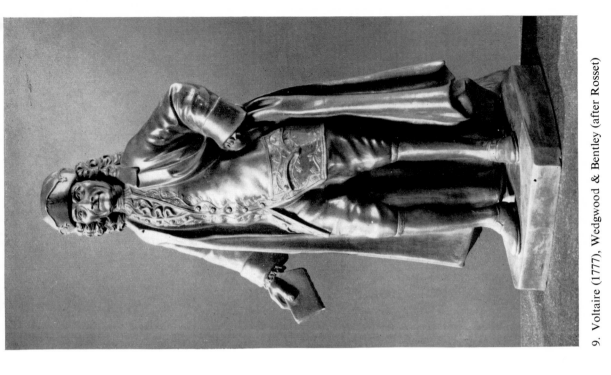

9. Voltaire (1777), Wedgwood & Bentley (after Rosset)

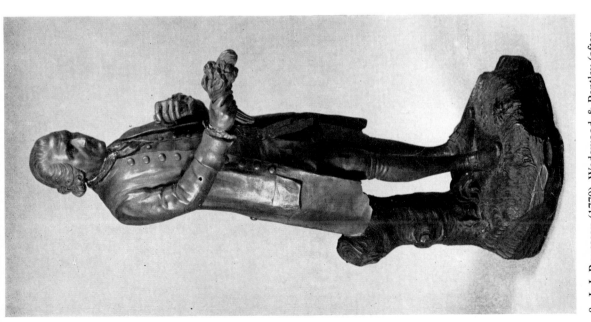

8. J.-J. Rousseau (1779), Wedgwood & Bentley (after Mayer)

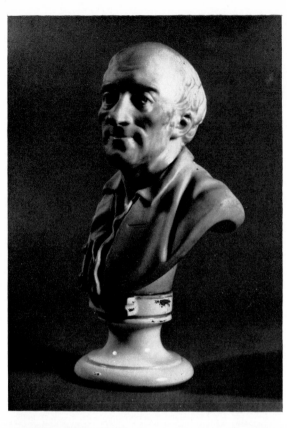

10. Voltaire (1767), Sèvres (after Rosset)

11. Voltaire (1778–1800?). Sèvres (after Houdon)
12. J.-J. Rousseau (Revolution?). Sèvres (after Houdon)

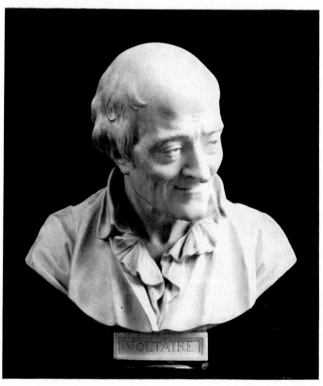

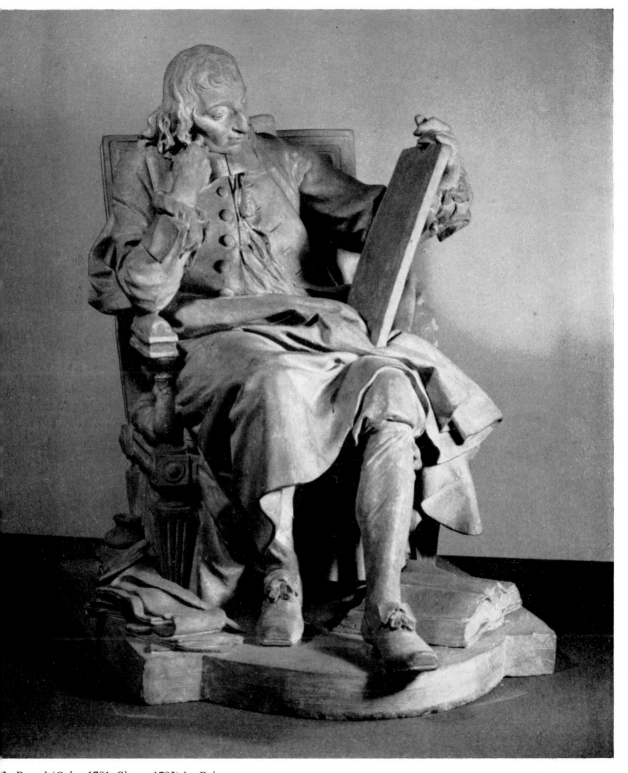

3. Pascal (*Salon* 1781, Sèvres 1783) by Pajou

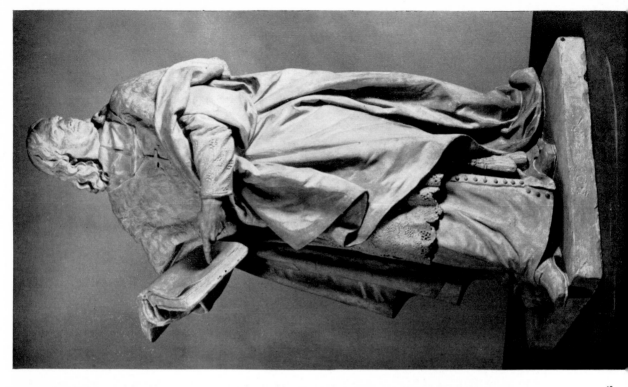

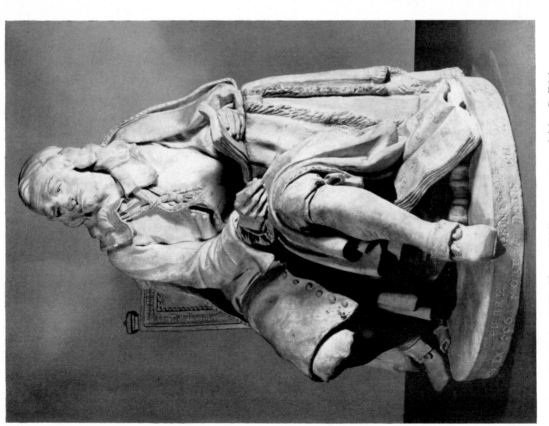

14. Corneille (*Salon* 1779, Sèvres 1783) terracotta model by Caffiéri (*Figures des Grands Hommes*)

15. Bossuet (*Salon* 1789, Sèvres 1783) by Paiou

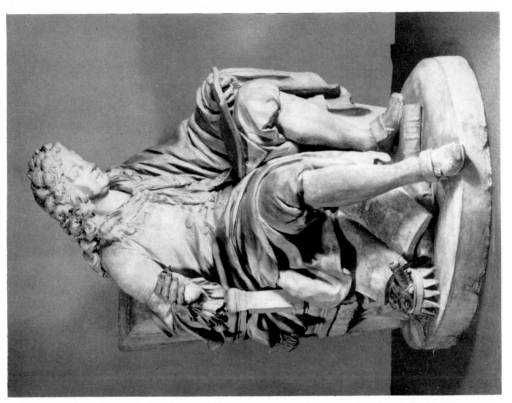

16. Montesquieu (*Salons* 1779, 1783, Sèvres 1784) by Clodion

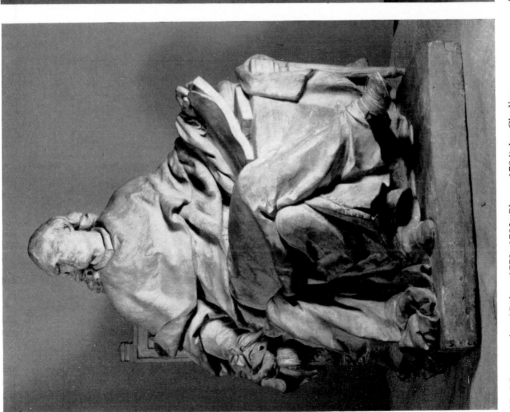

17. Racine (*Salon* 1785, Sèvres 1785) by Boizot

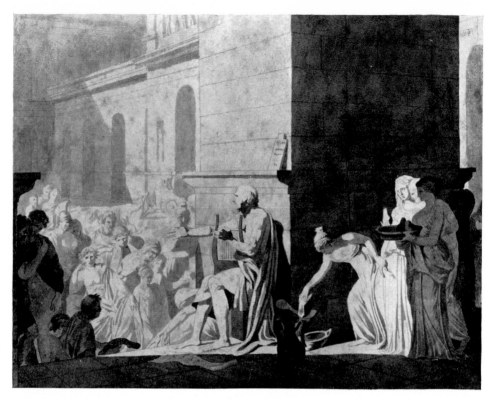

18. J.-L. David, *Homère récitant ses vers aux Grecs*

19. J.-L. David, *Homère endormi*

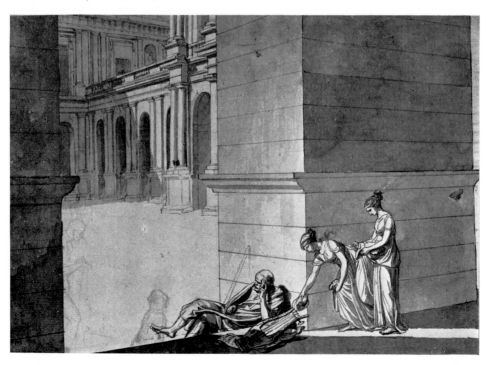

20. L. A. G. Bouchet (after), *Homère chantant ses vers*, C. Landon, *Annales du Musée* (Paris, 1814), pl. 40

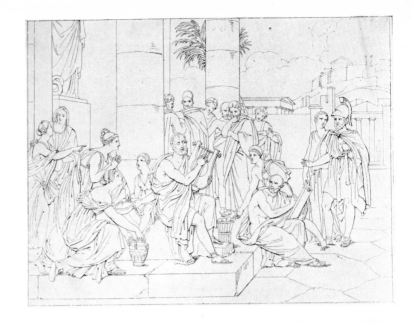

21. J.-L. David, *Bélisaire demandant l'aumône*

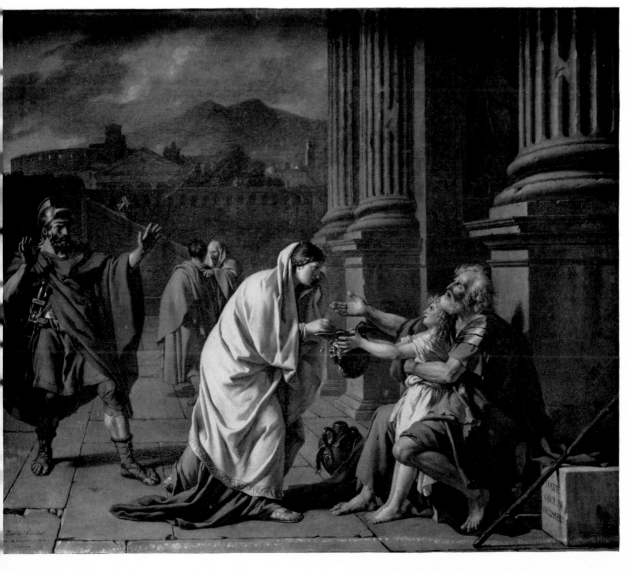

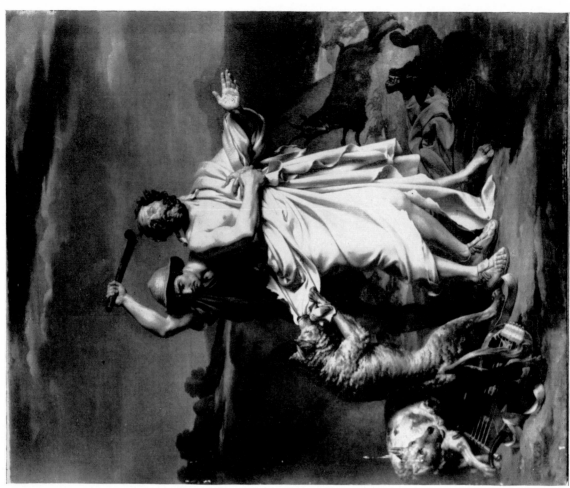

22. H.-F. Gravelot (after), *Bélisaire*, frontispiece
to the first edition of J. Marmontel, *Bélisaire*
(Paris, 1767)

23. J. P. Granger, *Homère et Glaucus*

24. F.-P.-S. Gérard (after), *Homère et son guide*, C. Landon, *Annales du Musée* (Paris, 1814), pl. 65. The original was destroyed by the artist: see H. Gérard, *Correspondance de François Gérard* (Paris, 1869), p. 16

25. F.-P.-S. Gérard (after), *Bélisaire*, C. Landon, *École française moderne*, Vol. II (Paris, 1832), pl. 48. The original, formerly in the collection of the duc de Leuchtenberg, is now lost

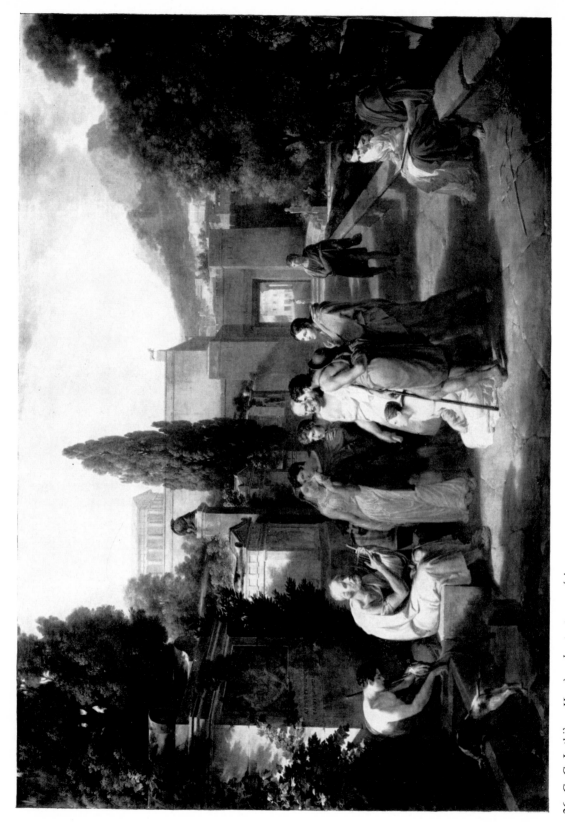

26. G. G. Lethière, *Homère chantant ses poésies*

27. H.-F. Gravelot (C. Le Vasseur, engraver). Illustration for Voltaire's *Henriade*, Chant VIII (*c.* 1768)

28. Baron Gros, *Napoleon on the battlefield of Eylau* (1870–8)

29. Benjamin Zix, *Napoleon on the battlefield of Eylau* (1807)

30. J. B. Debret (L. J. Allais, engraver), *Napoleon on the battlefield of Eylau* (1807)

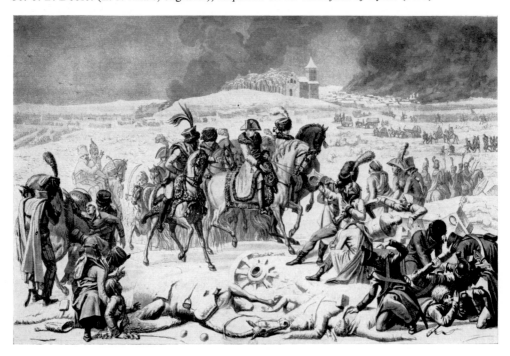

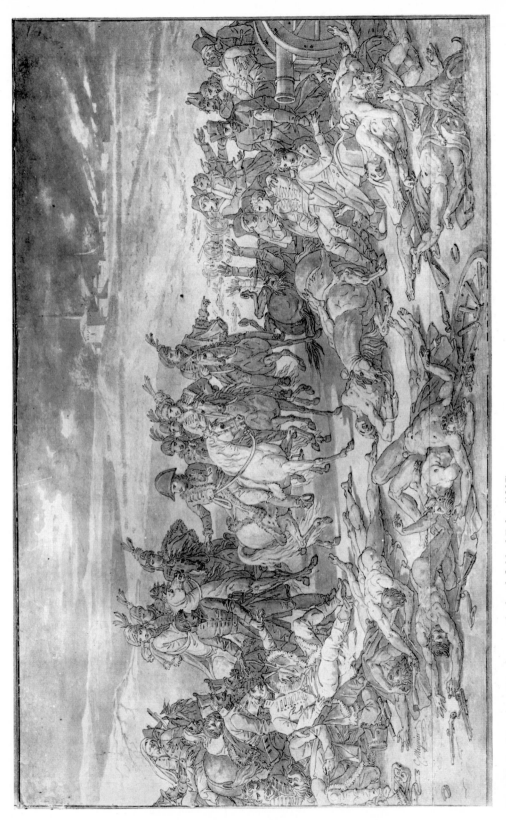

31. Charles Meynier, *Napoleon on the battlefield of Eylau* (1807)

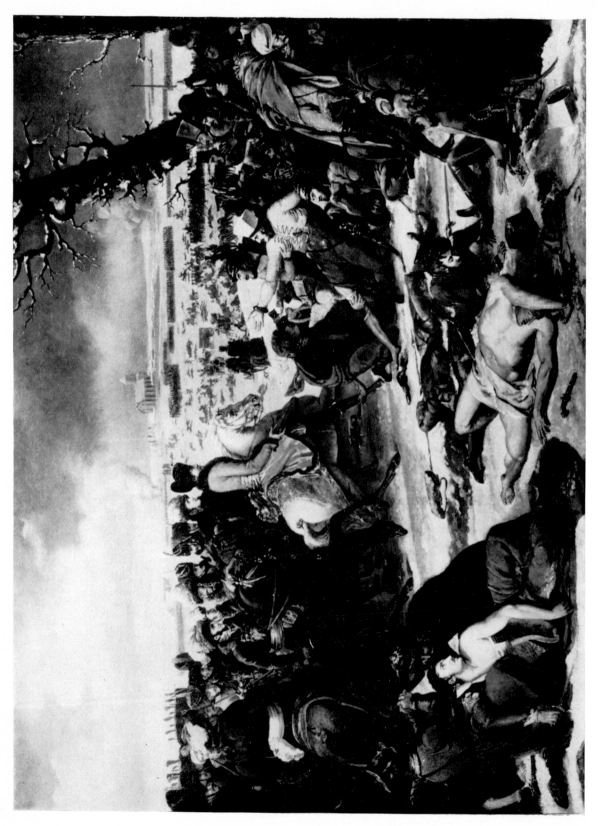

32. Artist unknown, *Napoleon on the battlefield of Eylau* (c. 1807)

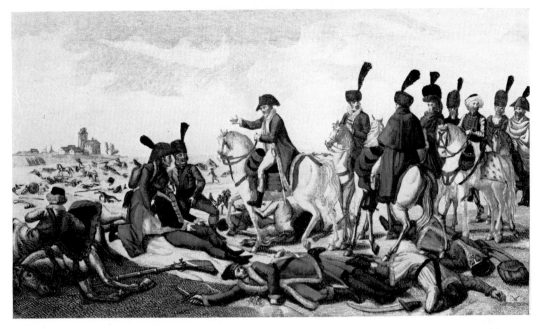

33. Popular broadside, '*Un Hussard lithuanien*', *Napoleon at Eylau* (*c.* 1807)

34. Popular broadside ('chez la Veuve Chéreau'), *L'Empereur visite le champ de bataille de Pruss-Eylan, le 17 mars 1807* [i.e. Eylau, 9 February 1807] (*c.* 1807)

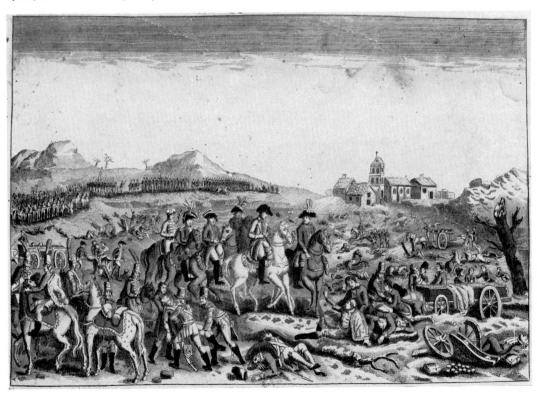

35. F. J. Belanger (Baugean, engraver), *Project for the re-establishment of a statue of Henri IV on the Pont Neuf* (May 1814)

36. Pierre Martinet (an unknown lithographer), *The Statue of Henri IV being drawn through Paris, August 1818* (1818). *Legend:* 'Jouis de notre amour, amant de Gabrielle, / Pour achever ta marche et presser tes honneurs, / A ton char en ce jour un peuple entier s'attèle / Tous les bras sont au Roi qui gagne tous les cœurs.'

37. Frédéric Lemot, *Henri IV* (1815–18)

38. Engraving by Jazet of painting by Heim, *Charles X distributing prizes to artists at the* Salon *of 1824*

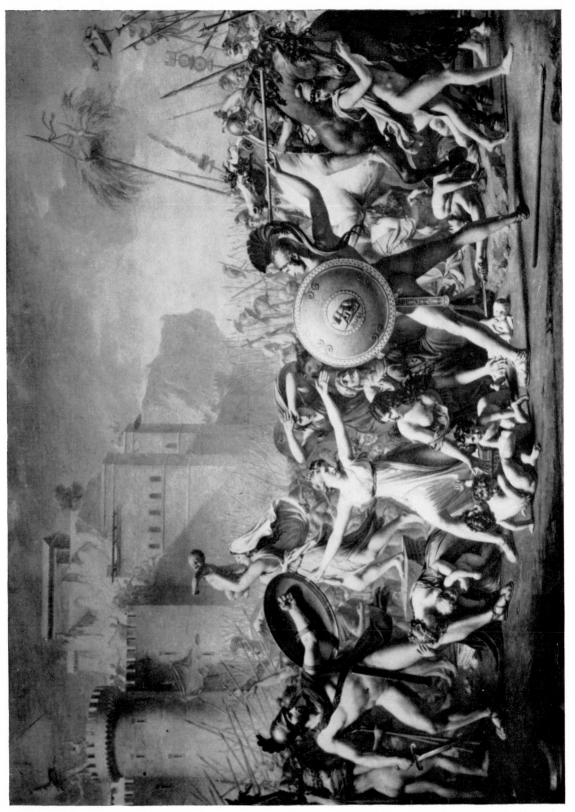

39. J.-L. David, *The Sabine Women* (1799)

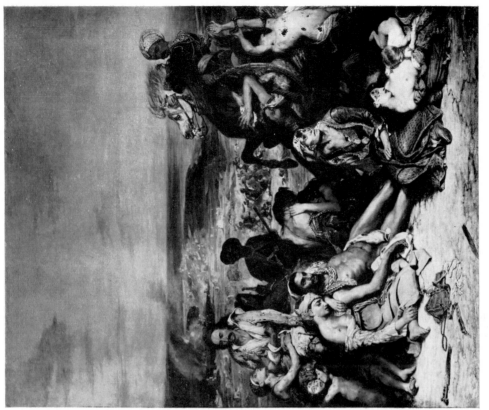

41. F.-V.-E. Delacroix, *Massacre at Chios* (*Salon of 1824*)

40. A.-L. Girodet, *The Deluge* (*Salon of 1806*)

42. F.-P.-S. Gérard, *Louis XIV and the Spanish Ambassador* (*Salon* of 1824)

43. F.-P.-S. Gérard, *Corinne au Cap Misène* (1822). A slightly different variant of this picture was shown at the *Salon* of 1824

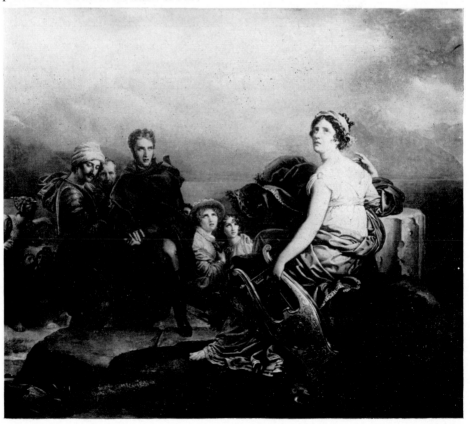

44. H. Vernet, *Battle of Montmirail* (1822) (*Salon* of 1824)

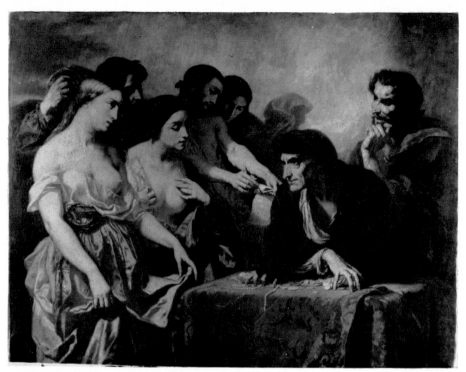

45. Thomas Couture, *L'Amour de l'or* (1843)
46. Thomas Couture, *Les Romains de la Décadence* (1847)

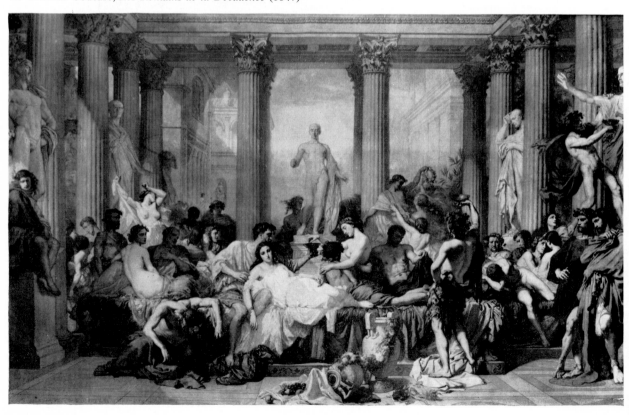

47. Théodore Géricault, *Le Radeau de la Méduse* (1819)

48. Thomas Couture, *Orgie romaine* (1843)

49. P.-A.-V. Cassel (Perronel, engraver), *Nina attendant son bien-aimé*

50. J. Bourdet, *Une Petite Fille d'Ève*

51. F.-C. Compte-Calix, *Les Sœurs de lait*

52. Alfred de Dreux, *L'Enlèvement*, Lithograph

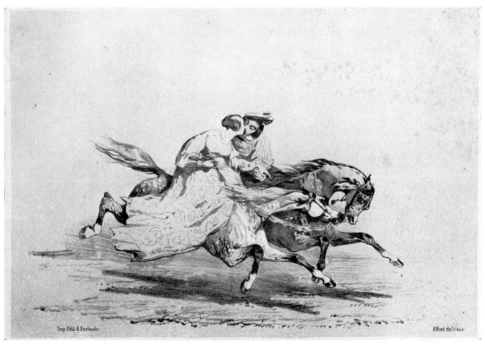

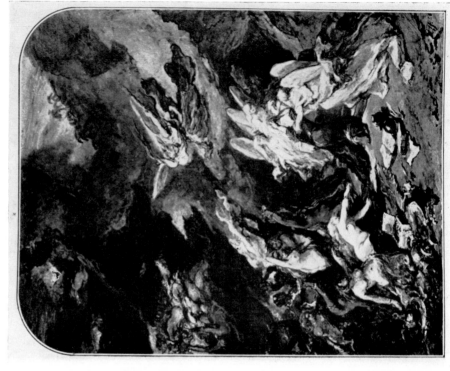

53. Georges Rochegrosse, Illustration of Flaubert's *Tentation de saint Antoine* (1707), p. 32

54. Eugène Isabey, *Tentation de saint Antoine* (1868)

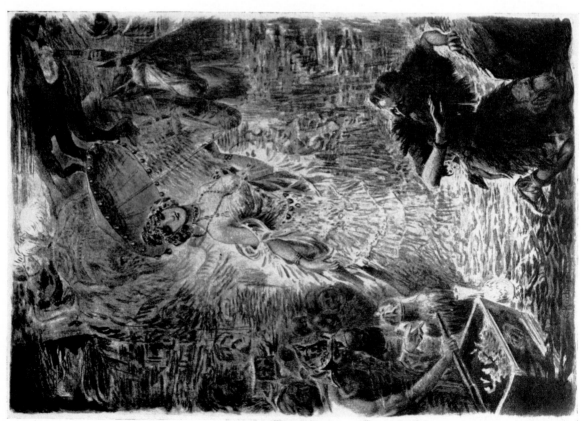

55. Paul Cézanne, *Tentation de saint Antoine* (*c.* 1875)

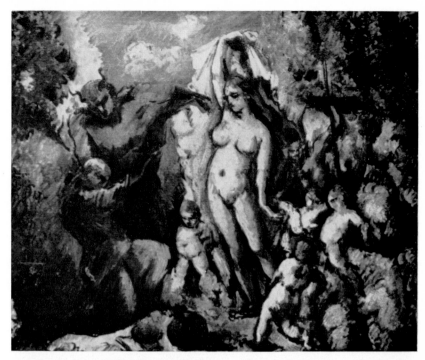

56. Fernand Khnopff, *Tentation de saint Antoine* (1883)

57. James Ensor, *Tentation de saint Antoine* (1887)

58. Henri Rivière, *Tentation de saint Antoine* (Paris, 1888), p. 63

60. Odilon Redon, *Tentation de saint Antoine* (1896), pl. 4

59. Odilon Redon, *Tentation de saint Antoine* (1888), pl. 3

62. Grandville, *Concert à la vapeur*. from *Un Autre Monde* (Paris, 1844)

61. Grandville, *Pensée*, from *Les Fleurs animées*, Première Partie (Paris, 1847)

LA BATAILLE DES CARTES.

63. Grandville, *La Bataille des cartes*, ibid.

64. Grandville, *Iron Bridge spanning the Planets*, ibid.

66. James Abbott McNeill Whistler, *Portrait of Stéphane Mallarmé*, lithograph (1892)

65. James Abbott McNeill Whistler, *The Winged Hat*, lithograph

68. Odilon Redon, *La Fleur du marécage une tête humaine et triste*, pl. II from *Hommage à Goya*, lithograph

67. Odilon Redon, *Un Fou, dans un morne paysage*, pl. III from *Hommage à Goya* (1885), lithograph

70. Odilon Redon, *Au réveil j'aperçus la déesse de l'intelligible,
au profil sévère et dur*, pl. VI from *Hommage à Goya*, lithograph

69. Odilon Redon, *Il y eut aussi des êtres embryonnaires*, pl. IV from
Hommage à Goya, lithograph

72. Odilon Redon, *Un Étrange Jongleur*, pl. V from *Hommage à Goya*, lithograph

71. Odilon Redon, *Dans mon rêve, je vis au Ciel un visage de mystère*, pl. I from *Hommage à Goya*, lithograph

73. Wilhelm von Kaulbach, *Goethe in Frankfurt*, from *Les Femmes de Goethe. Dessins de W. de Kaulbach avec un texte de Paul de Saint-Victor* (Bruxelles, 1872)